Rock Trails

South Wales

Paul Gannon

Pesda Press LTD

www.pesdapress.com

Cover Photo: Mynydd Du looking east towards Fan Gyhirych

Published 2016

Published in Great Britain by Pesda Press
Tan y Coed Canol
Ceunant
Caernarfon
Gwynedd
LL55 4RN

ISBN: 978-1-906095-52-9

Printed and bound in Poland, www.lfbookservices.co.uk

To the colliers of South Wales

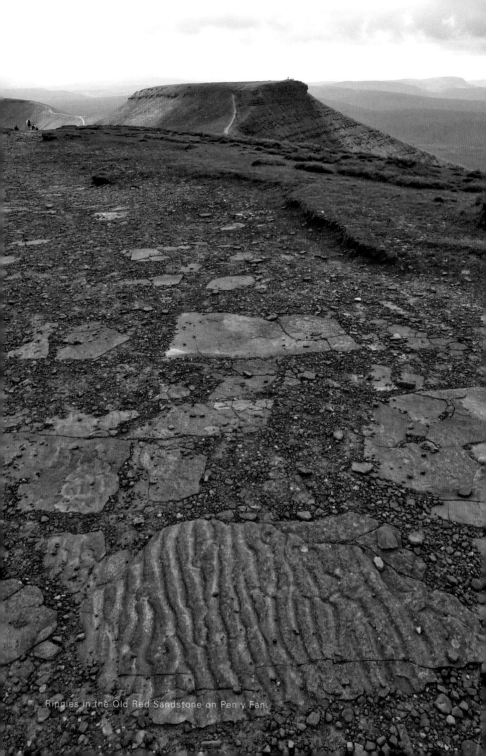

Ripples in the Old Red Sandstone on Pen y Fan.

Contents

CONTENTS

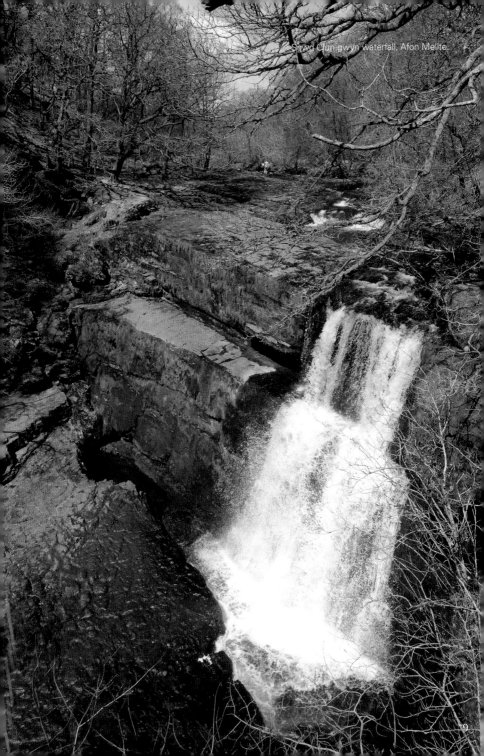

Sgwd Clun-gwyn waterfall, Afon Mellte.

Introduction

The hills, valleys and coasts of South Wales are some of Britain's most celebrated and iconic landscapes. The coasts of Gower and Pembroke, and the shapely peaks of the Brecon Beacons, are especially popular, attracting many hundreds of thousands of visitors. South Wales also offers other less well known yet immensely attractive landscapes.

These varied landscapes reflect a highly diverse geology. From the rolling hills of Mid and West Wales, the spectacular heights of the Brecon Beacons, the rocky outcrops of Fforest Fawr and Mynydd Du, the valleys and moors of 'the coalfield', to the delightful scenery of the southern and western coasts – each has its own fascinating geological story to tell. This book is aimed at the walker who sets out among these hills and coasts and who wants to learn a bit more about the forces that forged this landscape.

The development of the South Wales landscape is an amazing story involving the gargantuan forces generated by the collision of continental 'tectonic plates', as well as the slow, chemical breakdown of the rocks. This book gives the reader an appreciation of the relationship between geology and landscape. Whether it is detecting gross tectonic forces in folded rocks on the coast and inland, spotting 'sink holes' where surface water mysteriously drains underground, or identifying fissures that are precursors to landslides in the coalfield, this book will help the walker unravel the landscape they see around them.

The book is divided into two parts: the first is an account of the geological history of South Wales, while the second part contains sixteen walks where you can see evidence of the geology, along with some of the most outstanding scenery of the region. Inevitably, in choosing just sixteen walks to represent the landscape of such a large area, I have had to make tough, arbitrary choices over which walks to include and which to leave out. However, it should be possible to apply what one can learn from the book, whether it be folds, sink holes or fissures, on walks elsewhere in the region.

The walks are not the usual type of 'geology walk', visiting a site close to the road to see a specific rock outcrop, and smashing lumps out of it with a hammer to study with a hand lens, aiming to identify the constituent minerals of the rock. Rather I aim to explain the geology you will encounter on an ordinary hill or coastal walk, relating the rocks to the landscape. The rock type and the scenery often have a very close relationship in South Wales, and some understanding of the geological forces behind the scenery opens a new way to appreciate

the landscape for hill and coastal walkers. There is no need for hammers or other special equipment. The only requirements are attentive eyes and an inquisitive outlook (although strong reading glasses can be very handy for looking at fossils in rocks).

I aim to explain in clear, straightforward language the forces that have created the landscape, with a minimum of jargon. All the same, geology is a science which depends heavily on a scientific terminology, and it will be necessary to use a number of geological terms such as 'strata', 'weathering', 'moraines' and the like. I identify such jargon the first time it is used by putting it in 'quote marks'. Many of these terms are defined in the glossary at the back of the book, but not all – in some cases I have assumed that the meaning is plain from the context.

It may well help the reader to have at hand the 1:50,000 scale OS maps while reading the book, in order to get a view of the landscape under discussion. South Wales is a big area and that would demand several printed maps. However it is now possible to buy (fairly cheaply) the 1:50,000 scale map for the whole of Britain in digital form. It is recommended that the appropriate 1:25,000 OS map is used for navigating on the walks. An index of local place names mentioned in the text is provided at the back of the book, along with a grid reference for each entry to help locate places on a map. A glossary of Welsh words is also provided, as place names in Welsh are often evocative or descriptive and add to the lustre of the landscape.

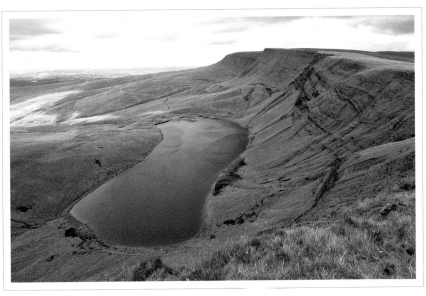

Photo 0.1 | Llyn y Fan Fach, a lake occupying a glacial basin carved into the Old Red Sandstone 'escarpment' under Bannau Sir Gaer (Carmarthenshire Fans) in the western Brecon Beacons.

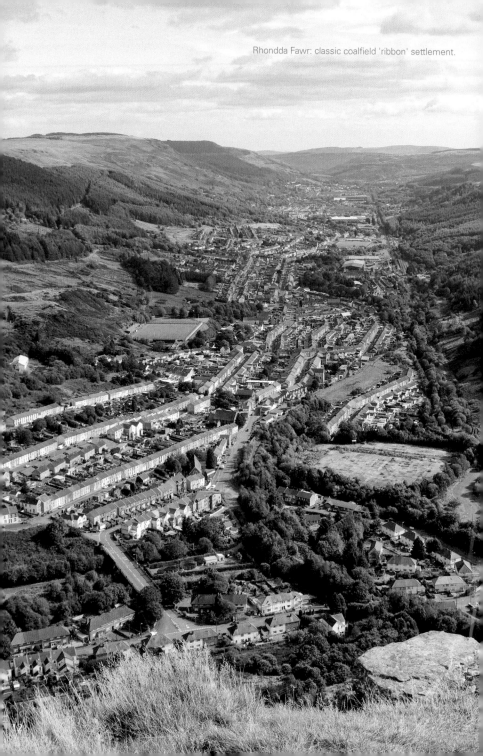

Rhondda Fawr: classic coalfield 'ribbon' settlement.

CHAPTER 1

Under Wales

We can start our look at the landscape and geology of South Wales by reviewing the scenery to be seen from atop Pen y Fan, the highest point in South Wales, and the most popular destination for hillwalkers in the range of hills known as the Brecon Beacons. The rocks making up these hills are called the 'Old Red Sandstone' by geologists and are estimated to date from over 360 million years ago, a truly staggering amount of time. The present-day hills are the remnants of once much mightier mountains, most of which have now been eroded away to leave this much loved landscape.

On a clear day the views from these ancient mountains are magnificent, and the eye can follow the line of hills of the Brecon Beacons range, running some 50 kilometres from Mynydd Du in the west, all the way to the Black Mountains and the border with England in the east.

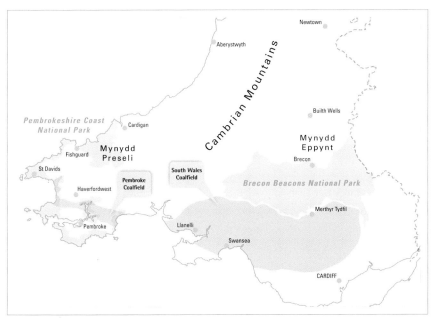

Map 1.1 | South Wales.

The sharp, steep, north-facing ridge forms one of the most dramatic features of the South Wales landscape (see Photo 1.1).

To the north are the rolling hills of Eppynt and beyond you can see the eroded plateau of the Cambrian mountains of Mid Wales. In good visibility the great lump of Pumlumon is distinguishable on the far skyline. Hidden under the vegetation covering these hills are rocks that are even older than the Old Red Sandstone, being up to 400 million years old (and there are some even older rocks which occur just north of Builth Wells, and in Pembroke too, which date from around 600 million years ago).

Photo 1.1 | Pen y Fan, the highest point in South Wales.

Turning round to look south (see Photo 1.2) we can see somewhat younger rocks dominating the view. These date from about 300 million years ago. Just south of the Old Red Sandstone the rock type changes to what is called 'limestone', then back to more sandstone (of a coarse type known as 'Millstone Grit'). Younger still are the rocks, including rich seams of coal, which form the southern skyline and the 'coalfield plateau' (see Photo 1.3).

There are even younger rocks on parts of the coast due south of here (some as 'young' as just 200 million years old), but the core of the South Wales landscape is built on rocks created roughly in the time span between 420 million and 290 million years ago. From this high point of Pen y Fan, you can thus cast an eye over rocks that were laid down over several scores of millions of years.

However, even that seemingly incomprehensible stretch of time is only a small part of the earth's overall life span of (so far) 4.5 billion years. In understanding our home planet, the key concept of modern geology is that of 'plate tectonics'. This is one of the great scientific revolutions of the 20th century and is still being developed today, gaining in richness of insight into how the inner workings of our planet determine its outer shape.

Photo 1.2 | View south from Pen y Fan towards the South Wales coalfield (distant skyline).

The idea is that the earth's surface is a series of independent but interlocking 'tectonic plates' with the brittle upper topping known as the 'crust'. There are two types of crust, continental crust and oceanic crust. The continental crust extends some way out to sea as a continental shelf, so the actual boundary between continental and oceanic crust is thus some distance out from the coast. Much of our story will take place towards the edge of a chunk of continental crust on which the rocks of present-day South Wales were laid down – with much of its time spent just under or just over sea level on the continental shelf.

Way beneath our feet, completely out of sight and quite deep in the earth's crust, lie some truly ancient rocks which form the 'basement' or foundations on which the rocks of the Cambrian mountains, the Brecon Beacons and the coalfield were laid down.

This ancient underlying chunk of continental crust was, 420 million years ago, located a short distance south of the equator. Over the next 130 million years it was slowly driven

northwards while the rocks we see today were being laid down on top of the ancient basement. During this time the plate crossed the equator, to end this time period a short distance further north. Since then the northward journey has continued, and our bit of a plate, attached to the much bigger Eurasian plate, is but temporarily where it now is.

It is thought that the plates are driven around the surface of the earth by convection currents within the earth's 'mantle', which in turn are powered by radioactive heat in the earth's central 'core' - see Diagram 1.2. The diagram shows an idealised version of the convection currents and the actual situation is more complex and the subject of intense debate among earth scientists.

The plates can pull away from each other, slide past each other or collide. Each type of interaction affects the geological record differently. We can see these processes at work in the world today:

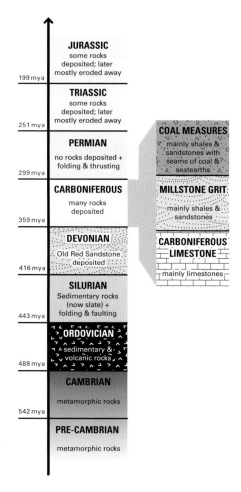

Diagram 1.1 | Geological timescale in South Wales.

the collision of continents builds mountain ranges, such as the Alps and Himalayas; the collision of the Pacific oceanic plate with the Asian continental plate creates the 'ring of fire' with its volcanoes and earthquakes; meanwhile oceanic plates pulling apart in the middle of the Atlantic result in the creation of new oceanic plate at mid-oceanic volcanic zones.

The rocks that form the tectonic plates essentially originated from volcanoes which spewed out lava and volcanic fragments. These hot volcanic emissions rapidly cool down and solidify into solid rock - known as 'igneous' rocks.

The presence of an active atmosphere, with plenty of rainwater, creates the conditions for erosion of the rocks, by physical battering in floods, and by freeze-thaw in the cold. Rocks in contact with the atmosphere are also broken down by chemical weathering. Streams and rivers carry the eroded sediments down to lakes and seas, dumping them there. The sediments slowly dry out and get compressed into hard rock, known as 'sedimentary rock'.

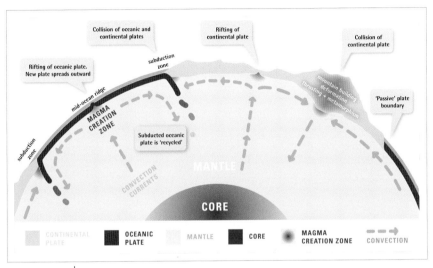

Diagram 1.2 | Plate tectonics.

Another type of sedimentary rock is formed in part from the remains of shell animals in the form of a 'limestone' mud, which is deposited in shallow tropical seas and then hardens into solid rock. Also, some layers of rock in the landscape are interspersed with seams of 'coal'. The coal was created by the compression of vegetation in the swampy conditions on the continent edges in tropical climates around 300 million years ago.

Geologists also recognise a third category of rocks, namely those known as 'metamorphic' rocks. These are rocks which have undergone considerable transformation due to the long-term application of heat and pressure – conditions that occur deep in the earth's crust.

In this book we will meet igneous rocks only marginally (in Pembroke and near Builth Wells), and just a few metamorphic rocks, such as 'slate'. The bulk of our story, however, will be about the environments in which the sedimentary rocks – sandstones, limestones and coal – were created. We will look at how these rocks were then turned into hills and, after that, how they were shaped by water and ice into the landscape that exists all around you, as you survey the scenery from atop of Pen y Fan or other high points in South Wales.

Before moving on in the next chapter to look at the earliest rocks of South Wales, it is worth making a comment about the importance of time in geological processes. Erosion by chemical and physical weathering may only reduce the height of a mountain range by a millimetre a decade. But over millions of years that can reduce large mountains to tiny stumps.

On the other hand, the processes of sedimentation may lead to just an extra millimetre a decade being laid down, eventually to become solid rock. Again, over millions of years, that can lead to rock outcrops that are hundreds or even thousands of metres thick.

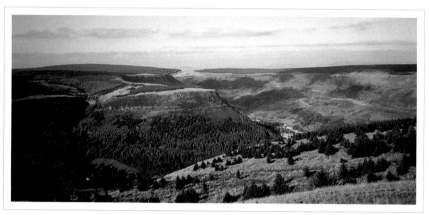

Photo 1.3 | An ancient eroded surface forming the coalfield plateau, with narrow valleys carved by recent glacial activity; Rhondda Fawr.

The capacity of geological processes to build and destroy enormous mountain ranges makes sense when you conceive of those processes operating with stubborn persistence over millions and millions and millions of years.

Having said that, as we shall see in later chapters, some geological processes are sudden and even calamitous. The hills of the South Wales coalfield in particular are frequently affected by landslides – there are hundreds of them scattered around the northern and central 'valleys' of the coalfield. Most of these landslides date from the last few thousand years (following the end of the last ice age). More recent landslides, in the past five decades or so, have been caused by mining, quarrying and dumping. Whether natural or human-induced, these sudden collapses take only a few seconds to happen. They are particularly dramatic aspects of the longer-term processes of reducing the hills to sediments which will then be recycled into sedimentary rocks anew.

CHAPTER 2

Early Wales

The oldest rocks in South Wales are found in the south-western tip of the region. The very oldest of these rocks, near St Brides Bay, date from a mind-blowing 641 million years ago (see Photo 2.1). Slightly younger rocks, found on the edge of St Davids peninsula, were created between 610 and 575 million years ago.

These ancient rocks are 'igneous' or 'volcanic' in origin and were formed mainly from molten 'magma' erupted either as 'lava' or as fragments from violent, explosive ('pyroclastic') volcanoes. However, some of these rocks were formed by magma that didn't reach the surface, but cooled down squeezed in between the rocks below the surface (and now exposed at the surface by erosion of overlying rocks). These are known as 'intrusive' igneous rocks.

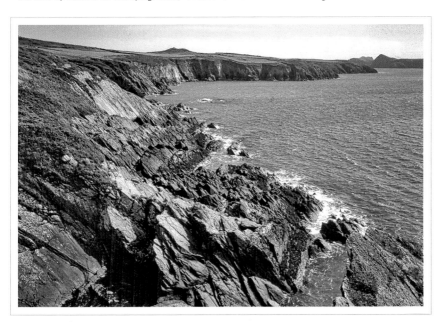

Photo 2.1 | The oldest rocks in South Wales, dating from about 640 million years ago, on the Pembrokeshire coast, near St Davids.

In the several hundreds of millions of years since they were created, the earth has undergone a lot of tectonic activity, and the ancient rocks have been subjected to intense tectonic forces during phases of continental collision. The rocks have been transformed internally (in a process known as 're-crystallisation') as a result of the high temperatures and extreme pressures they experienced during the continental collision. They are thus now classified as 'metamorphic' rocks, albeit of igneous origin.

These ancient metamorphic rocks lie next to slightly younger rocks which also include a few limited areas of igneous rocks (such as Carn Llidi, Strumble Head and Mynydd Preseli), but these neighbouring rocks are overwhelmingly sedimentary. They were formed from the eroded sediments of the earlier uplands, carried down by rivers and dumped in rivers, estuaries and the seas. The sedimentary rocks of West Wales merge into more sedimentary rocks that form the Cambrian mountains of Mid Wales.

These sedimentary rocks date from between about 541 million and 410 million years ago. Like the earliest rocks, they have also been subjected to a range of tectonic forces during collision of tectonic plates, most especially during the final few tens of millions of years of the time when the mountains of North Wales (as well as those of Lakeland, Scotland, Scandinavia and the Appalachians of north-east America) were being built.

All these ancient rocks of South West Wales are mixed up, creating the complex interplay of rock types we see on the geology map of the St Davids area today (see inside cover map and Map w15.1). Chunks of colliding continents were broken up, dragged down deep, and then thrust back up again by the enormous earth movements. Since then the big mountain range that was built up has been eroded away, revealing the stumps of those former mountains as today's landscape.

Much of this geological history is hidden from view under the lush vegetation that covers most of South West and Mid Wales. However, the coastal cliffs of Pembroke allow us a view into both the ancient and slightly less ancient rocks, and the tectonic indignities they have undergone.

Near Porth Clais a graphic example of an ancient intrusive igneous rock can be seen cutting through sedimentary rocks (see Photo w15.1). The wide band of igneous rock was injected in between layers of the sedimentary rock, but it never made it all the way to the surface, and cooled down to form rock some distance underground, cutting across the sedimentary beds of earlier rock. The igneous rock and sandstone are now exposed at the surface only because overlying rock has been eroded away.

Coastal erosion has also exposed some marginally less ancient volcanic rocks along the Strumble Head peninsula. On the eastern end of the peninsula at Pen Anglas, just north

of Fishguard, there is a spectacular display of a feature that occurs in some igneous rocks, known as 'columnar jointing' (see Photo 2.2). This is created when molten magma cools. If it loses heat quickly enough it will contract very slightly in a regular pattern to form hexagonal 'jointing'.

The best-known examples of columnar jointing are from Staffa Island in Scotland and Giant's Causeway in Northern Ireland, but it is quite a common feature in igneous rocks in Snowdonia and can be seen on a limited scale here in South West Wales. The photo shows a slice through the columns and shows, for scale, the author at the top of the outcrop. A few columns can be seen in section in the top right-hand of the photo.

Just a short distance further west along the coast, outcrops of rocks formed from molten lava that erupted under sea level can be seen from the coastal path. The great pressure of seawater confined the erupting magma into forming blob shapes. This is known as 'pillow' lava (see Photo 2.3). These rocks are about 200 million years younger than the oldest ones seen on St Davids Head, thus dating from about 430 million years ago.

The volcanoes that spewed out the lava, and also 'fragmental' (or 'pyroclastic') eruptions, were the result of a collision around that time between the continental plate holding our chunk of accumulating rock and the neighbouring oceanic plate.

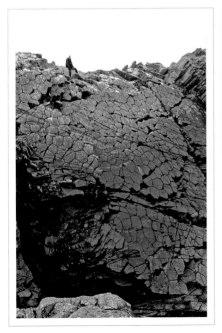

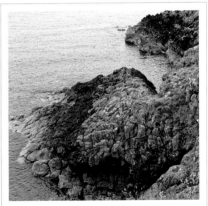

Photo 2.2 (left) │ Columnar jointing exposed on Pen Anglas, with the author for scale.

Photo 2.3 (above) │ Pillow lava near Penfathach.

Oceanic plates are thin and dense, while continental plates are thick and less dense. Therefore, when they collide into one another the denser oceanic plate dives down underneath the continental plate, in a process known as 'subduction'. The subducting plate drags down masses of seawater with it. Once it is underneath the continental plate this seawater is released into the upper 'mantle' and has the effect of lowering the temperature at which the rocks melt. Molten magma is thus created at the base of the plate and then rises up through faults, eventually to erupt onto the surface as lava or pyroclastic (fragmental) volcanoes.

The volcanic rocks of Snowdonia, Lakeland and elsewhere were created in the same volcanic episode as the rocks found near Fishguard (and also some found just north of Builth Wells). However, the volcanic phase occupied only a short period of time, and the bulk of the rocks created around this time and now occupying much of South West Wales and Mid Wales are sedimentary in origin, created as the volcanic rocks and surrounding hills were eroded away, and material was dumped in the shallow seas on the edge of the continental tectonic plate.

However, once the ocean had been fully destroyed by subduction there was a collision of two continental plates. In this case there was no subduction. As the two masses of similar density collided they were compressed into a mountain range. This process builds down as well as up, and the 'roots' of the mountain range dig deeper than its peaks reach upwards. The coast near Cardigan offers some stupendous views of the contortions into which the deeply-lying ancient rocks were bent during mountain-building episodes (see Photos 2.4 and w14.2).

The rocks we see on the surface are brittle. Take a hammer, smash the rock with it and the rock will shatter. When rocks are subject to great pressure they respond by cracking ('faulting') provided they are no more than 15–20km under the surface. This is known as 'brittle' deformation. But lower than 15–20km the pressures are so intense and temperatures so high that rocks respond with 'plastic' (or 'ductile') deformation – and can be folded into fantastic shapes.

The rocks exposed on the southern side of Pen yr Afr in Photo 2.4 show clear large-scale folding, and also faulting which has broken up the rock. The amount of rock exposed in the headland is but a fraction of the total rock mass that was shoved around and folded. The rocks underneath the thick vegetation that blankets Mid Wales would probably reveal many more such intense folds over a wide area if we could see them too. This small exposure thus offers only a minor hint of the magnitude of the forces needed to compress and fold, and then to fracture, these great thicknesses of rock during the mountain-building phase some 350–400 million years ago.

These are sedimentary rocks and the folded lines represent the 'beds' or 'strata' created as different layers of rock were laid down on top of one another, originally as more or less horizontal layers. The exposures of folds seen along this section of the coast are among the most

dramatic examples of 'anticlines' and 'synclines' seen anywhere in Wales, or indeed within the whole of Britain (see Diagram 2.1). The folds and faults are positive evidence of the mountain-building activities that once took place along the continental shelf near the edge of the ancient 'proto-European' continental plate (or actually a fragment of that plate called 'Avalonia').

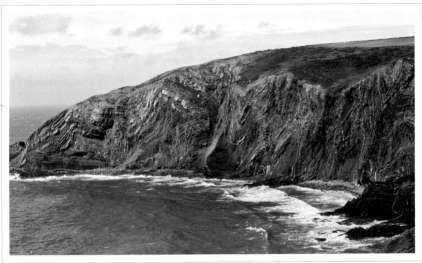

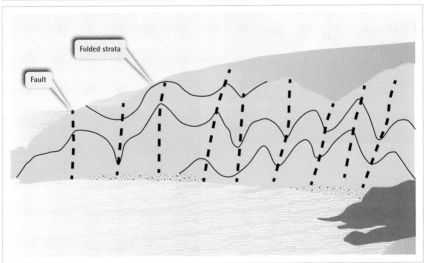

Photo 2.4 & Diagram 2.1 | Impressive, large-scale folds and faults in the rocks at Pen yr Afr, viewed from Foel Hendre.

The great pressures created by collision of continental plates can also have another consequence, the creation of a feature known by the name of 'slaty cleavage' by transforming rocks into what is called 'slate'. Slate is only created from very fine-grained rock (the original rock can be of either igneous or sedimentary origin as long as it is fine-grained). Slaty cleavage is the result of enormous pressure forcing the tiny, flattish microscopic minerals to line up in close formation with one another. This forms 'cleavage planes' between the minerals along which the rock can easily be split.

The formation of slaty cleavage is the product of pressure alone; high temperatures are not involved. This is known as 'low grade metamorphism', as opposed to the 'high-grade metamorphism' and attendant high temperatures and great pressures which 're-crystallised' rocks such as the oldest rocks in South Wales, mentioned at the start of this chapter.

If the cleavage planes are well developed so they split evenly and easily, the rocks can be used to make building or roofing material. The sedimentary rocks of South West Wales included large areas of fine-grained material which were subjected to the formation of slaty cleavage in the rocks, although in most cases not finely enough for exploitation by humans. Photo 2.5 illustrates one site of the slaty outcrops that are common on the Pembrokeshire coast, the once-worked slate quarry at Abereiddi.

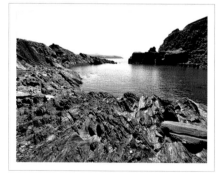

Photo 2.5 (above) | Slaty cleavage in coastal rocks; sunken remains of the former quarry at Abereiddi Bay.

Photo 2.6 (right) | Graptolites: scale: long axis of photo is 60mm; the jaw-like structure near the top is accidental.

The rocks of Abereiddi are renowned among geologists for the fossils which they contain. Indeed Abereiddi Bay has been declared a 'Site of Special Scientific Interest' (SSSI) because of those fossils. It is fairly unusual for fossils to survive the processes that create slaty cleavage. In the case of the rocks around Abereiddi, the cleavage planes, which are created perpendicular to the direction from which the compressing forces are coming, are by chance nearly parallel to the original bedding planes and so the fossils have survived. If the angle between the original bedding and the cleavage plane had been greater then it is unlikely that the fossils would have been preserved.

As Abereiddi is an SSSI, it is not permitted to hammer the rocks if you can spot fossils in them. However, at the time of writing, the old sea wall is rapidly being battered to bits by the waves at the northern end of the bay, and here you can find plenty of slivers of slaty rock with what look like little scratches. On closer examination the scratches turn out to be pretty regular with sharp points on one side – indeed close up they look like short fragments of a saw blade (see Photo 2.6). These are in fact fossils known as 'graptolites'.

Graptolites are thought to be colonies of individual animals, each sharp point representing one animal's mouth directed towards the sea from where food could be digested. The fossil remains are the 'skeleton' of the colony, made from a tough, organic material similar to collagen. It is not certain, but it is believed that the once-living animals were either attached to rocks, or may have formed clumps which floated just under the surface of the sea.

The graptolite is not the most stunning of fossils. Close examination shows how delicate these fossils are, tiny slivers of rock that contain a record of ancient life forms. Unless you know what you're looking for, you're quite likely to dismiss the small marks as scratches. However, the humble graptolite has filled a very important role in developing the science of geology.

Graptolite species evolve rapidly over time so there are lots of them – some 700 species have been identified within Britain and Northern Ireland (out of some several thousand worldwide). Geologists have studied the different species very closely and identified which layers of rock they have come from. This has enabled them to work out that a single 'graptolite zone' – the life span of one graptolite species – equates to about one million years of sedimentation. The graptolites have thus allowed geologists to work out two things; which rocks occurred in which order within South and Mid Wales, and a rough timescale for the time taken to lay down these rocks.

Naturally enough, scientists want to name the things they identify in, or assign to, nature, including the time divisions of the geological past. So, we need to take a short diversion here into the names of the geological 'Periods' into which geologists divide Earth's history. The Periods and other time divisions are divided by the fossils, such as the graptolite species, that they contain.

A lot of the early work by geologists in sorting out the different rocks and their relative ages was carried out in Wales, so several Welsh-related names were invented/borrowed. Traditionally the Periods start with the Cambrian Period, covering 541 to 485 million years ago, which was named after the Latin name for Wales (see Diagram 1.1). All the mass of time before the Cambrian was lumped together as the pre-Cambrian. Nowadays an additional Period, the Ediacaran, covers the time from 641 to 542 million years ago, given that more and more soft-bodied fossils are being uncovered from this time span. The oldest rocks in South West Wales date from this time, though they are limited in extent.

There are many outcrops of Cambrian Period rocks in Wales, especially in North Wales, but only a few in South Wales, nudging into the far west alongside the equally limited outcrops of pre-Cambrian rocks. The Cambrian Period is traditionally seen as the time when life forms exploded in quantity and variety, as evidenced by the vast range of hard-bodied fossils that appeared.

The Ordovician Period came next, and lasted from 485 million years ago until about 445 million years. This was named after Roman name for the tribes of Northern Wales, the Ordovices, where Ordovician rocks are common, especially in Snowdonia. More Ordovician rocks can be found in South and South West Wales. These are mainly sedimentary rocks, many of them subject to slaty cleavage (such as the slates of Abereiddi Quarry), though the volcanic rocks seen on Strumble Head and near Fishguard are also from the Ordovician Period.

After that came the Silurian Period, between about 445 million and 415 million years ago. The Silurian is also a name derived from Roman times, on this occasion borrowing the name of the Southern Wales tribes, the Silures. Rocks of the Silurian period form much of the heart of Wales, including the Cambrian mountains. Silurian rocks are indeed the most common rock types in Wales. This was the period in which continental collision created the folds exposed at Pen yr Afr.

Following the Silurian Period is the Devonian Period and then the Carboniferous Period, but as these Periods are of core concern for the next parts of our story, it makes sense to delay discussion of them until the next few chapters.

Given that the earth is 4.5 billion years old, the fact that the oldest rocks found in Pembroke are no more than 640 million years means that, despite their staggering age, they are actually quite youthful. There are rocks in the north-west of Scotland that are three billion years old, and even older rocks can be found in other parts of the world.

Geologists cannot be certain when life first began on earth, but it was probably somewhere around four billion years ago. What is more certain is that by at least 3.5 billion years ago life had taken a firm hold. After another 1.5 billion years, life developed the ability to photosynthesise,

beginning the long process of pumping oxygen into the atmosphere, and changing the world in other ways. For much of this time the earth would have had a blue ocean, and there would have been a cloud-laden atmosphere, but the continents were reddish in colour and totally free of vegetation. About 850 million years ago the look of the Earth's surface started to change as great masses of green photosynthetic life clustered in shallow seas.

By 650 million years ago oxygen levels were comparable with those of today, and multi-cellular life began to develop. Over several more tens of millions of years, now in the Cambrian Period, animals began to develop shells and skeletons. With the development of hard parts, the fossil record begins to deliver abundant evidence of a planet teeming with life forms that come and go over the years. The variety of life that developed is described as the 'Cambrian explosion' of life.

As we can now see, this amazing transformation of the planet and its life forms (albeit still limited to the seas and oceans), took place over the time when some of the rocks of South West Wales were being created.

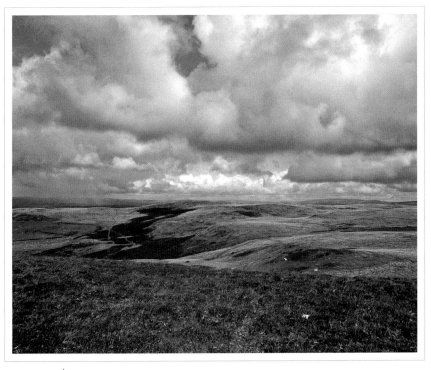

Photo 2.7 | The roughly vegetated, flattish plateau landscape of the Cambrian mountains.

Rock outcrops are rare in much of Mid Wales, except along the coasts, along some river courses, within quarries and at the few sites of igneous rocks (such as near Builth Wells and on Mynydd Preseli). Much of the bedrock is buried under lush green plant life, though the moorlands themselves are covered in rough, boggy vegetation. However, despite the cover of vegetation, there is a distinctive landscape which reflects the underlying geology of the Silurian Period; fine-grained sedimentary rocks often affected to some extent by slaty cleavage. The best description of the Mid Wales landscape is as an 'incised plateau'. The incisions are the steep-sided valleys that typify the scenery. The plateau is the more or less level moorland that is found if one walks up the valley sides (see Photo 2.7).

Indeed, so marked is this flat landscape that geologists are convinced that it must represent a plain that was carved out, either by sea currents or by rivers, many millions of years ago, but which has since been uplifted (or sea level has fallen) so giving rivers the power to cut down and create the steep-sided valleys.

In places the valley sides are less steep, and the overall effect is more of a rolling landscape, but the level nature of the higher points remains a conspicuous feature of the scenery. In fact there are several different levels that geologists have identified, and this feature of the landscape will be discussed again in later chapters (for example in dealing with the South Wales coalfield and Gower).

The underlying reason for the subdued landscape of Mid Wales, in contrast with the higher land to the north in the Snowdonia National Park and to the south in the Brecon Beacons National Park, is the comparative softness of the Mid Wales slaty/sedimentary rocks. Being less resistant to the forces of erosion, the rocks of central Wales have been heavily eroded into the present-day landscape. But, as we have seen, hidden from sight beneath the vegetation the rocks are intensely folded and faulted.

CHAPTER 3

Old Red Wales

Running east to west for some 50 kilometres across South Wales is an exceptional geological feature, an 'escarpment' that provides some of the finest upland scenery in the region. The escarpment or 'scarp' slope is the backbone of the 'Brecon Beacons' mountain range and extends from just south of Hay-on-Wye in the east, all the way to just north of Brynamman in the west (see Map 3.1). The Old Red Sandstone is replaced at the western end of the escarpment by a scarp cut into a rock type known as limestone (see Chapter 4). At its eastern end, the scarp turns north, and then south, around the Black Mountains and the eastern side of the coalfield. The naming of the whole range and its sub-sections can be quite complex – see Geographical Names box.

The most magnificent portions of the scarp slope are clustered in two places, in the centre of the range around Pen y Fan and Corn Du, and in the west around Fan Brycheiniog and Bannau Sir Gaer.

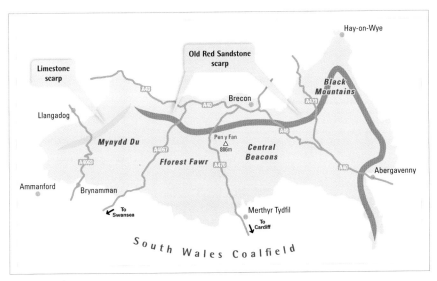

Map 3.1 | Brecon Beacons National Park.

The hilly architecture of the great scarp slope around Pen y Fan and Bannau Sir Gaer is certainly at its most dramatic when seen from the north, but these hills and slopes are also beautiful in profile. Around Pen y Fan the scarp slopes are up to 300 metres high, with layers of red sedimentary rocks clearly visible, poking through the vegetation (see Photos 1.1 and 3.1). The crags around Bannau Sir Gaer and Fan Brycheiniog are slightly less high at 250 and 200 metres respectively but are just as scenically impressive (see Photos 0.1 and 3.2).

In both these areas the current shape of the scarp slope is the product of geologically-recent glaciation, and there were several small glaciers based at the foot of the slope until just about 10,000 years ago (see Chapter 7). I have measured the height of the scarp slope by assessing roughly where the slope becomes less steep – this is frequently also the level at which one finds glacial remains such as glacial lakes and moraines (see Photos 8.5, w1.4, w4.2, w4.3, w4.4 and w4.5). Elsewhere the scarp slope is only marginally less dramatic, offering scenery dominated by sinuous curves and wide open vistas (see Photo 3.3).

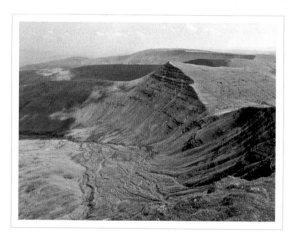

Photo 3.1 | North-facing scarp slope in the Old Red Sandstone, looking east to Cribyn from Pen y Fan.

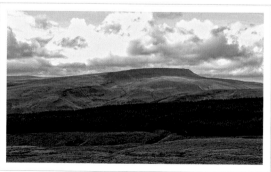

Photo 3.2 | North-east facing scarp slope on Fan Hir, looking west from the flanks of Fan Gyhirych.

Photo 3.3 | North-facing scarp slope in the Old Red Sandstone, looking west with Fan Nedd on the left and Fan Gyhirych in the centre distance.

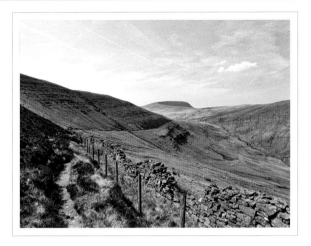

At Pen y Fan and the western 'Bannau', where the rocks are well exposed, the steep scarp slope has been sliced through clearly visible layers ('beds' or 'strata') which record the long, slow process of sedimentation. Eroded fragments of rock were carried down from an upland area to the north and were then dumped in rivers, deltas and lakes lower down. Very slowly the sediments accumulated and became quite thick, even some hundreds of metres thick. When the sediments dried out, and went through chemical changes, they became the solid rock that we see today exposed in the spectacular ridgeline.

As mentioned above, the rocks exposed in the steep scarp slope are what geologists call the Old Red Sandstone. This geological 'formation' covers a vast sweep through the centre of South Wales with a thickening of the width of the outcrop around the Black Mountains and towards the English border (see map on back inside cover). The main outcrop thins as one travels west across South Wales, but it stretches almost unbroken to the Pembroke coast. A southern loop runs north of Newport to the north-west of Cardiff, and an 'outlier' provides the highest points on the Gower peninsula, including Rhossili Down and Cefn Bryn.

The reason for calling the rocks 'Old' is not immediately obvious. They are reckoned to have been created mostly in the 'Devonian Period' (as you can also find Old Red Sandstone in Devon) between about 415 and 360 million years ago. Now that certainly is old on any conceivable human scale. All the same, it represents only about 8% of the earth's age, and there are many much older rocks than these. In fact the 'Old' in the name is used simply to distinguish these rocks from those of the 'New Red Sandstone' which are found elsewhere (in England), and which date from some 100 to 150 million years later, in the 'Permian' and 'Triassic' Periods.

The 'Red' bit of the name accurately conveys the colour of many (but not all) of the rocks which are included under this label. Some of the older Old Red Sandstone rocks are actually greenish, and some of the youngest are grey in colour.

The name is also generally accurate in describing the rocks as 'sandstones' though, as we shall see, other rock types, including 'mudstones', are also part of the Old Red Sandstone beds. 'Sandstone' is a rock made up predominantly of grains of 'sand'. For geologists the definition of 'sand' is any fragment sized between 2mm and 0.0625mm. Strictly speaking the term 'sand' doesn't tell you anything about the type of rock fragment, only its size. Smaller fragments are known as 'silt', and smaller still as 'mud'.

When these sedimentary fragments of 'mud', 'silt' or 'sand' dry out, harden, and undergo chemical changes to cement them together, they become, respectively, 'mudstone', 'siltstone' or 'sandstone'. The definition again depends purely on the size of the grains in the solid rock.

However, the 'sand' label can in fact give us some hints as to the rock type that has been eroded into fragments sized between 2mm and 0.0625mm. About 70% of sand in the world is made of grains of 'quartz' (a form of silicon dioxide). This is because quartz is resistant to both chemical and physical weathering. It takes a long time to physically batter and chemically process it down to the size of sand particles, and once it gets to that size it becomes even harder to get it smaller. On the other hand, other mineral types are broken down more easily. They too pass through the stage of being sand grain-sized, but soon get made smaller still and become silt or mud-sized fragments.

It thus comes as no surprise to learn that the Old Red Sandstone is predominantly composed of quartz (see Photo 3.4). It is thus a very tough quartz sandstone that forms the highest ground in South Wales. Indeed the tallest summits derive their loftiness from the thin remaining beds of a particularly resistant quartz sandstone, given the name of the 'Plateau Beds'.

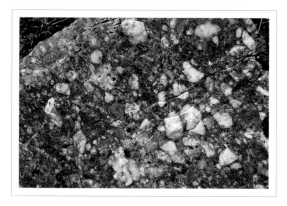

Photo 3.4 | Quartz pebbles cemented in a matrix of quartz sand grains – the red colour derives from iron in the rocks.

The Plateau Beds are only about 7.5 metres thick at their greatest extent, but their slow rate of erosion is what gives hills such as Pen y Fan, Corn Du, Fan Fawr, Fan Gyhirych and Bannau Sir Gaer their flat-topped but elegant profiles. Where the Plateau Beds are absent (because of erosion) the hills are slightly softer and more rounded in shape (such as Cribyn and Fan Nedd), lacking the very sharp slope edges seen in profile on Pen y Fan, Bannau Sir Gaer and Fan Hir.

When we look a little more closely, we see that these great red hills can also reveal information about the changing geography of the area when the grains of sand were laid down. The main events took place a short distance away from the area of our focus, with the complex collision of three continental plates, part of the even longer-term process of forming a single supercontinent. In our area this process involved three episodes of mountain-building, the first of which had the important consequence for South Wales of a large mountain mass developing to the north, in present day Snowdonia.

Erosion of this mountain mass meant that a large volume of eroded fragments of rock was available to be transported downstream by rivers and streams, to be dumped in the lowland river channels, lakes and eventually the seas of South Wales. Once dumped, the sediments slowly started to form layer after layer of rock.

It used to be thought that the subsidence could be entirely attributed to the depression of the underlying mantle rocks due to the weight of sediments being dumped in the basin ('load generated flexural subsidence' in the unlovely jargon of geology). However, in more recent times the view has swung round to the idea that tectonic activity caused 'extension' or stretching of the crust, creating a 'basin' in which the material needed to make the South Wales Old Red Sandstone rocks was dumped.

At this time the bit of tectonic plate that is today under South Wales was getting close to the equator and experienced a semi-arid climate. It is estimated that our chunk of tectonic plate moved during the Devonian Period from about fifteen degrees south of the equator to just five degrees south. New forms of plant and animal life were common, and many species thrived among the estuaries, broad river ('alluvial') plains, and wide, sandy, meandering, course-shifting rivers. The rivers were dry for most of the time, but intermittent downpours fed them with fast-flowing water laden with sediments carried down from higher parts of a desert landscape.

The sand and mud eroded from the newly-uplifted highlands found its way down to these areas. First, the finer material was carried some way out before it fell out of suspension in the water. Powerful floods would carry sand-sized grains and even larger particles, known as gravel and pebbles, less far out from shore and dump them here. The result is a mix of beds of mudstone and sandstone with some pebble-sized lumps (see Photos 3.4 and w12.1).

The rocks in some places show evidence of the currents of water that swirled around the environment where the sand grains were deposited – see Photo 3.5 which shows a feature known as 'cross-bedding' where water currents shift and cause new beds to cut across older beds.

The hills of Mynydd Eppynt are some of the oldest beds of the Old Red Sandstone and are a mix of sandstones and mudstones. Many of the older Old Red Sandstone rocks are not red at all, but green to grey. However, the younger rocks are more likely to live up to the 'red' label. The younger rocks also tend to become more dominated by sandstones with fewer beds of mudstone; notably, the Upper Old Red Sandstone which forms the Plateau Beds (see Photo 3.6), and the Grey Grits (this set of rocks, however, being distinctly grey and not red).

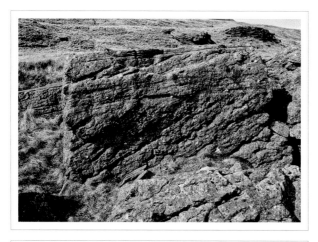

Photo 3.5
'Cross-bedding' in Old Red Sandstone, showing two beds in the perched block with larger lumps at the base of each bed.

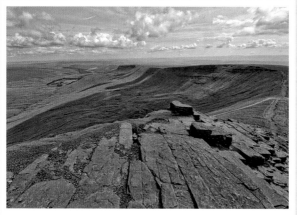

Photo 3.6
Red-coloured Plateau Beds exposed on the summit of Corn Du, looking southwards along the Taf Fechan valley, with the coalfield on the skyline.

In fact there is a big time gap within the Old Red Sandstone in South Wales. The Lower (i.e. older) Old Red Sandstone is present and makes up the bulk of the rocks. The Upper (i.e. younger) Old Red Sandstone is also present, as the Plateau Beds and the Grey Grits, but in much lesser thicknesses. However, the Middle Old Red Sandstone rocks, found elsewhere in Britain and other countries, are not present in South Wales.

This tells us that, for a while in the middle of the time span when the rocks were being laid down, the 'Welsh Basin' was sufficiently above sea level for no sedimentation to take place. Some interruption had occurred to the long-running process of subsidence, with the result that the Middle Old Red Sandstone rocks are missing from South Wales. Part of the answer lies in the fact that there was a phase of mountain-building pressure between about 400 and 390 million years ago. This led to compression of the plate resulting in elevation; as a result no sediments were laid down in that time span in the Brecon Beacons area (though the middle beds of the Old Red Sandstone were laid down elsewhere in areas not affected by the compression of the plate).

The older, Lower Old Red Sandstone rocks form the undulating scenery that merges quite inconspicuously into the lush scenery of parts of Mid Wales. Mynydd Eppynt is a classic example with its rolling hills and deep valleys. Access to Mynydd Eppynt has traditionally been difficult due to its role as a military training ground with lots of live shelling exercises; however some routes are now open to the public.

When the mountain-building phase came to an end there was renewed stretching of the plate, and the resulting subsidence meant that the area was again subject to seasonal rivers carrying and dumping sand and mud. This created the (younger) Upper Old Red Sandstone and laid the basis for the most dramatic scenery of the Brecon Beacons, with distinct uplands occurring wherever it crops out, including the great east/west scarp slope and the elegant dipping profiles of these hills.

The distinct 'dip' or 'tilt' of the strata from north to south is evident in the geological record, as younger rocks are encountered as you travel southwards from the ridge line of the scarp slope. The strata were originally laid down roughly horizontally, but have been tilted into their present position during another, later, mountain-building episode.

I have concentrated on the Old Red Sandstone of the Brecon Beacons, but the great scarp slope can be traced at the eastern end of the range running north/south before curving to the west again some way north of Cardiff. If you trace the Old Red Sandstone that runs along the southern edge of the South Wales coalfield you will find that it dips in the opposite direction to the Brecon Beacons Old Red Sandstone, despite being layers of the same rock. The reason for this is that the coalfield forms a downfold or 'syncline' (as seen in Chapter 6), so the Old Red Sandstone on either side dips down below the coalfield syncline.

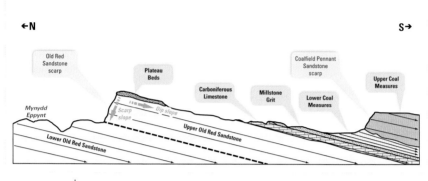

Diagram 3.1 | Geological cross-section of the Old Red Sandstone escarpment.

These folds were impressed into the Old Red Sandstone and later Carboniferous Period rocks by the last phase of the mountain-building episode. In the jargon, we can say that the Old Red Sandstone (and later) rocks underwent 'tectonic uplift' as well as folding.

This was the final phase in assembling the supercontinent of Pangaea, and which saw the collision of Europe/America (the product of the earlier mountain-building process which created the Caledonides mountain ranges) and 'Gondwana' (Africa and other chunks of continent). This process occurred roughly towards the end of the Carboniferous Period (about 300 to 290 million years ago), and thus many millions of years after the end of the processes of sedimentation that laid down the rocks of the Old Red Sandstone.

There then followed some almost 300 million years of erosion of overlying rocks, exposing the landscape we see today. The fact that the rocks of the Old Red Sandstone scarp once extended beyond the present position of the slope is clear from the scenery, and requires little effort to imagine. When today one peers northwards over the lower ground of Mid Wales from any of the superb vantage points along the east/west stretching scarp, we can enjoy the marvellous scenery created by the interplay of sedimentation, tectonic uplift and intense erosion.

Geographical names

As a rule throughout the book I have used Welsh place names, taking the spelling from Ordnance Survey 1:50,000 or 1:25,000 maps. However, there remain inevitable complexities and exceptions.

The name Brecon Beacons (Bannau Brycheiniog in Welsh) is commonly used in two ways: first it can be used mean the whole range from east to west; and second it is used for just the summits near to the town of Brecon and clustered around Pen y Fan. To avoid confusion I use the term only in the former sense as the Brecon Beacons range, meaning roughly the whole of the area covered by the Brecon Beacons National Park. Where I refer to the summits around Pen y Fan I use the rather utilitarian term, the 'Central Beacons'.

One slight problem is the area known as Fforest Fawr. This translates into English as Great Forest, and is the name given to what began as an 11th century hunting area (the original meaning of 'forest') belonging to the Lordship of Brecon. It covered a vast tract of land southwards from the river Usk, but parcels were sold off in later centuries and the area covered by the forest had shrunk by the time that industry and modern roads intruded into it. Strictly speaking Fforest Fawr includes some of the area around Fan Brycheiniog up to the Carmarthenshire border, with the forest limit passing Sinc Giedd (see Walk 2) and running northwards up the Afon Twrch and beyond. However, the major intrusion of the A4067 Swansea to Brecon road injects its own psychological boundaries in the modern mind, and Fforest Fawr is now often thought of as being confined to the east of that road, thus excluding the forest's western reaches which tend to be lumped together as the Carmarthen Fans, which in turn are seen as part of Mynydd Du.

Mynydd Du is another term that is used rather loosely. It translates as Black Mountain and this English name is still used in many guidebooks. However, there is inevitable confusion created by the fact that the hills at the eastern end of the Brecon Beacons range, up to and around the border with England, are known as the Black Mountains. To avoid confusion I have used Mynydd Du for the western hills and Black Mountains for the eastern ones.

Carmarthen Fans is strictly speaking only a near translation of Bannau Sir Gaer (Bannau = peaks, Sir = shire, Gaer = 'fort', referring to Carmarthen, site of a

Roman fort). Fan Brycheiniog translates as Brecon[shire] Peak'. The county border runs between the peaks within the same cluster. 'Ban' and 'Fan' are mutations of the same word in Welsh. It is worth noting that in Welsh a single 'F' is pronounced as a 'V' – this is occasionally reflected in English usage when the area is referred to as the 'Carmarthen Vans'.

This leaves the area between Fforest Fawr and the Black Mountains with no commonly used traditional name so, as mentioned above, I have used 'Central Beacons'. Beacons is an English loan from the times when these high hills would have been used for lighting beacons as a way of communicating over distances. 'Fan' or 'ban' in Welsh means a peak or crest, and 'pen' is the equivalent of English 'head' – so Pen y Fan, the highest point in the range, is the 'Head of the Peaks'.

CHAPTER 4

Limestone & Grit

The next chapter in the geological history of South Wales takes us into a new geological Period, the Carboniferous. This spread over a formidable time span of about 60 million years, running from about 360 million until 300 million years ago.

During this time the tectonic plate underlying present day Wales moved, very slowly at just a couple of centimetres a year, from the tropics just south of the equator to the tropics just north of the equator. This meant that the land surface and the seas above the continental shelf enjoyed a tropical/equatorial climate – hot, humid and teeming with plant and animal life.

Although different from modern-day trees, the Carboniferous Period saw the first trees (reaching up to 20–30m in height) and thus also the first forests on earth. At last, after about 4.2 billion years, the hue of the land was beginning to turn from rusty red/brown to our more familiar green.

There was, however, one major difference with today. We have an oxygen level in the atmosphere at present of 21%. In the Carboniferous Period it was nearer 30%. This oxygen-rich air supported monster-sized insects, uncovered as fossils, such as dragonflies with two-metre wing spans, and centipedes stretching up to a few metres in length.

The Carboniferous Period was the most important in the geological history of South Wales. The rocks laid down in this Period are traditionally divided into three well known categories: Carboniferous Limestone, Millstone Grit and the Coal Measures.

The Coal Measures cover the greatest area of these three great rock formations and have been economically, politically and culturally central to the history and present day life of the whole of South East Wales. We will look at coal and the coalfield, and associated rocks known as 'shale', sandstone, 'seatearth' and 'ironstone', in the next two chapters.

In this chapter I intend to cover both the Carboniferous Limestone and the early part of the Millstone Grit, leaving the upper part of the Millstone Grit to the chapters on coal. This may seem an odd division. Limestone is mainly 'biogenic', which means that it is often (but not always) derived from life forms. The lower part of the Millstone Grit, on the other hand, is a very tough sandstone, made up of eroded fragments of rock carried down by streams and rivers and dumped in lakes, river deltas and seas.

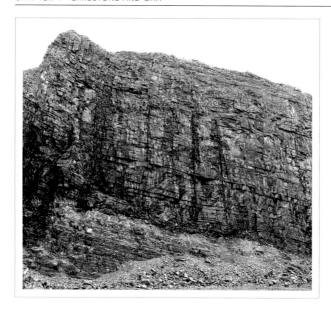

Photo 4.1

Limestone bedding,
tilted from north to south
(left to right), exposed in
Penwyllt quarry,
Fforest Fawr.

However in South Wales there are intimate geological links, especially when it comes to their joint effect on the landscape, that make it sensible to lump together in one chapter the Carboniferous Limestone and the early part of the Millstone Grit. South Wales is unusual in that features typical of limestone landscapes, such as rock 'pavements' and 'sink holes', occur more often in outcrops of the Millstone Grit than they do in the neighbouring Carboniferous Limestone. To understand why, it makes sense to treat the two rock types together.

Before moving on to look at the origin and nature of the rocks, it is necessary to take another short diversion down the geological side road of terminological torture. The Carboniferous Period as a whole is named after the carbon-rich seams of coal found within its rock layers. The limestone created in this Period is called the Carboniferous Limestone, but the 'carboniferous' tag here is purely to distinguish it from limestones created in other geological periods (such as the later Jurassic Period). The absence of the Carboniferous Limestone label does not signify that other limestones are not carboniferous, only that they are not from the Carboniferous Period.

A further terminological point that needs to be made is that the traditional names, Carboniferous Limestone, Millstone Grit and Coal Measures, are nowadays rather out of fashion with geologists, for various sensible reasons which we needn't go into, but roughly the Carboniferous Limestone is often now often referred to as the Dinantian, the Millstone Grit as the Namurian and more lately as the Marros Group, and the Coal Measures as the

Westphalian (and partly as the Stephanian) though the correlations are not entirely exact. However, the established names are the most widely known geological terms among the public at large, and for this reason I will stick with them throughout.

Any rock containing more than 50% 'calcium carbonate' is considered to be a limestone, but many of the great limestone outcrops of South Wales are much more pure than that – often 90% or more calcium carbonate. Limestone is mainly, but not entirely, a 'biogenic' rock, the result of recycling of the calcium carbonate created by organisms such as coral and 'foraminifera' (plankton) in warm and reasonably shallow seas.

Biogenic limestone can be created in a number of ways. Much of it is simply minutely-crushed shell fragments bound together by a limestone mud. When the creatures die their hard remains fall to the seabed, collecting in their billions. Tides and currents wash the remains about, slowly diminishing them in size as tiny particles are knocked off in collisions between the fragments. The calcium carbonate mud is secreted by micro-organisms that consume other life forms. Calcium carbonate mud can form a limestone rock on its own, as well as cementing together smashed shells and fossils. Through such processes, and over time, great thicknesses of rock can be built up in the form of a 'limestone platform' (see Photo 4.1).

The smashed fragments of shell and skeleton are so small that they are invisible to the human eye. However, if the conditions are right, visibly fossiliferous limestone can be created, with recognisable fragments or even entire remains of a variety of animal life, such as crinoids

Photo 4.2

Millstone Grit lying above Caboniferous Limestone, Carreg Cadno (with Old Red Sandstone forming Fan Gyhyrich on the left skyline).

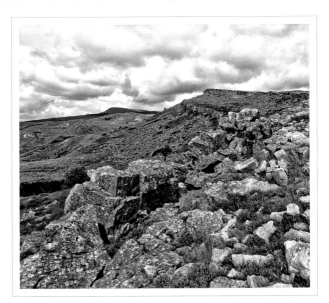

and shellfish (see Photos 4.3, 4.4, w11.3 and w12.3). There are some other types of fossils too, left by blue-green algae which existed in colonies of these micro-organisms. The sticky mucous upper surface of their colonies on which calcium could precipitate out of saturated seawater to create a hard structure for the 'algal mats' in which they lived. The colony would slough off the old mat and make a new one every so often. These mats sometimes leave their fossilised mark in the rocks (see Photo 4.5).

Non-biogenic limestone, known as 'oolitic' limestone, is also produced in warm, shallow seas which are saturated with calcium carbonate. Under these conditions, the calcium can precipitate out of the seawater attaching to a tiny particle to form minute balls or 'oolites'. As these are washed back and forth by currents and waves they provide a surface for further calcium carbonate to precipitate on to. With a hand lens or very strong reading glasses you can see the tiny fish egg-like balls that make up oolitic limestone. In this way too, great thicknesses of rock can be built up given sufficient time.

Patches or nodules of a rock type known as 'chert' are often found within the limestone rocks. Chert is a rock with a high proportion of silica. In the case of chert nodules it is possible that these represent the remains of silica-rich life forms, such as 'sponges'. Chert nodules can

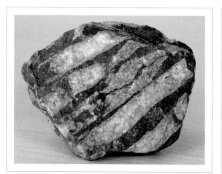

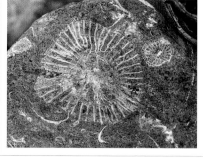

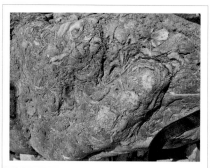

Photos 4.3, 4.4 & 4.5 │ Fossils of the Carboniferous limestone.

be seen on limestone outcrops and in caves (see Photo 4.6). Variable amounts of sediments can also be bound up in the limestone, reducing its purity.

The Carboniferous Limestone does in fact also have a limited number of ancient soil layers showing that now and again, for short periods of time, the top of the 'limestone platform' was above sea level, allowing a soil to develop. However, these were but short interludes, and the bulk of the time the top of the limestone lay below the sea surface.

Layer upon layer of limestone was built up (see Photo 4.1) as a platform that slowly subsided as extra weight was loaded on to it, and the rocks in the mantle beneath the tectonic plate underwent 'plastic' or 'ductile' deformation, being depressed by the increasing load. Another cause of prolonged subsidence was the 'extension' of the tectonic plate when it was stretched. In such situations the plates are pulled outwards and become thinner, dropping down along fault lines.

The lowest beds in the Carboniferous Limestone were laid directly on top of the Old Red Sandstone and are a 'shaly limestone', meaning that it is not a very pure limestone. Shaly limestone has a medium level of calcium carbonate and quite lot of very fine sediment, but not so much as to wholly prevent the development of limestone by smothering the sea floor in such sediment.

On top of this shaly limestone, much more pure limestone was created as the sea became shallower. This high quality limestone can be seen in numerous mountain outcrops, quarries and coastal cliffs throughout South Wales. Scenically, the limestone is most important in the great coastal swathes of Gower and south Pembroke, but it also provides some subtle beauty on the dip slope of the great Old Red Sandstone, and indeed takes over from the Old Red Sandstone as the rock that forms the great scarp slope west of the Bannau Sir Gaer.

Photo 4.6 | Chert nodules (whitish-coloured lumps) exposed in Carboniferous Limestone (grey coloured), Cribarth.

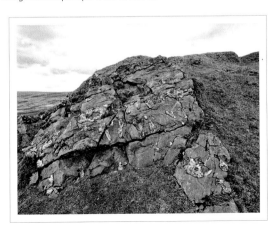

The inland mountain limestone, which runs all the way around the edge of the coalfield, is scenically restrained when compared with many other limestone areas in Britain. The outcrop of limestone is fairly narrow, and more scenic interest is derived from the Old Red Sandstone and the Millstone Grit which 'sandwich' the limestone.

There are exceptions to this generalisation, most notably on the line of two fault zones, known as the Swansea Disturbance and the Neath Disturbance, which run inland respectively along the line of the Swansea and Neath valleys, heading north-east for many kilometres. The tectonic activity which created these fault zones pushed the limestone out of place and tossed it around somewhat into steep folds, creating distinctive scenery at Cribarth in the Swansea valley (see Photo 4.7) and around Dinas Rock in the Neath valley (see Photos w7.5 and w7.6). The limestone also forms immensely impressive crags (heavily quarried) north of Mynydd Llangynidr and Mynydd Llangattock more to the east.

Another lateral displacement of the Carboniferous Limestone took place a few kilometres north-west of Cribarth at Carreg Yr Ogof (the crags of the cave). This is a remote and spectacular spot, a long walk from any road, and offering fine panoramic views to those who trudge out to savour its subtle attractions. It marks the point where the Old Red Sandstone scarp slope comes to a sudden end, replaced by an ever-declining limestone scarp for the next

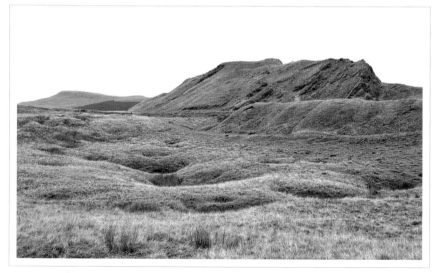

Photo 4.7 | Cribarth; the tilted rocks are part of a convoluted set of folds that have been shoved out of line with the main limestone outcrop along a major fault zone, the Swansea Valley Disturbance; note also the 'sink holes' in the foreground.

15km or so to the far western end of Mynydd Du. A final western displacement of a chunk of limestone to the north provides the crags on which is sited one of Wales's most dramatic medieval castles, Carreg Cennen.

Limestone is a pretty strong rock. The best evidence for this can be seen in the vertical or near-vertical sea cliffs which are cut into the limestone. If the rock was not strong it could not support vertical cliffs. Limestone is a rock on which you don't want to trip up, as sharp, jagged edges and unforgiving protrusions will cause nasty grazes, or even slice through the skin.

However, limestone is also one of the most vulnerable of rocks when it comes to rainwater, as it is dissolved by mild carbonic acid (such as rainwater which drips through peaty soils). This leads to the classic limestone features of underground drainage channels: sink holes, caves and caverns, dry valleys and springs.

This aspect of limestone scenery (known to geologists as 'karst' scenery) can be seen most impressively on the rivers Nedd Fechan and Mellte which drain the southern slopes of Fan Nedd and other peaks of Fforest Fawr (see Walk 6). Both rivers rise on the Old Red Sandstone and run on the surface in normal riverbeds. However, when they reach the Carboniferous Limestone the rivers become less deep as water seeps into the underlying rock. At some point along their course the surface river channels become dry. Exactly where this happens depends on the amount of recent rainfall. If the rivers are in spate, the Mellte finally disappears into a horizontal split in a limestone crag that bridges the river at Porth yr Ogof.

The Nedd Fechan under such conditions flows down to a point known as Pwll-y-rhyd. Here the thundering flood flow river simply pours into a great gash into the riverbed, forming a waterfall which is one of the most spectacular geological sights in Wales (see Photo w6.5). It is possible to stand above the mid-riverbed waterfall in an older, higher level riverbed that is now dry all the time. This higher level channel forms a narrow gorge for about 100 metres or so, and then stops at a drop of a couple of metres below which the river re-emerges from a cave. There is a similar, though shorter and less atmospheric, permanently dry river channel south of Porth yr Ogof, and a cave mouth where the river re-emerges on the Millstone Grit (see Map w6.1).

These rivers are dramatic sights in spate (see Walk 6), but underground drainage is quite common in limestone areas. Walk 2 also passes some points where streams descend into 'sink holes'. One such sink hole has a stream running up to it (see Photo w2.2) at the edge of a large bog, Waun Fignen Felen. The bog drains via the stream into the sink hole on the lower slope of a hill, despite the fact that a river, Afon Haffes, runs just past one side of the bog and a few metres lower down. Geologists estimate that the Haffes has cut back to 'capture' the streams that flow down towards this area from Fan Hir and Fan Brycheiniog, and which also used to flow into the bog and its underground outlet.

Elsewhere on the same walk, another river, Afon Giedd, which drains some of the Old Red Sandstone peaks, disappears into underground water channels at Sinc Giedd (see Photo w2.3). There is a slight rise in the land 'downstream' of the sink hole and a shallow channel forms a 'dry valley' until a spring appears and, according to the map, the river called Afon Giedd resumes its overground course. However, when dye was put into the water of the upper Afon Giedd above Sinc Giedd, the coloured water did not appear just a few score of metres down the dry valley into the lower Afon Giedd. Instead it surfaced the other side of the hills at Dan-yr-Ogof, the site of the local showcaves. The Waun Figen Felen water also runs down to Dan-yr-Ogof, so the Sinc Giedd waters seem to join that system. The entire mountain is underlain by a mass of caves and tunnels, with some of the longest underground systems in Britain. Similar cave systems exist under the other limestone outcrops between Ammanford and Blaenavon.

However, although sink holes form such an important aspect of limestone scenery, there are special reasons for delaying discussing these features until we have looked at the Millstone Grit. Before doing that it is worth mentioning some other limestone features.

Joints are internal fractures in rocks, but only where there has been no relative movement of the rocks on the sides of the joint – if there has been movement by one or both sides, then the fracture is called a 'fault'. Joints often form in fairly regular horizontal and vertical patterns in limestone (though the horizontal joints are often boundaries between different beds or layers). The vertical joints are called 'clints' and the horizontal ones 'grikes' (see Photos 4.1 and 4.8).

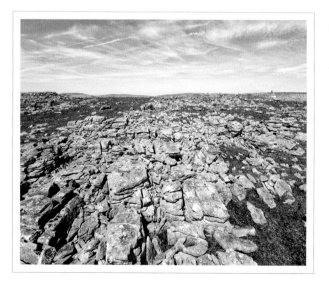

Photo 4.8

Limestone pavement on Cadair Fawr.

Photo 4.9 | Calcite filling
fractures in tension gashes.

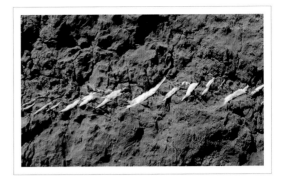

Freeze-thaw mechanisms, whereby water seeps into any minor fracture, expanding on freezing and then contracting on melting, start to break up any rock exposed at the surface. Such mechanisms were at their most active in cold weather such as during the ice age, but still take place today, if at a less frenetic pace.

One of the classic features of limestone is the so-called 'limestone pavement'. This is because limestone does not break down to produce minerals for soil, instead all the minerals are dissolved away. Thus, a soil will only develop on limestone outcrops if material is blown in from other areas. As the limestone outcrop north of the coalfield is fairly narrow it is, by and large, covered with soil and there are few limestone pavements to be seen, except in small patches such as that shown in Photo 4.8 on Cadair Fawr, south of Fan Nedd.

Limestone differs from the other rocks met in South Wales in another way too. When faults and 'tension gashes' are created within sandstones, shales and mudstones, the gaps are filled with silica or quartz that leach out of the surrounding rock. In the case of limestone the filling is not quartz, but 'calcite', the crystalline form of calcium carbonate. Tension gashes are minor fractures created when rocks are being bent (or 'folded') during the collision of continental plates and, in places, brittle deformation takes place. Such gashes sometimes occur in zones forming 'en echelon' tension gashes (see Photos 4.9, w2.4 and w11.4).

At this point we can move on from the Carboniferous Limestone to look at the earlier part of the next rock category to be formed – the lower Millstone Grit. It is worth starting with yet another of those nagging terminological points. 'Grit' is no longer a proper geological term, and what used to be called 'grit' is now properly referred to as sandstone, albeit at the coarser end of the sandstone scale. However, the informal name is so firmly embedded in the Millstone Grit label that it seems churlish to deny its use.

It is also necessary to say that the rocks found within the 'Millstone Grit' are not all coarse, gritty sandstones – the upper parts of the Millstone Grit are mainly a much weaker,

finer-grained rock, known as shale (see Chapter 5). All the same, the lower layers of the Millstone Grit (known as the Basal Grit or Twrch Sandstone Formation) are indeed tough, pebbly sandstones, and certainly justify the everyday use of the term grit.

I mentioned earlier that there must have been long-term subsidence of the land on which the limestone was deposited for great thicknesses of it to accumulate. This can be seen as the equivalent of a rise in sea level. However, the longer-term background trend over the whole period was a gradually falling sea level (the result of the continents collecting into one supercontinent). The deposition of limestone came to an end, and the dumping of sand grains began, when sea level fell and/or the land rose, in effect extending the continent out to sea for a short distance. This took the form of an expanding delta and lake environment at the margin of sea and land, and in which the sand grains were deposited.

The Millstone Grit rocks that were laid down in this environment are known as 'quartzite'. A quartzite is any rock with a very high proportion of silica (over 90%). Sometimes quartzites are 'metamorphic' rocks (such as those encountered in the Mamores near Ben Nevis in the Scottish Highlands). However, quartzites can also be sedimentary in origin.

A sedimentary quartzite is likely to be a much-abused bit of rock. The sand grains have probably been through several cycles of being encased for millions of years in rock, only to be briefly eroded into sand and pebbles, carried down to lower levels, washed about and all other minerals washed away, before being once again cemented into a solid rock. The repeated operation of these processes creates a gritty sandstone with unusually pure quartz sand grains and pebbles, thus earning the quartzite label (see Photo 4.10).

An indication of the purity can be gleaned from the fact that Millstone Grit quartzites were mined near Dinas Rock (see Photos 4.11 and w7.7) and elsewhere for making 'refractory bricks' to line furnaces – quartz having a very high melting temperature compared with other minerals.

Quartz is a very tough mineral; it is resistant to chemical weathering, to heat and to physical erosion. This resistance can be seen in the shape of the Millstone Grit outcrops which form distinct 'edges' in the landscape where layers have been eroded away (see front cover photo, Photo 4.1 and Photo w3.5). Unlike limestone, quartz is not dissolved and washed away. Rainwater runs on the surface, so the soil on top of quartzite is often boggy and nearly always pretty roughly vegetated.

However, South Wales is fairly unusual in that the sink holes usually associated with limestone often appear where the surface rock is the Millstone Grit. Indeed, the land surface of much of the lower Millstone Grit outcrop is pitted with small, medium and large depressions, rather like ancient impact craters. Elsewhere in Britain it is quite common for the

Photo 4.10

Millstone Grit quartzite.

Photo 4.11

Dinas Rock silica mine.

Carboniferous Limestone and the Millstone Grit to lie next to one another (in the Peak District and the Pennines for example), and sink holes can be quite common features – but there they occur only on the limestone.

South Wales not only has more sink holes than in any other part of Britain, but surprisingly the majority of them are actually found in areas where the Millstone Grit is the bedrock. However, if you were to dig down through the grit you would very soon encounter the limestone. Indeed, because of the gentle dip of the rock, the grit forms only a thin 'capping' above the limestone. Therein lies the explanation of why, in South Wales, we find sink holes in the grit – the surface sink hole is an expression of the existence of a cavern at some depth.

To understand how such sink holes develop we can begin by taking a look at standard limestone drainage. As mentioned above, rainwater dissolves the calcium carbonate and carries it away through underground water channels within the limestone. The process starts with the vertical joints (grikes) which allow rainwater to run down into the rock and dissolve

it from within. The horizontal joints or beds (clints) are also dissolved, forming channels which allow the water to run along the slight dip of the strata. Over time the rainwater dissolves out complete underground drainage systems with tunnels and potentially large caverns.

The surface water disappears into what are loosely called 'sink holes'. Here we enter a bit of a terminological minefield again, as there are several other names, including 'sink', 'swallow hole' and 'swallet'. Sometimes these names are used to distinguish different types of sink hole, sometimes they reflect local usage, but often they are used inconsistently. The recognised geological term for sink holes in general is 'doline'. However, following my policy of sticking with traditional names and avoiding complexity in terminology, I will use the general term 'sink hole' throughout, except where the Welsh term 'sinc' is used in names (though sometimes in Welsh, large sink holes are instead named as 'pwll', a pit or pool).

Sink holes are initially created by dissolution. The rainwater dissolves out channels through the rock with the water reappearing lower down at cave mouths or springs. Sometimes the underground drainage caverns can become so large that the roof falls in. The effects of such a collapse might be noticeable all the way up to the surface. This happens when the cohesive strength of the rock is exceeded by the force of gravity.

Such collapses also mean that sink holes can appear in the overlying rock (caprock), even some way above the base of the collapse, without necessarily having started off as a 'solution sink hole'. These are known as 'collapse' or 'caprock' sink holes.

As mentioned above, in South Wales the limestone dips underneath the younger, overlying Millstone Grit at a very shallow angle (continuing the gentle southward sloping dip as discussed in the previous chapter relating to the Old Red Sandstone). This means that the Millstone Grit quartzites provide initially only a quite thin cap to the underlying limestone. So, when a limestone cavern collapses below the quartzite caprock, if the quartzite cannot bridge the chasm developing below, it will drop inwards and create a sink hole on the surface even though a geology map marks the area as Millstone Grit. There are thousands of such Millstone Grit sink holes in South Wales, more indeed than there are on the Carboniferous Limestone outcrop in the area.

Apologies for piling on the nasty names, but as these sink holes cross between two different rock strata they are known as interstratal sink holes (in addition to being classified as collapse and caprock sink holes).

One part of the South Wales limestone and Millstone Grit outcrop, on Mynydd Llangynidr, between Aberdare and Abergavenny, has been declared a Site of Special Scientific Interest (SSSI) because of its 'interstratal' sink holes that litter the surface of the moorland made up of quartzites of the Millstone Grit (see Walk 5).

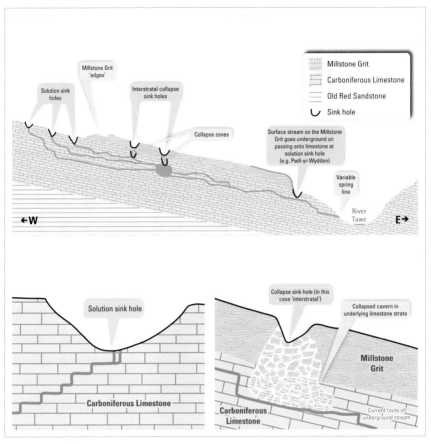

Diagram 4.1 | Sink holes and underground drainage in Limestone and Millstone Grit territory.

Interstratal sink holes can only develop under certain conditions, such as there being only a comparatively thin caprock. There also needs to be limestone at the surface somewhere lower down where the underground water can drain out at springs and caves, such as in a valley (see Diagram 4.1).

The gentle southward dip of the South Wales rocks in the area south of the Old Red Sandstone scarp meets these conditions perfectly. This is why it makes sense to combine the two contrasting types of rock, limestone and quartzite, in one chapter when considering their combined effect on the landscape, for make no mistake about it, the innumerable sink holes of this part of the South Wales landscape create one of its most remarkable experiences when out hillwalking (see Photos 4.12, 4.13 and 4.14; also see Photos for Walks 2, 3, 5 and 6).

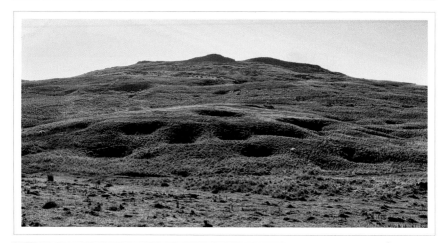

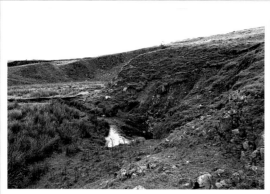

Photo 4.12 (above)
A pockmarked landscape
full of sink holes on
Disgwylfa, Mynydd Du.

Photo 4.13 (left)
The stream on the left
drains into a sink hole in
the centre of the photo,
Pwll Byfre, Fforest Fawr.

Sink holes often appear grouped in zones and frequently in linear groups, which suggests the presence of one or more underground drainage channels directly below. They also form clusters within wider depressions (see Photo w3.9), suggesting the large-scale collapse of a substantial underground cavern system. The small sink holes are effectively sink holes within a much larger sink hole.

Some of the largest sink holes are over 100m in diameter, while the smallest may be just a metre or two. The majority are 10–25m across. They can be just a few metres deep, or 25m or more in the case of the largest specimens. The majority of sink holes are circular or nearly circular, but some have an asymmetric profile. A few have streams which drain into them (see Photos 4.13 and w2.2). Some are choked with impermeable mud and sport a pond, but the majority are dry. Most have steep, conical sides which are vegetation-covered, but a few show

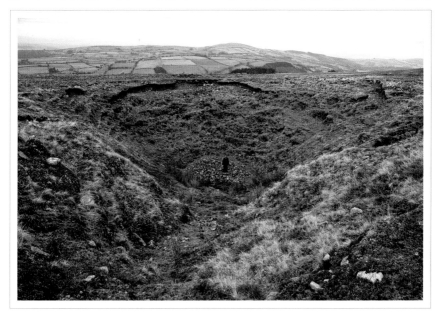

Photo 4.14 | A large sink hole at the western end of Mynydd Du.

rock outcrops. The sink holes with rock outcrops, usually on one side, are generally interstratal sink holes, and can give a clue to the way such collapse sink holes are created.

Two other scenic features are also found in the limestone and quartzite areas of the hills – dry valleys and 'foundered masses'. Dry valleys are common in limestone areas, but in South Wales they can also appear in the Millstone Grit where there is an underground drainage channel at a shallow level taking most of the drainage water, so that not enough is left to form a surface stream. Millstone Grit dry valleys are often associated with nearby sink holes. Such dry valleys, whether found in limestone or quartzite, were probably formed in the transitional phase at the end of the ice age where glaciers were melting, releasing vast quantities of water into powerful flows. However the ground was still frozen and water flowed on the surface, causing the meltwater streams to carve out the valleys that now lie above active underground drainage channels.

'Foundered masses', which are areas of blocky boulders of Millstone Grit, occur where the quartzite has blocked up an underlying collapse site, so a sink hole as a depression has not (yet) developed. These areas of awkward boulders can be a bit of a nuisance when walking away from clear paths, as they force one to go round them and, as they can cover significant amounts of ground, this can make navigation by compass bearing difficult in misty conditions.

Some other aspects of the scenery created by the quartzites of the Millstone Grit are worth noting. Patches of quartzite pavements are quite common (see Photo w3.6). Here the reason for lack of soil is not that minerals in the rock are dissolved away as is the case with limestone, but because the very chemical and physical stability of quartzite simply doesn't break down into useful minerals very quickly.

These pavements are often associated with 'edges' where beds have presented resistant zones and are now exposed at the surface (see front cover and Photos 1.2, 4.2 and w3.5). The quartzite beds were created as horizontal layers, but were tilted by tectonic forces and share the gentle dip of the Old Red Sandstone and the Carboniferous Limestone. Now the exposed edges create an understated, but undeniably beautiful, landscape. On Walk 3 on Carreg Goch you can see how the exposed pavements are broken down into masses of individual boulders at and around the edges. Sedimentary features such as cross-bedding and 'rippling' can also be seen on the quartzites.

It is generally fairly easy to tell whether you are walking on limestone or quartzite by the vegetation – short, bright green grass on the former, and lanky reeds and boggy patches on the latter. Combined, the limestone and quartzite make an intriguing landscape that is peculiar to South Wales, and offers fine walking as well as a unique geology.

CHAPTER 5

Coal & Shale

Coal plays an important role in the landscape as well as the history of South Wales. In Chapter 6 we will look at the geological factors behind the scenery of the South Wales coalfield, and in Chapter 9 we'll see how that scenery is developing even today. In this chapter we look at what coal is and how it came to be there in the first place.

The first thing to say is that the great mass of rocks that geologists call the 'Coal Measures' does not consist solely of coal. Indeed the coal is generally found in narrow seams, ranging from a mere film less than a millimetre thick to seldom more than a couple of metres. If you added all the coal seams together they still account for only 2–5% of the total thickness of the 'Coal Measures'.

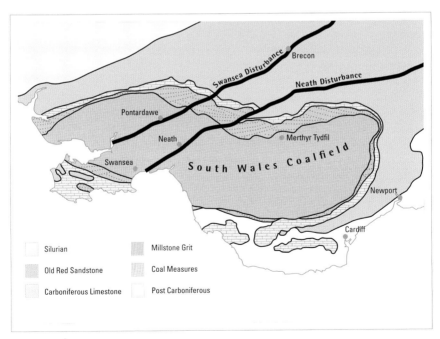

Map 5.1 | Outline Geology Central South Wales.

The other rocks we will encounter in the coalfield are mainly 'sandstone' and 'shale', along with more minor roles for 'mudstone', 'ironstone' and 'seatearth'. As we will see in the next chapter, it is the interplay between the different characteristics of shale and sandstone that is the key factor influencing the scenery of the coalfield, so in this chapter we will also look at these other rock types and how they relate to the coal.

Strictly speaking 'coal' is not a rock, rather it is a 'fossil fuel'. This is because the usual definition of a rock is 'an aggregate of minerals'. Coal is not an aggregate of minerals, being organic matter that has been compressed, chemically altered and heated, but which has not undergone decay and broken down into minerals.

Photo 5.1 | Coal.

Such pedantry, however, need not overly concern us here. Coal, like limestone, can be treated as one of the group of sedimentary rocks created from life forms. Coal, like other sedimentary rocks, is found in layers or 'beds' (often called 'seams' in the case of coal). Coal is obviously stratified with layers of organic matter of different types, though the individual layers within a seam are no more than a centimetre thick and often less. Coal, like other rocks, gets folded, bent, faulted, shifted down in the crust and shoved back up again, and it is affected by heat and pressure. Coal also, like other rocks, influences the nature of the scenery. So it is quite reasonable to treat coal as if it did fit into a reasonable definition of 'rock'.

The story begins about 300 million years ago when our chunk of continental plate was moving through equatorial regions, experiencing very hot and very humid climates. The area was close to the coast, remaining just about above sea level (except for occasional incursion by seawater). However, much of the area was under very shallow water in freshwater swamps and 'mires'.

Plant life had left the oceans and was rapidly turning the continents from reddish brown to green. The earliest plants, leafless vascular species, were established from about 425 million years ago, but by the Carboniferous Period leafy plants had taken hold. Roots, shoots and leaves all developed at roughly the same time. Great forests began to clothe the bare rock that had dominated the world since very early times. Within these forests there developed a wide variety of early types of trees and ferns. These plants grew to become quite tall – thanks to the evolution of a new substance, 'lignin'. It provided the strength for trees to reach 30m or more in the competition for sunlight. It was in these hot, waterlogged regions that the conditions were created for the formation of coal.

The great Carboniferous Period forest covered an area estimated to have been about 5,000km long by 700km wide and existed for about 15 million years about 310 million years ago. The forest thus covered a large area of the supercontinent Pangaea which existed at that time. Today the continents have moved apart, and the Carboniferous coal seams are scattered from North America to China as well as Europe. The British coalfields are small scraps of this once mighty forest swamp.

The area would have been one of winding rivers with shifting sandy channels carrying lots of sediments from higher ground. The rivers fed the lowland, creating lakes, swamps and mires. While great tracts of the area were wet or waterlogged, it was only to a depth of about one metre. Natural levees developed alongside the river channels, projecting above the water level. These were thickly vegetated by a range of plant types and extended the river channels into the sea forming an expanding delta.

When plants died the 'plant debris' – fragments of bark, wood, leaves and spores – collected in the mires and swamps. At a water depth of around one metre the plant debris was protected from decay in the dark, 'brackish', oxygen-poor water. If the water had been shallower, oxygenation would have taken place and the plant matter would have decayed. If the water had been deeper than one metre, then river-borne sand and/or clay sediments would have smothered the plant debris. In either event, no coal would have been produced.

As more dead plant material collected, the underlying debris was squeezed and compressed, forming 'peat'. Peat is a collection of unconsolidated, semi-carbonised plant remains, yellowish brown to brownish black in colour, and with a fibrous consistency and a high water content. It has a carbon content of less than 65%. When it is dried out peat will burn and is used widely as a fuel, in Ireland for example.

As the plant debris accumulated and further pressure applied, the peat experienced compression and underwent biological, chemical and physical processes which drove off 'volatile' elements (hydrogen, nitrogen, oxygen and sulphur), turning the remains initially into

coal, which is defined as having less than 40% of 'weight air dried' as inorganic matter ('ash') following combustion. The first type of coal to be formed is known as 'lignite' (or 'brown coal'), a 'low rank' coal with 65–80% carbon. It is a consolidated rock and is brown to black in colour, with obvious plant fragments. It often cracks and falls apart on drying. Lignite is often described as 'dirty coal' and its heat output is low. No lignite is found in the South Wales coalfield.

With more pressure and heat, applied over sufficient time, the proportion of carbon is increased and the rock becomes even more solid. 'Bituminous coal' has 80–91% carbon and 'anthracite' over 91%. The coals found in South Wales are bituminous and anthracite, the 'mature' or 'high rank' coals. They are hard, black coals with bright or even semi-metallic faces. Bituminous coals were used for steam generation and coke-making for iron smelting, while anthracite, which ignites and burns without smoke, was used for heating.

The type of coal varies depending on the plant composition of the peat, the depth (and thus the pressure and temperature) to which it is buried, and for how long. It is thought that there are two stages to the coal-making process; the first is mainly biological and produces lignite and takes place near the surface, while the second depends on chemical and physical effects and takes place at some considerable depth (in order to reach the required temperatures), and for sufficiently long. It takes about 7,000 years for about 10m of peat to accumulate but it takes another eight million years of deep burial before coal is produced.

As it is buried, the peat is compressed quite considerably, with 10 metres of peat being squeezed down to just about one metre of coal. Allowing for this considerable compression of the original plant debris, means that even the thin seams indicate that the right conditions for coal formation lasted for a long time in a fairly stable state. Although coal forms only about less than 5% of the rocks of the Coal Measures, the accumulation of plant debris probably accounted for 95% of the time during which all of those rocks were laid down.

We saw above that the top of the debris needed to be found at just about one metre depth in waterlogged mires for the right conditions to exist for coal to develop. As great thicknesses were built up, the implication is that there must have been a reasonably steady rate of subsidence to maintain the one metre depth. This subsidence was perhaps a result of the deformation of the underlying mantle under the accumulating weight, or perhaps, according to one theory, it was the result of cooling of the mantle beneath the tectonic plate due to the plate thinning as it was stretched by tectonic forces.

It is clear, however, that there must have been other factors at work as well. The coal seams are always found immediately on top of a 'fossil soil', known as 'seatearth'. This is

Photo 5.2 | Seatearth.

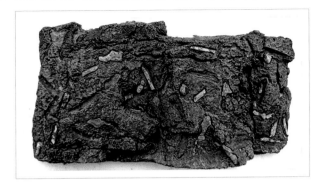

usually full of fossilised rootlets and other plant matter. The soil indicates that the land must temporarily have been above water level. Seatearths formed from clay sediments are often known as 'fireclay' as they were heat resistant and were used to line furnaces; seatearths formed from sandy sediments are usually quartzites and known as 'gannister'.

However the predominant rocks found in the Coal Measures are 'sandstone' and 'shale', a form of 'mudstone'. Sandstone we have covered in previous chapters, so it is here necessary only to recall that it is a sedimentary rock made up of consolidated sand grains (between 2mm and 0.0625mm), though we will return to the role of sandstone in the coalfield scenery in Chapters 6 and 9.

Mudstone is also a sedimentary rock, but the size of its constituent grains is smaller than in a sandstone. Mud sediments are smaller than 0.0625mm (sometimes subdivided into grains between 0.032 and 0.004mm classified as 'silt' and those below 0.004mm as 'clay', giving respectively 'siltstone' and 'claystone'). These tiny grains are invisible to the naked eye and need a microscope to be identified. In South Wales the mud sediments formed mudstone, a greyish rock with comparatively thick beds.

Mud-sized sediments also form the rock type known as 'shale'. It is a dark-coloured, often black, rock made up of very fine sediments, but mixed with the carbonaceous remains of organic matter. This organic matter can account for about 10% of the material in the rock and gives it the dark colour. Shale is very finely 'laminated' with an extremely thin bedding (see Photo 5.3). It is usually very weak and easily eroded, both physically and chemically. Indeed, it can often be crumbled between the fingers. One sample I had picked up and kept in my garden, simply broke up and disintegrated over a period of a few years in the damp Welsh atmosphere.

Though shale covers a lot of area in the coalfield (and in the upper parts of the Millstone Grit), it is not easy to see as it is usually covered by vegetation. It is perhaps most commonly seen in valleys where river action has uncovered a section of bedrock. This can happen, for

example, where a side stream joins a bigger river, or along riverbanks where the river has cut into a rock face. It can also frequently be seen beneath waterfalls which often form on shale and sandstone boundaries, but even here it can be hard to spot the shale, as tougher sandstone layers form overhangs, keeping the shale in the dark. It also tends to crumble quite easily, due to chemical weathering in the atmosphere, giving outcrops a very crumbly appearance (see Photos 5.3 and 5.4).

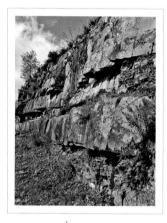 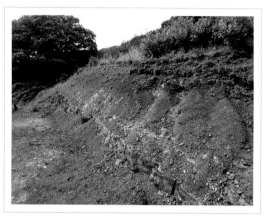

Photo 5.3 | Thick sandstone beds with thin interlying shales; Cwm Gwrelych.

Photo 5.4 | A thick layer of crumbling shale, with thin sandstone beds; Cwm Gwrelych.

I'm sorry to have to say that 'shale' is no longer an approved name – which is unfortunate given that the term has been widely used for many decades, and recently has been thrust centre stage with the avalanche of talk about 'shale gas' (the product of the organic matter in the shale). Properly, shale should now also be called 'mudstone', because they are both made up of similar sized sediments and this is the determining factor according to the present day practice. Shale-type rocks could be called something like 'laminated carbonaceous mudstone', but that's a bit of mouthful. I will be sticking with traditional usage, speaking of 'shale'.

There are some shale layers in the coalfield which were created under 'marine' conditions, when the sea had invaded the low-lying land, identifiable because they contain fossils of sea creatures. These layers are pretty thin and indicate that the incursion of the sea was fairly short lived. The bands represent only about 1% of the total rock mass of the Coal Measures. The bands are of use to geologists as the fossils are specific to short periods of time, and allow them to work out the order of rocks in the Coal Measures in South Wales, the rest of Britain

and even the wider Carboniferous Period coalfield. Indeed it is the analysis of this wider correlation that has led geologists to undertake a lot of the name changes that I am ignoring in this book in favour of traditional names.

The bulk of the shale in the Coal Measures was created from fine sediments and organic material in lakes and swamps in the low-lying coastal reaches of the major river system. As the sediments are very fine they remain in suspension in water for a long time and only settle to the bottom in still conditions. This sort of environment must have occurred for long periods to allow the beds of shale (and mudstone) to develop. Fossils of plants and freshwater creatures are found in the shales as well as the sandstones of the Coal Measures.

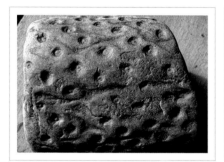
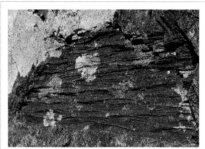
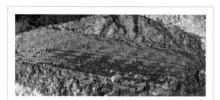
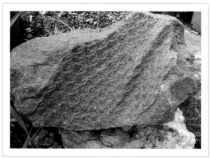

Photos 5.5, 5.6, 5.7 & 5.8 | Plant
fossils of the Coal Measures.

There is one more rock type we need to look at, 'ironstone', and we will return to it later in this chapter. But before doing that we should turn our attention to the way in which the coalfield is built up of repeated cycles of the rocks types we have discussed above. The idealised, simplified cycle is shown in Diagram 5.1. In reality the cycle varies over time and location. Often the marine band is missing from the cycle and frequently there may be several sandstone/shale layers between coal seams. The lower Coal Measures are dominated by shale, with the best coal seams and only generally thin sandstones. On the other hand, the upper

Coal Measures are dominated by sandstone with thinner and fewer coal seams and shale layers. At least 80% of the upper Coal Measures cycles consist of sandstone. Sometimes several seatearths and associated streaks of coal may appear before a proper seam of coal appears in the cycle. All the same, the cyclical nature of the rocks is a striking feature of the Coal Measures and demands an explanation, or set of explanations, of how it comes about.

As noted above, a process of slow, fairly steady subsidence must have been going on in the 'tectonic background', to allow great thicknesses of peat, shale and sandstone to be built up; but this doesn't help explain the cycles. Variations in sea level in various different cycles of about 100,000 and 40,000 years can be deduced from theory of sedimentation and mathematical calculations, and even longer cycles are also sometimes suggested. Some of these cycles are associated with intermittent ice age conditions which dramatically altered sea level. Such cycles may well explain the occasional incursion of the sea and the creation of the 'marine bands' with fossils of sea organisms, though some also suggest an intermittent and slightly greater than normal rate of subsidence. So these cycles do not fully explain the overall cyclical nature of the Coal Measures. One likely explanation of the cyclical aspects of the rocks layers is nowadays sought in the dynamics of an expanding river delta.

'Channel wandering', through a process known as 'avulsion', leads to new river channels being created in flood conditions which then build out new 'lobes' in a delta. In a storm/flood the sand grains, which would normally lie largely undisturbed on the riverbed or just be shuffled short distances along it, are carried along by the greater power of the flood flow. The sand grains would be carried further down than normal and the river level would be markedly higher than usual. This could lead to a sand-laden flow breaking over the tops of the existing river channels to create a new delta 'lobe'. The new lobe would break out across the lower land on the side of the river (see Diagram 5.2), taking a short cut by opening a new channel to the sea. When the flood flow receded the river level would drop and the sandy lobe would be marginally above water level. A soil would develop (later transformed into seatearth), before the area

Shale/mudstone (non-marine)
Shale (marine band)
Coal
Seatearth
Sandstone
Shale/mudstone (non-marine)
Shale (marine band)
Coal
Seatearth
Sandstone
Shale/mudstone (non-marine)
Shale (marine band)
Coal
Seatearth
Sandstone

Diagram 5.1 | Idealised, simplified cycle of sedimentary rocks in the Coal Measures.

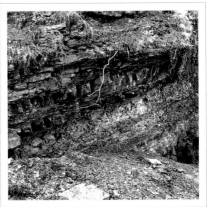

Photos 5.9 & 5.10 | Cyclical deposition of sediments in an expanding river delta created the rocks of the South Wales Coal Measures.

became waterlogged when plant debris would collect to form peat (later transformed into coal). Subsidence and/or a long-cycle sea rise then led to a marine incursion and repeat of the cycle. Over time, as new lobe after new lobe was pushed out the over the whole area, they would start to cover one another, creating the cyclical deposition of the rocks.

The overall balance of different rock types changed as the delta was pushed outwards. The lowest material was dominated by shale with occasional sandstones. The highest material was dominated by sandstone with occasional shales (some geologists question whether these thick sands actually accumulated in a delta or a low-lying 'shelf').

As noted above we can roughly divide the coalfield into lower and upper sections; the lower Coal Measures being predominantly shale but containing the thickest coal seams and fewer sandstones. On the other hand the youngest strata, the upper Coal Measures, are dominated by great thicknesses of sandstone known as the Pennant Sandstone, with fewer shales and fewer coal seams. We can recognise this change quite easily today in the scenery. As we shall see in the next chapter, the lower Coal Measures form subdued relief while the upper Coal Measures, with plenty of sandstone, form the upland plateau of the coalfield with its iconic steep-sided valleys.

I should also point out that my informal classification of lower and upper Coal Measures, though it can be found in some older books, is not currently used by geologists who divide the Coal Measures into three sub-units: lower, middle and upper. Furthermore the Pennant Sandstones, traditionally treated as part of the upper Coal Measures, are now part of what is called the 'Warwickshire Group', and are officially now outside the Coal Measures.

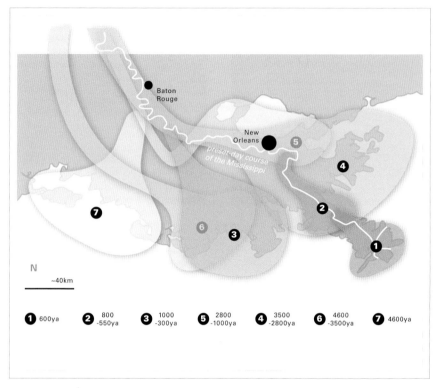

Diagram 5.2 | Delta expansion in the Mississippi.

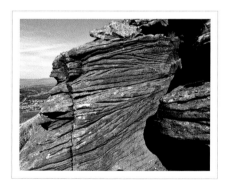

Photo 5.11 | Cross-bedding in Pennant
Sandstone representing the upper
part of a delta lobe; Tawe valley.

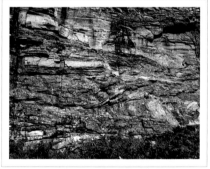

Photo 5.12 | Shale and sandstone laid
down in a complex variety of beds in
shifting river channels; Rhondda Fawr.

Once again, as per common usage for many decades, I have kept the Pennant Sandstone, with its significant contribution to the coalfield landscape, within the upper Coal Measures. The current geological names and divisions, which will no doubt change again in the near future, are given on page 281 for those who are interested.

We will look in more detail at the role of coal and the other rocks in the landscape, and how the scenery differs between the lower and upper Coal Measures, in the next chapter, but first we should look at one of the other rock types also found in the coalfield – a sedimentary rock called 'ironstone'. This occurs in a handful of shale layers within the lower Coal Measures, but it is not a particularly high quality iron and is largely forgotten about today. However iron is important as it was the catalyst of the industrial revolution in South Wales.

It was iron, not coal, which first attracted industry to South Wales in the late 17th century. The metallic mineral was found fairly close to the surface in an arc running inside the northern and north-eastern limits of what we now call the coalfield, with the quality improving to the east. The ironstone was often found in the form of 'nodules' in layers of shale, or as 'claybands'. These layers of rock containing ironstone were quite often found close to the surface and so were easily excavated. Ironstone appears in the rock cycle within shale layers, often quite close to coal seams (see Photos 5.13 and 5.14).

Limestone (also used in the iron smelting process) and coal were handily close to the easily-mined surface deposits of iron. Initially the coal too was extracted from close to the surface before deep mining became necessary. This combination of natural resources led to the treating of the iron locally and the setting up of what were to become the world's largest ironworks along the 'heads of the valleys' at Merthyr Tydfil and Blaenavon (see Walk 10). From here, South Wales was to develop as one of the centres of the Industrial Revolution,

Photo 5.13 | Ironstone nodule, approx. 25cm across.

Photo 5.14 | Ironstone nodule in shale layers, nodule approx. 20cm across.

developing the technologies of mining, metal working and railways (see Chapter 6), though by the mid-19th century cheaper, higher quality iron had superseded local supplies.

Iron is found in tiny quantities in nearly all sedimentary rocks, but only occasionally in sufficient amounts to form ironstone (defined as where the proportion of 'iron' is greater than 15% and that of all 'iron-bearing minerals' is over 50%). The light to dark brown, or sometimes black, ironstone nodules found in the Coal Measures in South Wales form a clay rock of carbonate iron with about 25–35% iron.

Iron occurs in many different states and is highly reactive to various chemical elements, so its particular form depends on the local environment. Most commonly 'sedimentary iron-stone' is deposited in sea water, but little is really known about how the rock is formed, in part because there is little ironstone creation happening today (apart from some 'bog-irons') to give hints as to the process.

It is thought that the hot, humid climate of the Carboniferous Period led to intense erosion, both physical and chemical. The chemical changes caused the release of iron from iron-rich minerals in igneous and other rocks. The iron became concentrated in the ground-water and soil from where it might have been transported to the sea by rivers. Alternatively the sea may have invaded the area of iron-rich soil and ground water. The environment would have been a 'reducing' one (the opposite to an 'oxidising' environment), with the iron combining with carbonates to form 'sideritic' iron nodules or beds (see Photos 5.13 and 5.14).

The miners who dug out the local ironstone soon discovered that they found no more nodules below a particular sandstone layer. They called this the 'Farewell Rock' (see Photo 5.15). When the coal industry outgrew that of iron extraction, the coal miners too found that no exploitable coal seams were to be uncovered below the Farewell Rock and it is now commonly taken as the base of the Coal Measures. All rocks below it belong to the upper part of the Millstone Grit, predominantly shale with a few very thin coal seams (none worth exploitation).

Photo 5.15 | Outcrop of sandstone known as Farewell Rock – wherever it appears in the coalfield, no iron or exploitable coal seams are found below; Cwm Gwrelych.

Carboniferous coal

To make coal, the accumulating plant debris must have been protected from decay by very rapid burial. Horsetails grew up to 10m high, as did tree ferns and tree-sized clubmosses. The first real trees were 'lycophytes' which could grow to 30m high and up to 1.5m in diameter. These trees did not have branches like today's specimens, but supported a canopy growing out of the top of the tree trunk.

These were the first plants to overcome the problem of how to grow tall. They achieved this by developing a tough supportive bark. These first trees had a much higher ratio of 'bark to wood' than modern trees – 8 to 1 or even 20 to 1 for the earliest trees, as against 1 to 4 in today's species. The major component of bark is a substance known as lignin. It is an 'organic polymer' and plays an important role in the carbon cycle, sequestrating atmospheric carbon into the living tissues of woody plants (and releasing it during decay). It is also important in conducting water through plant stems.

However, while the Carboniferous Period saw the development of the first true forests, initially there weren't any micro-organisms around then with the ability to break down the plant matter, most especially the lignin, which is resistant to decay. It can hang around in soil or peat for thousands of years, even retarding the decay of other substances in the plant debris. Most importantly, it requires very specific organisms to break it down and, as lignin had only fairly recently evolved (around 420 million years ago), these micro-organisms did not exist at the time.

Thus, the accumulation of the large-scale coalfields in the Carboniferous Period was due to this passing phase when a decay-resistant substance existed, but no means of breaking it down was in existence. This explains why there are few extensive coalfields from other geological Periods.

There are vast coalfields dating from the Carboniferous Period on the continents of today, from the Americas to Eurasia. Fifty or more years ago, in the days before the theory of plate tectonics was acknowledged, it was thought that the continents must have been much more substantial in the Carboniferous Period than they are now. This seemed to be the only way in which the widespread coal deposits, separated by several thousand kilometres of ocean, could be accounted for, given that the continents were seen as static, immovable objects. Similar contortions were needed to account

for the apparent oddity of a tropical climate affecting Britain in the Carboniferous Period while equatorial regions (as indicated by the rock record) seem to have suffered periodic glaciation.

Today we can see that the movement of the continents, as proposed by the theory of plate tectonics, solves both conundrums. The coalfields were laid down when the continents were clustering near the hot equator. Since then they have split away from each other and been propelled to their present positions. So the balance of continent and ocean was not so very different then than it is today. Nor was there some unexplained climate wobble. It is 'simply' that America and Eurasia have been driven apart from each other, with both being pushed northwards from the equator, but on increasingly divergent paths. It is not just the earth's surface which is in constant motion – so too are our ideas about the geological processes that shape our home planet.

CHAPTER 6

King Coal

'King Coal' as the industry was known, and its associated metal or mineral industries, forged the modern South Wales. The expansion in demand for coal from the mid-18th century led not only to the founding of the coal industry, but also played an important role in the early growth of geology as a practical science. Mapping the different coal seams and, despite the numerous faults that break up those seams, correlating them across different parts of the coalfield was a major undertaking, and has left us with an exceptionally well documented account of the rocks of the area, both underground as well as at ground level.

Our purpose in this chapter is to seek out the geological influences on the scenery of the coalfield. Some may view the concept of the natural scenery of the industry-defiled coalfield to be an oxymoron. Certainly, the South Wales coalfield usually comes low on the list of popular hillwalking areas. True, it can be a bit of a hit and miss job if you haven't planned a route. Footpaths can disappear into an impassable mush of bog, plantation or industrial devastation. Also agricultural and 'mechanised leisure' activities can unexpectedly intrude. However, there is much scenic beauty to be found in the coalfield for those with the eyes to see it.

In many places the heavy, polluting metalworking and mineral extraction industries have all but disappeared, at least from 'the valleys' in the central coalfield. It is true that open-cast coal extraction continues apace, but in the main it affects the subdued scenery of the narrow outcrop of the lower Coal Measures, between the Pennant Sandstone uplands of the upper Coal Measures to the south, and the Millstone Grit that leads onto the mountain territory of the Carboniferous Limestone and Old Red Sandstone to the north.

The valleys are certainly being 're-greened', and local authorities and other organisations are developing and marketing plenty of walking trails both in the valleys and on the uplands between them (the 'interfluves' in geological jargon). Leaflets and websites offer routes such as the Coed Morgannwg/Glamorgan Forest Way, the Rhymney Valley walk, the Sirhowy Valley walk, the Ebbw Vale walk, Lon Las Cymru/Wales Green Way (part of which runs through the Taff valley) and many others.

All the same, it remains the case that the human influence on the coalfield landscape has been extensive. It is no exaggeration to say that it can sometimes be difficult to tell to what

degree the scene in front of you is natural and to what degree it is human-made (see Photo 6.1), not least in areas that have been subject to 'landscaping' after open-cast operations have moved on. Yet, the natural lines of the landscape still stand out in many areas. Any walk in the coalfields is rich in industrial archaeology, as well as being of outstanding geological interest. Geology combines intricately with past and present human activity, creating even nowadays an active landscape. In this chapter, as we look at the relationship between the geology of the coalfield and its scenery, it is inevitable that human influence plays a part in the story (we will also return to look at more effects of geology and human influence on coalfield scenery in Chapter 9, dealing with the postglacial landscape).

The South Wales coalfield stretches 160km right across South Wales from the English border in the east to the Pembrokeshire coast in the west, covering some 2,700 square kilometres. We can divide it into two parts lying on either side of Carmarthen Bay. The Pembrokeshire coalfield is much the smaller part, being about 30km long and 5–10km wide, whereas the main South Wales coalfield is about 100km long and 30km wide (see Map 6.1).

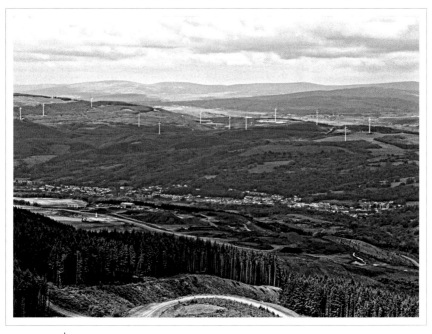

Photo 6.1 | The human landscape: forestry plantation in the foreground, open-cast coal extraction lower centre, 'ribbon' development of Glyn-neath in the centre, more forestry plantation upper centre, and a wind farm on the hill crest (and more open-cast out of sight on the far side of the hill).

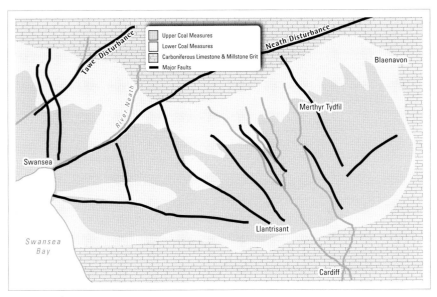

Map 6.1 | The South Wales coalfield.

The Pembrokeshire coalfield has received far less attention from geologists than its bigger eastern counterpart. I'm afraid that the awkward arbitrary decisions about what to include and what to leave out of a book, necessarily of limited girth, mean that I too will concentrate on the fascinating scenery of the main South Wales coalfield.

The main South Wales coalfield is unusual in Britain because its coals come in a range of rank, from bituminous to anthracite. The eastern part of the coalfield has lower rank, bituminous steam coals, while in the west the rank is higher, offering up high quality anthracitic heating coals (see Chapter 5). This reflects the underground structural analysis by geologists who reckon that the western parts of the coalfield were drawn down and held more deeply than the eastern parts, giving more time for the higher rank anthracite to develop in that part of the coalfield.

At its greatest extent the coalfield is up to 2.5km thick in the west, becoming markedly shallower to the east. This suggests that the sediments (to make sandstone and shale) and plant debris (to make coal) were deposited in a basin that itself progressively dipped downwards to the west, allowing greater quantities of material to accumulate there.

However, that original basin was later subjected to severe tectonic pressures and the original shape of the land has been lost in the folding, thrusting and faulting that occurred as a result. Nowadays overall the coalfield is a structural downfold or 'syncline', with the main

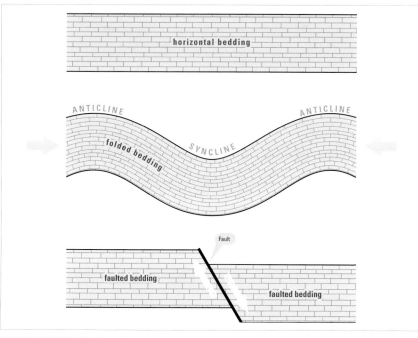

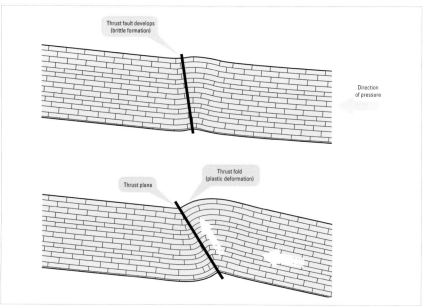

Diagram 6.1 | Folding and faulting.

axis of the syncline running roughly east to west. This syncline is the product of tectonic compression, as are the plentiful localised effects, including minor upfolds or 'anticlines', within the heart of the area. There are also arrays of 'faults', including 'thrust faults'.

Faults are breaks in the rock created by earth movements. Thrust faults are particular types of fault where the break has occurred while one set of rocks was thrust on top of another set of rocks during mountain-building episodes (see Photos w11.7 and w11.8 for thrusts affecting the Carboniferous Limestone). Movement along the faults, whether up and down or lengthways, breaks up the layers or beds of the rocks, including coal seams. The faults made mining a geological guessing game as the colliers, working along a seam, sought to work out where the seam might be found once a fault was encountered. Thus the overall geological structure of the coalfield is quite complicated.

We can start our look at the coalfield scenery by seeking out how it got its overall syncline shape, other minor folds and the fault zones. The key factor in this part of the geological story of South Wales was a collision of continents some way to the south. This collision is known to geologists by the esoteric label of the 'Variscan Orogeny'. Just as the names given to the geological Periods of the Ordovician and the Silurian were named after Roman tags for ancient British/Welsh 'tribes', so the Variscan is derived from the medieval Latin name for the homeland of an ancient Germanic 'tribe', the Varisci. The other part of the name, 'orogeny', is a coined term, though this time from Greek, and means a 'mountain-building' episode. The orogeny was caused in this case by the collision of tectonic plates during the formation of the Pangaea supercontinent.

The folds generated by the rocks, propagated through the plate, and began even in the late Carboniferous Period before all the coalfield sediments and plant debris had been laid down. Enormous pressure, coming roughly from the south-east, pushed the Coal Measures, dominated initially by comparatively weak rocks such as shale and coal, squeezing them against tougher, more 'coherent' rocks to the north. The Coal Measures (and the Millstone Grit, Carboniferous Limestone and Old Red Sandstone too) were folded and crumpled rather like snow being disturbed and compacted by the advancing blade of a snowplough. The snowplough is a good metaphor for the collision of two continents and the South Wales landscape was essentially created by being at the advance edge ('foreland') of the disturbed rock strata.

During this process the rocks of our area experienced both 'brittle' and 'plastic' deformation, resulting in the faulting and folding respectively. Brittle deformation, creating faults, means that the rocks crack under compression. Plastic (or 'ductile') deformation, creating folds, means that the rocks do not crack but undergo stretching and change of shape. Thrusting, where rocks are pushed up on top of each other, involves both brittle and plastic deformation.

In the west, in the area of the Pembrokeshire coalfield, the folding led to a compression of the plate by up to 40% of its original extent, with considerable thrusting and folding. To the east the effects were marginally less dramatic, with only 20–30% shortening in the main coalfield. This compression reversed the general stretching or thinning of the plate underlying our area that had been the tectonic background during the Devonian and early Carboniferous Periods.

During the late Carboniferous Period these compressive forces caused the rocks to the south of our area to crack and fold in a great thrust. This led to an upthrust of rocks, creating a modest highland area which became the source of the material that was eroded and dumped into the developing coalfield syncline and formed the thick Pennant Sandstones. After the Carboniferous Period further thrusting took place, but this time it occurred within the coalfield, causing many of the complications which bedevilled later colliers. Unfortunately these folds and thrusts are not easily visible on the surface, and there are no coalfield coastal cliffs giving us slices through the rocks to expose dramatic folds, as with the much earlier rocks we looked at in Chapter 2.

Two major fault zones run across the coalfield plateau, roughly dividing it into two regions. The great fault zones, known as the Neath Disturbance and the Tawe Disturbance, run south-west to north-east, and have seen major sideways movement of the rocks along them (see Map 6.1). This has resulted in the displacement of the rocks, so that for example, Carboniferous Limestone is found further south than elsewhere along the line of these fault zones.

The rocks near these faults display intense folding and dipping (see Walks 3 and 6). This is seen in the prominent position occupied by Cribarth (see Walk 3) in the middle of the upper Tawe valley and Craig y Ddinas/Dinas Rock near Pontneddfechan in the Neath valley.

These two major fault zones are accompanied by numerous counter faults that run south-east to north-west. These are much smaller affairs, with only local effect, although they help define the course of some of the valleys that dissect the central part of the coalfield. These faults also caused many problems to miners. There are also minor folds (compared to the major feature of the overall syncline). The most important of these is known as the Pontypridd Anticline. It runs roughly east/west in the centre of the coalfield, and has the effect of bringing the lower Coal Measures up to or near to the surface in the valleys cut into the sandstone plateau.

The overall synclinal shape of the coalfield is evident in the scarp slope that surrounds parts of the coalfield. The scarp, however, only defines the area of the upper Coal Measures, whereas the lower Coal Measures form low, subdued ground around the coalfield along the whole of the northern, as well as parts of the southern, boundaries. The actual boundary between the Millstone Grit and the Coal Measures is not noticeable. Along the eastern boundary the lower

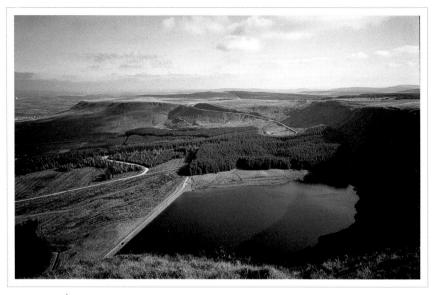

Photo 6.2 │ The Pennant Sandstone escarpment at Craig y Llyn, with lower and middle Coal Measures to the left (north) and upper Coal Measures forming the plateau (south).

Coal Measures are very thin in outcrop, and the scarp is sometimes subordinated to the Old Red Sandstone scarp which forms the dominant feature between Abergavenny and Pontypool.

The scarp between the lower Coal Measures and the Pennant Sandstone plateau of upper Coal Measures is an impressive geological feature, not least in the area near Glyn-neath and Hirwaun, where the highest point in the coalfield is found on the high land at the head of the Rhondda Fawr valley (see Photo 6.2). The Pennant Sandstone scarp slope is a slightly smaller version of the great scarp slope in the Old Red Sandstone that lies about 10 to 15km to the north. It is broken by valleys that cut through the Pennant Sandstone. The scarp slope at the northern edge of the upper Coal Measures is even marked by a number of glacial 'cwms' or 'corries', just as is the case with the Old Red Sandstone escarpment. Further hollowed out areas that once housed the seat of a glacier are found in some of the steeper valley sides in the sandstone plateau, such as in Rhondda Fawr near Treherbert (see Chapter 8).

The Pennant Sandstone plateau in the central and eastern parts of the coalfield is deeply incised by glacial valleys. Indeed, the South Wales coalfield is so intimately linked with the images of mines located in these narrow, steep-sided valleys that the name of 'the valleys' is often used as a synonym for the whole area. Redolent names such as Rhondda Fawr and Rhondda Fach, Ebbw Vale and Taff among them, are the iconic landscapes of the coalfield.

The area with such deep, narrow valleys is largely limited to the central and northern part of the upper Coal Measures (see Map 6.1). In large parts of the coalfield west of the Neath Disturbance, the hills become more rounded and the valleys shallower and wider. However, the difference between the scenery of lower and the upper Coal Measures remains distinct. Across the entire coalfield the Pennant Sandstone plays another role as the dominant building stone, and casts a distinct dark hue on the ribbon settlements of the area.

The core reason for the difference in the scenery of the lower and the upper Coal Measures is the predominance of shale in the lower, and sandstone in the upper. The key point is that shale is weak and more easily eroded away both physically (by ice and flowing water) and chemically. Sandstone is more resistant and forms the uplands, thus the sudden, sharp scarp slope at the northern edge of the sandstone.

This difference in resistance to erosion between the rocks not only determines the sharp large-scale contrast between the subdued land and the upland plateau, it also results in more subtle effects in the landscape. The weakness of shale is in effect the main factor in the coalfield landscape. At one level this is expressed in the 'shelves' or 'benches' that

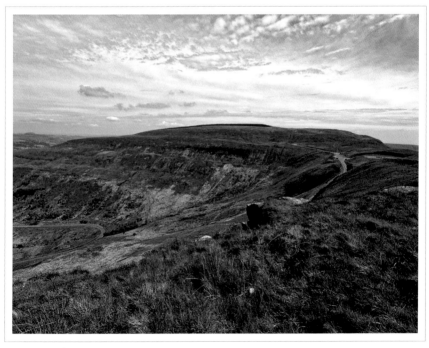

Photo 6.3 | Benches or shelves marking layers of different resistance to erosion; Rhondda Fawr.

are characteristic of the hillsides (see Photo 6.3). Sandstone layers may stand proud on the valley sides (see Photo 6.4). These benches are due to the shale being more easily eroded than the sandstones.

The contrast between shale and sandstone lies behind many of the natural post-ice age landslides that litter the slopes of the coalfield plateau – a subject we will return to in Chapter 9. It is no exaggeration to say that the difference between shale and sandstone (Photo 6.3) is the central dynamic of current landscape processes in the coalfield – with the 'wild card' of abandoned mines thrown in to add extra random effect.

The exploitation of coal – initially for domestic heating – probably goes as far back as (at least) Roman times, and is certainly known from the medieval period, with documents about quarrying of exposed coal outcrops dating from the 13th century. Neath became an important metal-working centre in the 16th century, and the western part of the coalfield was the first to be widely developed as the wide, shallow valleys were more easily accessible to the sea. It was iron that introduced industrial activity into the inland parts of the coalfield. Demand for iron grew, and by the late 17th century was being extracted in the north-eastern

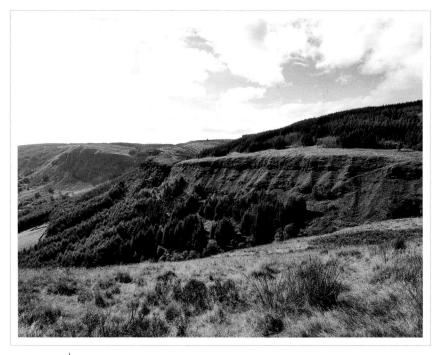

Photo 6.4 | Layering, resulting from interbedded tough sandstone and weaker shale; Rhondda Fawr.

corner of the coalfield where good quality iron was found close to the surface. Over time, the iron industry moved increasingly from using wood for iron smelting to the employment of coal in the form of coke (produced by heating coal without oxygen). The lower Coal Measures form a wide area around the north-eastern corner of the coalfield, so that there was access to ironstone and to coal suitable for coke-making. This led to the growth of places such as Blaenavon (see Walk 10) and Merthyr Tydfil as iron and coal centres.

In the early days both iron and coal were extracted where they were found on the surface of moorlands or along valley sides. Shallow pits would be dug and the iron or coal removed. This was an early form of open-cast and was known as 'patching'. However, the rocks are generally tilted in one direction or another, so a seam of iron or coal exposed along a line on the surface usually soon disappears underground.

If an iron or coal seam was covered by glacial deposits of boulders, soil and vegetation, rainwater would be collected in a reservoir and then released in a sudden flow to scour away the superficial material, giving surface access to the seam for exploitation. Most of these early surface workings created by this method have disappeared under later operations, but some 'hush' gullies, though now re-occupied by soil and vegetation, have left their mark on the land-scape and can still be seen in places, such as above the area marked on the OS 1:25,000 map as 'Tir Abraham-Harry' (see Photo w10.2). Landowners disliked this practice as it silted up rivers and streams. So, the combined disapproval of powerful landowners, and the tendency for seams to dip out of sight below other rocks, meant that other techniques were needed to meet demand.

The 'miners' (for iron) and the 'colliers' (for coal) started to dig downwards, creating 'bell pits', and also sideways (into the hills) in 'adits' or 'levels'. A bell pit would start as a shallow shaft which would then be widened out at the base where the iron or coal layer was encountered, the widening going as far as practicable before roof collapses became a problem. Levels were usually not actually level but often tilted upwards as they went into the hillside, for this would ease the task of dragging the coal and waste out of the mine and help drain the mine of water – a perennial problem.

By the middle of the 19th century the iron working industry was firmly established at places such as Blaenavon, Merthyr, Aberdare, Neath and Ystalyfera, requiring ever more iron to feed the furnaces. Up to seven different layers of ironstone were exploited in parts of the coalfield. The metal industry's demand for ironstone exceeded local supply and the ironmasters found imported iron ore was of higher quality and cheaper.

Although the local ironstone deposits were worked out or became uneconomic, the demand for coal continued to grow and was perforce sought in more difficult places. There were fewer coal seams in the predominantly sandstone plateau of the upper Coal Measures,

but those seams that did exist were exposed on the hillsides and could be exploited by levels. The remains of such shallow exploitation can be seen on many a hillside throughout the coalfield, as rows of small waste tips and areas cut into the slope. Levels are less conspicuous and nowadays are generally tidied up and/or hidden by dense vegetation, though many traces are still visible (see Photo 6.5).

However, levels could only help with the exploitation of the few thin seams of coal found in between layers of the Pennant Sandstone within the upper Coal Measures. It became necessary to start digging deeper. From the 1840s the search for coal extended into the central coalfield valley floors. The coal seams of the lower Coal Measures came close to the surface, or even reached ground level in some of the deep valleys, such as the Rhondda, due to an anticlinal fold bringing older, lower strata near to the surface. So deep mines were sunk into the valley floors aiming to intercept the productive coal seams of the lower Coal Measures. These deep mines, whose winding wheels and tunnels, where brave men hacked coal manually out of a narrow coalface, were once the iconic images of the industry in its prime.

The deep mines were provided with a vertical shaft that went down as far as the depth of the coal seams. The colliers would then dig out the coal manually using the 'stall and pillar' method whereby they would dig into the coal seam, leaving a good proportion as 'pillars' to prop up the 'roof'. Initially up to 40% of the coal would be left, but then, once the seam had been worked out, the colliers would work backwards, thinning out the pillars, even removing them altogether and allowing the roof to collapse. This was extremely dangerous work.

Photo 6.5

Adit mine entrance (now closed); Ystalyfera.

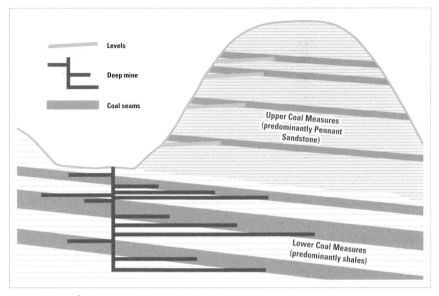

Diagram 6.2 | Deep mining and coal seams cross-section.

Conditions in the mines are now unimaginable. Methane gas is given off by the coal and would collect in the workings. One collier, the 'fireman', would lie down and extend a pole with a burning candle into a tunnel, hopefully to burn off any gas that collected, before work could start to hack out coal, probably while lying on their side working a seam only a foot or two thick, with the coal then to be dragged away by women and children (until the 1840s).

By the second half of the 19th century considerable quantities of steam coal were exported around the world, through the major ports at Cardiff, Newport, Barry, Briton Ferry and Swansea. At its height the industry employed 250,000 in some 620 mines throughout South Wales and accounted for many thousands of other jobs in rail, shipping, metal and associated industries.

The complex geology of the South Wales coalfield was part of the industry's undoing. The difficulty of following the frequently-faulted coal seams meant that manual methods of removing the coal continued long after mechanisation was deployed in other coalfields and had altered the economics of coal extraction. In 1913 only 1% of coal was extracted by mechanised methods, and low levels of investment in such methods set the South Wales coalfield on the long, slow road to decline.

The stall and pillar method was not very useful for mechanised working, nor was it suitable for the production of 'steam coal' for shipping which required large lumps of coal. The pressure of the overlying rocks was concentrated on the pillars and as they were

progressively removed the process resulted in a lot of useless 'small coal' (which often mine owners didn't even bother bringing to the surface). For these reasons another technique became more common – the 'longwall' method. Two 'roadways' or parallel tunnels would be dug, a couple of hundred metres apart, through a coal seam to its far side. Then the mechanical cutters would cut through the entire seam either at the nearest point or the farthest point from one roadway to the other. The roof would be supported in the working area, but once one length had been extracted, the colliers would start extracting another length. As they advanced, length by length through the coal seam, the supports would be withdrawn and the roof allowed to collapse behind the current working length.

More than any other British coalfield, the South Wales mines were subject to a continual 'squeeze' of tunnels, as the rock mass sagged under its own weight, crushing the hard won workings. This happened even when the tunnels were driven through otherwise undisturbed strata.

The industry reached its height in the early decades of the 20th century and has undergone a long decline since then. Today all the deep mines are closed and nearly all signs of the deep mine colliery buildings have been removed, leaving only traces of the industry and plenty of flat, empty 'brownfield' sites. Winding wheels remain on display at mining museums at the Big Pit World Heritage Site, Blaenavon, where you can also go underground, and at the Cefn Coed Mining Museum, Creunant, near Neath. Also, the winding engine of the more recently closed Tower Colliery is still in place at the time of writing (see below). Elsewhere there are reminders of the industry in odd places throughout the coalfield area, often being slowly digested by vegetation.

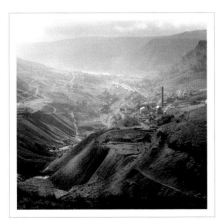
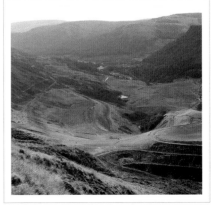

Photos 6.6 & 6.7 | Fernhill Colliery, Upper Rhondda valley (left) and the landscaped site today (right).

Upper Coal Measures:
Mountain
Wenallt
Brithdir
No. 1 Rhondda Rider
No. 1 Rhondda
Daren Estyn
No. 2 Rhondda
Paynes
Upper Welch
Lower Pinchin

Lower Coal Measures:
Eighteen Inch
Hafod (aka Clay)
Welsh
Abergorky
Red
Soap Vein
Penny Pieces
White Four
Eighteen Feet
Upper Six Feet (No. 1 Yard)
Cornish
Red Vein
Harnlo
Nine Feet
Bute (aka Brass, Peacock)
Gwendraeth
Yard
Lower Peacock
Lower Brass
No. 2 Yard
Upper Bluers
Lower Bluers
Grey Middle
Stinking
Five Feet
Gellideg
Garw

Diagram 6.3 | Coal Seam Names: selection of coal seam names from each of the sub-divisions of the Coal Measures (youngest seams at the top, oldest at the bottom; some names varied with location).

In recent decades, although deep mining has disappeared, large-scale open-cast mining has expanded in its place (with a fraction of the number of jobs). The area where the lower Coal Measures form the bedrock has been widely dug into by giant machines. Some of the open-cast pits are up to 200 metres deep, with millions of tons of rock shifted in order to extract the small proportion that is coal. The average life of an open-cast pit is estimated to be between 5 and 15 years before all the 'fossil fuel' is extracted. Modern open-cast operations are normally well screened from view by earth banks along the roads in the area, however views down onto extraction sites can be found on the northern edge of the sandstone plateau (see Photos 6.8 and 6.9). There is of course much waste material and this is used to fill in behind the cutting operation. Thus the hole moves across the ground. The waste material is subject to 'landscaping'.

Tower Colliery, the last deep mine to close in South Wales, illustrates the process of change. Its winding wheel standing in the shadow of the Pennant Sandstone escarpment, below Craig y Llyn, marks the heroic struggle by its employees. It stayed in operation long after the bulk of the other deep mines were abandoned, managing to struggle on until 2008 when it finally closed. However, Tower re-opened shortly afterwards, having gained planning permission to develop an open-cast operation measuring 80 hectares, with pits up to 165m deep, in order to extract about six million tons of anthracite (see Photo 6.9). Tower is now one of several open-cast gashes in the surface, and its transition illustrates the end of a phase of historic mining methods and the rise to dominance of another, much cheaper, mode of extraction. The valleys may be being re-greened, but the coalfield landscape is still being altered by the coal industry.

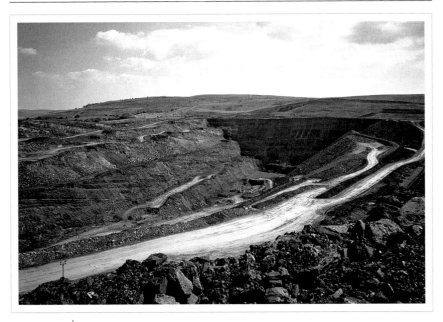

Photo 6.8 | Open-cast coal pit, lower Coal Measures.

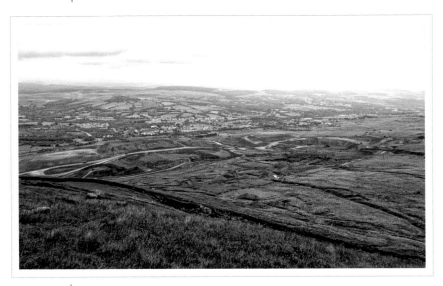

Photo 6.9 | Part of the Tower Colliery open-cast site; the dark line running
at a slight angle across the lower part of the photo is a 'counterscarp' where
the sandstone plateau is extending and breaking up (see Chapter 9).

We have already noted the influence of open-cast on the landscape – with the unconvincing landscaping efforts (see Photo 6.10). Deep mining by contrast would seem to leave little legacy in the landscape, apart from a wealth of minor hidden archaeological remains slowly being ingested by lush, damp vegetation. However, it is not quite as simple as that. Mining has left an underlying legacy in the form of large spaces between rock layers under and inside the hills. Billions of tons of overlying rock press down on those spaces and intense tensions are built up in the rocks, above and below the mined gaps. We will see the effect of all this later on in Chapter 9 which looks at postglacial South Wales.

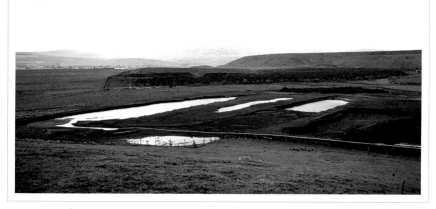

Photo 6.10 | Post open-cast 'landscaping'.

CHAPTER 7

Post Carboniferous Wales

One of the most audacious of the ideas about the workings of our planet that derive from the theory of plate tectonics is the suggestion that, every 500 million years or so, all the continents gather together to form a 'super continent'. They remain linked for several million years before breaking apart, drifting around as independent entities, ploughing their own courses with the odd collision now and again. Then the whole cycle of combining and separating is repeated. It is thought that this may have happened as often as five times in the last 2.5 billion years.

The last time the continents were united was about 250 million years ago. In the millions of years leading up to the creation of the supercontinent, our chunk of continental plate was compressed by the long, slow collision of continents, forcing the ground to be pushed upwards. This meant that our area was well above sea level for a period of about 55 million years, during which time no new rocks were laid down in South Wales and those rocks exposed above sea level experienced erosion. This period of uplift and erosion took place in what geologists call the Permian Period, which ran from about 298 million to 252 million years ago.

However, the absence of Permian rocks does not mean that the Permian Period is unimportant in the geological history of South Wales. As was mentioned in the previous chapters, compression of the rock strata led to the folding and faulting which gave the South Wales coalfield its overall geological structure of an east/west aligned basin, or syncline, with subsidiary, minor east/west folds. This structure represents the tectonic compression forces applied from the south.

These folding and faulting pressures also affected areas outside the coalfield, to its north as well as to the south and west, including South Glamorgan, Gower and Pembroke. Present day outcrops which show signs of folding, faulting and even 'thrusting' (where one set of rocks is pushed on top of other younger, or similar age, rocks) can be seen in the coasts of Pembroke and Gower (see Photo w11.6). The scenery of Gower with its isolated high points of Cefn Bryn and Rhossili Down are also reflections of these tectonic pressures with the Cefn Bryn Anticline forming a key structural feature of Gower (see Map w11.1).

At the same time as tectonic processes uplifted the area, there was also erosion of the exposed rocks taking place, which in turn reduced the level of the land. It is estimated that

between 3,000 and 4,500 metres of high land were eroded away during this time from the top of the anticlines in the Vale of Glamorgan, Gower and Pembroke.

It was only around 215 million years ago, near the end of the next Period, the Triassic, that new rocks were once again laid down on the tectonic plate that today underlies South Wales. At this time our chunk of continent was at around 20 degrees north. This is about the same as the present day Sahara and the area thus experienced a hot desert environment. The uppermost Triassic rocks reflect that desert environment with valleys and limestone hills. The rocks consist of desert red sandstones, laid down in deserts as scree slopes and during infrequent but intense floods as sediments in 'wadis' (normally dry valleys subject to such sudden flooding). There are also mudstones from a large saline lake or gulf covering much of southern England as well as South Wales, and which would have been subject to intermittent wetting and drying out.

The exposed rocks on the coast often reveal details of their desert origins: sporting the impressions of the footsteps left by dinosaurs (near Barry and Porthcawl), showing signs of having cracked in the sun when the lake or gulf dried out, or in places being pitted with holes caused by heavy rain drops during the occasional desert storm. The salty semi-desert environment was not very conducive to life, and few fossils are found in these rocks.

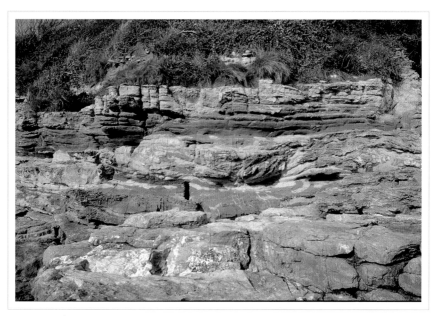

Photo 7.1 | Triassic mudstones.

A few hints of a wider cover of Triassic rocks are found in tiny pockets on the coast of Gower in places such as Limeslade Bay, Port Eynon, Fall Bay and Mewslade Bay. In such places small quantities of Triassic material has seeped into dissolved channels in the Carboniferous Limestone. These deposits must have come from once-overlying Triassic sediments which have been eroded away (see Photos w11.5 and w12.4).

Geologists have suggested that the shape of the present-day South Wales coast and the overall structure of South Glamorgan were both determined around this time and would have roughly similar lines to today. Towards the end of the Triassic Period and into the Jurassic Period tectonic pressures began to change, and the area (now about 30 degrees north of the equator) was stretched, resulting in subsidence and the incursion of a warm shallow sea. Throughout the rest of this time more sedimentary rocks were laid down, now exposed in astonishing detail in the sea cliffs of South Glamorgan (see Walk 13 and Photos 7.2, 7.3, 7.4).

The Jurassic rocks found in the south of our area are the youngest rocks in Wales and were deposited in shallow seas about 200 million years ago. The Jurassic Period is the best known of the geological periods, because it was the time of the dinosaurs and attracts the attention of millions of school kids. Geologists and walkers also like the Jurassic Period for its fossil-rich limestones and charming scenery. The limestones, shales and mudstones of the Jurassic Period form the marvellous exposure of layers of rock on the South Glamorgan coast, most especially between Southerndown and Lavernock (see Walk 13). These rocks are known to geologists as the Lower Lias. They are richly fossiliferous rocks and a walk below the cliffs almost anywhere along this stretch of the coast is likely to show fossils either embedded in chunks of rock or as individual fossils (see Photos 7.5 and 7.6).

These rocks are again laid down with alternating layers of mudstone and limestone. The thickness of each layer varies, with some sections having roughly equal limestone and shale layers, while other sections are predominantly limestone with only a few streaky beds of mudstone. The layering is the most immediately obvious feature of the cliffs seen along the coastal exposures of the rocks. Less immediately apparent are cracks in the cliffs, either 'joints' or 'faults' – the difference being whether there has been any movement of the rocks on either side of the crack. The interlayering of different strength rocks, and the presence of weaknesses in the form of joints and faults, all help to make these rocks pretty unstable when carved into by the sea to make cliffs.

More rocks were probably laid down in our area during the Cretaceous Period (which followed the Jurassic). The Cretaceous is named after the great beds of 'chalk' found on both sides of the English Channel. Chalk is a very pure form of limestone, made up of tiny skeletal remains. It is generally accepted by geologists who work out the course of past geological

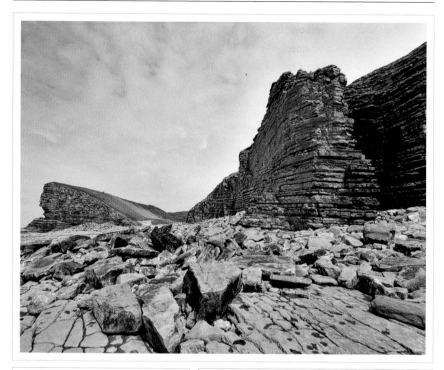

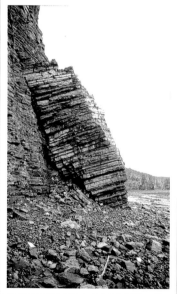

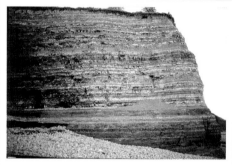

Photos 7.2 (top), 7.3 (right) & 7.4 (left)
Jurassic limestones and shales on the South
Glamorgan coast; note the loose rockfall material
in Photo 7.2 and the collapsed block in Photo 7.4.

events that the warm shallow sea in which the chalk-forming life forms lived must have covered South Wales (and indeed all or most of Britain). Perhaps some of the highest points – Pen y Fan, Bannau Sir Gaer, Craig y Llyn – stuck up above the chalky sea, but the implication is that South Wales was once covered by chalk which has since been entirely eroded away.

No further rocks were laid down in Wales after this and the rocks described in this book form the earth's surface or 'bedrock' in South Wales. The bedrock is covered only by 'superficial' deposits. Soil is one such superficial deposit, and is created from the breakdown of the rocks and the release of minerals, as well as decayed plant matter. Other forms of

Photos 7.5 & 7.6
Jurassic fossils
from the South
Glamorgan coast.

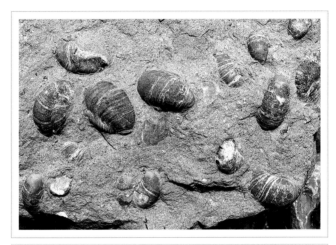

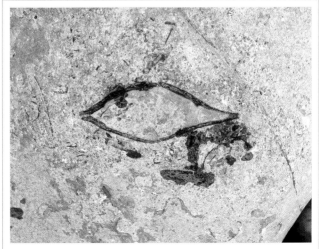

superficial deposits are 'fluvial' mud (deposited by rivers), and also moraines and other 'glacial depositional' features (see Chapter 8). However, large parts of South Wales are covered by glacial depositions that created a superficial material now known as 'till' but previously called 'boulder clay'. Some of these superficial deposits might possibly be transformed into rock if the right circumstances are maintained, but the bulk will be swept away by erosion. Indeed superficial deposits will have come and gone many times in the millions of years we have covered in this brief chapter.

From about 175 million years ago the supercontinent was ripped asunder by the start of the opening of the Atlantic Ocean (which is still widening today). In the last 50 million years or so Wales has experienced 'uplift', that is, tectonic forces have elevated this part of the continental plate. The fairly level hill and mountain summits seen in many parts of South and Mid Wales could well be remnants of 'erosion surfaces' cut by the sea during this time (as per wave cut platforms), and subsequently raised to their present position. It was also during this time that the Carboniferous Limestone cave systems began to develop. Much of the South Wales landscape of those times may well have been similar to that of today, though there would also have been some marked differences.

About 45 million years ago the earth's climate started to cool down. By 2.7 million years ago temperatures had fallen far enough for the earth to enter its current ice age, and a new factor with considerable power began to smother and affect the landscape.

CHAPTER 8

The Ice Age in South Wales

We saw in the previous chapter that the youngest rocks in Wales today, the Jurassic limestones and mudstones, were laid down about 200 million years ago. Any rocks laid down since then have all been eroded away. Vast amounts of rock have been removed from above the present land surface in the years since the dinosaurs roamed. The events that affected the geology of South Wales in these intervening years are largely unknown to us. We know most about the most recent of episode erosion – the ice age.

The earth began to enter a cold phase about 45 million years ago, but the ice age as such began about 2.7 million years ago and lasted until just about 10,000 years ago. Indeed, notwithstanding the short-term effects of human-induced global warming, we are probably in an 'interglacial' phase and not at the end of the ice age as such. There have been several such interglacial phases in the last 2.7 million years with temperatures similar to today.

Between the interglacial phases, however, there was a series of much colder phases, when 'ice sheets' and 'glaciers' spread their icy paws out across much of South Wales. Ice can be a very effective agent of erosion, and played a key role in etching out specific aspects of the present-day landscape, though not as dramatically as in North Wales for example.

The overall shape of the landscape was probably fairly similar to that of today, with the same relationship that we see nowadays between rock type and relief. The most significant of the erosive effects of the ice age is seen in the deep, narrow valleys found in the central core of the coalfield. On a smaller scale we will also note the glacial 'cwms' (also known as 'corries' and 'cirques') cut into the slopes on the higher hills and mountains in the Old Red Sandstone and the Pennant Sandstone.

'Glacial deposition' has also played an important role, by smothering much of South Wales beneath material eroded and transported by the ice and then dumped elsewhere. We will focus our attention on a limited range of such features from the higher land, namely 'moraines' and other 'depositional mounds' found at the foot of the great Old Red Sandstone scarp slope. We will also look at signs of glacial action on the hills – in the form of ice-smoothed surfaces and so-called 'erratics', rock boulders from elsewhere and dumped by glaciers when they melted. A few erratics found in South Wales originate from near Harlech in North Wales.

On the question of erratics, it has often been suggested that glaciers may have carried the 'bluestones' from their place of origin on Mynydd Preseli in West Wales (see Walk 16) to Stonehenge. Some geologists have rejected these claims and insist that they must have got there in some other manner on the powerful grounds that there is no evidence of glaciation reaching that far south. Some archaeologists, however, have tended to favour the glacial transport theory, as they consider unrealistic most of the ideas about how humans could have shifted such large stones over such a distance, given the available social and technological resources 7,000 years ago. Like Stonehenge itself, the method of transport of the bluestones remains a mystery.

The previous interglacial period lasted from about 120,000 years to 110,000 years ago – about as long as the present interglacial period has endured. From 110,000 years ago it became steadily colder until about 20,000 years ago. At this stage a number of 'ice sheets' covered most of Wales, and sea level was as much as 200m lower than at present. These ice sheets were based in different centres on high ground in Wales, Ireland and England and pushed outwards, generally transporting ice to the south and east. The southern tip of the ice is thought to have run, roughly east to west, across the Vale of Glamorgan and south Gower. Temperatures began to rise about 18,000 years ago, steadily warming over the years, though with a brief cold period between 12,500 and 11,500 years ago, during which the upper valleys and mountain cwms were host to smaller glaciers that have left us with various moraines and depositional mounds.

Glacial ice takes several years to form, so there needs to be a good supply of snow over the entire period, and somewhere for the snow to collect in a place where it doesn't melt in summer. As the snow collects, its weight presses down on the lower layers and air is expelled, reducing the air content from about 85–90% to about 20–30%. The snow needs to be at least 30m deep before glacier ice starts to develop.

If conditions are cold enough, an ice sheet that covers a considerable area will develop. Ice sheets can be 1–2km thick, but those covering South Wales were probably much thinner than this as the area was at the southern limits of the ice cover. As the centre of a developing ice sheet thickens and pressure on the lower ice increases, the ice starts to undergo deformation and moves out towards the sides of the sheet. In South Wales the ice could only move to the south and east, because of large ice sheets spreading from Ireland to the west, and North Wales and northern Britain to the north.

Ice sheets don't excavate all the ground beneath them, but slide over much of the ground, concentrating erosion in certain areas and in 'outlet glaciers'. Thus, much of the landscape of South Wales is thought to be similar to the pre-glacial landscape, apart from the coalfield valleys. These were probably initially dug out by outlet glaciers fed by the ice

Photo 8.1

An 'erratic' boulder dumped by a glacier some distance from its original location.

Photo 8.2

A glacially carved valley; Rhondda Fawr.

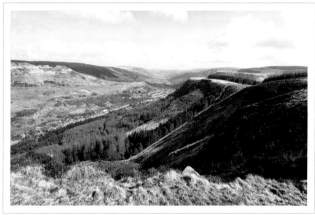

sheet. Later, when rising temperatures reduced the extent of the area covered by the ice sheet, 'valley glaciers' developed which continued to carve out the valleys. Glaciers are often called 'rivers of ice', and this is an apt description for the solid mass of ice which, thanks to both brittle and plastic deformation, can indeed flow *en masse* downhill. This moving ice, when confined in a narrow space, can smash up solid rock and dig out steep-sided valleys.

The valleys of the central South Wales coalfield are classic examples of glacial valleys, comparatively deep and narrow. They often have fairly straight sections and lack the 'interlocking' spurs which typify river-cut valleys. The ice often found weaknesses in the bedrock where parallel faults existed. Several of the classic, narrow, deep central coalfield valleys follow such fault zones for at least some of their course. Indeed the overall north-west to south-east trend of such faults lies behind the overall south-east trend of the rivers of the central coalfield.

The valleys west of the Neath Disturbance are somewhat less narrow. Both the Swansea valley (or Tawe valley after the name of its river) and the Neath valley drain in a contrasting direction, north-east to south-west. Again, this trend is determined by these two major fault zones that run in the same direction and cross the trend of the mass of minor faults in the central coalfield (see Map 6.1).

All these valleys were probably excavated over a series of cold spells, and the ice repeatedly found it easiest to concentrate in existing valleys cut by previous glaciers, thus deepening the valleys in each cold spell. As evidence of this there are some moraines or remains of moraines, in both the Neath and Swansea valleys, which are thought to date from earlier cold periods than the last one. The village of Glais in the Swansea valley is situated on one such moraine.

An ice sheet and large valley glaciers could only be sustained when the temperatures were low enough for glacier ice to exist at low heights, but when temperatures were still lower than today but higher than at the coldest times, glacier ice could only be developed at higher levels (500–600m and above). Under these circumstances, the conditions might be right for the development of small cwm glaciers that might have been only a couple of hundred metres long. The existence of a score or so of what were once glacial cwms, found along the Old Red Sandstone scarp and also within the coalfield, is clear evidence that such glaciers did exist.

Snow collects in a sheltered hollow and, if it doesn't melt in the summer, it can build up to a depth where compression starts to turn the snow into glacier ice. The weight of the overlying snow and ice can force the lowest ice into rotational deformation so that the ice begins to flow downhill.

Cwm glaciers sometimes cut down into the hollow and form a basin with a lip, which can later be filled with water to form a glacial lake after the ice has melted (though glacial cwm lakes can also be held in place by moraines rather than solid rock). During glacial conditions, if the upper surface of the ice forms a continuous downslope, then even the ice in the basin can be transported, despite the fact that the lowest ice has to move uphill before it can move downhill.

For enough snow to collect and stay unfrozen, allowing cwm glaciers to develop, required fairly special conditions. There had to be a supply of snow being blown in the right direction. There was also need for suitable sites that allowed snow to collect, protected from the wind, which would otherwise blow the snow away. The collecting point also had to shield the gathering snow/ice from sufficient sunlight to melt the snow.

These conditions mean that glacial cwms developed only where the topography was favourable. Glaciers were more likely to develop where the scarp slope or coalfield valley run at right angles (roughly north-west to south-east) to the predominant wind direction (south-west). Snow would blow over the scarp edge and collect in a north-east facing dip

or hollow, where it would be protected from too much 'insolation' (melting induced by 'solar radiation' or sunlight).

The precise combination of topography that creates a spot for sufficient wind-blown snow to collect in a suitable, shaded north-east facing scarp or hollow can seem rather arbitrary. Walk 1 in this book describes a route from Pen y Fan and Corn Du heading roughly south along the edge of a rather spectacular slope above the head of the Taf Fechan (Taff Minor) valley. Two very sharp-edged sections, named Craig Gwaun Taf and Craig Fan Ddu, each about a kilometre in length, stand above a very steep headwall and lower down there is a shallower area (see Map 8.1, Diag 8.1 and Photo 3.6). To the north-east of Craig Fan Ddu there is even a small rise in the ground (marked by a small 'ring' contour at height 650m). Both these steep, sharp-edged crags were carved out by small glaciers that existed in these north-east facing hollows and cut back into the headwall.

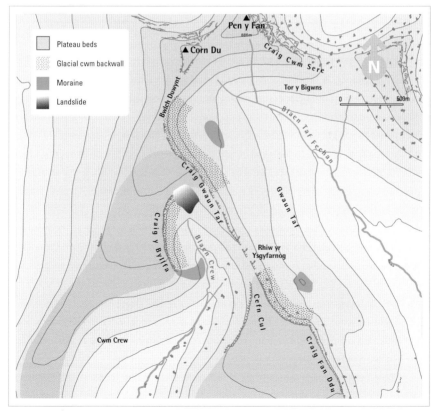

Map 8.1 | Glacial cwms in the Taf Fechan and Cwm Crew.

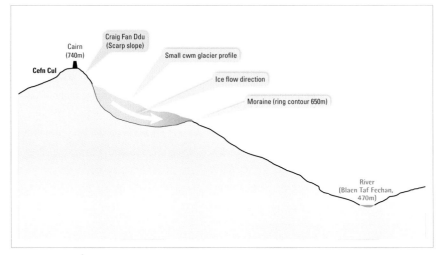

Diagram 8.1 | Cross-section of terrain on western side of Blaen Taf Fechan, Craig Fan Ddu.

Yet, these two minor glacial cwms are separated by a rather wider and shallower edge, Rhiw yr Ysgyfarnog, at the head of a valley to the west, Cwm Crew. The slope east of this part of the ridge didn't sport a glacier. The reason for the contrast with the sections of the ridge immediately north and south lies in the presence of this side valley. Cwm Crew runs largely south-west to north-east – until its last kilometre where it turns sharply to just west of north. A sharp edge can be seen on the western side of this uppermost section of Cwm Crew, Craig y Byllfa. Also some hummocks can be seen lower in the valley, around where the change of direction occurs. These are 'moraines' (see below) and tell us of the existence of a small glacier at one stage in the last tiny corner of this valley.

Snow was blown up the western slopes of Cefn Crew into a hollow at the head of the valley and accumulated there, eventually creating a small glacier in Cwm Crew. The consequence of this is that there was insufficient snow then available to sustain a glacier to the east of Rhiw yr Ysgyfarnog, unlike below Craig Gwaun Taf and Craig Fan Ddu. These minor accidents of topography serve to decide on what did and what didn't happen.

There are about 30 glacial cwms in South Wales, most of them in the Old Red Sandstone, but with a good half-dozen found in the central coalfield, mainly near the highest point in the Pennant Sandstone plateau.

These coalfield cwms are particularly impressive as they are found in fairly densely settled areas and are well seen from main roads. The road that climbs the Pennant Sandstone scarp between Hirwaun and Rhondda Fawr (to a parking place at grid reference SN 927 030)

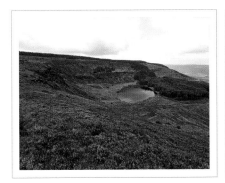

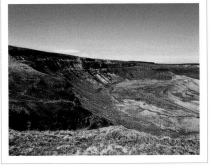

Photo 8.3 | Llyn Fach, a glacial lake, northern Pennant Sandstone scarp; Glyn-neath.

Photo 8.4 | Graig-fawr, near Treorchy.

gives a fine view over Craig y Llyn and Llyn Fawr (see Photo 6.2). Those who leave their motors and walk west along the scarp top will be able to see a more hidden cwm and its lake, Llyn Fach (see Photo 8.3).

A few kilometres further south, at Treorchy, another road climbs to the higher land separating Rhondda Fawr from the heads of the Garw, Ogwr and Afan valleys. Two well-rounded glacial cwms, Graig Fâch and Graig-fawr, are seen as one ascends the road, and can be examined at leisure from the lip of the corries starting from another well-placed parking area at SS 939 945 (see also Walk 9). A third cwm, Tarren Saerbren, is less easy to see due to woods on its slopes. It lies a little to the north of Graig-fawr.

The glacial cwms in the Old Red Sandstone can be scenically quite spectacular, especially the cwm containing Llyn y Fan Fach (see Photo 0.1) on the northern scarp slope underneath Bannau Sir Gaer (Carmarthen Fans). Here the ice has managed to find a hollow which faces east even though the general trend of the scarp slope in that area is east/west. The atmospheric wild lakes of Llyn y Fan Fach and Llyn y Fan Fawr (see Photo w4.3) feature highly in Welsh lore and legend.

Several of the glacial cwms in the Old Red Sandstone, and in the coalfield, have some form of 'glacial deposition' features in the vicinity. The most well known of such features is the 'glacial moraine'. Material eroded by a glacier is carried along at the glacier's base, or on top of it, or along its sides, and then dumped as the glacier melted and released its load. Frontal moraines can often illustrate the furthest point of ice cover or stages in its retreat. A 'terminal moraine' marks the furthest point of a glacier's extent, while a 'recessional moraine' is formed at a short-term resting point of the snout of a 'retreating' glacier. Note that it is the melting point of the ice which 'retreats', not the ice itself which flows forward to wherever it melts. If a glacier

re-advances or a new ice age begins, the renewed flow of ice will wipe away any previous moraines, as they are just a mound of loose boulders and finer material, and present no resistance to the forward momentum of the ice flow. Lateral moraines also develop at the sides of glaciers.

A very small glacier, or one which is at the end of its life, may not extend further than its own glacial cwm, and it is not unusual for moraines to exist at the margins of such cwms. Also such moraines may be responsible for holding in a glacial lake. Llyn y Fan Fach is one of the most beautiful of South Wales's many lakes. It is tucked into a scoop out of the northern base of the great Old Red Sandstone scarp under Bannau Sir Gaer, and although heightened by an artificial dam, is held in place by a wide, hummocky moraine on its northern edge. However, Llyn y Fan Fawr, its counterpart on the eastern side of the scarp, exists because there the ice cut down several metres into the bedrock. The very slight rises in the ground on the eastern side of the lake, just a few metres above the lake level, have only a smattering of deposited material with no known moraines.

Llyn Cwm Llwch is the only glacial cwm lake on the northern edge of the scarp in the area around Pen y Fan (see Photo w1.4). It is a miniature lake in comparison with Llyn y Fan Fawr and Llyn y Fan Fach, and its tiny size is emphasised by the grand, deep valley in which it sits, Cwm Llwch. The cwm was carved into a hollow about halfway down the north-western ridge descending from the Pen y Fan/Corn Du high point. The cwm neatly faces north-east, the perfect spot for snow blown by westerlies up the slope from Glyn Tarell and over the ridge, to collect and be converted into ice. The lake is held in by a set of curved moraines which can easily be seen from the peaks (Walk 1).

Ridges or mounds are a frequent feature at the base of the Old Red Sandstone scarp between the central Beacons (around Pen y Fan), through Fforest Fawr and onto the Mynydd Du massif (around Bannau Sir Gaer and Fan Brycheiniog). On this western part of the scarp, geomorphologists have identified nine or possibly ten mounds over the 7km stretch of slope.

The mounds run virtually all the way from Llyn y Fan Fach, on either side of Fan Foel which sticks up northwards and where there is a small gap, and then to well south of Llyn y Fan Fawr, where there is again a gap. Along the north-facing section of the scarp they are almost continuous, broken only by small gaps. All this would intuitively suggest that these mounds must have a common origin, and that they would most likely seem to be glacial moraines.

However, despite the common-looking aspects of the mounds, this idea is disputed by geomorphologists, and it is thought that a variety of causes have led to the creation of a similar set of features.

Certainly some are moraines, but others are hard to classify in this category, as they lie under crags which face north-west or even west, and thus would have been subject to

too much heating by the sun for snow to collect sufficient to make a glacier. Others are considered to be too straight, unlike moraines which are often curved (or 'arcuate'). Photo w4.5 shows a straight mound that lies at the northern foot of the scarp between Bannau Sir Gaer and Fan Brycheiniog. Photo w4.4 shows the same mound from above, and another nearby mound that is clearly curved and which looks much more like moraine.

One idea is that some of these mounds may be 'pronival ramparts' (previously known as 'protalus ramparts'). These fancy-sounding names are given to the suggestion that such mounds could have been created by rocks falling off the scarp slope down to a patch of ice/snow at the base of the slope, but having sufficient momentum to carry on across the frozen zone and to collect there as a mound. The amount of sunshine was not sufficient to prevent all freezing at the base of the scarp, just enough to rule out the development of a glacier.

The most impressive of these mounds is a magnificent ridge that runs for 1.2km, north/south, along the bottom of the scarp slope under Fan Hir (the 'long ridge') on the eastern side of Mynydd Du (see Photo 8.5). This mound has traditionally been viewed as a classic example of a pronival or protalus rampart. It looms as much as 30 metres above the base of the scarp. The recommended route in Walk 2 of this book views the extraordinary mound from above, but to get the best impression of its presence and mass it is actually necessary to walk along the generally narrow summit line of the ridge itself, or at its base, between the towering scarp (which rises up to 120m above the base) and the mighty ridge.

The mound curves into the scarp slope itself at its southern end, and here a stream has cut a sharp-sided gorge into the mound so that water can drain out of the area between the scarp and the mound. There are a couple of small mounds that lie within the gully between scarp and mound, about two-thirds of the way down the mound's length.

Photo 8.5 |
The ridge-like mound
at the foot of Fan Hir.

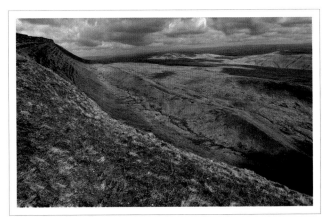

However, a detailed study revealed that about 20% of the rocks and boulders within the mound are marked by 'glacial striations', caused by being scraped against bedrock while being transported along the base of a glacier when it flowed. This discovery led to a re-appraisal of thinking about the origin of the Fan Hir mound, and gave rise to the idea that a small glacier existed in the gap between the mound and the scarp. Geomorphologists conjured up the idea of a glacier looking rather like dough baking into a loaf and rising up above a baking tin. This has taken over as the generally-accepted view of the origins of the mound. A weakness of this idea (apart from the lack of modern examples) is that there is no real explanation of where the material that forms the mound was excavated from by the pudgy little glacier.

However, a modern corollary of free-standing moraine mounds can be seen in various places in currently glaciated regions, such as the Alps, where glaciers are 'retreating' under the impact of global warming of the climate. An example is shown in Photo 8.6. It is possible that the Fan Hir mound is such a moraine, and was deposited in this manner alongside a major glacier or ice sheet lobe that was passing south just a few metres east of the ridge. Certainly there is good evidence that such ice sheet lobes did pass southwards here, in particular the lineations and benches formed by the passage of ice that can be seen on the lower flanks of Fan Hir and Fan Gyhirych.

The case of the Fan Hir mound shows how hard it is to determine for certain why these similar-looking mounds have all clustered around this and other parts of the scarp slope base. No doubt worthy academic exploration for an explanation of their origins will continue over the coming years. What is clear is that they are one of the more enigmatic of the glacial features of the South Wales uplands.

Photo 8.6

The shrinking Gornergletscher in the Swiss Alps has left an isolated moraine (the dark curving patch that runs to the bottom of the photo near the lake) perching on the mountainside some metres above the ice.

CHAPTER 9

The Living Landscape

In the previous chapter we looked at some of the landscape features of South Wales which we owe to the effects of ice during glacial episodes. In this chapter we will look at the landscape in our current post- or inter-glacial period. It's worth introducing two more technical terms here, 'paraglacial' action and 'periglacial' action. Periglacial activity happens when there is frequent freezing and thawing of water at ground level. Such activity mainly occurs around the edges of ice sheets and glaciers, but it can also happen in cold winters in interglacial phases.

These 'freeze-thaw' mechanisms allow water to seep into faults and joints in rocks, expanding on freezing and contracting on melting. If this happens often enough it can cause rocks to break up into boulders or pebbles. This happens often on exposed slopes and scarps where the lumps of rock, freed by freeze-thaw, collapse under gravity to form large 'scree' slopes (also known as 'talus' slopes).

There are some tremendously impressive scree slopes along the great Old Red Sandstone escarpment, especially around Bannau Sir Gaer (Carmarthen Fans) and Fan Brycheiniog, although they can in fact be found just about everywhere that there is a steep slope (see Photos 0.1, 1.1, 1.2, 6.3, 6.4, 8.2, 8.4 and several others). Most scree slopes will now be cloaked by layers of vegetation, though they are still identifiable by the change in angle of the slope. Where you can see a scree slope without vegetation you can assume that the scree creation is still pretty active, and is sufficient to prevent the accumulation of vegetation.

Paraglacial action, by contrast, refers to a situation which has been created during the ice age, but with effects that only occur after the ice has melted. The simplest example is the landslide that occurs once a valley glacier has melted. During the cold period the glacier would have cut quite steep valley sides, too steep to be supported under their own mechanical strength. While the glacier existed it provided support to the 'over-steepened' valley sides. But, once the glacier melted, the valley sides lacked support and, sooner or later, landslides occurred.

Major landslides can be found in all sorts of rocks throughout South and Mid Wales: such as at Banc Dolhelfa, near Llangurig, one of the largest bedrock slides in Mid Wales, involving Silurian rocks; several landslides such as at Fan Dringarth, Cwm Cerrig Gleisiad and Cwm Crew in the Old Red Sandstone of the Brecon Beacons range; and in the Carboniferous

Limestone at Oxwich Bay (though at the site of an old quarry in this case), to mention just a few examples. However, the South Wales coalfield is particularly affected by landslides, in part because of the geology, with its mix of soft shale and resistant sandstone (see Chapters 5 and 6), and in part because of the legacy of mining. We will return to the coalfield landslides later in this chapter. Before that we can usefully look at some of the other aspects of the post-glacial landscape of South Wales.

During an ice age, when glaciers are plentiful, a lot of the world's surface water is locked up as ice and the sea level falls, to perhaps as much as 200m below its current level. So when the glaciers melt in all regions (except the poles and high mountain ranges) vast quantities of water drain away, ending up in the sea. The result is that sea level rises and the shore line changes.

One of the most prized of the multitude of ancient archaeological sites in Wales is Paviland Cave, found between Rhossili and Port Eynon on the south Gower coast (see Photo 9.1). The cave is not terribly easy to access as it is sited a short way up the steep limestone cliffs that characterise the coast here (see Walk 12). The oldest known remains of a modern human in northern Europe were uncovered in the cave. For a long time the ochre-dyed bones were thought to be those of a woman, and were known as the Red Lady of Paviland. However in more recent times it has been realised that the bones are actually those of a young man and date from around 33,000 years ago.

Photo 9.1 (left) | Paviland Cave.

Photo 9.2 (below) | Glacial meltwater channel, near Newport, Pembrokeshire.

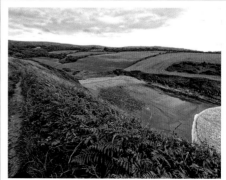

To gain access to the cave today it is essential to time your visit to coincide with low tide. Yet 33,000 years ago the people who laid out the remains of the young man in the cave would not have had to worry about tides, for the cave is estimated to have been as much as 100km away from the then coastline. This was during a cold period and the ice sheet from the north would have been no more than a short distance to the north of the cave (though some scientists believe that the young man may have lived in a slightly warmer period). There were continuous land links with Ireland and with continental Europe until about 14,000 and 7,000 years ago respectively, when glacial meltwater redefined the coast and gave us near enough our current shoreline.

The glacial melting was at times very rapid, so it would have created powerful meltwater flows. These are thought to be responsible for some of the wide dry valleys found in the Carboniferous Limestone and Millstone Grit in the mountain areas north of the coalfield. Ground water would have remained frozen for some time after the glacial ice had started to melt, so meltwater would have flowed on the surface and carved out the valleys. Glacial meltwaters were also responsible for digging out flat-bottomed, trench-like valleys in Pembrokeshire and Cardiganshire (see Photo 9.2), and deepening some of the valleys now containing fairly small rivers or streams.

When the ice melts it leaves bare rock, and it takes little time before chemical weathering (see Photo 9.3) and lichen begin the process of breaking down the rocks and making soil. Minerals on the surface of the bare rock react with the atmosphere and chemical changes take place. This can be seen in the way in which a freshly broken piece of rock is usually a quite different colour from rock that has been exposed to the atmosphere for some time. The houses, chapels and industrial buildings of the coalfield are often a dark brown colour, most noticeably among the Pennant Sandstones. However, freshly quarried Pennant Sandstone is not brown but grey/blue.

Lichen is a symbiotic life form, combining algae and fungi. They live on the bare rock and extract minerals from it. They also dispose of unwanted matter that becomes the basis for the development of soil. It is often difficult to tell whether a rock is covered by lichen without taking a close look, though some highly-coloured lichen are fairly easy to spot.

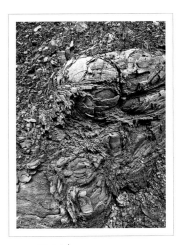

Photo 9.3 | 'Onion skin' weathering in sandstone.

As the sea level falls, the erosive power of waves and tides causes the creation of cliffs at a new level. The power of the seawater to pound the rocks is heavily concentrated on, but not entirely limited to, the zone between high and low tide levels. Storm-driven waves smashing against a cliff exert enough force to cause joints and faults to expand and weaken. The shock waves generated within the rock extend up and into the cliff beyond the immediate tidal zone. Waves undercut cliffs too, by smashing boulders against the base of the cliff.

When the tide is out the cliffs often stand some distance from the sea, separated from it by a 'wave cut platform'. Outstanding wave cut platforms, which offer those interested in geology fascinating slices through rock outcrops, are found on the coasts of South Glamorgan, Gower and Pembrokeshire (see Walks 11, 12, 13 and 15; see also Photos 9.4 and w11.1 and w13.5).

There is some partly-hidden evidence of old wave cut platforms lying beneath scree and other superficial deposits on the south Gower coast, pointing us to variations in sea level. Diagram 9.1 shows an idealised and simplified profile of the cliffs roughly between Mumbles Head and Pwlldu Head (see Walk 11). An old wave cut platform can be seen forming a level platform and steep cliff some height above sea level. The platform and cliff are smothered by scree and loose material so it is not easy to recognise.

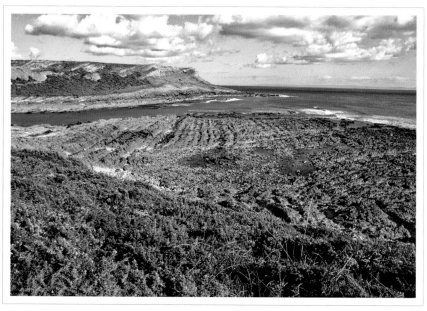

Photo 9.4 | Wave cut platform, Gower coast.

However an easily-recognisable common feature is the steeply-eroded base at the front edge of the superficial deposits. This has been created by storms over the past few thousand years (see Photo 9.5). Another feature associated with this small eroded zone is a 'raised beach', which lies on the forward edge of the ancient wave cut platform and was created when that represented sea level. The beach can often be identified on a small scale by the 'patella' or limpet shells it contains. These are just a few thousand years old and are very young pre-fossils, not yet having been converted into solid rock (see Photo 9.6).

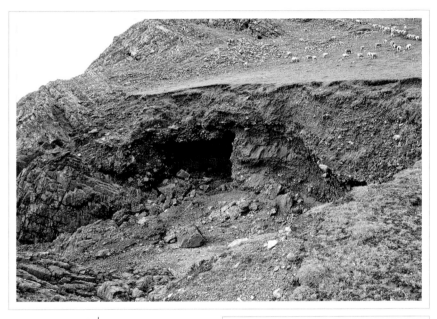

Photo 9.5 (above) | The storm-eroded cliff cut into superficial deposits with a 'raised' or 'patella' beach at its base on the south Gower coast (near Port Eynon).

Photo 9.6 (right) | Patella fossils in the making.

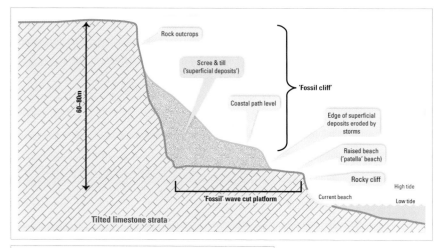

Diagram 9.1 |
Idealised cross-section through
a south Gower sea cliff.

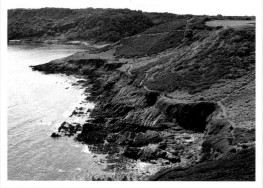

Photo 9.7 |
South Gower cliffs
near Pwlldu Bay.

The erosion by waves of the rocks in some places, such as along some parts of the South Glamorgan coast, produces cliffs that are pretty regular, almost monotonous, forming a long, largely unbroken line. Elsewhere, however, they are intensely intricate, forming a vast variety of shaped headlands and coves. These differences reflect the geological features of the rocks. Those in Pembroke which form such endlessly fascinating ups and downs and ins and outs, offering a new and repeatedly stunning view every few score metres, reflect the intensely mixed and jumbled rock types, and the presence of faults generated in the midst of one or more episodes of mountain-building.

On the south Gower and the South Pembrokeshire coasts the intricate coastal cliffscapes are also the product of compression, folding and faulting, though during a single phase of mountain-building offering weaknesses which the waves exploit to batter away at the rock.

Inlets carved out by the sea form delightful bays, often sited on fault lines – something which is evident in several narrow dry valleys running to the coast between Rhossili and Port Eynon on Gower (see Walk 12). Erosion of headlands leads to features such as natural arches (see Photo 9.8) where the power of the sea is directed at the inner corners (see Photo w15.5). These are clearly transitory aspects of the landscape and illustrate the active nature of the scenery.

South Wales is renowned for its waterfalls. The area around Pontneddfechan, where several rivers that rise on the Old Red Sandstone coalesce into the river Neath, is even known as Waterfall Country for the spectacular set of waterfalls in one small area (see Walk 7). Most of these falls occur on the rocks of the Millstone Grit which mixes tough sandstones or grits and softer shales. Where tectonic forces have moved rocks up and down, breaking up the original beds, it is not unusual for sandstone and shale to be thrust into adjacent positions on the present-day surface, and many of these falls are the result of differential resistance of the various rock types.

The waterfalls near Pontneddfechan are generally pretty easy to access from the car park in the village, with a straightforward walk along a good river path, most especially to the fall known as Sgwd Gwladus. There is another very fine waterfall, Scwd Einion Gam,

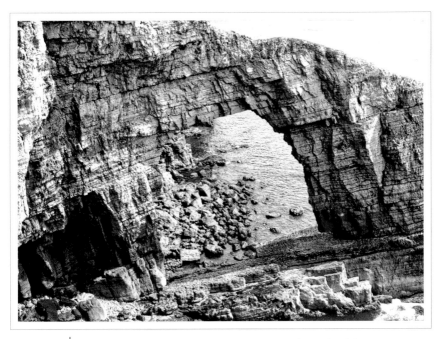

Photo 9.8 | The 'Green Arch of Wales', south Pembrokeshire coast. Photo: Reg Atherton.

not very far from Sgwd Gwladus. However, there is no riverside path to help ease the way, and it is actually necessary to wade across the river a couple of times to get anywhere near Scwd Einion Gam which means that it is seldom visited. This is a pity as it is one of the most enchanting of the waterfalls in the area (see Photo 9.9). This fall straddles the geological boundary between the Millstone Grit and the Coal Measures, with the tough sandstone at the base of the coal, the so-called Farewell Rock (see Chapter 5), forming the top of the fall and Millstone Grit shale forming its base.

There are many other waterfalls to be found throughout South Wales, especially in the coalfield. Here many waterfalls are the product of glacial action, which carved out deep valleys, but left shallow, high-up side valleys where a tributary falls over the steep valley side on its way to joining a major river. Melincourt and Aberdulais in the Neath valley are two fine examples, but they can be found at various places throughout the valleys, that is the central part of the coalfield where valley glaciers cut out steep-sided valleys during the ice age. Walk 8 at the head of Rhondda Fawr passes, or comes close to, five such waterfalls.

Before ending this rapid glance at the post-glacial landscape of South Wales, we need to spend a bit of time looking in some detail at one facet of the present landscape that brings geology right into the lives of people today. As noted at the start of the chapter, the South Wales coalfield in particular is one of the most landslide-prone areas in Britain owing to its geology. There are landslides in other geological areas within South and Mid-Wales; however, it the coalfield that is particularly prone to landslides.

Yet, even with the coalfield the dis-tribution of those landslides is not even, and they tend to be concentrated in the valleys of the central (Rhondda, Ogwr, Garw and Llynfi) and the north-eastern (Ebbw, Sirhowy and Rhymney) areas. There are far fewer dense concentrations of landslides in the western coalfield,

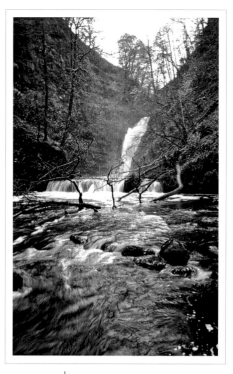

Photo 9.9 | Scwd Einion Gam.

though there are several slide sites in the Neath and Swansea valleys where they are an ever-present threat (see 'Tawe landslides' box). The wide, gently sloped Gwendraeth valley in the north-west of the coalfield has very few landslides, with about just 0.6% of its area affected, while an astonishing 5% of the area of the Rhondda Fawr is covered by landslides deposits.

Well over 2,200 landslides have been recorded in the coalfield thus far (out of some 8,800 in the whole of Britain). The bulk of these landslides happened after the end of last ice age, between 10,000 years and 8,000 years ago, when the ice melted leaving 'over-steepened' valley sides. There was also one major slide that was triggered just 5,000 years ago.

There is a limit to the strength of the sandstone itself. The bedding planes between individual rock layers in sandstone are one zone of weakness. As the sandstone is largely horizontal or gently tilted, the bedding planes too are horizontal or gently tilted. When the ice melts and leaves the rock faces overlooking the valleys unsupported, the sandstone also expands laterally and creates fractures known as 'joints'. These joints open up more or less vertically, and gravity pulls the rock mass apart near the valley sides along the joints, creating fissures, depressions, 'counterscarps' and other features such as 'graben' which are areas of subsidence between steep banks or slopes, often found lying across the tips of ridges running off the plateau.

The phenomenon is known as 'lateral extension' or 'lateral spreading', and is commonly associated with a strong overlying 'caprock' such as the Pennant Sandstone, and a weaker, deformable underlying rock such as shale or seatearth.

The upland areas ('interfluves') separating the glacially-carved valleys of the central coalfield are pretty narrow, sometimes only 1 or 2km wide. This is especially the case of the high land between the valleys of Sirhowy and Ebbw Fach, Rhondda Fawr and Rhondda Fach, and Garw and Ogmore. This means that the sandstone is left unsupported on two sides of a fairly narrow block adding to its instability. The spreading of the sandstone occurs on hillsides above shale and other weak rocks. The rock in effect starts to separate into individual blocks, separated by joints and/or faults, when the weaker rocks are deformed after deglaciation, as a result of 'rebound' from the compression experienced when the rock had been loaded with ice. This rebound allowed weathering and erosion to work at the rock.

Mining is another factor that has contributed to the development of features such as fissures and graben, but they are primarily natural features which also occur in some places in Britain where there has been no mining. It is thought that some of the fissures and other features of lateral extension pre-date the earliest OS maps, and are thus unlikely to have been caused by mining. All the same, the collapse of the roof over mined areas often leads to subsidence at surface level and movement along faults or opening of joints. Longwall mining techniques (see Chapter 6) in particular set off instabilities in the overlying rocks that can

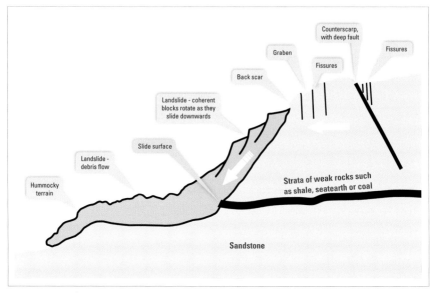

Diagram 9.2 | Lateral expansion of sandstone masses and landslides.

have effects even after the roof of the mined area has collapsed. The longwall method sets off a sort of slow speed wave motion through the rock mass as the mined area is progressively extended and abandoned. Mining can certainly exacerbate or reactivate ancient landslide sites.

The surface fissures are probably the least conspicuous features of lateral extension, though some can in a few cases be as much as 10m wide, but most are much narrower (see Photo 9.10). Indeed some may be easy to overlook and these fissures can be a hazard to walkers as they are sometimes hidden by vegetation. So it is important, if walking away from paths on the coalfield plateau in such areas to keep your eyes open for signs of fissures. They can often be many metres deep, so it would be easy to slip into one and break a bone in the leg or ankle (or worse – see page 125).

The graben also require a bit of looking for. At times it can be difficult to decide whether a rock face or sharp slope is a part of a graben or an abandoned quarry, but you can recognise them in several places, such as alongside Rhondda Fawr (see Photo 9.11) and on either side of Ebbw Vale. Some graben are large-scale features, up to 4km in length, 300m in width, and with depths of up to 6m, but others are much smaller than this.

Another feature of the lateral extension of the Pennant Sandstone is the 'counterscarp' slope or bank found on the plateau and its sides (see Photos 6.9, w9.1, w9.2, w9.3, w9.4 and w9.5). They can be up to 4 or 5m high and some can run for several hundred metres, looking

Photo 9.10
Fissures above
Ebbw Vale.

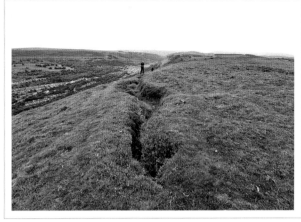

Photo 9.11
A 'graben' on a ridge
in the Rhondda Fawr.

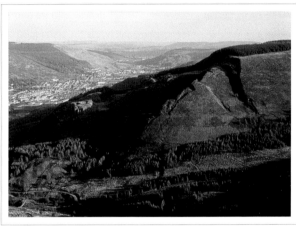

very much as if they are some early medieval territorial dyke. When you get close to such a scarp you find that there is no ditch on one side as would be expected next to a human-made bank, and which would be necessary to provide the material to build up a dyke. Instead you are likely to find fissures in the ground on the lower side of the bank. I should emphasise that the 'lower' side of the bank is found on the side nearer the top of the plateau or hill. This is because the bank shows the surface is slipping downhill, carrying much of the ground with it to form the bank. Thus the name 'counterscarp' indicates that the scarp slope runs counter to the slope of the valley side. These are not just features of surface movement, as some counterscarps are the surface expression of significant faults in the underlying rock, such as the Tableland Fault on the moorland to the west of Rhondda Fawr (see Walk 9 and accompanying photos).

These features can be found alongside one another on the coalfield plateau. They are signs of the active landscape, indicating deformation and displacement of the underlying rock mass as the rocks adjust to the removal of the ice supports in the valleys. These features are most common in the central and northern parts of the coalfield plateau. Here the plateau is at its highest and the valley sides are narrow and steep. It is not known for sure whether lateral spreading is still happening today, or if it was confined to the immediate post-glacial period, but some geologists believe that very small movements are still occurring.

We need, however, to look beyond the sandstone itself to see how landslides occur and look at the other rock layers adjacent to the sandstone. The majority of the coalfield landslides occur at or near the junction between the lower and the upper Coal Measures. At this level, sandstones at the base of the upper Coal Measures lie immediately above shales at the top of the lower Coal Measures. Here, water that seeps through the Pennant Sandstone meets the largely impermeable shales and drains along the 'dip' of the rocks, forming springs along a 'spring line' at the rock junction where the water meets the side of a valley.

The slow spreading of the land to create fissures and other features can be a precursor of more dramatic events – landslides. Strictly speaking we should distinguish between a variety of types of landslide from the slow creeping of soil downhill to a fully-fledged collapse of a rock mass. Roughly speaking we can divide the flow/collapse of 'superficial' material as landslips and the collapse of bedrock as landslides. These can be symptoms of the same underlying instability as slips often happen before and after slides.

Landslides are usually preceded by heavy rain, which adds to groundwater pressure and provides lubricant for the sliding of rocks. Whatever its immediate cause, the underlying reason for a landslide is a loss of coherence in the rock. A weaker layer of rock, such as shale, provides slip surfaces along which the rocks can slide downwards when the pull of gravity overcomes the mechanical cohesion of the rocks. In a rotational landslide whole blocks of the overlying sandstone may retain coherence and slide down as a large blocks. In other cases the rocks may shatter into smaller boulders.

Water contributes to the process. Sandstone is porous, though within tight limits, and water can be stored in and move through joints and fissures. Shale, except where broken by faults and joints, is impermeable. So when water meets shale it will be directed to flow along whatever way the rock is tilted. This provides lubricating fluid on the 'slide surface' created by weak, easily-shattered shale or other softer rock such as seatearth (see Chapter 5).

The key scenic features of landslides are the rock face, or back scar, and broken ground made up of fallen boulders and a hummocky 'debris flow' beneath; the back scar marks where the overlying rock has broken away from the main mass of sandstone. It may at times be

difficult to distinguish between a natural landslide back scar and a quarry. Below the back scar the slumped rocks usually form some type of broken, hummocky ground, often extending way into the valley floor depending on the angle of the slope. Once again it may be difficult to tell landslide 'debris flow' hummocks from waste tips. Sometimes quarries, mines and waste tips are located among natural landslide areas adding to the complexity of interpreting the landscape.

Photo 9.12

Landslide at the head of Rhondda Fawr; another landslide is just visible below the ridge in the right of the image.

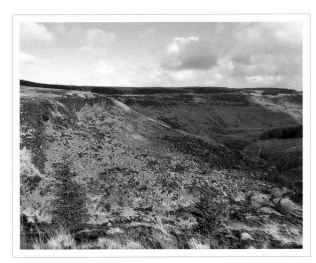

The story does not end there. In addition to the ancient landslides that occurred mainly in the couple of thousand years after the end of the ice age, there has been a new phase of landslide activity in the past few decades. There are now over 100 active slides in the coalfield including 30 in the Ebbw valley, 20 in Rhondda Fawr and 15 in the Ogwr valley. Several major landslides of the past 150 years, such as at New Tredegar, Bournville, Blaencwm, Troedrhiwfuwch and Darren Ddu are all associated with features such as fissures and graben. A major slip affecting the upper Tawe valley occurred while I was researching this book – see box 'Tawe landslides'.

This new wave of landslides is due to human activities and in particular to the effects of coal mining. When a mine is abandoned some more or less empty spaces are left behind. These create significant zones of weakness, concentrating stress lines into remaining supports and pushing them down into the rocks below. Research has shown that this leads to catastrophic failure of slopes as the stress rips apart the rocks both above *and below* the mined space.

Mining operations also add to the complexity of underground drainage, altering its routes, thus contributing to the development of landslides. The tipping of waste creates yet

more problems, especially if tipping adds to the existing load on top of weak or previously collapsed land. Indeed, tipping alone can create its own hazards.

There are various types of waste tip collapse. 'Flow slides' involve the collapse of loose structures (such as soil) into a semi-fluid movement. 'Debris slides' are similar to flow slides, but are not so fast-moving. 'Outbursts' are the rapid, or even explosive, release of ground water and debris flows, where material moves downhill rather like wet concrete, moving slowly at first then gaining speed.

A waste tip failure occurred at Abergorchi on 4th November 1931. The colliery's existing tips were overloaded, so a new tip was opened some 500m away. Unfortunately the new tip was located over the head of a stream. It continued to flow, eventually undermining the tip, which collapsed leaving an 80m-wide back scar. The debris flowed as far as the colliery workings. Seven out of eight boilers were put out of action when the boiler room was partially overwhelmed; however there was just enough steam to bring back the 700 miners from underground.

At Mynydd Corrwg Fechan, above Glyncorrwg, the waste dumped on top of the hillside was sufficient to set off a landslide in the bedrock at the boundary between shales at the base of the hill and sandstone forming the bulk of its mass. In 1939 a tip slide at Cilfynydd should have warned the coal industry. As has been written, "Why weren't the lessons learnt?"

The potential for the loss of life due to poorly-managed waste tip dumping was illustrated by a tragedy that occurred in 1961 in the Belgian coalfield at the town of Jupille. Seven children and four adults were killed by a landslip that occurred on a 29m-high waste tip when the wet base of the tip gave way. Over half-a-million tons of waste ash travelled about 700m in 60 seconds over a very low angle slope (just three degrees) to bury several houses. Again, it is surprising that no lessons were learnt from this Belgian disaster, as a bigger catastrophe might have been avoided.

Two shafts of the Merthyr Vale colliery were dug into the floor of the Taff valley near the village of Aberfan between 1869 and 1875, intending to intercept the rich seams of the lower Coal Measures. The colliery was said to produce some of the best steam coal in the South Wales, supplying the famous Cunard line with the fuel for its liners. The coal was separated from shale by 'washeries' which produced a lot of waste in the form of pulverised shale.

Initially waste from mining operations was dumped nearby in the valley floor, but this soon ceased to be practical. Eventually a winding house was built on the hillside to haul waste up an 'inclined plane' from below to where it would be dumped, forming a tip lobe. After a while another, higher tip lobe was created, but it rested only partly on the hillside (with a 1 in 4 slope). It also stood partly on top of the underlying old tip lobe. This process

was repeated with a third tip. For the fourth tip a new method of spreading the waste was employed, creating a cone. Tip 4 became unstable in 1943, but no one noticed, and it collapsed later in the 1940s. Tip 5, built in the same way, started to bulge in 1945; this time tipping on it was stopped. Tip 6 was squeezed in above, resting on the lower lobes. Similarly Tip 7 was added on top.

The cause of the eventual slide was not just the consequence of relying for support of new tips partly on top of older ones. The tipping ignored the geology and natural drainage of the hillside, which contributed enough water at the base of the tips to provide internal disruptive pressure as well as lubricant for the slide. The rocks comprised sandstone, seatearth, coal and more sandstone and, crucially, dipped slightly to the west – towards the valley. The seatearth was largely impermeable and a line of springs developed along its outcrop. The first tip to be developed was abandoned when a spring undermined it, but still the next tip was partly leaning on the first one.

There was an incident on Tip 7 in 1963 when the last seven metres of the end of the lobe collapsed. No one worried and tipping was continued, and over the next three years the profile was rebuilt to be the same as the slope profile just before the 1963 incident. The tipping crews had to move their crane back from the end of the lobe each evening, as a tension gash two to three metres wide would open up each night in the same place as the collapse in 1963. Unfortunately no one took care to notice that the tip was extending beyond the end of lower-lying tips, which were relied on to provide support.

On 21 October 1966 the tip finally gave way and about 38,000 cubic metres flowed down the valley side in a short time. The sludge travelled some 450m, jumping over a railway embankment and engulfing part of the village. Tragically, 116 children and 5 teachers died in the school, and another 23 people were killed in the village. A witness described the first wave of the slip as higher than a house and carrying boulders, trees, mine tram wagons, bricks, slurry and water. Some hours later a stream at the head of the slip started to flow down the debris, converting some of it into a mudflow which did further damage.

There are few remnants nowadays of the old coal industry in South Wales. The once ubiquitous conical waste tips that stood on the hills above the valleys were

1909 – Pentre Rhondda

1931 – Treorchy

1939 – Cilfynydd ("Why weren't lessons learnt and Aberfan avoided?")

1960 – Corrwg Fechan

1966 – Aberfan

Diagram 9.3
Tip slips in South Wales.

progressively reduced in height after the massacre at Aberfan. The colliery buildings and related paraphernalia such as overhead gantries and railways were taken away for scrap after the miners' strike in the mid-1980s and it now seems as if nearly every relict of that industry has been carefully removed.

This doesn't mean that the coal industry's effect on the landscape is a thing of the past. The coalfield in scattered with 'timebombs' in the form of old mines and underground workings. Thanks to human intervention, the landscape of the coalfields is experiencing rather rapid change (in geological terms).

In the background, the greatest challenges we face globally are scepticism about, and ineffective action to deal with, human-induced climate change. The cause of that climate change is the amount of carbon dioxide released into the atmosphere – ice cores show that the rate of increase is faster over the last 150 years than at any previous time. The coal of the Carboniferous Coal Measures continues to play a role, affecting the climate and human society, even after it has been dug out of the ground.

Ystalyfera's landslides

It was a dark and stormy night on 22nd December 2012, so there were fortunately no residents on the streets of Panteg, near Ystalyfera, in the upper Tawe valley.

It was all over within a few seconds. Those at home, or in the nearby pub, who heard it happen, reported that it sounded like 'an express train'. When they went outside to look at what had created the sudden loud noise, they found that a stretch of the hillside, some 150m long, had slumped down as a mass of mud, boulders and vegetation, crossed the road and risen a short way up the side of some of the buildings on the far side.

December 2012 was a pretty notable month in terms of landslides and landslips throughout the whole of Britain. The average number of all types of landslides in the period from December 2006 to 2011 was 14, but in 2012 the number reached 76. November and January 2013 also saw much higher numbers of landslides than average, but not as dramatically so as in December. Significantly, rainfall was also higher than average from April through to December (except for May) and, not surprisingly, much higher than average during December itself (about 180mm as opposed to the average of about 125mm).

There can be no doubt that the high level of rainfall in December helped trigger the Panteg landslip, but rainfall was not the underlying cause of the sudden mass movement. In fact the 2012 landslip involved the 're-activation' of an old slide surface dating from about 8,000 to 10,000 years ago, just after the end of the last ice age. This is marked by a rock face, or 'back scar', that is about 15m high, although there has been a lot of quarrying to provide building stone for the local villages, and the now largely-vanished coal and metal-working industries. There have indeed been several incidents in the last 75 years. There was a serious event in 1986 that encompassed a previously unaffected area. This was caused by high groundwater pressure forcing the release of a large body of water into an ancient debris flow area, which in turn reactivated the debris itself, sweeping it through two houses. Engineers view this type of landslide as particularly dangerous as no warning signs appear before the mass failure.

Significantly, the geology of the hill (Allt-y-Grug – the hillside of heather) is favourable to sliding because of the gentle west to east dip of the rocks in the area (see Diagram 9.5). This means that rain water seeps through the porous sandstone until it meets the impermeable layers of shale, associated in this case with the Lower Pinchin seam of coal. Water is then directed by gravity towards the east to drain out above the villages. This helps to destabilise the coal and shale layers, and eventually the overlying sandstone loses its coherence, and blocks slide and crash down the hillside. This is what created the original, ancient, natural landslide, debris from which covers

Photo 9.13 | Landslip December 2012, Panteg, upper Tawe valley.

about 15 hectares. 'Rotational failure' of blocks led to them sliding downwards. They are now mixed up with soil and boulders in a hummocky landscape that is difficult to distinguish, because of woodland growing in the debris area and the area around it.

In geologically-recent years the hillside was extensively mined for coal with innumerable levels dug into the slopes, even mining into the base of the landslide back scar. Old open-cast workings stand just above the landslide back scar. Small-scale mine workings using levels continued on these hills into the early years of the 21st century (see Photo 6.5), and only stopped fully after three fatalities, caused by sudden flooding within a small mine on the other side of the valley.

To prevent flooding of mine workings, the operators dug drainage channels to divert and direct water towards the surface near the entrance to the level. But when mining ceased these channels were no longer maintained and the inevitable collapses of underground workings altered the drainage routes, leaving it to chance to decide where the water drains to. Geologists and engineers are quite clear that recent landslides are due to the effects of mining and quarrying.

The quarry, which had installed its own drainage channels to divert water flows away from its workings at the Panteg back scar area, ceased operations, abandoning the water diversion channels, just six years before the major slide. At least one of the levels dug into the base of the back scar to mine coal also discharged water into the slide area. Decay of the quarry water systems added to the build up of underground water, with heavy rainfall giving the added pressure to cause it to be released. According to one report, "In the case of the Panteg landslide, groundwater flow paths are modified by the presence of mine workings in the Lower Pinchin [coal] seam that probably discharges concentrated flows into the landslide".

The December 2012 landslip involved superficial material including boulders and finer debris which became rain-sodden and unstable. Over the months after the landslip, the local authority cleared the road and smoothed the slip site. More remedial work was needed on the slope in autumn 2013 when the smoothed surface suffered further slides in places.

At the same time as the landslip, local residents also heard about a planning application to open a level into Allt-y-Grug from the west, in the neighbouring valley. Some of them got together to oppose the plan (intended to extract anthracite for use as filters in the water purification industry). The protesters rightly pointed out that the rocks

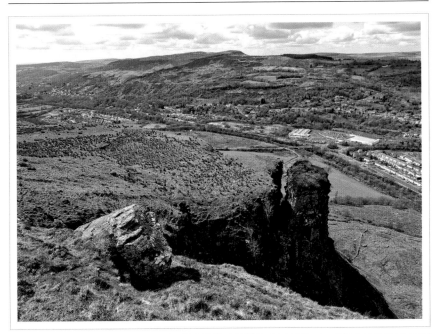

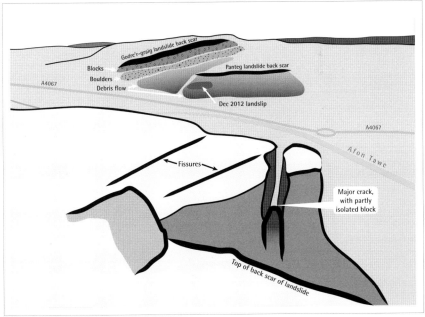

Photo 9.14 & Diagram 9.4 | Landslides in the Godre'r-graig & Ystalyfera area, upper Tawe valley.

dipped towards the village, and argued that the new level could lead to greater drainage disruption and more slips and slides in an incident-prone locality immediately above local housing. Only when the villagers pointed out a fault overlooked by the developers did the local council reject the planning application. The geology of the coalfield is a living issue, and potentially affects people in their homes, shops, workplaces and schools.

The Panteg landslide is not the only one in the area. Evidence of three major landslides can be seen in Photo 9.14. The closure of the open-cast workings on the top of Allt-y-Grug in 1954 is blamed for a major event in 1959 when the nearby Godre'r-graig landslide occurred, and the then main road had to be closed permanently to motor traffic. Over 100 houses were abandoned and the whole of the Pantyffynnon village ceased to exist. As with the 1986 Panteg landslide, the 1959 Godre'r-graig landslide involved reactivation of, and movement at the base of, a post-glacial landslide, with the upper parts seemingly still stable.

This was a much bigger slide, covering some 40 hectares. The top of the landslide is at about 300m and is marked by a significant rock wall that is between 15 and 25m high. It is complicated by the presence of large blocks that have loosened from the main mass of rock but have moved only a short distance, forming in places narrow

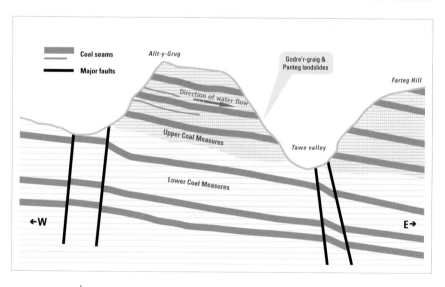

Diagram 9.5 | Cross-section of geology of Allt-y-Grug.

Photos 9.15a & 9.15b │ Geology and politics brought together by the December 2012 Panteg landslip, with a geologically literate protest poster.

gorge-like features. The area is nowadays very heavily vegetated with dense bracken and gorse and other nasty stuff, all of which makes it quite difficult to get close to a lot of the upper areas of the landslide, though public footpaths do pass through the area.

The slide deposits reach almost all the way to the valley floor at about 60m above sea level. The abandoned houses, as with many houses throughout the South Wales valleys, were perched about 10 to 20m above the valley floor, tentatively seeking some sort of shelter between the river that thunders and threatens to flood the valley, and the danger of rock collapse from above. The 1959 landslide involved movement on the slide surface beneath the houses (unlike the 1986 Panteg landslide).

There had been a whole series of more or less minor events which preceded the major slump in 1959. Soil slid onto the road because of disrupted quarry drainage in 1946. The early 1950s saw three minor flows of mud or boulders onto properties, and a few houses were vacated. In October 1957 the main road was blocked over a 100m stretch by thousands of tons of mud, rock and trees. Two years later the most serious slide led to more damage to houses and blocking of the road. More incidents took place in the early 1960s, and in December 1965 the road was buried under 4.5m of mud, 32 houses and an electricity pylon were also damaged and the houses evacuated. Further problems in 1967 led to the council declaring the situation 'incurable'. Houses were demolished and the road, which suffered severe cracking, was abandoned, a new one being built alongside the old canal in the valley floor. More problems occurred during the 1980s until the present day.

More signs of instability can be seen on the opposite side of the valley, at the area marked as Y Darren Widdon on the OS maps. The curved back scar of a landslide forms quite a conspicuous bite into the hillside. In one corner of the back scar there is an enormous chunk of rock, separated by a few feet from the main rock mass, awaiting the day when it will totter and slide down to join the hummocky landscape below that marks the debris of earlier landslides (see Photos 9.14, 9.16 and 9.17). Here you can see how large blocks of rock can detach themselves from the main rock body. As such blocks of rock often slide down they sometimes retain their coherence as blocks, or they break up and pound one another into everything between boulders and very fine material. The combined debris forms the hummocky terrain at the foot of a slide.

The foolhardy can climb behind this towering finger of rock (see Photo 9.17) by ascending into the area below the back scar and climbing over fallen boulders. The more sensible will admire it from afar. Those who explore the high land above the finger will find several curving fissure lines – indicating that a much more substantial collapse is in the offing. This whole area around Godre'r-graig, Panteg and Ystalyfera is very much a landscape still in motion.

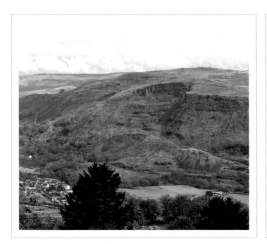

Photos 9.16 & 9.17 │ View towards the Y Darren Widdon landslide in the centre of the photo; 9.17 Approaching the tottering tower of sandstone (see also Photo 9.14).

About the Walks

The walks have been selected on two grounds: first, to try to ensure a wide taste of the geological variety to be seen in South Wales; and second, to offer walks in some of the best scenery in the region. The aim is to suggest a range of walks where you can see the rocks, topics and features covered in the first part of the book. I have also tried to arrange a balance of long mountain walks with less demanding routes. The South and West Wales coasts also offer some spectacular scenery, so I have included several coastal walks. Inevitably personal preferences play a part in the selection, and many of these walks are favourites of mine.

Most geology guidebooks direct the reader to a small 'exposure' of rock and discuss it in great detail. The sites visited are often linked by motor travel and the rock exposures all too often are roadside cuttings. This book is specifically aimed at those who prefer to get out on foot into the landscape, and who want to gain an appreciation of how geology and scenery are intertwined, taking the wider view.

Some of the walks are fairly limited in length, such as Walk 9 (Werfa) and Walk 10 (Blaenavon), while most of the others will occupy a whole day in the open air. Several of the longer walks can easily be reduced in length if necessary; suggestions are given in the walk descriptions. For example, Walk 7 (Pontneddfechan) can be divided into two different short walks rather than being done as a longer, circular walk.

As this is a book about South Wales it will be no surprise that all the walks (except for the first half of Walk 7 Pontneddfechan) involve going up and down hills. Even the coastal walks often demand quite substantial amounts of ascent and descent, as you are repeatedly required to climb up to the cliff tops and then drop down to bays and inlets.

Some of the walks cross mountainous terrain, such as on the central Brecon Beacons and its western reaches, Mynydd Du. It is advisable only to undertake such walks in good weather (unless you are an experienced hillwalker who doesn't mind tempestuous conditions). Do not underestimate the potential for horrendous winds and rains to make walking extremely difficult in these wide open areas. The topography seldom offers a respite from westerly storms, and conditions can change from pleasant to awful in minutes. Check the weather forecast before venturing out on the hills.

To give the reader an idea of how hard a walk might be and what sort of challenges it may pose, I have borrowed and slightly adapted a system for ranking walks from Ralph Storer's book, *100 Best Routes on Scottish Mountains*. This system ranks the walk in three ways: navigation, terrain and 'severity'. The last category is a qualitative judgement of the overall toughness of the walk, and the distance from help or a road if things go wrong.

Some knowledge of navigation is vital for the hill walks. Even on popular routes, such as climbing up Pen y Fan in the central Brecon Beacons, there is potential for taking the wrong well-worn track as a result of a minor error, and ending up in the wrong valley. All the walks in the Brecon Beacons (Walks 1, 2, 3, 4 and 5), and some of those in the coalfield (especially Walk 9), cross vast areas of open land, often with a minimal range of topographic features, and a mistake could lead you across many miles of rough terrain before you reach a road.

It is important on such walks to take with you a map and compass and, critically, a knowledge of how to use them for navigation. Electronic devices such as GPS-enabled phones and dedicated GPS units are mighty helpful, but are useless if the battery runs down, or signals get 'reflected' and misread by the device giving you false information, or the device decides to stop working in very wet and windy weather, or even just cold weather.

The best map to use is the appropriate OS 1:25,000 map. A laminated map or a map case is vital to prevent the map being destroyed by wind and rain. The OS 1:50,000 maps are useful but lack detail for fine navigation. Harvey maps are also useful, but only as a backup to the OS 1:25,000 map, and are not an adequate substitute for it. My sketch maps are not intended to be used on their own without a proper map.

The British Geological Survey (BGS) 1:50,000 geology maps contain masses of information, and are useful if you want to dig deeper into the geology of an area. The maps show a detailed time column of the different rocks and cross-sections, as well as information about synclines and anticlines, superficial deposits such as moraines, landslides, and a host of other features. You would need to make a significant investment if you wanted to cover the whole of South Wales, but if you walk a particular area regularly it is worth getting the map for that area. The website www.geosupplies.co.uk is a good source for ordering printed geology maps.

An important new development is online mapping. You can download a couple of free apps from the BGS website for use on mobile phones and tablets (currently for iPhone and Android operating systems), and also for use on a home computer. The basic system for mobile devices ('iGeology') allows you to look up basic details of the geology of your location (provided you can get a mobile phone signal, as it doesn't work out of range) or at a specified

location if using a home computer. A three-dimensional version is also available and can be useful. The amount of information is very limited compared with printed maps, but this is a very welcome feature and the BGS is to be congratulated on its approach.

A word or two of warning. On the hills the landscape is littered with industrial remains and old mines and the like. Take great care when mooching around industrial archaeological sites and avoid entering old mines etc. On the coasts, watch out for tides if you drop down to sea level. The Bristol Channel has some of the highest tidal movements in the world. Also take care in high winds along exposed cliff-top paths.

Very special care needs to be taken in areas in the coalfield where fissures in the ground may be encountered (see pages 109/110), especially in summer and autumn when bracken may hide these cracks in the bedrock. Just before this book was due to go the press I spoke to someone who had fallen into a fissure that was hidden by bracken (in the area shown in the centre of Photo 9.14). His fall was broken, below head height, by his feet becoming jammed in the narrowing gap. He struggled to climb out of the fissure as the rocky sides were slippery, offering no grip to his boots, and only succeeded by pulling himself out by grabbing vegetation above head height.

And finally a word of regret. The mention of archaeology should not be confined to the warning section. The South Wales hills form one of the richest areas in Britain for archaeology, both ancient and recent. Many of the areas we now consider desolate and deserted, such as the moorlands of the Brecon Beacons range, were once fairly densely settled and heavily exploited for agricultural, and then industrial, purposes. Alas, there is indeed so much archaeology on the described walks, that it has simply not been possible for reasons of space to include references in the walk descriptions other than the occasional comment, although Walk 10 at Blaenavon could be seen as a stroll through an industrial archaeological site as much as a geological walk. Walk 16 on Mynydd Preseli, source of the Stonehenge bluestones, is also as much about archaeology as geology.

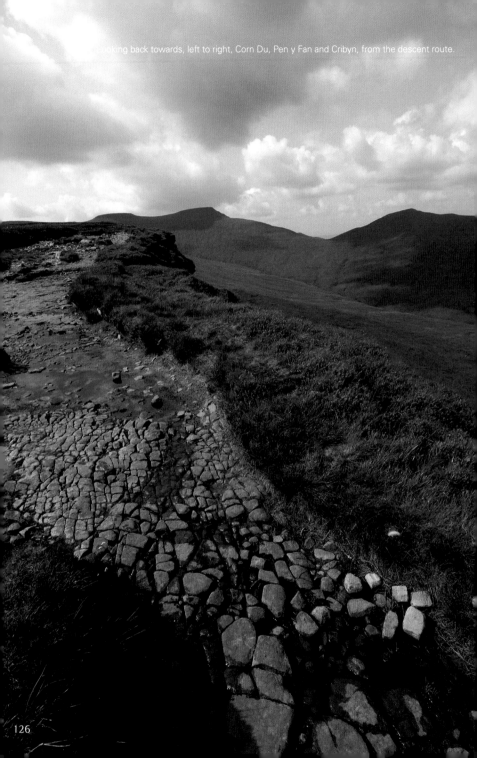

Looking back towards, left to right, Corn Du, Pen y Fan and Cribyn, from the descent route.

Walk #1 – Pen y Fan

START	▶	SO 0377 1696
FINISH	●	SO 0377 1696
TIME	⏱	5 HOURS PLUS
GRADE	⬆	NAVIGATION ● ● ● ●
	☁	TERRAIN ● ● ● ●
	⊗	SEVERITY ● ● ● ● ●

This route over Pen y Fan and Corn Du (and optionally Cribyn), as well as along an airy ridge from Craig Gwaun Taf to Craig Fan Ddu, is one of the most magnificent hill walks in South Wales, rivalled only by walks on the peaks of the Bannau Sir Gaer (Carmarthen Fans) some 15km to the west (see Walks 2 and 4).

Pen y Fan, at 886m, is the highest point in Wales south of Cadair Idris and the mountains of Snowdonia. Pen y Fan translates into English as the 'head of the peaks' and it sits, along with the slightly lower Corn Du, near the centre of a long scarp slope that runs for some 50km, from the Black Mountains in the east to Mynydd Du (also known as the Black Mountain) in the west.

Pen y Fan

Fittingly for the highest points on the ridge, Pen y Fan and Corn Du are very attractive peaks, poking above the long sinuous lines of the overall Old Red Sandstone scarp when seen from the west, south and east. From the north they present a scene that is even more dramatic, carved into layer upon layer of the Old Red Sandstone.

A walk across these two peaks, and perhaps some of the nearby tops, is essential for any visitor to South Wales, both to appreciate the sumptuous views, and the fascinating geology. An ascent from the north, from the direction of Brecon, is awe-inspiring in its later stages, but demands a long slog up through the lower approach land. The popular 'tourist' route up to the summits from the Storey Arms, on the western flanks, is the quickest and most direct route, but it misses out on much of the best scenery. It's fast food compared to the well-cooked and leisurely fare of the recommended route.

My favourite way of climbing these stately peaks starts to the south of the Beacons and goes round an impressive high-level 'horseshoe'. This takes in the best of the peaks along the spectacular scarp slope and glacial corries to the north, as well as the sharp ridges defining a valley, with its own glacial features, cut into the plateau to the south. The optional extra ascent needed to cross Cribyn also offers stunning views of the northern aspect of Pen y Fan, giving the best of both approaches.

The geology of the area is entirely within the Old Red Sandstone of the Devonian Period (between about 415 and 360 million years ago). There are also great views of intense glacial erosion on the scarp slope and a small glacial lake, as well as passing several of the seven or eight glacial cwms on this section of the Beacons between Craig y Fan and Corn Du.

Large numbers of people climb these peaks every year and in good weather they can seem quite benign. However, the open hills mean that they are often battered by strong winds and intense rainfall. High winds can present a serious hazard on the open ridges and summits. Great care is needed when navigating in cloudy or misty weather, especially in finding your way around the badly eroded summit plateaux. Such conditions can occur at any time and with little or no notice. On my last trip, starting out with a sunny sky, cloud arrived suddenly and enveloped the summits at the same time as I reached the top of Pen y Fan. The dense cloud endured for nearly an hour before it equally suddenly cleared away. I was in no hurry, waiting around for the opportunity to take some photos, but if I had needed to move on in that time, a map and compass would have been vital.

The journey to the start point is also part of the attraction of the route, as you need to go well off the main road through superb scenery. Access to the start point by car is by leaving the A465 Heads of the Valleys road near Merthyr Tydfil at the A4054 junction. Turn north and immediately take the minor road on the right to the start point, via Trefechan and Pontsticill. The car park at SO 0377 1696 may be full on summer weekends, as may be the overflow car park at SO 0410 1637.

Access by public transport requires more creative thinking. There may be a bus service (no. 24) between Merthyr and Pontsticill on Mondays to Saturdays (but not at the time of writing on Sundays), although this service may not survive into the future. In any case it is a further 5km (each way) between the last bus stop and the start point.

However, another approach which I have used is to catch the train between Cardiff and Merthyr, taking along a bicycle, and then cycling up to the start point using the signposted 'Taff Trail' cycle and walking route. If you are on multi-day trip, and have the time, you could try cycling all the way from Cardiff on the Taff Trail and staying in or north of Merthyr. This is an excellent way of seeing the coalfield scenery.

The start point is also accessible from the north by bicycles (using the Taff Trail), and cars, using a minor road from Talybont-on-Usk.

From the car park follow the tarmac road to the point (SO 0351 1739) where a bridleway strikes off right (while the tarmac road heads towards the Neuadd Reservoirs). Follow the stony bridleway as it ascends at a very gentle angle across the south-western flank of Fan y Bîg (the 'pointed peak') towards Bwlch ar y Fan (the pass of the peak). The view of Cribyn, Pen y Fan and Corn Du is very impressive from the start of the easy 166 metres of ascent to the pass.

As you ascend the bridleway heading towards the bwlch, take note of the high ridge line, Craig Fan Ddu, to the left which will be your return route. The eroded descent route from the ridge is quite clear. The sharp edge to the ridge stands above a steep slope, below which there is a distinct sloping shelf or bench, and then a further steeper slope down to the river itself (see Photo w1.1). Though hard to distinguish at this distance, there are remains of glacial deposits below both Craig Gwaun Taf and Craig Fan Ddu (which will be better seen later in the walk).

Pen y Fan

Photo w1.1 | Looking towards Pen y Fan and Corn Du from near the start of the walk.

Craig Fan Ddu, Craig Gwaun Taf, Corn Du and Pen y Fan all have sharp edges to their profiles, but Cribyn is more rounded. This is because Cribyn has lost its protective capping of tough Plateau Beds (see Chapter 3), whereas the other named points still have at least some of these resistant grits and coarse sandstones. As will be seen later on, Pen y Fan and Corn Du still possess just small areas of Plateau Beds isolated from much larger areas on the dip slope all the way from Craig Gwaun Taf to Craig Fan Ddu and beyond, as well as out of sight on the other side of the valley to the east of Fan y Bîg. The Plateau Beds form the rocky band visible along the ridge top in Photo w1.1.

Bwlch ar y Fan is soon reached and offers the walker several choices. Those with the energy and stamina may want to explore Fan y Bîg and perhaps beyond to Craig Cwmoergwm or further.

The recommended route ascends Cribyn, but it is possible to bypass this peak using the path on its southern flank. The ascent of Cribyn is initially steep, but only for a short time, and you soon reach the long ridge of its summit area and then head gently up to the very fine summit, enjoying superb views over Cwm Cynwyn.

On the way to the summit, it is worth taking the odd opportunity to leave the track to go over to the edge and peer down into the valley and along the line of Cribyn. The layers of the rocks from the top of Lower Old Red Sandstone, the Brownstones Formation, can be seen quite clearly running along the steep slope. The more prominent strata are tougher, more resistant sandstones, with weaker sandstones in between. The slope is mainly covered in vegetation with only a few rock 'ribs' sticking through, however, there are several places where the vegetation has been ripped away in landslips.

Looking down the slope, two sets of glacial deposit mounds can be detected amongst the hummocky ground towards the head of Cwm Cynwyn (SO 033 209 and SO 034 213), both thought to be moraines pushed out by small glaciers towards the end of the ice age.

The bedrock is exposed in the track as you get near the summit of Cribyn and also around the summit cairn. The exposures display natural 'jointing' or breaks within the rock. Water can seep into these tiny spaces, freeze and expand. If this happens often enough, the rock is progressively broken apart.

Arriving at the summit, views open up over the northern scarp, Bryn Teg and Cwm Sere as well as to the layered northern face of Pen y Fan. This interplay of narrow ridge, rising to a peak with rounded valley heads on each side, typifies the northern side of this section of the Old Red Sandstone scarp slope. The view from Cribyn towards Pen y Fan with its armchair-like northern aspect is stunning (see Photo 1.1).

The view is one of the highlights of the South Wales scenery. The tiny outcrops of the Plateau Beds give Pen y Fan and Corn Du (seen to the left of and behind Pen y Fan) their distinctive flat-topped crest shape. The Plateau Beds on both Corn Du and Pen y Fan are 'outliers' of the more substantial outcrops to the south (see Map 8.1). Really Pen y Fan and Corn Du are one peak, but with the tough capping of Plateau Beds having been eroded away in between them.

The Plateau Beds are only about 10m thick. They belong to the Upper Old Red Sandstone, and there was a gap between the deposition of the Brownstones and the Plateau Beds of a few million years.

Drop down to the col and then climb up above Craig Cwm Sere towards the summit of Pen y Fan. This route has suffered from severe erosion and it is preferable to stick to the well-made track rather than walk alongside it. However, in order to study the geology of the northern scarp, it is reasonable to leave the track as you ascend and peer over the edge for fine views back to Cribyn (see Photo w1.2) and a close-up view of the layered sandstone (see Photo w1.3), then return to the track and head up to the last few metres, where you have to climb up the exposed layers of the Plateau Beds.

The summit plateau itself can a bit of a disappointment – a wide, largely vegetation-free flat area that clearly experiences regular scrubbing by large numbers of walking boots – but the devastation is put aside when you take in the superlative views.

The tiny glacial lake nestling in Cwm Llwch, under the ridge descending from the north-west corner of Corn Du, presents a contrast to the great swathes of sharp green vegetation. The shallow lake is held in position by a crescent-shaped set of moraines that are easily visible from the summit of Pen y Fan and all the way round to Corn Du. The moraines are up to 18m high, but the lake is only 6m deep. They are most easily distinguished when they

Pen y Fan

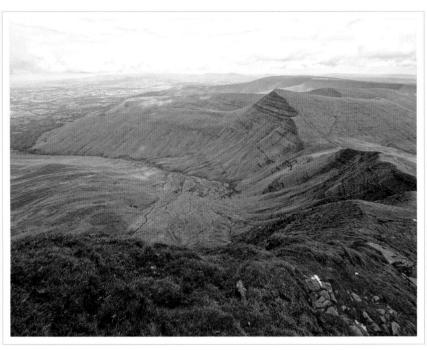

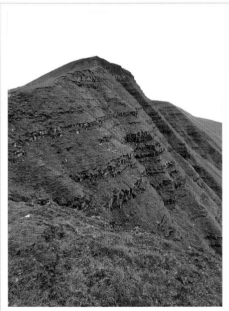

Photo w1.2 (above) | View from Cribyn looking roughly east along the Old Red Sandstone escarpment.

Photo w1.3 (left) | Layered beds of Brownstones Formation sandstone, Craig Cwm Sere.

cast a shadow in slanted sunlight (see Photo w1.4). The glacier was sited in a spot where the wind was concentrated as it passed from the west over this arm of the Beacons, blowing snow into the sheltered spot below the ridgeline. Alternatively it has been suggested that these moraines may actually have been dumped in place by a larger glacier/ice sheet lobe entering the valley.

Dotted in places around the summit cairn you can find ripples in the sandstone bedding (see frontispiece photo) which are a record of the currents that, 300 million or so years ago, shaped the sandy riverbeds from which these rocks have been made.

When you've seen enough of the summit and drawn deeply on its views, it's time to head off to the next peak, Corn Du. The route goes to the south-west. The gap between the two summit plateaux is quite short in both distance and height. However, that gap marks where the resistant Plateau Beds have been fully eroded away. This fate will be shared in the future by the two summit plateaux which will then lose their distinctive sharp-edged flat-topped summit shapes, and become more like Cribyn.

More outcrops of the Plateau Beds are found on the ridge line to be followed for the recommended descent route. Excellent views of that ridge line are had as you walk between Pen y Fan and Corn Du. Although from afar Corn Du appears of similar girth to Pen y Fan, closer up it is a much smaller plateau area.

Photo w1.4 | The small glacial lake, Llyn Cwm Llwch, is held in place by a set of moraines; note the joints in the rocks in the foreground.

Pen y Fan

When you've seen enough (the views are not markedly different to those of Pen y Fan except you get a closer view of the moraine holding in Llyn Llwch), head further south-west. To leave the summit, head almost due south and stick to the centre of the narrowing summit area. You will step down across conveniently-shaped blocks of sandstone. The blocks are defined by the joints (providing vertical breaks in the rock) and the beds (which are effectively horizontal).

Great care needs to be taken at Bwlch Duwynt where the popular Storey Arms route branches off downhill to the south-west. My recommended return route follows a track that heads, initially, just west of south, then south, and then just east of south along the crest of the ridge, Craig Gwaun Taf. You will usually leave the crowds behind after passing on to the ridge to enjoy a fantastic high-level and virtually level walk for some 3km and with outstanding views. As can be seen on Map 8.1, the absence or presence of the Plateau Beds affects the sharpness of the edges and the nature of the ridge.

You may be able to distinguish the moraine ridges below the ridgeline on your left as you pass along Craig Gwaun Taf. This airy ridge edge is delightful and you feel truly on the lip of the great glacial valley, Taf Fechan (Taff Minor), which starts below your feet on the left (east). There is a steep slope immediately below the edge, but after 50 metres or so the slope becomes much more gentle, forming a sloping bench before getting slightly steeper nearer the head of the river. You may be able to distinguish some hummocky shapes on the sloping bench about 100 metres below the ridge edge. These hummocks are thought to be moraines from a small glacier that was nestled into the slope on and around the sloping bench below the edge.

Head along the ridge edge, enjoying the views, as well as taking care not to trip. After about a kilometre the sharp, rocky ridge edge fades away and there is a slight drop in height, to the section of the ridge named Rhiw yr Ysgyfarnog. Also the plateau to the right (west) narrows considerably and you can see down into a side valley, Cwm Crew (see Photo w1.5), heading off to the south-west to join Taf Fawr (Taff Major). After a couple of hundred metres you can see the point where the stream in Cwm Crew turns from heading just east of south to head south-west (SO 009 195). Look for the glacial moraines clustered around this point.

There is a short run of crags, Craig y Byllfa, on the western side of the upper part of Cwm Crew, above the section where the stream runs south and then just east of south. During the ice age, winds would blow snow into a sheltered hollow below Craig y Byllfa where it accumulated in sufficient quantities to form a glacier which, in its last few years, left behind the moraines (and the deep cut valley).

However, this meant that less snow was available to be dumped in the other side of Rhiw yr Ysgyfarnog in Gwaun Taf. This explains why there are no moraines below the ridge in that valley (though as we saw a while ago there are moraines below the sharp edge of Craig

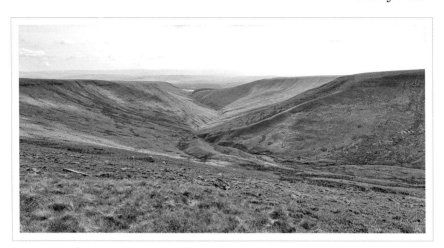

Photo w1.5 | A cluster of moraines in shelter of the east-facing scarp slope in Cwm Crew.

Gwaun Taf). Very shortly the ridge rises slightly in height, widens out again and also has a sharp rocky edge again, named Craig Fan Ddu. In addition, there are again moraines in Gwaun Taf below Craig Fan Ddu as once again this was the first place where snow could be dumped by the westerly winds rising up the western flank of the high land.

A long time ago there was a slight dip at the head of a shallow pre-glacial valley on the line of the present-day Cwm Crew. The resistant Plateau Beds were eroded away and snow was able to accumulate here in sufficient quantities to sustain a glacier capable of carving out the deeper valley we see today. Geologists sometimes describe the Cwm Crew glacier as a 'parasite', consuming the snow that would have gone into Gwaun Taf, but that seems an odd way to express the vagaries of how, why and where glacial ice can develop.

Rhiw yr Ysgyfarnog is an example of an 'arete', where a narrow ridgeline has been carved out by glaciers in adjacent valleys. From the previous paragraphs it would seem that the glaciers responsible for this feature did not exist at the same time. The small glaciers in Gwaun Taf, below Craig Gwaun Taf and Craig Fan Ddu, and in Cwm Crew, below Craig y Byllfa, existed at the end of the ice age, when the temperatures had moderated sufficiently that only small high-level glaciers could still be sustained. Gwaun Taf itself was carved out by a bigger valley glacier at a colder stage when bigger, lower-level glaciers were possible.

Continue along the ridgeline above Craig Fan Ddu enjoying the views on this extended high-level corridor (see Photo w1.6). There are more moraines to be seen below the ridge at about 650m height. A glance at the map also shows that the ridge curves here forming a poorly-developed glacial cwm.

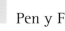

Pen y Fan

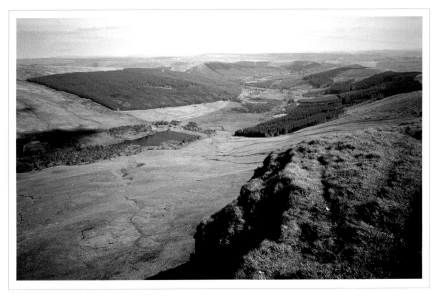

Photo w1.6 View south from Craig Fan Ddu down the Taf Fechan.

The track eventually changes into a muddy path and starts to curve round to the right. Quite suddenly the cairn at the top of the descent route appears (at SO 0193 1827). Provided you get the right track back at Bwlch Duwynt, and that you stick close to the ridge edge, you should be able to find this descent point with its sizeable cairn without trouble even in misty conditions.

The first few minutes of the descent are unpleasantly steep and stony, but you very soon get past that section and onto a muddy track that leads you down to the small reservoir and on to the tarmac road not far from the starting point.

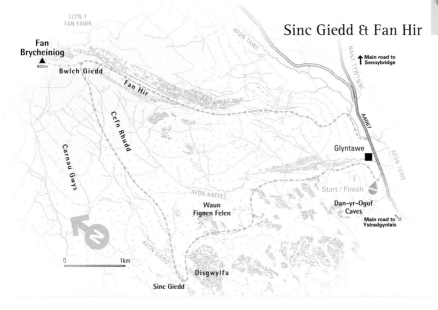

Walk #2 – Sinc Giedd & Fan Hir

START	▶	SN 8428 1618
FINISH	●	SN 8428 1618
TIME	◗	5 HOURS PLUS
GRADE	⊕	NAVIGATION ● ● ● ● ●
	☁	TERRAIN ● ● ● ● ●
	❸	SEVERITY ● ● ● ● ●

The great mountain and moorland mass that stretches west from the uppermost reaches of the River Tawe is known as Mynydd Du (Black Mountain). While there are some very distinct and well known crags, Fan Brycheiniog and Bannau Sir Gaer (Carmarthenshire Fans), much of Mynydd Du is an undulating moorland with limited rocky outcrops.

I first learnt to love this landscape in the 1970s as a student at Swansea University, and subsequently living in Swansea and then Cardiff. At that time walkers were discouraged from venturing out onto Mynydd Du for fear that they would become lost in the great expanse of navigationally challenging terrain. Indeed the authorities

137

were removing indications of paths from the maps of the area precisely to try and convince people that this was not an area where they should set foot.

Nor was the landscape of the Mynydd Du given proper appreciation by the mountaineering culture of the times. A popular guidebook writer of that era was W A Poucher and in his book, *The Welsh Peaks*, he did direct walkers to the peaks of Bannau Sir Gaer and Fan Brycheiniog, which account a tiny fraction of the whole area. He labelled this small area the 'Lost Mountain' because it was so little known. Then he casually dismissed the great expanse of Mynydd Du with the words, "the rest of its topography lacks interest".

On the contrary, for those with an interest in the processes that create the landscape, there is a wealth of interesting, nay fascinating, geological features, as well as plenty of scenic interest to be found around Poucher's Lost Mountain.

One of the most striking facets of this area is the large number of 'sink holes' or 'dolines'. There are literally thousands of them to be found in a wide band of land running right across the centre of Mynydd Du, small funnel-like shapes that litter the landscape. Craters resembling shell holes compete for attention with much more substantial depressions 100m or more deep, and with no obvious way for rainwater to escape except down through the ground. A large band of Mynydd Du, where the Carboniferous Limestone and the Millstone Grit jostle to be the bedrock, makes for an utterly enchanting example of 'karst' scenery – for those with eyes to appreciate it. I count it as one of the scenic gems of Wales.

This walk and Walk 3 visit some of the most impressive sink holes to be found on Mynydd Du. This walk also looks down on a stunning glacial moraine (or possibly a feature known as a 'protalus/pronival rampart' – see Chapter 8). The recommended route takes you over the top of Fan Hir to peer down on this impressive mound, as well as offering stunning panoramic views. However, if you've already walked along Fan Hir on previous occasions it is also a good idea to drop down from Bwlch Giedd to Llyn y Fan Fawr, and then to walk along the top of the moraine, or at its base, to get a good impression of its sheer size.

It is also possible to cut the walk in half by leaving out the long haul up to Fan Hir, returning to the start point from Sinc Giedd using a fairly clear bridleway (as used in part on the outward leg).











It is important to take account of the difficulties of navigating on Mynydd Du. The terrain can be quite confusing even when the sun is shining and the skies are clear, so it definitely makes sense to avoid the area on misty days, unless you have sufficient navigational experience and confidence. W A Poucher observed that "anyone caught here in bad weather, where no landmarks exist, would have great difficulty in finding the exits, even with map and compass". Poucher is largely but not entirely right in this observation. The alert walker with an interest in geology will find that several useful landmarks which can serve as navigational aids do exist. However, navigating in the mist off the bridleway is not advised.

The sheer size of the whole area makes day walks either limited to accessible areas or long trudges. The routes I have suggested here, and in Walks 3 and 4, cover some of the more accessible parts of Mynydd Du. The western end of the area is also worth visiting, and is easily accessible from the A4069 road where it crosses the range. If transport can be arranged, a superb walk can be had by starting from the highest point on the A4069 and hiking east to the Tawe valley, taking in all the main peaks. The area to the east of the Tawe valley between Fan Gyhirych in the north and Carreg Cadno in the south is also well worth exploring.

The start and finish points are a car park at the entrance to Dan-yr-Ogof show caves; buses also run from Swansea and Brecon. Start by walking along the entrance road for the caves. This is about 125 metres to the north-west of the public footpath shown on the OS map. It is also possible to start about 500 metres further north along the main road where a bridleway is marked, but it is then necessary to ford the Afon Haffes (at around SN 8418 1670) or keep on the right-hand side of the river, crossing very rough, often wet, terrain to ford the river higher up (beyond the waterfall, Sgwd Ddu) – this alternative route is only advisable in dry weather conditions.

On the recommended route, a short diversion to the left can be taken to an interesting collection of Welsh rock types on display towards the car park and ticket office, and a tour of the caves is possible. Otherwise, to follow the walking route, at the end of the entrance drive turn right, then passing a modern stone circle and campsite. Shortly you will come across a signpost directing walkers to the left and on to the mountain.

Rise up to a gate at grid reference SN 8419 1667. The track bears sharp left after the gate, but ignore the track and turn right to overlook the Haffes. There are a tremendous

number of large rounded boulders in the riverbed and also to the sides in the wider channel cut by glacial meltwaters. There is a superb view of Fan Gyhirych in the distance – a hill that always adopts a stately profile, but most especially from the Tawe valley. The 'lineations' on Fan Gyhirych mark erosion by glacial ice sheet lobes passing over the col (heading south).

Bear upwards, initially keeping to the edge of the steep drop into the valley floor. It is a fairly steep slog upwards over rough terrain, but you gain height rapidly and enjoy marvellous views of the Haffes. As you go further up it is probably best to move a bit away from the river valley, but still remaining below the highest ground over on the left. There is no track to speak off initially, but a narrow track does eventually appear.

After crossing a couple of streams (or more accurately crossing the boggy ground on either side of a couple of narrow proto-streams), you should pass a pile of rocks on your left (at SN 8379 1692). The pile takes a fairly angular form and there are rises in the ground which indicate that this was formerly a medieval dwelling. There are excellent views across to Fan Gyhirych, a shock of deep green forest to its right, the old tramway linking some small quarries further right, then the great gash of Penwyllt quarry, and behind it the Millstone Grit edges.

Once you go further up the valley beyond the remains, the view ahead opens out. There are some clear rock edges above to the left. Note the clear difference between the green grass around the rock outcrops and the rougher, reedy vegetation below and underfoot. The green grass shows the position of the well-drained limestone, while impermeable rocks of the Millstone Grit lie below. You'll probably notice that the terrain gets more awkward and wetter on these impermeable soils – but the track becomes clearer and guides you on the easiest route through this section.

Fan Hir looks tantalisingly close on the right as you enter a sort of bowl where the Haffes rises up fairly close to the track in a wide, shallow valley. At around grid reference SN 8274 1793 keep well left, moving away from the river, following round to the left past the last high ground on the left. You come to a sink hole and in the near distance a fence. Further on there are some higher points with rock outcrops. As you pass the sink hole you then see that it is one of a series of sink holes in a row – indicating the presence of an underground water channel running below ground.

Follow round on the right of the line of sink holes and look over to the right to a great bog, now behind a wire fence. The great bog, known as Waun Fignen Felen (Rough Yellow Moor), is slowly being recovered (thus the fence) after beginning to erode in recent times (see Photo w2.1). The reason for the decay of the bog is not really known, but the Dan-yr-Ogof caves company reported increased silt levels in the streams coming through the cave, and

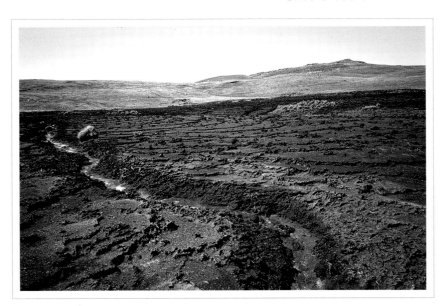

Photo w2.1 | The great bog of Waun Fignen Felen before restoration measures.

cavers noticed an acceleration in the rate of erosion within the cave system. The fence keeps out grazing animals and a mulch of crushed gorse cuttings is brought in by helicopter to provide sustenance to help rebuild the peat bog.

It is claimed that the CO_2 emissions from the helicopters are lower than what would be emitted if the peat were permitted to continue to decay. In any event the bog is slowly recovering its green colour thanks to this temporary patching up. Of course in the long run the peat will be eroded by wind and rain (or by ice in the next cold period of the ice age), whatever we do.

As you go further, you can see a valley cut into the ground ahead of you and also, on the hillside further away, a line of sink holes. Aim for the left end of the valley ahead. As you approach you can see that the valley ends in a sink hole at some 25m high crags (see Photo w2.2). This is where the water draining from Waun Fignen Felen disappears (SN 8256 1767).

A glance at the map shows that Waun Fignen Felen is lodged in a shallow bowl with its eastern lip no more than 10m above the Haffes valley, and no further than 100m away from the river itself. How odd then that the bog should drain south-east into higher ground and not east into the lower Haffes. Perhaps this is not so odd as bogs are acid environments and enrich the acidity of rainwater, thus increasing its power to dissolve the calcium carbonate of the limestone. The bog has thus helped create its own drainage points into the limestone, though it may once have drained into the Haffes.

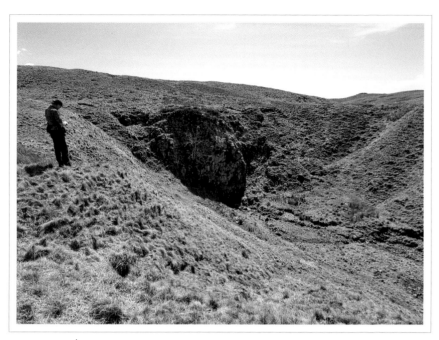

Photo w2.2 | A stream drains from the Waun Fignen Felen bog into this sink hole.

In fact, geomorphologists reckon that the Afon Haffes has cut back up into the mountain and 'captured' the streams coming off Fan Hir before they could enter the bog and then the underground cave passages, so much more water once used to flow through the caves and dissolved out more and more passages. The bog straddles the boundary between the sandstone and the limestone, so that water draining off the surface of the sandstone started to dissolve passages into the rock once it had crossed onto the limestone.

The Dan-yr-Ogof cave system is one of the biggest in Britain, even though there are clearly many more underground passages than have so far been explored and mapped. Water that enters the caves from the sink hole that still drains much of Waun Fignen Felen runs down what cavers call the Great North Road.

From the sink hole, follow the fence on your right to pick up the main track, a bridleway (at about SN 8205 1770) and bear right onto the track. You now enter an area of scores of sink holes, usually forming lines or linear zones – an indication of several more underground water channels.

Pass a sink hole filled with water on your right at SN 8162 1827, and then go off the track up to a slight rise on the right of the track, with small outcrops of limestone sticking out of

the grass in a highly eroded form. The high point gives you a good overview of Waun Fignen Felen and also of the track continuing to wend its way through the gentle, hummocky terrain.

Return to the track and bear right. Further on note some very small sink holes on the left. At SN 8148 1837 there are big sink holes on both the left and right of the track. The sink hole on the right is similar to the one seen a short while ago draining Waun Fignen Felen, with a stream draining into the bottom of a crag, whereas most of the other sink holes look funnel-shaped. There are in fact a few different types of sink hole, but these are the most common shapes to be seen on the hills, with the small funnel-shaped depression being by far the most common type.

The different names given to these features – sink holes, swallow holes, swallets, shake holes and dolines (the latter being the technical scientific name used by geologists) – are sometimes used to identify the different types, so the 'sink holes' are those with streams running into them, while the funnel-shaped depressions are shake holes, and so on. For ease of comprehension I have stuck with the prosaic sink hole for all the variations of the feature.

Look beyond the big sink hole on the right up towards Fan Hir to see that the sink hole is one of a line of such holes showing where one of the streams draining off Fan Hir's flank has been diverted underground.

At SN 8141 1840, you can see a sink hole with pond on the left of the track. Go to the left of the pond and on to another sink hole (Pwll y Cig). At the time of my last visit here this second sink hole (with a small satellite sink hole as you approach it) was clearly beginning to drain, as there was a good 1.5m area all the way round the edges where the glacial 'till' (soil and boulders) are exposed – something not seen at any other sink hole so far on this walk. The soil shows 'tide' lines where the pond level had shifted down in steps.

To your right you can see a valley ahead. The land you cross to approach the valley is more till (previously known as 'boulder clay'), a glacial deposit of material carried and dumped by ice flows. The ground is pockmarked by plenty of 'dissolution' sink holes in the underlying limestone, with collapse of material from the till into the depression, sometimes even presenting an impermeable cover in which water may collect.

Approach the valley keeping on the high ground to its left. The valley is what is known as a 'blind valley' because the valley runs into a closed depression. Exactly what you see will depend on the level of recent rainfall. Most times that I have been here the riverbed in the valley has been dry, but after wet weather a river flows over the reddish boulders. Keep going along the high ground above the valley to the pair of sink holes in the limestone rock face on the other side of the riverbed at the blind end of the valley. Known as Sinc Giedd (and sometimes as Sinc y Giedd), this is where the Afon Giedd, when it flows this far, disappears underground (at SN 8101 1786).

Sinc Giedd & Fan Hir

The sink holes have developed on exposed strata of tilted limestone. A look at the OS map shows that water surfaces at a series of unnamed springs about 600m south of this point. The river that flows towards the Tawe from these springs shares the Afon Giedd name. However, the water flowing in the upper Afon Giedd before draining into Sinc Giedd is not the same as the water flowing in Afon Giedd in the lower part of the valley from the unnamed springs. This has been established by pouring dye into the waters of the upper Afon Giedd. The dyed water drained down to Dan-yr-Ogof via the cave systems under the great bog we saw earlier. Indeed, based on current understanding of the cave system, Sinc Giedd and the sink holes in the river channel to the north-east form the most important source of water for the Dan-yr-Ogof system – however, the underground linking passages between Sinc Giedd and Dan-yr-Ogof have not yet been found.

Go as far as the end of the upper Giedd valley where there are some large boulders of Millstone Grit sandstones (see Photo w2.3). Drop down to the sink holes and take a look at where the river channels disappear, then head up the riverbed or valley side. The limestone beds dip down into the ground in front of your eyes here, butting up against the Millstone Grit to the immediate south, and also forming the higher ground to the east.

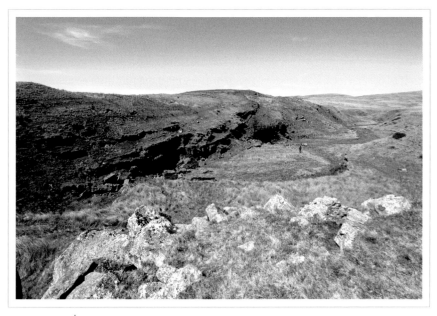

Photo w2.3 | Sinc Giedd sink hole in the centre of the photo with Carboniferous Limestone strata (dark patches in centre of photo) dipping under Millstone Grit (foreground).

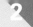
I have been here many times over the years, but always in dryish weather, so I have never seen water flowing into the sink hole, but no doubt it is wet often enough around here for this to happen – though mainly in conditions that make it generally inadvisable to be up here at such a time.

Pick your way along the dry riverbed (or river bank if it should indeed be wet). The dominant rock type seen in the riverbed is Old Red Sandstone in the form of reddish pebbles, brought down from higher up the slopes. However, there are some fascinating rocks to be seen in the riverbed – see Photos w2.4a and w2.4b which show a limestone boulder with 'tension gashes' (the white streaks) and fossils. Tension gashes are created when rocks are folded by mountain-building forces and undergo 'brittle' deformation, causing these minor cracks (filled with calcite which leaches into the gash as it grows).

On the surface of the limestone the fossils are a lighter colour grey, almost glassy, being composed of nearly pure crystal calcite which has replaced the original calcium carbonate structure. The fossils are clearly a bit more resistant than the surrounding rock (or 'matrix') and bits of the fossil stand proud of the rock surface. However, these bits standing above the surface have changed colour to brown and show clear signs of decay, being broken and punctured by small holes, indicating slow but sure dissolution.

At grid reference SN 8117 1825 the stream divides. If the riverbed has been dry so far you may notice that there is some water ahead. The stream disappears at another sink hole at the base of a small crag, though this time on the other side of the river from Sinc Giedd. On my last visit a new sink hole was beginning to appear next to the sink at the base of the crag (see Photo w2.5).

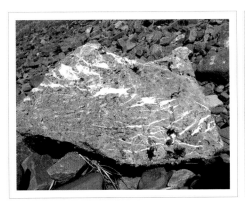

Photos w2.4a & w2.4b | Limestone block in the dry bed of the Afon Giedd displaying tension gashes across the centre and fossils lower left, shown in detail in Photo w2.4b.

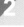

Sinc Giedd & Fan Hir

Photo w2.5 | In dry conditions water draining from the Old Red Sandstone
(coming from the lower right) disappears underground at this sink hole;
the valley in the upper half of the photo leads to Sinc Giedd.

You can follow either stream from here as they rejoin in a while. Further on, at SN 8115 1855 the track of the bridleway fords the Afon Giedd. If you think that the full recommended return route is too much, you can return to the start by following the bridleway track to the right (and keeping on the track past Waun Fignen Felen bog). Otherwise start the slog up to Bwlch Giedd. It's a long way, but it's a very gentle slope upwards.

The route is enlivened a bit by the presence of the river and the odd waterslide or waterfall over tilted beds. The first such diversion is met at SN 8157 1936. This marks the transition into the Old Red Sandstone. Although you are going uphill you are also at the same time passing from younger rocks (the Carboniferous Limestone) to older rocks (Old Red Sandstone) – and which lie *underneath* the younger ones. This apparent contradiction is explained by the way the rocks have been tilted by earth movements and the way in which their different abilities to resist erosion have cut them into the present shape (see Diagram 3.1).

Another diversion is provided by several red, pebbly boulders that you pass. Less diverting and more tedious are the patches of reedy and boggy ground that are encountered, though most of the route is across quite reasonable terrain.

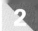
Slog on to the col, Bwlch Giedd, with the immediate reward of fantastic views towards the central Brecon Beacons. It is an easy diversion to ascend Fan Brycheiniog (where there is a useful shelter if the conditions are windy – be advised that the top of Fan Hir will offer no protection).

Llyn y Fan Fawr, which sits below Bwlch Giedd in a ledge at the base of the Old Red Sandstone scarp, is a glacial lake and the former home to a glacier. The lake is famous in ancient British legends and its raw beauty has long been celebrated.

Head up the gentle slope to the top of Fan Hir, one of the finest ridge walks in southern Britain. There is a stunning 360 degree panorama – there's no doubt that the effort of the long hike up from Sinc Giedd is more than justified by the wide-ranging views of South Wales. You also get a good overview of the eastern half of Mynydd Du, and the area of limestone and grit which you walked up through.

Pen y Fan and Corn Du stand proud on the distant skyline to the east, though the much closer and very fine profile of Fan Gyhirych is much more immediately imposing (see Photo w2.6). The profile of the whole scarp slope between Fan Hir and Pen y Fan is fairly obvious, with the flattish tops to the peaks (thanks to the especially resistant Plateau Beds at the top), and a steep scarp slope that leads down to a flattish shelf, which runs further north to another dip running down into the valley, in which sits the town of Brecon. This profile has a geological origin and reflects the different rock formations within the Old Red Sandstone (see Diagram 3.1). The linear features on Fan Gyhirych and the nearer Cefn Cul are thought to be glacial in origin, when ice sheet lobes crossed these hills and passes, and at different heights at different times.

To the right of Fan Gyhirych there is more Carboniferous Limestone and Millstone Grit. The Millstone Grit forms the obvious tilted rock outcrops (or 'edges') seen on Carreg Cadno. Further right one is looking at the South Wales coalfield and the Pennant Sandstone scarp marking the upper Coal Measures.

There are several minor features that can be noted in the rock outcrops at the edge of the ridgeline – pebble beds, cross-bedding and rock pavements abound. You can also see how the resistant exposed edge of the Plateau Beds is slowly being eroded, with great chunks ready to topple down at some time in the future.

However, the main feature of geological interest has to be the great moraine that runs parallel to the ridge at the base of the scarp slope (see Photo 8.5). There are three different (or possibly combined) explanations for this feature (see Chapter 8). It used to be accepted that this mound was a 'protalus rampart' (now often called a 'pronival rampart'), where in colder times rocks had collapsed off the scarp and tumbled down to meet ice at the bottom. The

Photo w2.6 │ View east over the Old Red Sandstone scarp; Pen y Fan and Corn Du, centre distant skyline, Fan Gyhirych, centre right.

fallen rocks slid across the ice to form a mound. However, more recently the mounds have been reinterpreted as glacial moraines with a small glacier running down from the lake area beneath the scarp slope.

More plausible seems a third suggestion, that the Fan Hir mound is the remains of a moraine deposited alongside an ice sheet lobe passing southwards across the slopes below here and stretching across Cefn Cul to the lower slopes of Fan Gyhirych. This ice sheet didn't reach all the way to the base of the Fan Hir scarp slope, allowing space for the moraine to develop a short distance from the scarp.

Follow the Fan Hir ridge along until it starts to merge into the overall landscape. Pick up the clear track towards farm enclosures at Ty Henry (SN 8480 1743). The actual route around the farm is somewhat different from that shown on the OS map but is fairly well signed, with the path being diverted to the riverside where a footbridge (at SN 8484 1720) leads to the road a short distant north of the starting place on the A4067.

Glyntawe ■
Dan-yr-Ogof
Caves
AFON TAWE
Castell y Geifr Pwll-yr-Cawr Start / Finish
Disgwylfa (sink hole)
Carreg Goch Craig-y-nos
 Pant-y-wal
Dorwen ar Giedd Garreg Fawr Cribarth
0 1km 423m

Walk #3 – Carreg Goch & Cribarth

START	▶	SN 840 152
FINISH	●	SN 840 152
TIME	◖	5 HOURS PLUS
GRADE	⦿	NAVIGATION ● ● ● ● ●
	◔	TERRAIN ● ● ● ●
	◕	SEVERITY ● ● ● ● ●

The industrial revolution had dramatic effects on the landscape of South Wales, most especially in the coalfield, but it also had some impact north of the Coal Measures within the boundaries of the present-day Brecon Beacons National Park. This walk through Carboniferous Limestone and Devonian scenery visits some remarkable natural geological features, but also passes sizeable areas of open-cast mining and devastating quarrying, as well as numerous old tramways and railways.

The Carboniferous Limestone is often the transitional zone between the heavily industrialised landscape and the mountain landscape. The upper Tawe valley features some conspicuous scars, such as Penwyllt quarry above Craig-y-nos on the eastern

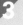

side of the valley. On the other hand, on the western flanks of the valley, seen from the low ground around Craig-y-nos, the prominence known as Cribarth doesn't look so heavily worked as Penwyllt. This is an illusion; a walk along or around the complex ridge unfolds surprisingly many views over historical workings, and the complexes of inclines used to lower the extracted material to the valley floor.

Cribarth is also geologically interesting in its own right. A glance at the OS map of the upper Tawe valley shows that the mass of Cribarth lies directly in the middle of the general course of the river. The Tawe has to loop around the bulk of Cribarth and then curve more tightly back round Craig y Rhiwarth. To achieve this the river has cut a fairly deep gorge. Cribarth shows us the way in which the 'Swansea Valley Disturbance' has shifted the limestone laterally out of line with the general trend of the main limestone outcrop (Chapter 6).

This walk is also geologically interesting for the number, variety and in some cases, the impressive size of the sink holes that are encountered en route. One sink hole, Pwll-yr-Cawr, near the start of the recommended route, is 20–30 metres deep and 100 metres or more across. Some other sink holes are so large, covering hundreds of metres of ground, that they contain several small sink holes littered about their floors. There is a particularly impressive example to be seen on the north-western flank of Cribarth.

The walk also visits Millstone Grit outcrops and enjoys stunning views from Carreg Goch over this part of Mynydd Du. This walk takes you right into the heart of this desolate but beautiful landscape, one of the scenic highlights of the British hills.

The route is in the form of a 'figure of eight'. It is possible to miss out the upper loop and thus cut the overall route length in half. Allow a whole day for the full route and a half day for the truncated version.

The upper loop to Carreg Goch and back to the pinch point in the figure of eight poses potentially severe navigational problems. Even in good weather the repetition of one gently tilted set of strata, with low rocky scarp slopes and gentle dip slopes, can be confusing. The gentle slopes also mean that you often have restricted visibility, so that it is easy to misinterpret the landscape, especially on the return route. If you have a GPS you can enter the grid reference of the corner of the fence/wall at the pinch point (SN 8264 1587) and use the device to guide you back to it in case of confusion, although in misty weather there is little point in walking the upper loop. Navigation on the lower part of the loop is a bit less complex, but the convoluted structure of Cribarth, and its myriad paths, tracks and tramways, still offers potential for confusion.

The route begins at Craig-y-nos where there are parking places; it is on the bus route between Swansea and Brecon. Start passing through the complex of footpaths and paddocks at the horse trekking centre opposite Craig-y-nos, following footpath signs to open fields. The OS map shows an apparently straightforward routing, but you are in fact guided through a series of fenced paths. Rather than going up to the open land at the first opportunity, bear right along a muddy bridleway towards the base of a valley, crossing a stile and a wet patch/stream, and then another stile at about SN 8374 1539 (marked as a ford on the OS 1:25,000 map). Cross the stream and then bear left uphill to a fence and another stile (at the boundary of open land). Cross the stile and bear half right towards the valley. Drop down into the valley which is devoid of any stream (though in summer you may find you have to forge a route through a mass of bracken, in which case you may well prefer not to drop into the valley but walk along the lip of the valley side).

The valley is home to several sink holes, which run above an underground cavern system, and is a pleasing mix of grassy slopes, rock outcrops and piles of scree (see Photo w3.1). Dry valleys such as this used to be seen by geologists as signs of cavern collapse, but the view nowadays is that they were created towards the end of the ice age, when frozen ground prevented water seeping into the limestone and quantities of melt water cut surface channels. The streams which carved the dry valleys now run underground.

Photo w3.1 | Dry limestone valley, near Craig-y-nos.

There is only one slightly difficult section where the valley narrows to a choke point between a resistant limestone outcrop (at SN 8351 1553). Once past this narrowing point, you meet a couple of muddy tracks crossing the dry valley (at SN 8343 1555); look up right to spot a short section of stone wall. Head up to the left end of the stone wall. On the way keep an eye out on the land to the left of the stone wall, where a very large and quite deep sink hole becomes apparent.

Although it is not in line with the dry valley, this sink hole is part of the same drainage system. Cross to the lower side of the large sink hole. It is so substantial and so impressive a feature as to earn its own name, Pwll-yr-Cawr, which translates as 'the giant's pit'. You can judge its overall size from the stone wall which runs through it – and which itself is up to 1.5m high (see Photo w3.2).

The fact that the sink hole is located on a slope means that it has an asymmetric profile with a long slope down from above and a shorter, sharper slope at the lower end. Any surface water drains down into a sink on the lower side of the depression. If you go down into the sink hole to look at the actual sink you can see down for a good couple of metres into the jumble of boulders blocking the entrance. Obviously there is a large cavern (or complex of

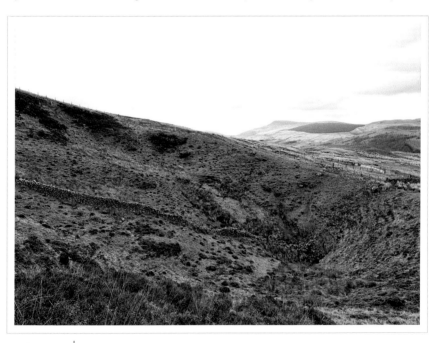

Photo w3.2 | Pwll-yr-Cawr (the giant's pit), a large sink hole.

caverns) below this area as well as below the dry valley, and indeed these caverns are all part of the Dan-yr-Ogof showcaves found a short distance from the starting point of this walk.

At Pwll-yr-Cawr you can decide whether you want to take a diversion here to the site of standing stones, Saith Maen (Seven Stones), which is just the other side of the dry valley you came up. One of the standing stones is visible from this point, and you can work out your own route minimising either directness or height loss/regain to get there (SN 8335 1542). The visible stone is just a couple of metres from a large sink hole, though this is only evident as you get closer. Having seen the site, return to the fence above the top of Pwll-yr-Cawr.

If you miss out on the diversion to Saith Maen, walk past the Pwll-yr-Cawr's eastern side with the fence on your right. The terrain is a bit rough and you may have to move away from the fence in a few places to avoid too many awkward tussocks and boulders. Don't forget to turn around now and then to enjoy the views to the other side of the Tawe valley. The gently tilting Millstone Grit beds to the right of, and behind, the Penwyllt quarry are particularly striking when seen in good lighting conditions.

The large hummocky ground you encounter around Pwll-yr-Cawr is not natural. The innumerable small pits and mounds are the remains of 'rottenstone' quarrying, not sink holes. Rottenstone is the name given to a very dark limestone that decays fairly rapidly in contact with the atmosphere, and could be fairly easily crushed into polishing material for the metal trades that flourished in Swansea and its hinterland during the industrial era. The rottenstone pits occupy much of the area between the wall/fence and the approaches to Cribarth, and are a form of early open-cast mining.

Walk uphill beside the fence, ignoring the stile at grid reference SN 8322 1569, up to a second large sink hole, also with its own name, Pwll-yr-Wydden (pit of the trees). This one is quite different from its larger, lower cousin, Pwll-yr-Cawr. The lower side of Pwll-yr-Wydden is similar to the previous sink hole, with a steep grassy slope. On the upper side of the sink hole, however, there is a stream and waterfall, tumbling over striking, upright rocky crags, with a mass of fallen boulders at the base of the hole and into which the stream disappears (see Photo w3.3). Another smaller sink hole sits next to the lower edge of Pwll-yr-Wydden.

The reason for the different shapes of these two large sink holes is that this one is sited on the boundary between the soluble Carboniferous Limestone and the insoluble Millstone Grit, here seen in the form of a particularly tough type of sandstone known as 'quartzite'. This is a sedimentary rock formed of pretty pure quartz sand particles.

The quartzite forms a clear line of crags running along the hillside. Where the stream draining from above crosses from the quartzite into the limestone it immediately starts to dissolve the underlying rock, and thus, over time, creates underground drainage channels or

Carreg Goch & Cribarth

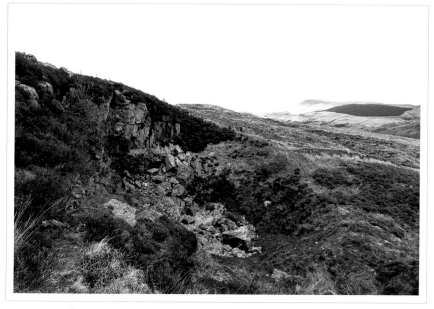

Photo w3.3 | Pwll-yr-Wydden, on the boundary of Carboniferous Limestone (centre and right) and Millstone Grit (upper left); fence posts on the upper left skyline, and a red figure just visible in the upper centre of the photo, give an idea of scale.

caverns. When these caverns are big enough, the roof collapses forming sink holes on the surface. Clearly there is a large underground cavern system running down the slope from Pwll-yr-Wydden to Pwll-yr-Cawr and then under the dry valley seen earlier on.

It is necessary to make a decision here on whether you want to carry on following the whole recommended route, or to take the shorter version. If you want to cut the walk short, then return down beside the fence to the stile at SN 8322 1569 where you pick up a track which heads south-west, past a smaller and less impressive version of the last sink hole, known appropriately as Pwll-yr-Wydden Fach, and an area of several sink holes to a stile (near some rottenstone quarrying remains) at SN 8301 1503. Cross the fence and follow the track to SN 8302 1490, where some clear crags appear running off to the right; rejoin the recommended route here (see below).

To follow the full recommended route, climb past Pwll-yr-Wydden and carry on heading north-west alongside the fence, eventually coming to a stile and a corner in the fence at SN 8264 1587 near a massive erratic. Cross the stile and bear roughly north towards some distinct crags at SN 8257 1607, with a shallow lake a short distance to the south-west.

Navigation from here on can be very confusing, as the map detail is hard to read and the landscape very repetitive, with the lie of the strata leading to limited visibility. Initially at least you climb to one high point, only to be confronted with another. The way to Castell y Geifr and then onto Carreg Goch is not too difficult in clear weather, as you keep going to the next high point, until you reach the highest point where you get all-round views. Before giving further routing instructions, the next few paragraphs point out the various features to be seen on this part of the walk, until you get back to the stone wall/fence having completed the loop out to Carreg Goch.

As mentioned above the rocks are known as quartzites. The definition of quartzite is a rock with very high proportions of quartz. This produces a tough, rather jagged rock often with an almost milky, glassy sheen. Quartzite offers little in the way of minerals for vegetation so a sparse reedy coverage is broken by innumerable patches of quartzite pavement.

The rock 'bedding' is tilted gently off-horizontal and the rock is cut by plenty of more or less vertical 'jointing'. When the rock is exposed to the surface, the pressure on the rock mass relaxes slightly allowing water to enter any cracks or 'joints' and, on freezing, to expand and crack open the rocks resulting in the broken crags and pavements (which can be quite demanding to walk on). The surface of some pavements and the vegetated areas is strewn with glacial erratics as well as freeze-thaw boulders (see Photos 8.1, w3.4, and w3.6).

The erosion along bedding planes and joints, allied with the overall tilt to the south, accounts for the general shape of the landscape here. The fairly short but steep 'scarp' slopes are cut into the strata or 'bedding' of the rock, while the beds themselves form the 'dip' slope with its easy angle tilt to the south (see front cover photo). This pattern is repeated on a larger scale to the north in the higher hills of the Old Red Sandstone. The long slopes down from Fan Hir and the other tops is the dip slope. The Old Red Sandstone then dips underneath the later Carboniferous Limestone, which in turn disappears under the Millstone Grit. The result is that the Millstone Grit is a series of layers exposed with small crags. Unfortunately, as noted above, this leads to a profusion of similar-looking scarp slopes and the consequent need for navigational alertness. On the other hand it does create a highly attractive scenery.

Each bedding surface represents a top of some sediments, so each bed you walk over is an ancient sea or riverbed. In some places you can see ripples created by wave action in the bed of loose sediments while it was still wet. Even after undergoing compression, drying and a series of chemical processes which cement the loose grains into solid rock – thus after becoming sandstone (of the quartzite variety) – the ripples were preserved by luck, to be exposed on the surface some 300 million years later (see Photo w3.7).

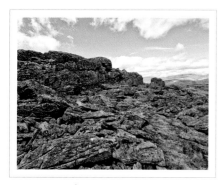

Photo w3.4 | A Millstone Grit edge being broken up into boulders due to freeze-thaw action.

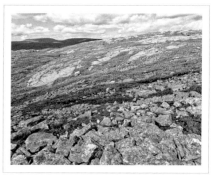

Photo w3.5 | Foundered quartzite grit in the foreground and quartzite pavement in the centre.

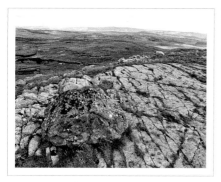

Photo w3.6 | Old Red Sandstone erratic stranded on a quartzite pavement.

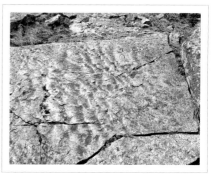

Photo w3.7 | Ripples in exposed Millstone Grit bed.

The rocks also display a feature known as cross-bedding, where a shifting current cuts through earlier beds to produce bedding patterns that are cross-sections through rippled bedding. Some rocks contain small pebbles and look almost like some concrete. Keep an eye out for these features as you make your way across the gritty pavements and joint-cut craglets.

Two other features of the Millstone Grit are 'foundered grit' and sink holes. Foundered grit (see Photo w3.5) is the name given to patches of Millstone Grit boulders or 'blocks' which are not obviously part of the rock edges undergoing freeze-thaw erosion. Though the area crossed on the recommended route is mainly Millstone Grit, there are places where limestone comes to the surface (such as near Castell y Geifr), and patches of foundered grit are found on top of limestone in places – representing the last remnants of Millstone Grit

which once covered the limestone, and which has now all but been eroded away except for these patches of awkward stones. Sometimes these may lie in a shallow depression indicating an underlying sink hole.

Sink holes are often found in Millstone Grit in the whole Brecon Beacons range, though this is unusual (but not entirely unknown) elsewhere (see Chapter 4). There is more limestone underlying the Millstone Grit, and collapsed caverns in that underlying limestone has led to collapse of the overlying 'caprock' formed by the Grit.

Having looked at features to be seen on this section of the walk, it's time to look at directions for the recommended route (or you can follow your own agenda here and wander at will, as long as you find your way back to the corner of the stone wall/fence).

From the distinctive crags at SN 8257 1607, aim to follow the high ground initially heading north-east, then north and then north-west, moving steadily towards Castell y Geifr (castle of the goats). Note that the highest point on Castell y Geifr is some way north of where the name is printed on the OS 1:25,000 map. The high point at grid reference SN 8249 1663 is not the high point on Castell y Geifr, which is the next peak on, at SN 8237 1682 (spot height 531m).

From the 'summit' of Castell y Geifr aim just south of west, passing some distinctive crags, to avoid wet terrain and a pond in a sink hole (SN 8207 1676) with the aim of approaching Carreg Goch from the south/south-east. You should pass to the left of the pond and the right of another (dry) sink hole.

Find a way through the mass of boulders and small rocky edges that guard the approach from the south-east. The grid reference of the highest point is SN 8189 1702. It's worth spending some time here appreciating the magnificent all-round views with the tops of the Old Red Sandstone, Bannau Sir Gaer (Carmarthen Fans), Bannau Brecheiniog and Fan Hir forming the high rim on the northern and eastern skyline. Closer to your viewpoint you can see the great bog, Waun Fignen Felen (see Walk 2). Innumerable sink holes litter the slopes to the east of this viewpoint, marking limestone in the lower ground between the higher points.

If you look back to Castell y Geifr you can see that the grass below it is quite green compared with the reedy vegetation below and around the top of Carreg Goch. This is because limestone crops out on Castell y Geifr, while most of the other tops passed on the recommended route are part of the Millstone Grit. Limestone also forms the bedrock to the north and east of this viewpoint. The mass of tilted Millstone Grit extends for another kilometre north from here to Disgwylfa, and also underlies the dense, rough vegetation to the west and south.

Carreg Goch & Cribarth

There are also superb views to the west over Mynydd Du and south down the Swansea valley, with the peaks of Varteg on the left and Allt y Grug on the right guarding access to the valley as it cuts through the tough Pennant Sandstone of the upper Coal Measures. To the left, behind the wind farm, is Craig y Llyn and the northern rim of the central coalfields, also part of the Pennant Sandstone and the highest point in the coalfield. In front of these hills lies an area of low land where the Lower Coal Measures come to the surface (and are often exploited by open-cast operations which can sometimes be distinguished as dark patches on the lower ground).

The panorama is completed looking east over Fforest Fawr with its fine mix of Millstone Grit and Carboniferous Limestone scenery, and on to Fan Gyhirych and Fan Hir, the elegant Old Red Sandstone hills at the head of the Swansea valley.

Having come this far you may well be tempted to carry on for about another kilometre to the high point at 544m on Disgwylfa. In the valley to the west of the stretch between Carreg Goch and Disgwylfa you can see the 500 metre gap and dry valley between Sinc Giedd and the springs that feed the southern Afon Giedd (see Walk 2). If you do head out to Disgwylfa, when you've enjoyed the views return to Carreg Goch.

It's not very practical to return in a direct line from Carreg Goch to the stile and corner in the fence at SN 8264 1587 because of wet boggy ground occupying the route. The recommended return route from Carreg Goch to the stile and corner in the fence follows a slight loop around to the west of the boggy lower area in the middle of the way back. Start off heading south, taking in the minor high points, then swinging south-east to pass a sink hole (marked on the OS map) at about SN 8205 1595. It looks pretty easy on the map, but it is more difficult to discern a route on the ground and it would be easy to be drawn too far south towards Nant Ceiliog.

The impressive sink hole at SN 8205 1595 is well within the Millstone Grit, and illustrates quite clearly how underground limestone caverns must exist below this point. Walking around the sink hole also shows some of the rock strata of the Millstone Grit with tilted bedding (see Photo w3.8).

From the large sink hole head roughly south-east to cross a dry valley. Dry valleys, like sink holes, are usually a feature of limestone, not Millstone Grit, but once again they are a fairly common feature in these rocks in the Beacons.

Aim to pick up the stone wall/fence somewhere south of Carreg a'r Gap, near the stile at grid reference SN 8264 1587. Follow the fence south, passing a small sink hole at about SN 8265 1535. At the fence corner bear roughly south-east to top a crest and find a footpath at around SN 8300 1480; turn right onto the footpath.

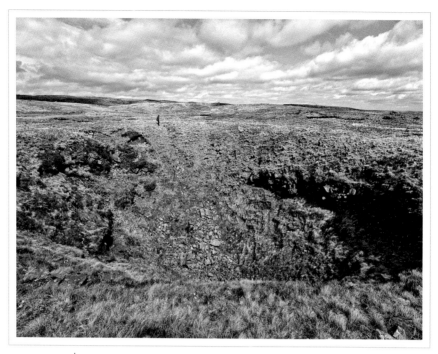

Photo w3.8 | Unnamed sink hole on Mynydd Du (SN 8205 1595)
with Millstone Grit strata at surface level.

The shortened route rejoins the recommended route near here and the combined route now continues south-west into an increasingly asymmetric valley with an extremely impressive scree slope developing on the left-hand side; these rocks are part of the Millstone Grit. The footpath (which is only shown on the OS 1:25,000 map south from grid reference SN 8290 1463) follows the route of a tramway used for quarrying operations. It has deteriorated in places and can be difficult to walk along, but the views, especially of the growing scree slope on your left, will make up for any minor discomfort.

Further along and ahead to the right is Garreg Fawr, a very large depression with scores of small sink holes distributed around its lower slopes. A superficial look at the OS map might lead you to expect a hill here, as the contours form concentric rings, just like those that do indeed represent the hill at the top of the scree slope (marked as height 426m on the map). The ring contours here however actually indicate a depression, deep enough to justify several contour lines, each indicating a further 10m of depth. Indeed, the depression is 30 to 50 metres deep and some 300 metres long, depending on how you specify its outer limits (see

Carreg Goch & Cribarth

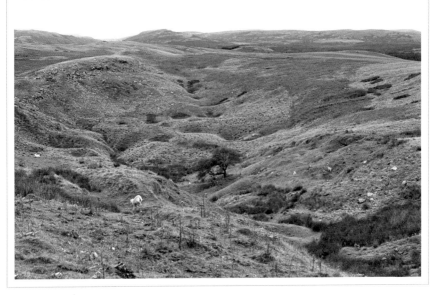

Photo w3.9 | Garreg Fawr, a large depression with dozens of sink holes within its bounds.

Photo w3.9). A particularly good viewpoint is gained by taking a short diversion to the end of a prominent quarry waste tip at about SN 8264 1465. Return to the right of way/tramway and follow it along the base of Cribarth. Leave the tramway when it becomes a cutting across boggy ground, and head up left towards some grassy hummocky terrain which turn out to be quarry waste tips at the base of a junction of tramways (at about SN 8251 1398).

The story of quarrying on Cribarth is too complex to summarise in the space available in these pages, but a very useful introduction is found in Stephen Hughes's book, *The Archaeology of an Early Railway System: The Brecon Forest Tramroads*. There were 33 large quarries on and around Cribarth and quite a few smaller ones too. Altogether some 17 kilometres of tramways and railways, and 18 inclines, were built between the opening of the Swansea Canal in 1794 and the decline in the industry in the 1890s, to transport quarried material off Cribarth alone. It may not seem like it today, but this was once a busy industrial landscape.

Turn back and head uphill, keeping to the right of the prominent tramway which runs right up to the top. On reaching a quarry barring your way, bear left onto the tramway. There are super views down the tramway to a junction of tramways lower down and beyond that to the Tawe valley. Slog up to the crest, working your way round to the trig point marking the high spot on Cribarth at SN 8284 1419.

From the summit, turn round and follow a route along Cribarth heading north-east. You get good views here of the dramatic tilt of the rocks which form part of an anticline (see Photo 4.7). Cribarth is part of the 'Swansea Valley Disturbance' as geologists call it. The whole area has been thrust out of position by forces generated some distance away during the collision of tectonic plates. Cribarth is cut by faults and is part of a small area of folds. It forms a tough chunk of rock around which the river Tawe has had to carve a curving gorge.

Look out for nodules of 'chert' (rocks with a very high silica/quartz content) which form within the limestone (see Photo 4.6). These are possibly formed by silica-rich life forms, such as sponges, that lived in the tropical shallow sea where the limestone was created, but this is not certain.

Carry on north-east either using tramways on the left side of the ridge for the easiest route, or via quarry waste on its right for opportunities to study the rocks to find fossils, or pick a route along the crest for the best views of the surrounding landscape (see Photo w3.10).

The track back to Craig-y-nos drops off to the left to cross a stone wall at about SN 8358 1490, so you can start to descend when you like, however it is worth striding out to

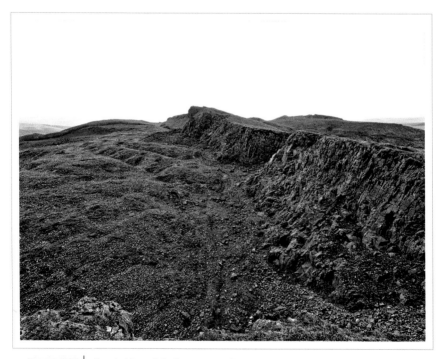

Photo w3.10 | Quarried face of the limestone on Cribarth.

the final high point on the ridge at about SN 8370 1475 for commanding views of Craig y Rhiwarth, with its vertical bedding, and higher up the gently-tilted limestone and Millstone Grit above that.

Work your way down to the stone wall at a suitable point and then follow it back along to the crossing point at SN 8358 1490. Note the sink holes littering the valley as you drop down. After crossing the stone wall follow the obvious track. You pass close by some of the sink holes that you saw from a distance earlier on the way down. You also get good mid-distance views of the two large sink holes (Pwll-yr-Cawr and Pwll-yr-Wydden) seen on the outward route, and the area of rottenstone excavations. A closer examination shows the edge of the Millstone Grit running across the hillside (and crossing the back of Pwll-yr-Wydden) and also the dry valley crossed near the end of the Millstone Grit on the return route.

The track follows a steepening and narrowing valley which guides you to a muddy lane, and then down to the trekking centre and its complex of pathways leading to the road.

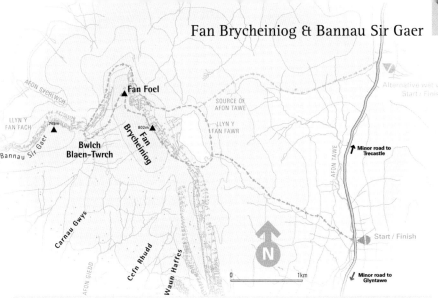

Walk #4

Fan Brycheiniog & Bannau Sir Gaer

START	▶	SN 853 204 OR SN 855 223
FINISH	●	SN 853 204 OR SN 855 223
TIME	☾	5 HOURS PLUS
GRADE	⊙	NAVIGATION ● ● ● ● ●
	⛰	TERRAIN ● ● ● ● ●
	⊗	SEVERITY ● ● ● ● ●

Fan Brycheiniog and Bannau Sir Gaer form a distinct and impressive part of the Old Red Sandstone scarp. The beauty of the overall scene is enhanced by the presence of two fine and fairly large glacial lakes, Llyn y Fan Fawr and Llyn y Fan Fach. For those with an interest in geology, the views are supplemented by an intriguing array of mysterious glacial mounds of one sort or another, that form a virtually continuous linear feature at the base of the scarp slope.

Fan Brycheiniog reaches 802m and Bannau Sir Gaer tops 749m, making this the second highest section of the scarp, and the wide views easily rank with those from the top of Pen y Fan and Corn Du, the highest points in the entire range (see Walk 1). A visit to these tops is an essential part of appreciating the overall grandeur of the Brecon Beacons range.

The recommended walk is entirely within the Devonian Period rocks of the Old Red Sandstone. The bulk of the rocks underlying the mountain are the Senni Beds and the Brownstones Formation of the lower Old Red Sandstone. The Senni Beds are crossed only at the start and end of the walk, but the Brownstones Formation is exposed in the scarp slope, as well as around occasional features such as waterfalls on the way to the scarp.

The highest points and the scarp edges, however, owe their existence to tough Plateau Beds at the top of the Old Red Sandstone. The capping provided by the Plateau Beds is quite distinct, indicating the geological boundary between different rocks within the Old Red Sandstone. The Plateau Beds belong to the upper Old Red Sandstone. Elsewhere geologists have identified other rocks laid down in the Devonian Period between the Brownstones Formation and the Plateau Beds. This means that there was a period of several million years during which no rocks were laid down in this particular area.

On the return leg of the journey the route takes you close to some outstanding hummocky shapes found at the base of the scarp slope – these are generally thought to be 'moraines' dumped by glaciers, though some geologists argue that they are a feature known as 'protalus/pronival ramparts', where rock has accumulated after falling off the slope higher up and rolling across ice at the bottom of the scarp. In either case these are conspicuous evidence of the action of ice in shaping the scarp slope scenery, as are the two lakes.

The walk also provides a fine overview of the great mountain moorland of Mynydd Du to the south, with its mix of Carboniferous Limestone and Millstone Grit – this is an otherworldly landscape of funnel-shaped 'swallets' and sink holes where rivers disappear underground.

To follow the recommended route it is necessary either to ford the young Tawe or brave the boggy land at its head. It is possible to avoid this by extending the walk using the footpath that begins about 150m south of where the minor road leaves the

A4067 (at SN 850 172), thus including Fan Hir in the itinerary. Buses do not serve the minor road, though they do run on the A4067 between Swansea and Brecon.

Navigation could be difficult in misty weather, especially in the early and final stages, getting to and back from the scarp to the start point. The area today is bleak in all weathers, with little diversity of vegetation, yet it is also dense with ancient archaeology, with plenty of cairns, standing stones and circles, as well as remains of settlements. Llyn y Fan Fawr also features in ancient Welsh legend.

If the river Tawe is low, it should be possible to ford it somewhere around grid reference SN 853 204, just east of the stone circle and avenue marked on the OS map along with standing stone, Maen Mawr ('large stone'), which should be visited on the return leg. Pick a route roughly alongside the northern bank of the Nant y Llyn stream now and again passing some pretty waterfalls (see Photo w4.1).

If fording the river Tawe is not feasible, continue along the road to about SN 855 223 and slosh upwards in a roughly south-westerly direction, passing through the area declared the source of the Tawe, up to Llyn y Fan Fawr.

If you follow the recommended waterfall route, the rocks vary from finer-grained sand to coarser, with some beds of pebbly gravel of the lower Old Red Sandstone. The different beds indicate changing conditions when the sediments were originally laid down. The lower beds were largely laid down in sandy-braided streams which flowed only seasonally and at other times were dry. Higher up, however, the rocks consist of sandstone flood deposits interlayered with mudstones and siltstones from sediments deposited in lakes and slow-moving water.

A feature known as cross-bedding is visible in some of the outcrops – this indicates how the sand grains were laid down in shifting currents within a river delta.

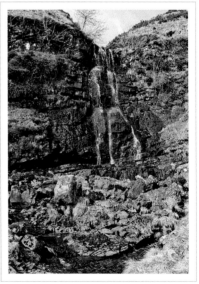

Photo w4.1 | A minor waterfall reveals bedding in the Old Red Sandstone.

Fan Brycheiniog & Bannau Sir Gaer

However, there are but a few rock exposures to enlighten the slog over coarse vegetation to Llyn y Fan Fawr. The lake appears quite suddenly, hidden behind some low hummocky mounds (see Photo w4.2).

The outlook here, except in early morning sun, is often quite bleak with the windswept lake clinging to the foot of the steep scarp slope exposing the layered beds of the lower Old Red Sandstone. The top 6.5 metres of the slope behind the lake, at the very summit of Fan Brycheiniog, belongs to the Plateau Beds of the upper Old Red Sandstone. These tough beds provide a resistant cap for much of the Brecon Beacons scarp slope.

The lake sits, somewhat improbably, on a shelf at the bottom of the scarp with only a slight rise in the land along its northern, eastern and southern limits. A mass of moraine material is responsible for the slight rise on the northern and eastern sides, but bedrock rises to the south, separating the bowl holding the lake from the scar slope below Fan Hir. There is a distinct difference between the colour of the vegetation on top of the well-drained moraine and that on the bedrock.

Follow the track, much improved by the National Park Authority, up to Bwlch Giedd and then on to Fan Brycheiniog (where there is a shelter – a useful feature on this slightly sloping

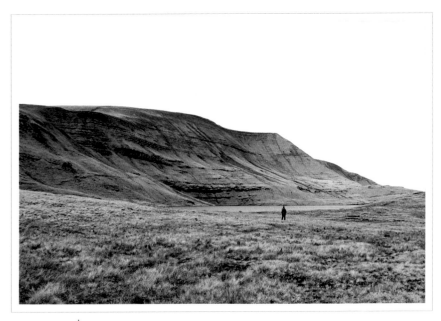

Photo w4.2 | Fan Brycheiniog and a glimpse of the glacial
Llyn y Fan Fawr at the base of the scarp slope.

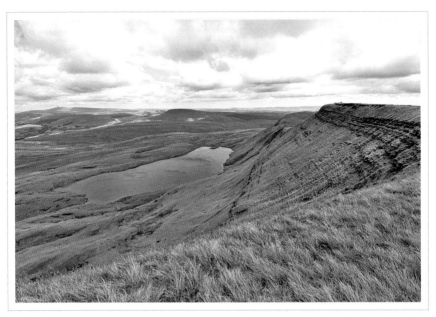

Photo w4.3 | Llyn y Fan Fawr seen from Fan Brycheiniog; note the Plateau Beds forming the clear lines just below the top edge of the scarp slope.

plateau, open to the full force of the wind from whichever direction). The views east from here are quite marvellous, with the twin peaks of Pen y Fan and Corn Du visible in the distance, and Fan Gyhirych, Fan Nedd, Fan Llia and Fan Fawr filling the area between the central Beacons peaks and this viewpoint on Fan Brycheiniog. The two steps in the north/south profile of the Old Red Sandstone represent the underlying Senni Beds forming the northernmost slope and flatter area, followed by the main scarp in the Brownstones Formation capped by the Plateau Beds (see Diagram 3.1).

Continue along the summit to the headland at SN 8248 2204 for an excellent view of the scarp slope above the lake, and the conspicuous bands of the Plateau Beds running just below the rocky edge to the summit plateau, disappearing from view just beyond the trig point (see Photo w4.3). The Brownstones Formation is largely hidden underneath vegetation here, indicating that erosion of the scarp is extremely slow. One tough band of sandstone does stick out somewhat in the middle of the scarp within the Brownstones Formation.

The hummocky moraines plastered on top of bedrock to the north and south of Llyn y Fan Fawr are quite easy to see from this viewpoint, and it is clear that the lake is only housed on a shelf at the base of the scarp slope.

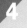

Continue on to Fan Foel (SN 8217 2233) for more excellent views, then drop down to Bwlch Blaen-Twrch (SN 8166 2174) and decide whether to take the shorter route home, by following a steep, twisting path down to the north (to SN 8161 2194) or to hike over Bannau Sir Gaer and round Llyn y Fan Fach.

If you take the longer route, note the deep red colour of the rocks exposed at various spots along the ridge. A fantastic viewpoint back along the ridge is encountered as you get to Waun Lefrith (see Photo 0.1) at the western end of the ridge as you start to curve round the lake. The classic glacial cwm of Llyn y Fan Fach is especially impressive with its rock walls over 150m high. The western end of the cwm curves round to provide a sheltered hollow where wind-driven snow could collect with ease, hidden from the sun, and in cold times became so thick that it was compressed by its own accumulating weight into glacial ice.

Drop down to the lake's northern side by descending the ridge beyond the cwm, and work your way over and under a maze of moraines to meet the shorter route at grid reference SN 8161 2194 at the base of Bwlch Blaen-Twrch. This is an enchanting walk over and around some oddly well-defined moraines and towering crags.

The shorter route offers the option to descend from Bwlch Blaen-Twrch on a twisting, narrow track to meet the longer route at the base of the scarp slope.

The long, straight mound at the foot of the slope is highly distinctive, looking almost like a human-made earthwork. Up to six metres high, the mound sits isolated on flat ground up to 100m away from the base of the scarp slope. It seems difficult to account for its shape and location as being deposited by glacial action as a moraine, but this is not entirely ruled out. It may be a 'protalus rampart', or 'pronival rampart' as they are now called (see Photos w4.4 and w.4.5).

As with so many of the other mounds clustering around the scarp slope between the two lakes, geomorphologists are divided on whether they are moraines, protalus ramparts, the remains of old rock glaciers or just accumulations of material from rock collapses. On the one hand it would be nice to seek a single explanation for the variety of hummock forms passed today, but it may be that the variety of forms reflects a variety of causes. This also applies to the long ridge running below Fan Hir (see Chapter 8 and Walk 2). It may well be but pure happenstance that a variety of mounds have accumulated in one particular area to form a set of hummocks running almost continuously underneath the scarp for some seven kilometres.

The next set of hummocks to be encountered heading north along the foot of Fan Foel were probably moraines created by glaciers (seen just left of and beyond the straight mound in Photo w4.4). The reasoning behind this is that, unlike the previous dead straight mound, this set of mounds is curved, and this is a common feature of moraines. The next

Photos w4.4 & 4.5

Glacial ridges at
the base of the
scarp slope.

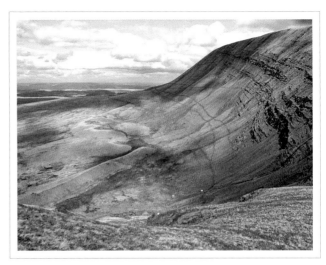

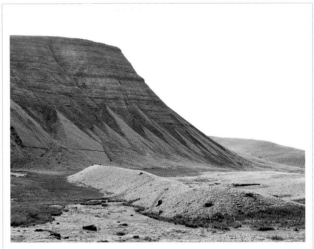

set of moraines after that is possibly the remains of a 'rock glacier'. This is a 'periglacial' feature that occurs when the temperatures are too high to support glaciers, but cold enough that water between fallen rock boulders can freeze. The film of frozen ice between the boulders acts as a lubricant, and the mass of boulders moves forward, perhaps at only one or two metres a year.

The scarp slope leading up to Picws Du on Bannau Sir Gaer shows how erosion of the rock face is taking place in gullies, with fan-shaped debris flows accumulating at the scarp foot.

Fan Brycheiniog & Bannau Sir Gaer

The route then heads roughly north, then east and finally south to go round the bottom of Tro'r Fan Foel. The higher the line you take, the much shorter the distance you will need to walk to get around the tip of the high land. A track around the 650m contour is about the best route, and takes you past hummocky ground, probably more glacial moraines, at SN 8329 2255, and then past a ruin (Gŵal y Cadno) at SN 8252 2228.

The crags rear up above you and offer plenty of opportunity to appreciate the way in which the crags are being eroded in sections, with large debris fans at the base of the crags. The gully leading up to Tŵr y Fan Foel is particularly impressive.

Carry on towards the moraine area to the north of Llyn y Fan Fawr. Work your way round the lake on either side (the eastern being a lot easier) to pick up your return track. If heading for the road at the lower start point, try to aim for the stone circle at grid reference SN 8511 2062.

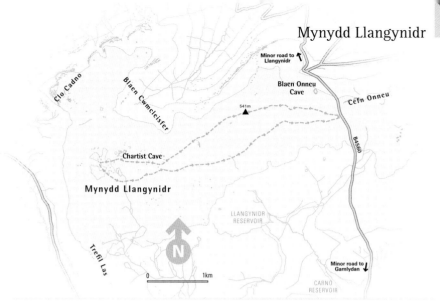

Walk #5 – Mynydd Llangynidr

START	▶	SO 1627 1593
FINISH	●	SO 1627 1593
TIME	☾	4 HOURS PLUS
GRADE	�׀	NAVIGATION ● ● ● ● ●
	☁	TERRAIN ● ● ● ● ●
	⊗	SEVERITY ● ● ● ● ●

The B4560 road between Aberdare and Crickhowell is a bridge between two different worlds. At its southern end you find the industrial maelstrom of the northern coalfields, even today a busy place despite also experiencing fearfully high levels of unemployment. The landscape is littered with industrial buildings, townships, roads, electricity pylons and the 'landscaped' remains of the once-dominant coal and metal industries. Even the flat-topped hills between the valleys which run south have been partly shaped by industry – the highest point on the mountain between the Ebbw and Sirhowy valleys is a waste tip.

Mynydd Llangynidr

Follow the B4560 to its northern end and you enter a green, rural countryside, with wealthy-seeming towns like Abergavenny and Crickhowell admirably framed by the shapely ridges of the Black Mountains. These look like friendly mountains (in nice weather at least).

The area that the road bridges between these two distinctly different parts of South Wales is a bleak, boggy and undistinguished moor, Mynydd Llangynidr. This is apparently the South Wales landscape at its least attractive.

The bulk of the moor is underlain by rocks of the Millstone Grit. The undulating landscape is pretty heavy walking with plentiful wet patches and acres of awkward heather and bilberry. True, there are fine views of the uplands of the coalfield to the south and east, and of the Black Mountains and the central Beacons, with Pen y Fan and Corn Du clear on the northern skyline, but there seems little else to attract the walker.

For the geologist Mynydd Llangynidr also seems to offer little. True, there is an impressive approach from the north where quarrying has cut into limestone forming looming crags, but otherwise there appears to be no more on offer than a handful of rock outcrops reached only by miles of wet tramping.

Despite this superficial lack of attraction, Mynydd Llangynidr has been declared a Site of Special Scientific Interest (SSSI) for its 'karst' geology. Even from the road some pretty substantial sink holes are visible. A glance at the OS 1:25,000 map will show markings for dozens of sink holes. On the ground several of them turn out to be over 100 metres in diameter. What makes the area so special for geologists is the combination of neglect and the interplay of the Millstone Grit and Carboniferous Limestone.

Sink holes are common features in limestone, but are far less likely to occur in rocks made up of sandstone or grit, such as the tough quartzites of the lower Millstone Grit. But all along the northern edge of the coalfield one finds a comparative geological rarity – sink holes in the Millstone Grit. Several thousand have been recorded. This is unique in Britain and is to do with the geological structure of the Carboniferous Limestone and the Millstone Grit (see Chapter 4).

Sink holes are usually created by dissolution of the rocks at, and just below, the surface. Such 'dissolution sink holes' are very common in limestone rocks as the calcium carbonate in the rocks is easily dissolved by rainwater. On the other hand, the quartzites of the Millstone Grit are pretty chemically stable, consisting by definition of a very high proportion of quartz or silicon dioxide, a mineral highly resistant to both

chemical and physical erosion and little affected by rainwater. So it is unlikely that the sink holes seen in the Millstone Grit are dissolution sink holes.

The origin of sink holes in the Millstone Grit lies in dissolution of caverns and drainage channels in the Carboniferous Limestone which lies *underneath* the Millstone Grit at quite shallow levels. The growth of these caverns and drainage channels eventually leads to their collapse. If the collapse exceeds the strength of the overlying rocks, then they too may collapse, thus leaving a depression – known as a 'collapse sink hole' – at the surface (see Diagram 4.1).

Mynydd Llangynidr's claim to SSSI status depends on the fact that it has lots of collapse sink holes which are of a subtype known as 'capstone sink holes' or 'interstratal sink holes', that is sink holes reflecting the interlayering of different rock strata. This walk passes by a few of the sink holes on this distinguished moorland, which illustrate that these are indeed sink holes created where the surface quartzite rocks (providing the 'capstone') have collapsed due to being undermined by lower-level cavern or drainage channel collapses in the underlying limestone (thus being 'interstratal').

Navigation could be extremely tricky in the mist and this walk is best reserved for clear weather, though if you get lost it should be fairly easy to locate the B4560 road by following and holding an easterly bearing (or a westerly bearing if you venture on to Mynydd Llangatwg to the east of the road where there are many more sink holes). The OS 1:25,000 map is essential for providing navigational detail and shows many of the larger sink holes. Although I recommend a particular route, its main purpose is to direct you past some sink holes which illustrate the development of collapse sink holes, but it is quite possible to work out your own itinerary from the OS map to visit more of the several hundred sink holes on this fine moor, and/or to include a visit to the impressive quarry faces and crags on the northern slopes of this mountain.

Start from the B4560 road at about grid reference SO 1627 1593, near spot height 518m on the OS 1:25,000 map. Head west over very rough ground towards the northern end of the large sink hole marked, as a horseshoe-shaped depression, on the map at SO 1610 1590. Here a wide, shallow bowl tilts towards a lower end, which includes a couple of sink holes (see Photo w5.1). The whole thing is known as a 'subsidence depression'. This is not a particularly large subsidence depression, but it indicates the collapse of a sizeable nature, such as an

underground cavern, some distance below the surface. It is in effect a large collapse sink hole, but with its own smaller collapse sink holes within it.

Continue west, passing other sink holes of different sizes including a large one at SO 1567 1598. Some of the sink holes are entirely cloaked in vegetation, but in others there are sometimes boulder fields, another common feature known as 'foundered Millstone Grit masses' (see Photo w5.2). The mass of boulders represents the remains of the 'caprock' that collapsed, creating the surface depression when the size of the underlying collapsed cavern in the limestone became too great for the natural mechanical strength of the Millstone Grit to bridge.

A track heading west, not shown on the OS 1:25,000 map, comes in from the right and eases the going slightly. You will also cross two clear north/south tracks at various points – these are shown as rights of way on the OS map. The first major landmark to aim for is the trig point at SO 1470 1593, just after crossing the first of the right of way tracks. The trig point stands at a height of 541 metres and offers superb all round views, most strikingly of the Black Mountains to the north.

A slight height loss is necessary as the track continues roughly west, passing more fascinating sink holes. The next objective is a sink hole at SO 1267 1521 (see Photo w5.3). Here you can see a partial collapse of the caprock with collapsed boulders. The arched outcrop

Photo w5.1 | A subsidence depression with smaller sink holes at the head.

Photo w5.2 |

Sink hole revealing 'foundered Millstone Grit mass'; remnants of the collapsed caprock.

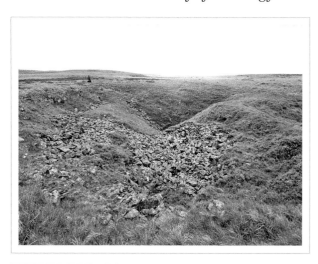

Photo w5.3 |

Arched caprock being undermined by collapse of lower rocks.

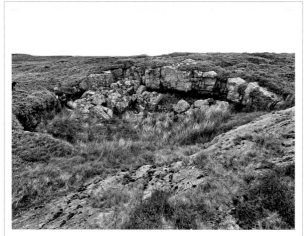

of Millstone Grit quartzite illustrates how the caprock is being hollowed out from below. The nearby Chartist Cave, where it is claimed some local Chartists hid weapons during the great Chartist campaigns, is found at SO 1277 1523.

From this point head towards the cairn on Garn Fawr at SO 1235 1513, the highest point on Mynydd Llangynidr at 557m. Again, the wide-ranging views are worth the slog across rough ground necessary to get here. The Black Mountains and the Brecon Beacons are easily visible on the northern skyline, and the coalfield plateau to the south, with the sandstone scarp marking the upper Coal Measures except where cut through by valleys.

Mynydd Llangynidr

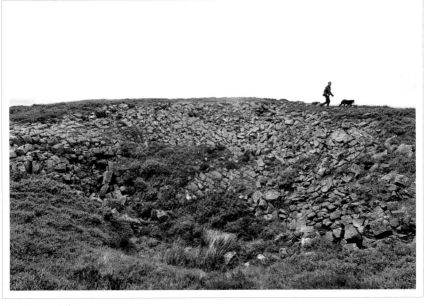

Photo w5.4 | Coherent mass of subsiding quartzite pavement in the
centre, with a jumble of collapsed rocks on the right.

Head roughly south-east to skirt the boggy area around Llyn Y Garn-Fawr on its
south-western side, then bear more or less eastwards keeping where feasible to the highest
points on the return leg of the journey, but take care not to get pulled to the south or south-
east. The lake expands and contracts seasonally across its shallow, flat floor and is accompa-
nied to the east by five depressions probably representing old sink holes now choked with mud
and other matter. The route I suggest goes via the series of sink holes/depressions marked on
the map at SO 1273 1463, SO 1306 1463, SO 1334 1481 and SO 1365 1480; however you
can omit this curving route if desired and take a more direct bearing back to the start point.

An interesting sink hole passed as you head east gives another illustration of the method
of caprock collapse (see Photo w5.4). Although it is not very clear in the photo, the visible
mass of foundered Millstone Grit is divided into zones. The largest zone on the right (below
the figure) is truly a jumble of individual blocks. However, the section of rock in the centre left
of the photo is more cohesive. The individual blocks are outlined by clear 'jointing', but the
whole section looks a bit like a pavement that has subsided, but all still joined together. The
smaller section of rock on the far left shows the same two facets, but on a slightly smaller
scale, with a jumble in the foreground and a more coherent section on the crest.

Aim for a shallow depression with a small crag and sheep shelter (shown on the OS map at about SO 1391 1533) and climb up the crags behind the shelter to come across an interesting set of sink holes at about grid reference SO 1400 1535.

This is a set of several small sink holes which have developed into a linear trench. The outlines of the smaller, original sink holes can easily be seen as you approach. The trench is not quite complete however, and at one point there is still a land bridge, though bowing downwards, across the trench separating two smaller sink holes. Closer examination shows the land bridge to be precisely that, a rock arch covering a short tunnel between the two original sink hole depressions (see Photo w5.5). The remnants of a similar feature can be identified at the next sink hole linking point along the trench.

Once again you can see evidence of how the rock founders below the caprock, which will it-self eventually collapse as the underlying limestone rocks undergo further dissolution by rainwater.

Continue back towards the starting point, passing another large sink hole at SO 14055 15416. This sink hole has a rock outcrop on one side and a small mass of foundered boulders sitting in the centre of the depression, again illustrating stages in the development of caprock collapse sink holes in the Millstone Grit (see Photo w5.6).

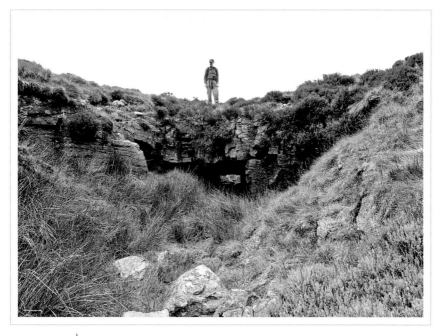

Photo w5.5 | Millstone Grit caprock being undermined in a linked series of small sink holes.

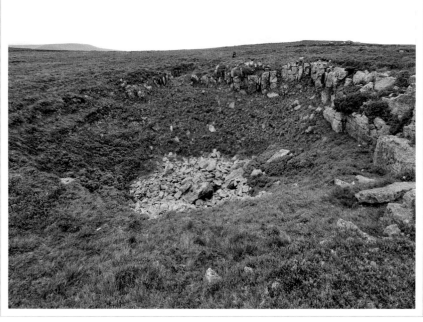

Photo w5.6 | An outcrop of Millstone Grit on the right, and a small mass of foundered Millstone Grit boulders, are the only pointers to the collapsed caprock that once covered this sink hole.

On return to the start point, it is worth heading just about a kilometre south along the road to see Pwll Coch, another large sink hole, 55m wide and 17m deep. This one, however, has a stream running into it, unlike all but one of those seen earlier on this walk. More large and interesting sink holes can be found on Mynydd Llangatwg if you have the energy and time for more rough moorland walking on this fascinating natural bridge between the coalfields and limestone.

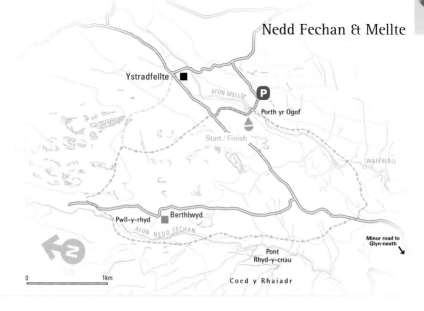

Walk #6 – Nedd Fechan & Mellte

START	▶	SN 928 124 OR SN 929 134
FINISH	●	SN 928 124 OR SN 929 134
TIME	◐	5 HOURS PLUS
GRADE	◉	NAVIGATION ● ● ● ●
	◐	TERRAIN ● ● ● ●
	◉	SEVERITY ● ● ●

The ability of rainwater to dissolve limestone creates some very special effects on drainage and scenery. The points where water disappears underground, and where it reappears at the surface, are unusual features which command our attention. Several of the other walks in this book recommend routes that pass by lots of 'sink holes', some with streams running up to them, but mainly just holes in the ground allowing surface water into the underworld. This recommended walk, by contrast, takes in some exceptional sites where an entire river disappears into the ground in the middle of the riverbed, and where the water reappears further downstream from cave entrances.

Nedd Fechan & Mellte

This walk concentrates on some very special 'karst' features which are found where the rivers, Nedd Fechan and Mellte, cross from the Old Red Sandstone onto the Carboniferous Limestone, and then onto the Millstone Grit as they flow southwards. The rivers sink entirely below ground at some point after crossing into limestone territory (which is about 1–2km wide north to south in this area), and then re-emerge approaching the boundary with the Millstone Grit. For both rivers the main entry points into the underground river courses are quite spectacular – most especially in the case of the Nedd Fechan at Pwll-y-rhyd. When the river is in full flow Pwll-y-rhyd is a testament to the power of nature. Another site visited, Porth yr Ogof, is only marginally less dramatic, but its setting is more charming. Access to Porth yr Ogof is much easier than to Pwll-y-rhyd, but the latter definitely repays the effort of getting there.

Just what you will see depends very much on how much rainfall there has been recently in the area. In wet conditions the riverbeds can carry rivers across the limestone some way to Pwll-y-rhyd and Porth yr Ogof. In spate the flow of the Nedd Fechan into Pwll-y-rhyd is awe inspiring. The raging river thunders down the riverbed, but suddenly pours into a sink hole that is a great gash in the riverbed, the floodwaters disappearing in a violent waterfall, of which you cannot properly see the base. However in dry weather the riverbed may well be entirely dry for as much as 300 metres from the sink hole and it is possible, with considerable care, to peer down into the sink hole itself by approaching along the pebbly riverbed.

In both the cases of the Nedd Fechan and the Mellte there is a short length of ancient river gorge that is now entirely free of a flowing river however hard the rain has lashed down of late. These dry gorges are replete with 'fossil' waterfall sites and are taken as evidence that the rivers have been 're-juvenated' or given more erosive and down-cutting power at some fairly recent point, possibly due to the earth's mantle slowly and jerkily moving upwards, since the weight of ice which depressed it in the ice age has now long melted. This rejuvenation gave the slightly acidic rainwater the ability to dissolve the limestone at lower and lower places within the rock mass as long as a route could be found lower down for the water to resurface. Eventually the caves took all the waterflow, and left the dry gorges which are suspended a few metres above the existing river channels at both of their ends. At their lower ends the surface rivers have now cut a channel base that is lower than the abandoned

gorges. This is more obvious at the southern end of each of the dry channels, but most forcefully when the Nedd Fechan thunders into the sink hole at Pwll-y-rhyd.

The walk also visits a particularly beautiful, and conventionally wet, waterfall, Sgwd Clun-gwyn. Some of the riverside paths followed on the walk are steep and narrow. Care needs to be taken at all times on these paths.

Though it is possible to enter caves from various points on the walk, it is highly advisable not to do so, though many will be tempted to wander a few metres into Porth yr Ogof in dry conditions. Do not enter caves unless you are accompanied by an experienced local caver, have the right gear, and know which caves are 'safe' and which aren't. There are fast-flowing streams, 'sumps' and other life-threatening challenges in these caves. The water levels can rise very rapidly indeed if there should be a sudden heavy shower. There were 10 fatalities in the Porth yr Ogof cave system between 1957 and 1992. Don't add to the total.

Start at the car park at SN 928 124. The narrow lane leading to this car park leaves the road between Pontneddfechan and Ystradfellte at SN 926 128. Oddly, there is no sign at the junction pointing to the car park or the site of the National Park Information Office. Opposite the junction, however, is a private drive with the farm name, Penllwyn-Einon, so turn when you see this sign (in the opposite direction to which it points). More parking is available in the village of Ystradfellte (SN 929 134) and a footpath leads to Porth yr Ogof from SN 931 130 if you park there instead.

From the Porth yr Ogof car park and information centre, follow the sign towards Porth yr Ogof itself and enjoy the approach, noting the sloping layers of limestone. If it has been dry you may well be able to walk northwards (away from Porth yr Ogof) in the riverbed where you can see lots of reddish pebbles of the Old Red Sandstone, as well as greyer pebbles. The red pebbles have been washed down from Fan Nedd to the north.

At the time of my last visit there was a noticeable landslip on the outer bend of the river gorge as it approaches Porth yr Ogof. This is typical of how rivers cut down into the outer side of bends (and, on the other hand, deposit material on the inner sides). Head north up the riverbed for the short distance until you find where the river finally seeps away into the limestone. This can be as far as one kilometre north at Church Sink where there is always water entering the sink hole there, but is often far closer to Porth yr Ogof. The water does not disappear dramatically, but clearly seeps into the underlying riverbed, so that the flow becomes marginally noticeable and then slowly gets more substantial.

Nedd Fechan & Mellte

Turn round and head back towards Porth yr Ogof, visiting another cave entrance just north of Porth yr Ogof on the eastern side of the river. If you listen carefully you may well hear the roar of the underground river off to the left of the dry riverbed. Follow a narrow sidetrack to a small cave entrance above the underground river. There is a fast-flowing river inside and it is important not to enter this cave. You can hear the power of the underground flow of the river and contrast it, if it has been dry, with the feeble flow seen in the last areas of water in the riverbed shortly upstream of the cave.

The geomorphology of the South Wales limestone and surrounding rocks is ideal for the development of long, underground river drainage routes, thanks to the gentle southward dip of all the rocks on the north side of the major syncline which tilts down into the coalfield. The gentle dip also means that the underground drainage channels dip at the same easy angle as tunnels are formed along the bedding planes. However, they also form quite complex systems of cave passages and caverns, with changes of height and direction where water dissolves channels through vertical joints in the rock. Maps of the cave systems show multiple channels with sudden branching or changes of direction.

Walk back to the riverbed, or along the riverside path if the river is flowing, all the way to Porth yr Ogof – 'gateway to the cave' (see Photo w6.1). This is the largest and most impressive cave entrance in South Wales, reaching almost 20m wide and 3m high. In the very wettest conditions the river Mellte flows as high as the top of the cave entrance.

If it is dry you can walk right up to, and even a short way inside, the cave entrance, but it is inadvisable to go any distance into any side tunnel, or to stray too far into the main channel entrance without adequate preparation.

Return to the car park and drop down to the road crossing over the bridge. Follow the public footpath south, then follow the sign saying 'access for cavers'. Pass some wooden barriers, erected to make it difficult to approach two more caves, one on each side of the path. The path then passes into the old riverbed, now a mossy, bouldery gorge. Before the river had cut its full course into subterranean channels this was the riverbed, but now it is just a 'fossil riverbed' devoid of running water, with a couple of sites where once there would have been waterfalls, but which are now 'fossil waterfalls', marked only by a change in ground level. The 'scalloped' walls of the gorge, and the rocks around the resurgence of the river, show how the river course was battered out by rock-shifting flood flows.

Follow the gorge for about 200m until the path brings you to a wider channel. The river reappears at a cave mouth below you on the right (see Photo w6.2). Do not enter the cave here under any circumstances, as more people have been killed just inside the cave here than at any other limestone cave in Britain.

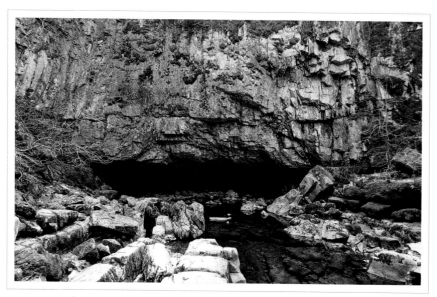

Photo w6.1 | The Afon Nedd, lower left, flows into the cave mouth at
Porth yr Ogof at the start of its short underground journey.

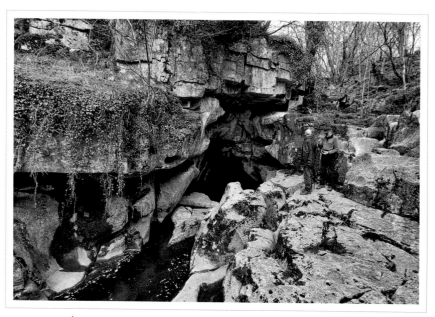

Photo w6.2 | The Afon Nedd re-emerges at this cave mouth.

From overlooking the resurgence, return a short distance to bear round right and take the path southwards along the eastern side of the river. Around grid reference SN 926 116 the river once more enters a narrow gorge, which would have been deepened at the same time as the river higher up had cut down further into the limestone to leave the ancient gorge 'high and dry'.

Follow the track to a footbridge near Sgwd Clun-gwyn waterfall. You may want to ignore the footbridge when you first meet it and follow the sign to the waterfall, which is about five minutes further on (see photo on page 9). You will also get a get a good view of the falls even if you ignore the waterfalls sign and cross the bridge on first meeting it. Either without the detour, or after having taken it and returned to here, cross the footbridge and follow the sign towards the car park. A short distance further on, take the left fork in the path to the top of the falls. If you are sprightly enough – and conditions permit – you can scrabble down to the base of the falls in the western corner.

If you do drop down, on your return to the top of the falls see if you can spot a sharp fold in the rocks near the top of the falls, most clearly seen in the thin beds of sandstone and shale. There is a corresponding fold that can be seen in the rocks exposed in the slight drop down to the bed at the top of the falls – again only in dry conditions. The folds form a 'monocline' created during the mountain-building episode that also created the folds in the coalfield a bit further south.

The fold is associated with deformation of the rocks on either side of a major fault. The bedrock on one side of the fault has shifted 15m downwards (on the southern side) resulting in softer rock being left adjacent to harder rock. Where the river crossed the fault it has cut down into the softer rock on the southern side to form the waterfall. The river crosses the general dip or tilt of the underlying rocks at a bit of an angle, dipping towards the east, with the result that the river channel cutting power is concentrated on the eastern side of the river. This means that the river channel is slowly shifting to the east, abandoning the wide, flat channel to the west (except in flood conditions). The tilt and one-sided nature of the river can be seen in the photo on page 9, which shows how the waterfall has migrated to the right-hand side.

Return to the upper path and follow it to the car park on the road at SN 918 107. Turn right onto the road and follow it north for about 300 metres to a footpath on the left at SN 918 109. Follow the footpath to meet the Nedd Fechan at Pont Rhyd-y-cnau (SN 913 115). Take the footpath on the eastern bank of the river, to head northwards.

Stick by the riverside as far as the pretty Pwll Du (black pool) at about SN 912 120. This is the main place of surfacing for the river entering upstream before or at Pwll-y-rhyd. Though the pool is often still, with water surfacing in the pebbles on the far side of the river, in flood the waters flow fiercely here. To reach this resurgence point the river water has had

to descend to a depth of 50m below the surface to pass a great block of Millstone Grit (up to 400m wide) which has been 'downfaulted' here. Only when it has passed under this can the water rise back to appear on the surface (unless there is a fault through the quartzite sandstone of the Millstone Grit that provides a conduit through the otherwise impermeable faulted block). Just south of Pwll Du is the furthest southwards reach of the limestone in and around this valley, with a narrow surface outcrop running along the line of the gorge north from here for nearly one kilometre until it widens out and the Millstone Grit, which forms the high land on either side of the valley, is fully replaced by the limestone.

From Pwll Du it is necessary to backtrack a short distance to pick up the footpath that goes higher up the valley side, next to a barbed wire fence. Some sections here are quite narrow and demand care. Follow the path to a bridge (at SN 911 126) where you have to cross the river, and then take the path on the western side of the river. Unfortunately the

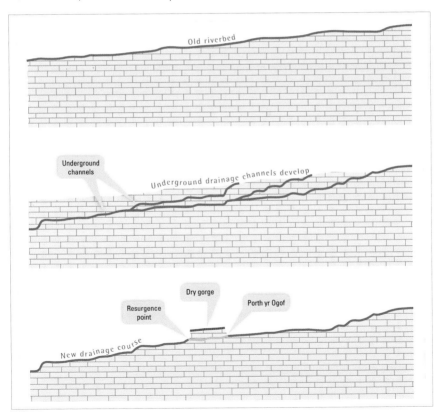

Diagram w6.1 | Geology of the area around Ystradfellte.

path climbs up the valley side and removes views of the one kilometre gorge below you. At its northern end the gorge is cut into the limestone alone, but at its southern end it has cut through the Millstone Grit to reach the underlying limestone.

At SN 907 138 turn tight right and follow the wide vehicle track back down to the river and eventually to a bridge, Pont Cwm Pwll-y-rhyd. Depending on the level of recent rainfall, the riverbed below the bridge may be dry or it may have more or less of a river flowing across it. Cross the bridge and then turn right over a small stile to follow a muddy track back south along the eastern side of the river. A cave entrance is seen immediately on the left. Some nine kilometres of known cave passages can be explored under the Nedd Fechan riverbed, but only by experienced cavers (who use an entrance north of the bridge).

A short distance further on, the path moves right down to a riverside rock face to pass a pool where the river disappears in dry weather (if indeed it gets this far). You may have to go higher up the valley side to pass this point in wet weather.

Further on, if there is no water in the riverbed you may want to go and peer down (with care) into the sink hole of Pwll-y-rhyd (the pool of the ford) at grid reference SN 911 137. There is little indication of what is ahead as you approach the sink hole until, quite close to it, the riverbed, which has been fairly gently sloped, starts to dip downwards. Eventually you can peer down into the sink hole proper. A pool of water in the base of the sink hole hides the fact that water seeps underground on its western side at the base. The layering and jointing of the limestone rocks have obviously influenced the way the sink hole is shaped, giving it its rectangular form and fairly regular sides. The layering provides for a small platform that extends around the eastern end of the hole, just above the pool itself (see Photo w6.4).

However, if the river is flowing you have to go high up above the valley side to get above and beyond the sink hole. Once well beyond it you can then drop down to an abandoned gorge. You can get some good views of the river raging and tumbling into the sink hole from a viewpoint at the northern end of the dry gorge (Photo w6.5). To see the river thundering into the sink hole and disappearing a few metres below you is one of the highlights of the natural karst scenery of South Wales. Once the river would, of course, have flowed where you are standing and it would have been a suicidal spot to stand when the river was in flood. When you've seen enough of the waterfall follow the narrow, dry gorge (see Photo w6.6) to the point where the river reappears (except in very dry weather) at SN 911 136, known as White Lady Cave.

The water that pours into the sink hole at Pwll-y-rhyd in flood conditions is the same as the water that resurfaces here at White Lady Cave, as a small subsidiary cave system runs

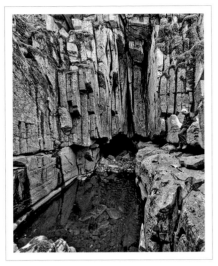

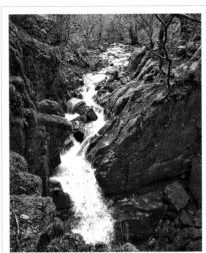

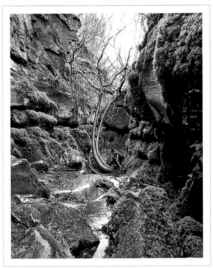

Photo w6.4 (top left) │ The sink hole at Pwll-y-rhyd in dry weather; in flood a waterfall drains the river across where the figure is seen, centre right.

Photo w6.5 (top right) │ The Afon Nedd in flood, seen from the dry gorge; the river is pouring down a waterfall just where the figure is seen in Photo w6.4 in dry weather.

Photo w6.6 (right) │ The now dry gorge that was once the riverbed of the Nedd Fechan.

between these two points. The main cave system, which drains the water that leaves the surface further north (near and beyond the bridge) is directed into a complex system that diverts some distance east before resurfacing at Pwll Du.

Return along the narrow gorge and then riverbed (see Photo w6.7) or if necessary the riverside path, back to the bridge at Pont Cwm Pwll-y-rhyd, then follow the tarmac up to a road junction, where you turn left and follow the road to a bridleway at SN 912 141.

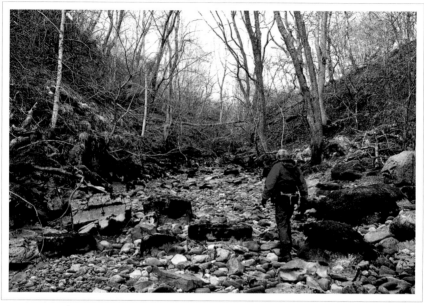

Photo w6.7 | The dry weather riverbed of Afon Nedd Fechan just north of Pwll-y-rhyd.

Follow the bridleway south-east through fields, then more easterly across open limestone country to SN 920 138 where you turn right (south) onto a track. Note en route the sink holes in the land around you, and the odd limestone outcrops forming low ridges, with some limited limestone pavements. Note too the north/south oriented shallow dry valleys running through the limestone moorland. The main cave system of the Nedd Fechan river (draining river water entering the system north of, and near, the bridge at Pont Cwm Pwll-y-rhyd, but not at Pwll-y-rhyd itself) lies below these dry valleys, and it is quite possible that the Nedd Fechan itself once flowed on the surface in these dry valleys (during periods of the ice age when the surface was frozen and rainwater could not penetrate into the caves). The cave system developed later, when freezing conditions eased, and the river itself was diverted into the present course of the Nedd Fechan which lies along a fault.

From the track junction at SN 920 138, follow the minor road back to the car park at Porth yr Ogof. If you have parked at Ystradfellte, do not turn right at SN 920 138, but carry on eastwards to a junction of paths at SN 924 138 where you bear south-east to the village.

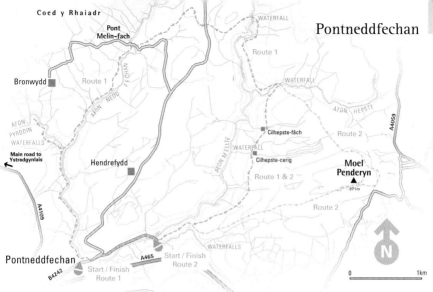

Coed y Rhaiadr

Pont Melin–fach

WATERFALL

Pontneddfechan

7

Route 1

Bronwydd Route 1 AFON NEDD AFON FECHAN

WATERFALL

AFON HEPSTE A4059

AFON PYRDDIN WATERFALLS

Cilhepste-fâch Route 2

Main road to Ystradgynlais

Hendrefydd AFON MELLTE WATERFALL

Cilhepste-cerig

Moel Penderyn ▲ 371m

A4109 Route 1 & 2 Route 2

Pontneddfechan WATERFALLS

A465 Start / Finish Route 2

B4242 Start / Finish Route 1

↑ N

0 1km

Walk #7 – Pontneddfechan

START	▶	PART 1 SN 9008 0764
START	▶	PART 2 SN 9110 0790
FINISH	●	CIRCULAR ROUTE
TIME	☻	4 HOURS PLUS
GRADE	⊙	NAVIGATION ● ● ●
	⌂	TERRAIN ● ● ● ●
	⊗	SEVERITY ● ● ● ●

The village of Pontneddfechan (bridge over the Neath minor) in the upper Neath valley is the gateway to some of South Wales's most cherished scenery. This is Wales's renowned 'Waterfall Country', famed for the variety and beauty of the cascades as water tumbles down the fast-flowing rivers: Nedd Fechan, Mellte, Sychryd and Pyrddin. As well as being very pretty, the waterfalls are also interesting geological features.

Pontneddfechan is also a good starting point for a look at the 'Neath Disturbance', the name given by geologists to a significant zone of 'faulting' and associated 'folding'. It runs all the way up from the coast just east of Swansea, right along the

189

Neath Valley and way beyond, reaching even across the border with England. The tectonic movements on this fault have pushed the Carboniferous Limestone out of its regular linear course north of the coalfield and brought a narrow, deeply faulted and folded outcrop down a kilometre or so to the south-west of the main line of the outcrop (see Map 6.1).

There is an information office set up by the Brecon Beacons National Park Authority at Pontneddfechan which is worth a visit. The recommended routes take in several of the most popular waterfalls, as well as visiting some limestone rocks that have been severely folded and faulted at and around Craig y Ddinas.

It is quite feasible to do this walk as a circular route. However, this involves passing behind a waterfall, Sgwd yr Eira. This may present problems in very heavy river flows, and also at times the local authorities have closed the path, declaring the final part of the footpath approach from the Craig y Ddinas/Moel Penderyn direction to be unsafe due to rock falls above the path. To make the walk description useful whether the path under the falls is open or not, I have described two routes each starting and finishing at Pontneddfechan. If you want to follow a circular route, a return route via Craig y Ddinas is also given.

One particularly beautiful waterfall, Scwd Einion Gam is no more than about 200m further on than the very easily reached Sgwd Gwladus, the first waterfall to be seen on the walk, but Scwd Einion Gam is nowhere near as easy to get to. From Sgwd Gwladus it is necessary to ford the river twice or more in order to approach close enough to see the waterfall. This is only practicable in reasonably dry conditions, though that unfortunately is of course when the waterfall is at its least exciting. It is also possible to approach Scwd Einion Gam from the A4109 'Inter Valley Road' using rights of way starting from either SN 8856 0911 or SN 8724 0932 to gain access land on the northern bank of the river. Take care to go beyond the waterfall before attempting to descend to it. The final drop down into the bowl around the waterfall is the toughest part of the route – I recall going this way some several years ago one winter's day when the waterfall turned out to be a stunning frozen icefall.

A 'geo trail' at Cwm Gwrelych is quite close by and you could include it with part of this walk if desired. The walk section around Craig y Ddinas and Moel Penderyn could be altered to a circular route returning via Cwm Gwrelych using footpaths and/ or minor roads that offer underpasses to cross the A465, 'Heads of the Valleys' dual

carriageway. There are information boards and number posts scattered throughout the geo trail with some information about the geology and history. A leaflet is available from the National Park Office at Pontneddfechan giving basic information about the area, but offers limited detail (the geo trail post number 4 is listed in the leaflet as 'Cwm Gwrelych rocks').

Part 1 – Waterfalls walk

Start from the prominent wall advertising the fact that this is Waterfall Country, opposite a public house at SN 9008 0764. An interpretation board with maps and photos is worth consulting; more information can be found in the National Park Information Centre opposite the pub.

Follow the footpath alongside the west bank of Afon Nedd Fechan. There are outcrops of a sandstone known as the 'Farewell Rock' in and around the village. This is now taken as the base of the Coal Measures. It first gained its name when the search for ironstone was underway in the 18th and early 19th centuries. Iron prospectors soon worked out that they would find no more ironstone once they had reached this particular layer of sandstone (or its equivalent in other areas). Later, when ironstone exploitation had ceased, and coal extraction came to dominate, colliers drew the same conclusion, as only very thin coal seams are found below the Farewell Rock. The sandstone, up to 75m thick, forms the impressive outcrops at the start of the walk along the riverside track.

As you walk along the riverbank here you are walking through progressively older rocks, that is those that lie beneath the Coal Measures and which are traditionally known as the Millstone Grit. The rock types are mainly sandstone and shale, which are interlayered. The sandstone outcrops are usually quite obvious, forming crags quite close to the river. The crags show a distinct tilt or dip. The shale outcrops are more difficult to see as, although they cover a greater area than the sandstone, they are typically covered by vegetation. The shale is best seen as cuttings in the riverbanks and where side rivers join the main flow.

The sandstone is more resistant than the shale, so when the river flows across a boundary between these two rock types it will begin to cut down more easily into the shale, thus producing a waterfall. The sandstone collapses when the underlying shale has cut back behind and below the sandstone until an overhang can no longer be supported.

Pontneddfechan

Faults often play a role too, by shoving sandstone and shale next to one another in unexpected places. The upper and lower Sgwd Clun-gwyn and Scwd Einion Gam falls are all located on the line of faults.

The rivers draining from north on the Old Red Sandstone and Carboniferous Limestone pass onto Millstone Grit quartzites and then onto Millstone Grit shales and create waterfalls. Further falls occur at junctions between shale and sandstone layers in the upper parts of the Millstone Grit.

Continue along the path to the junction of the Nedd Fechan with Afon Pyrddin about 1.5km from the starting point. Ignore the footbridge that crosses the river to stay with the Nedd Fechan. We will return to the bridge soon, but first walk further along the west bank of what is now the Pyrddin for about 150m to the first waterfall of the day, Sgwd Gwladus. This fine waterfall occurs here because a bed of sandstone (known as the Twelve Foot Sandstone) crosses the river with softer shales downstream. The overhanging sandstone is quite easily seen, formed from a series of beds which arc across the river. The shale is harder to see as there is much vegetation, but it is clearly cut back below the sandstone.

There is another extremely atmospheric waterfall just a short distance further up the Afon Pyrddin, Scwd Einion Gam. The Welsh word 'gam' means twisted or bent and Einion's

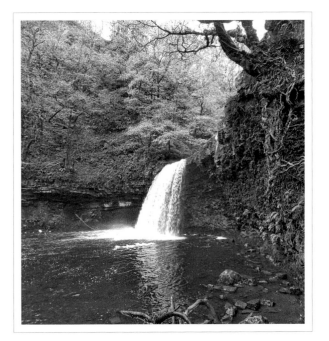

Photo w7.1
Sgwd Gwladus; the overhanging layers of sandstone can be seen forming the lip across the middle of the photo, with softer shale undercut beneath the sandstone.

waterfall does indeed have a distinct twist in its course halfway down the fall. Perhaps this site gains part of its enchantment from its remoteness and lack of visitors, or perhaps it is the wide gorge-like amphitheatre which surrounds the waterfall, but Scwd Einion Gam is one of the most atmospheric of the Pontneddfechan waterfalls (see Photo 9.9). The sandstone exposed at Scwd Einion Gam is the Farewell Rock, which marks the base of the Coal Measures. However, Scwd Einion Gam is hard to access requiring several fordings of the river.

At Sgwd Gwladus decide whether to use the stepping stones to cross the river or to return to the footbridge encountered earlier, and then head northwards to follow the west bank of the Afon Nedd Fechan, passing a series of waterfalls, the first being the 'horseshoe falls' and the lower Scwd Ddwli (see Photos w7.2 and w7.3). Further upstream you reach the upper Ddwli falls.

On reaching Pont Melin-fach it is necessary to decide whether to return the way you have come, or to use the public footpaths passing close to Glyn-mercher-uchaf and He-ol-fawr, SN 915 109, to reach the road at SN 918 109, then turn right and take next footpath on the left to the footbridge near the upper Clun-gwyn falls on the Afon Mellte at about SN 924 111. Cross the river and continue downstream on the eastern side of the Mellte to pass the upper Clun-gwyn falls (see Walk 6), lower Clun-gwyn falls and Sgŵd y Pannwr falls and others before arriving at the cove containing Sgwd yr Eira, 'the snow falls' (see Photo w7.4).

Pass under the waterfall and follow the bridleway via Cilhepste-fach and Cilhepste-cerig to Pontneddfechan at Craig y Ddinas. When you approach Craig y Ddinas you will have to decide whether you want to take a short diversion to see the silica mine entrances or not. At Craig y Ddinas itself you will also have to decide whether to take another short diversion to see the Bwa Maen anticline. From Craig y Ddinas, use the bridleway on the south side of the river as far as the footbridge at SN 906 078 then follow the road back to the starting point.

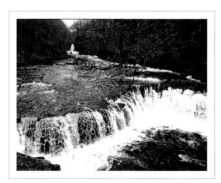
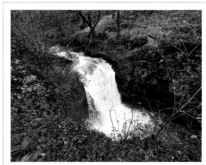

Photos w7.2 & w7.3 │ Waterfalls on the Nedd Fechan.

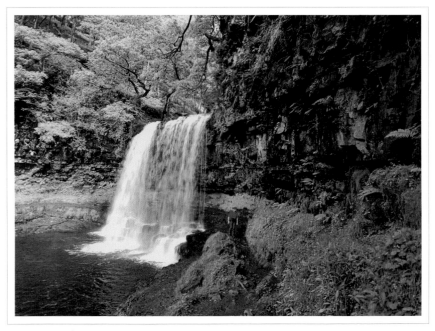

Photo w7.4 | Sgwd yr Eira (the snow falls); the route passes
underneath the overhanging sandstone layers.

Part 2 – Craig y Ddinas and Moel Penderyn walk

Start from the car park at the eastern end of the road through Pontneddfechan at SN 911 079.
The car park leads directly onto the impressive, tilted limestone crags of Craig y Ddinas (Dinas
Rock). Useful maps and display boards help with orientation. The rock face of Craig y Ddinas
is made up of limestone which has been severely tilted upwards so that it is now only just
short of vertical (see Photo w7.5).

From the car park take the signposted 'all abilities' track to Bwa Maen, following the
gorge through which runs the Afon Sychryd, with impressive rock outcrops in the limestone,
cave entrances (helpfully identified by 'no entry to caves' notices) and waterfalls. The high-
light of this section of the walk is the folding to be seen at the head of the accessible part of
the gorge – see Photo w7.6.

The area was subject to intense pressure from the collision of continental plates a
few hundreds of million years ago which caused this and other folds in the area. The great

Photo w7.5 | Craig y Ddinas tilted limestone beds.

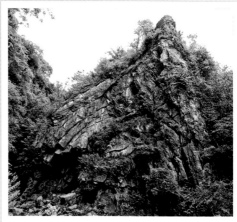

Photo w7.6 | Bwa Maen anticlinal fold.

pressures also created a major fault (or reactivated a pre-existing fault) with the result that the rocks on the northern side of Afon Sychryd moved upwards relative to those on the southern side. The fault is part of the major 'Neath Disturbance', one of the key structural features of the coalfield and Millstone Grit areas of South Wales.

From here the gorge narrows into a waterfall that is impassable on foot, so it is necessary to turn round and return to the car park.

From the car park take the track which rises up to the left of Craig y Ddinas. The outcrops of limestone in the first section of the track are awkward when dry and slippery when wet, so the local authority has erected a handrail here (and in a couple of places further on near the silica mine). Once you have climbed to the crest of the rock, follow the footpath until it splits and take the right-hand side path down steep steps to the old silica mine. Keep an eye out for the entrances to the mine, off to the left of the path (seen clearly in a photo dating from the mid-1990s (Photo w7.7), before vegetation growth had largely hidden the entrances from view).

The silica mine exploited the very high level of quartz found in the Millstone Grit quartz-ites. A band of very high quality pure, fine-grained quartzite about four metres thick was the object of the workings. It was used to make 'fire bricks' for use in metal smelting furnaces as it could withstand high temperatures before melting. Quartz unites silicon and oxygen molecules in a very tight bond (as silicon dioxide) and is resistant to physical and chemical weathering. Quartzite is a rock with a very high proportion of silica/quartz and can be produced by metamorphism or as sedimentary rocks with very pure quartz sandstone, as is the case here.

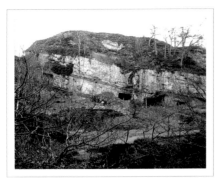

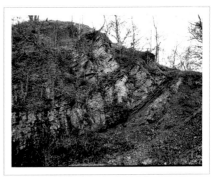

Photo w7.7 | Silica mine entrances near Craig y Ddinas; mid-1990s.

Photo w7.8 | A 'monocline' in the Millstone Grit rocks near Craig y Ddinas.

It is highly inadvisable to enter the mines as there is a real danger of rock fall. Hardy, or foolhardy, people have entered them in the past and it makes sense to leave it to their photos to give us an idea of what the mine looks like from inside (see Photo 4.11).

An interesting outcrop of mixed sandstone and shale can be seen on the left as you descend past the mine entrances. Another mine entrance is seen by crossing the river on a footbridge. Although it is hard to see given the vegetation, these hills are well folded, such as the 'monocline' shown in Photo w7.8 which was taken in the mid-1990s.

Return across the river and reascend the same way as you came down, then resume your route along the bridleway at the top of the ridge. Keep on the bridleway to ascend Moel Penderyn, a limestone hill. From the summit cross access land to pick up the track at about SN 9379 0918. Follow the obvious track on the ground (rather than trying to follow green rights of way shown on the OS 1:25,000 map) to the top of the footpath above Sgwd yr Eira.

Here you can drop down to the cove enclosing one of the most enchanting waterfalls in Wales (see Photo w7.4), but this section of the way is sometimes closed because of rock fall. It is also possible, with care, to cross the river underneath the falls, depending on the strength of the water flow. To return follow the bridleway via Cilhepste-fach and Cilhepste-cerig back to Craig y Ddinas, or follow in reverse the directions for the waterfalls walk given above for a circular walk.

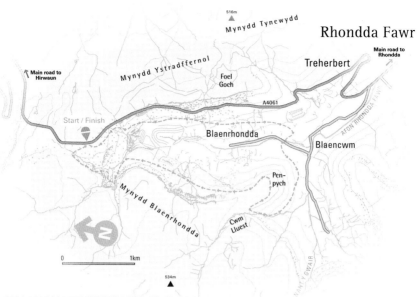

Walk #8 – Rhondda Fawr

START	▶	SN 923 020
FINISH	●	SN 923 020
TIME	◔	5 HOURS PLUS
GRADE	◑	NAVIGATION ● ● ● ●
	☁	TERRAIN ● ● ● ●
	❸	SEVERITY ● ● ● ●

The Rhondda is one of those names inextricably linked with the extraction of coal from the South Wales valleys. There are in fact two Rhondda valleys and two Rhondda rivers; Rhondda Fawr and Rhondda Fach. The slightly longer Rhondda Fawr rises a couple of kilometres above Treherbet and this walk takes a circular route around the head of this valley.

The two Rhondda valleys meet at Porth, some ten kilometres to the south-east. Just five kilometres further on, at Pontrypridd, the single Rhondda river joins with the Taff and other rivers draining the central coalfield area and which converge on Cardiff and the coast.

Rhondda Fawr

From the mid-19th century these previously fairly quiet valleys were rapidly invaded by prospectors seeking coal. The geology of the area is part of what geologists have traditionally called the upper Coal Measures, which offer only thin coal seams interlaid between thick layers of sandstone. However, the more productive lower Coal Measures come close to the surface below the valley floor and deep mines have been dug down to intercept the rich seams to be found there. The area has also been severely affected by earth movements and is heavily faulted, so coal seams seldom run for any continuous length before shifting location.

The result is that the hillsides and the valleys are littered with remains of deep mines. The 'steam' coal that was dug out, mainly by blood and sweat, was used to power Britain's industrial trains and ships in the later part of the industrial era. Names such as Tonypandy in Rhondda Fawr and Maerdy in Rhondda Fach are redolent of the area's conflict-ridden industrial and cultural history. Settlements are strung out in what geographers call 'ribbon' fashion along the narrow valley floors, and often contain just one or a handful of streets squeezed in with roads, railways, canals and collieries. The coal industry in these valleys started to contract in the 1950s. That process sped up, with devastating consequences, in the rushed de-industrialisation policy of the 1980s and 1990s. Tourism is only just finding its way onto the agenda as one small potential economic alternative.

Certainly, the area has much to offer the hillwalker. A fairly dense road network gives access from the south and the north (using the A465 'Heads of the Valleys' road). There are innumerable paths and tracks. There's plenty of superb scenery to be explored. There's lots of archaeological interest too. For those interested in geology, there's a wealth of fascinating features to be seen.

Not surprisingly perhaps, coal mining is one such geological feature. Perhaps less obvious is the fact that coal mining, despite now being almost entirely an activity of the past, is an important factor in the way the landscape is currently developing. Landslides are a natural occurrence given the geological interlayering of tough sandstone and weak shale, so major landslides around here occurred at the end of the ice age. But the digging and abandoning of mines has speeded up the process of land collapse, and this walk passes two major landslides that have occurred in recent decades, as well as older ones too.

The walk also passes several fine waterfalls – another product of the varying resistance to erosion of the 'layered cake' geology of the valleys. One of those waterfalls

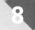

in particular offers a fascinating cross-section of the Pennant Sandstone, and shows how it is made up of river-borne sediments in a complex of shifting channels.

This walk is a 'valleys' mix of industry, ribbon development and semi-tamed moorlands, offering superlative views. It may not be wilderness walking territory, but it is very fine hillwalking terrain and will surprise many who have never before thought of stepping out in the coalfield to find attractive scenery.

The walk is described beginning from a parking area on the A4061 atop Rhigos Common, but it could equally well be started in Treherbert (or more precisely in the parts of Treherbert known as Blaencwm and Blaenrhondda) if using public transport and approaching from the south. However, if possible it is worth starting at the northern end for the immediate and highly impressive view down Rhondda Fawr it offers.

An information board at the parking place (SN 923 020) is worth consulting for details of the prehistoric settlement, remains of which are passed on an early leg of the walk. Cross the road with great care, as you are on the inside of a bend, and then go through the gate, bear left and follow the track through rough vegetation towards the south. The bases of the stone walls of several prehistoric huts are seen very close to the left-hand side of the track.

Shortly after that the views start to open out and you get the first good looks down the upper part of Rhondda Fawr, with Treherbert coming into view as you carry on. After crossing a stream the views open out further, and you get good prospects on the valley side on your left and the topmost part of the valley (see Photo w8.1). The view of the glacial valley, with its flattish plateaux on either side, is characteristic of this region.

Photo w8.1 |

View down the Rhondda Fawr valley from the head of the valley; Fernhill Colliery once occupied the flat area in the centre of the photo.

Rhondda Fawr

The area down in the head of the valley is a mix of natural landscape running up to a human-made area where there once stood Fernhill Colliery (see Photos 6.6, 6.7 which show the view down the valley in the 1960s and in the 2010s). The pit wheel and other workings, as well as old railway lines, have all been removed and the area extensively 'landscaped'. Looking closely you can see that the young river Rhondda Fawr disappears underneath the landscaping, which crosses the entire valley lower down. In fact the river runs in several sections of tunnel under various landscaped areas almost all the way down to the first houses in Blaenrhondda.

The sandstone plateau into which the valley had been incised is evident in the crags which mark the valley on both sides. On the right (western) side as you look down the valley there is a clear line of crags with a sloping apron of vegetation-covered scree below (see Photo w8.1). This scree has clearly fallen off the crags as a result of freeze-thaw mechanisms working to prise open the rock in any cracks of 'joints'. The extent of post-glacial rockfall can be judged from the height and extent of the vegetation-covered scree slopes.

On the left (eastern) side of the valley the rocks have undergone a more devastating collapse. A great mass of the rock has sheared off in a single event after the end of the ice age and collapsed down the slope. The fallen mass of rock didn't break up immediately into a mass of small fragments. Certainly it produced lots of individual boulders, but it also broke into large blocks that retained their coherence. The result is a much more broken, 'hummocky' terrain than the more uniform slopes on the western side of the valley. Though the landslide happened after the ice age, it has recently been reactivated in places by the building of the modern road which cuts right through the landslide area.

The road was first constructed in 1929 – until then wheeled traffic could go no further north than Blaenrhondda and foot traffic used the track you are following. A period of unusually heavy rain and a landslide occurred only a week after the road was finished, leading to the flow of superficial material undermining the road. Embankments and retaining walls were built to control the flow, but only added more complexity to the shape of the slope.

In the intervening years the roads authority has had to cope with both rockfalls and repeated slipping of the road foundations, which rest on old landslide deposits and on material which is still in (very slow) motion. The road cuttings were subject to constant rockfall and two watchmen were employed on 12-hour shifts to keep the road clear. They were only made redundant in 1989 when the present netting was installed. However, problems with slipping persist, and the road has often required repair and has occasionally had to be closed. Road repair staff were shovelling rubble over the roadside barrier when I last walked down here.

The most problematic section of the road is where it passes over the rear scarp slope of

the ancient 'rotational' slide. Tough Pennant Sandstone slid down on a 'failure surface' where it rested on weaker shale rocks.

There are plenty of different paths once you've gone through the hummocky slide area, and it takes a little care to follow the public right of way down to Blaenrhondda, though if you do go wrong it should be fairly easy to locate the village. When you reach the village, follow roads and then a footpath down to the new school building and across the river. Turn right at the T junction and then take the first left. Turn right when the road bends and pick up a footpath after about 200 metres on the left (at about SS 926 995). Turn sharp left onto the footpath which makes its way quite gently up the hillside.

The track then starts to climb more steeply as it enters the short valley of Cwm Lluest. After a stiff climb you approach a two-stage waterfall. If you want you can get down to the first stage of the first waterfall by leaving the path to the left at a safe point. Return to the path and rise up steps to the second waterfall and its impressive and fearsomely overhanging rock face that is well over 20m high (see Photo w8.2).

The sandstones display sedimentary structures such as cross-bedding, eroded base contacts and deposits of ironstone, quartz pebbles and 'reworked' (i.e. eroded) coal lumps. The cross-bedded sandstones are interbedded with sandstones that have irregular 'rafts' of coal and plant fossils. The beds have clearly been laid down by shifting river channels and some of the channels are identifiable.

Huge blocks of sandstone have been displaced from the main face, and fallen to collect in a mad jumble all around the base of the waterfall and rock face. The blocks contain large concentrations of plant fossil material (see Photo w8.3), including *Lepidodendron*, *Calamites* and *Sigillaria*. These rich concentrations of plant fossils are referred to as 'log-jams'.

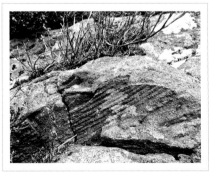

Photo w8.2 | Pennant Sandstone exposed in a rock face.

Photo w8.3 | Plant fossil from the Upper Coal Measures.

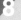

When you've soaked up enough of the atmosphere and detail of the rock face, follow the track further up onto the plateau, Pen-pych. When the route reaches the top look out for a minor track on the right which leads you along the very edge of the plateau, with increasingly superb views of the valley and the hills.

As you walk along this edge you'll no doubt be distracted by the panoramic views. Take a moment to look across directly south to the hillside in the side valley above the village of Blaencwm and the rough, hummocky land. This rather bleak and desolate slope hides a dramatic story. Clearly a lot of this slope is human-made with mine workings spread about and waste tips covering much of the slope. This is not all, however, and there is also a major landslide area here (see Photo w8.4 and accompanying diagram).

The slide site is complex with three major slide blocks and plenty of hummocky terrain. The first part of the slide took place in 1947, but the latest episode occurred in 1989 and in-volved about 750,000 cubic metres of rock, and a 50m wide chasm, still visible today, appeared.

The geology is common to the area with the Pennant Sandstone (Rhondda Beds) lying on top of the 'Lynfi Beds' which consist of weak shale (or mudstone) as well as 'seatearth' and coal seams, including the 'No. 2 Rhondda Seam' which was extensively mined and, crucially, lies at the base of the sandstone scarp slope (see Chapter 5).

Two collieries, Glenrhondda and Tydraw, were both closed in the 1960s and there are several large tips of waste from their workings dumped around the area, some of which have experienced landslips themselves, resulting in 'landscaping' works. All this makes the hillside rather difficult to disentangle, but the slide is seen above the settlement of Blaencwm with tips on either side.

The rock strata tilt at a very gentle angle indeed (just four degrees) but different strata have different levels of permeability. The seatearths (which are found at the base of coal seams) do not allow water to seep through them, although the strata can be affected by faults and mining operations which open up new drainage possibilities for water to seek out. The prob-lems occur around these weak rock strata at the base of the sandstone, causing large landslides. The process would have been aided by the presence of a 'graben' or trench caused by 'lateral extension' or expansion of the sandstone due to the weaker, underlying rocks (see Chapter 9).

The overlying sandstone is affected by nearly vertical joints that are several metres long and occur roughly every 1–3 metres. The presence of the breaks in the sandstone beds and of the near-vertical joints (oriented at about 120 degrees, i.e. north-west to south-east) mean that individual blocks of sandstone within the main slide can break off and start to slide downwards.

So, within the great mass of sandstone, 'sheets' of sandstone a few metres long and a couple of metres wide have broken off and slid down on failure surfaces which are even more

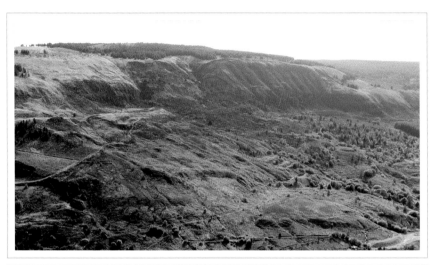

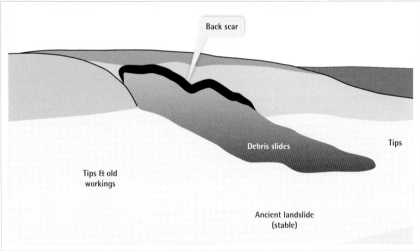

Photo w8.4 & Diagram w8.1 | The Blaencwm landslide is visible in the upper
centre of the photo, surrounded by a complex set of mine waste areas.

gently-angled than the underlying main landslide failure surface. This complex sliding has
produced a series of upward-facing 'counterscarp slopes'. Below the collapsed blocks there is
a large boulder field or 'debris slide' which runs all the way down to the village. The slide is
still active, with movement of the debris slide area of up to 5 metres a year, and 1 or 2 metres
a year in the collapsed blocks area.

Carry further along the edge, following the narrow path around the edge of the plateau. Look out for the end of the ridge on the western side of the main Rhondda valley as it comes increasingly into view. There are signs of 'extension' and breaking up of the Pennant Sandstone plateau at its edges. The signs are scars or trenches that run across the two ridge ends (see Photo 9.11). Horizontal extension of the sandstone is a common feature around here and occurs because the tough sandstone is underlain by softer shales. After supporting ice in the valleys melted at the end of the ice age, and as the shales give way, the sandstone is stretched and begins to separate along vertical joints in the rock. Near the edge of a plateau these joints can develop into fissures or trenches, known to geologists by the German term, 'graben', for a trench or channel.

Continue along the edge to the flagpole for excellent views down Rhondda Fawr and its 'ribbon' development. The terrain is rather rough from here, so to go beyond Pen-pych it's best to struggle over the tufts to get back onto the wider track which bears north a short distance from the edge of the plateau. You get a good overview from this part of the route of the landslide that affects the road on the eastern side of the valley.

Alas this section of the walk with its excellent views is all too short and at about SS 919 099 you have to leave the plateau and descend a forest track to the valley floor. It may look tempting to continue high up, but to do so leads to very rough, damp terrain and the need to cross three streams without the aid of bridges – something which may be quite impracticable in wet conditions.

Instead, start heading downwards on a wide, muddy forest track for some distance and then, after about 600m, take the first turning on the left, rising back up a short way before the track levels off and carries along the valley side, passing some way above the landscaped site of the old Fernhill colliery.

After crossing the stream on a footbridge, you stand at the bottom of another landslide, Garreg Lwyd. Like the landslide at Blaencwm seen earlier on, this one is unusual in having experienced toppling of individual blocks within a large slumped rock unit. The back scarp is at the top of the fall with a mass of boulders below and hummocky terrain at the foot of the debris slide (see Photo 9.12).

Follow the track towards a waterfall and some old ruined waterworks, then head north before picking up a path which rises up the eastern side of the valley head to reach the car park and starting point.

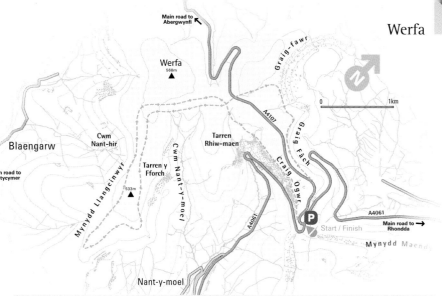

Walk #9 – Werfa

START	▶	SS 939 946
FINISH	●	SS 939 946
TIME	◔	4 HOURS PLUS
GRADE	◉	NAVIGATION ● ● ● ● ●
	☁	TERRAIN ● ● ● ●
	✪	SEVERITY ● ● ● ●

Werfa is a rather undistinguished, if pretty typical, South Wales coalfield uplands scene – a rough moorland, often quite boggy in places, which sits at the centre of a cluster of valley heads. There are far-ranging views across the heart of the coalfield plateau, but only a few rock outcrops of the Pennant Sandstone break through the vegetation. So, seemingly this is an unlikely place for a geology walk. However, there are certainly some quite remarkable geological and geomorphological features to be seen.

The walk starts off by looking at two impressive glacial cwms carved right into the uplands just off the well-populated Rhondda Fawr valley (a third glacial cwm lies a bit further north out of sight here but overlooking the Rhondda Fawr valley at

Tarren Saerbren). The glacial cwms show how, at particular stages in the ice age, small local glaciers existed in this area. However, the main purpose of this walk is to look at some features of post-glacial times – landslides, graben, fissures, 'counterscarps' and other features which provide ample evidence that since the glaciers have melted the great sandstone uplands have started to literally fall apart (see Chapter 9).

Two particularly striking linear banks are encountered, which look for all the world as if they might be the human-made leftovers of ancient earthworks, or perhaps even the remains of more modern mining. The banks can be up to four metres high and run for hundreds of metres across the area. One of them, named the Table-land Fault, actually extends as a noticeable feature on the ground for 3.5km. It cuts across valleys and ridges between valleys ('interfluves') alike, regardless of the terrain, and thus obviously represents a deep break in the rocks. The embankment is pulling away downhill, while on the uphill side there is a zone of fissures. The other major embankment to be seen runs along the top of Werfa for about 2km and is obviously a line on which the land is pulling apart, as shown by the fissures at its base. Further banks, and graben or rift valleys, are also seen on the walk.

The narrow fissures can be a severe hazard. While most are easily visible, they may have narrow, hidden sections (especially when the bracken is profuse) and can be many metres deep (see page 125). I have twice fallen into hidden holes in the ground in the fissure zones, once here and once near Craig y Llyn, both times admittedly while concentrating on taking photos. On both occasions it would have been easy to have fallen in such a way as to break a leg or ankle, so tread with very great caution in the areas where fissures are found on this walk.

Werfa is a large, rounded summit and the geography of the area can be a bit confusing given the number of valleys and ridges that run away from the highest point. The presence of two telecoms masts at the highest point can be a useful navigational aid.

From the lay-by and bus stop at the starting point, enjoy views over the lower part of the Cwmparc valley and village. Note the layering on the hillside on the right, under Mynydd Maendy (see Photo 6.3). This is a reflection of the geology with different rock strata leading to 'shelving' or 'benching', where slightly less resistant rocks have been eroded, and steeper sections where more resistant rocks reach the surface.

Cross the road, listening as well as looking out for speeding traffic, and use a set of steps to climb up to an upper, now disused, car park. From the disused car park follow the edge of the A4107 road northwards. After a few hundred metres the road and the valley head start to diverge. Bear right to look over the edge of Graig Fâch, viewing the first of two glacial cwms, this one being the smaller of the two, as the 'fach' name suggests. It's worth carrying on around the edge of Graig Fâch, losing a little bit of height and crossing a stream to get a view of Graig-fawr (see Photo 8.4), the second and larger of the two cwms.

At intermediate times in the ice age, when it was not cold enough for very large ice sheets or valley glaciers to form, glaciers would have existed within these hollows, running for some short distance down the valley below.

Don't go far along Graig-fawr, but instead turn away from the edge and head roughly in the direction of the telecoms masts, aiming to meet the A4107 road at about SS 9215 9518, where the road dips and then turns north. Cross the road and walk along a concrete-tracked bridleway, again heading towards the two telecoms masts. Keep an eye out to the hillsides, Tarren y Fforch, on your left, above Cwm Nant-y-moel. On the middle distant slope you can see a line running diagonally across the hillside (see Photo w9.1 and accompanying diagram). This is a 'counterscarp' bank that marks a break in the underlying rocks.

On the next spur you can also make out a graben, a wide, shallow trench-like feature with a lower counterscarp and a wide flat area leading up to a higher bank. You can see this feature from above later on, and you can descend then for a closer look if you want. Both these features are examples of 'lateral displacement' of the Pennant Sandstone in post-glacial times. There may have been shallow valleys here in pre-glacial times, but during the ice age those valleys were cut deep into the sandstone. When the ice melted the valley sides were no longer supported by the ice and began to slip and slide under their own weight. As the rocks relaxed, natural joints opened up and the rocks began to pull apart creating such features.

The process is aided by the presence of relatively softer rocks, such as shale and coal, nearer the valley floors. These provide a weak and easily-eroded basement on which the more resistant sandstone rests. The shales are also impermeable, and rainwater which permeates through pores and joints in the sandstone starts to drain laterally along shale when it meets it. This can provide a slip plane on which the lateral extension of the sandstone can take place.

Leave the track after about 150m and follow the bridleway towards the crest of the broad ridge, leaving it to reach the indistinct tumulus marked on the OS 1:25,000 map at SS 9130 9415. When you leave the track and start to cross rough ground to reach the tumulus area, take care to look out for hidden fissures and holes in the ground.

Werfa

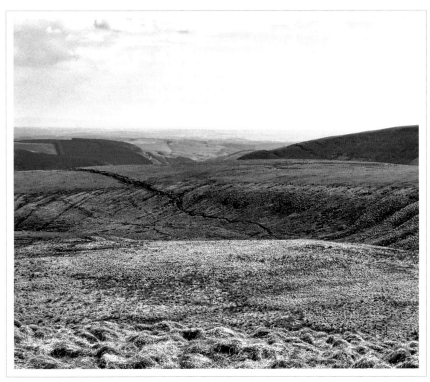

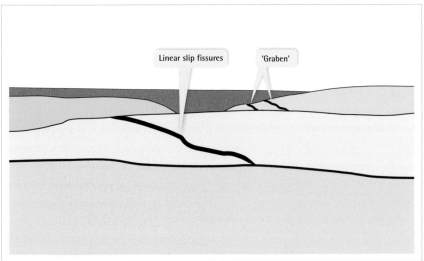

Photo w9.1 & Diagram w9.1 │ 'Lateral extension' features on the moorland, Werfa.

When you reach the high point, look for a low bank which starts to appear just to the right and then runs south along the ridge. Head towards the bank, which has all the appearance at first glance of a medieval dyke or embankment (see Photo w9.2). However, as you reach the bank you notice a number of characteristics which distinguish it from human-made versions. For a start there is no sign of a ditch beside the bank from where the soil making the bank would have been dug. Instead there are obvious fissures which clearly go quite deeply into the ground. On its eastern side the ground just runs straight up to the fissures and the bank. On the west side of the bank the ground runs on without indication of any digging or the like.

Looking south you can see that the bank runs in an almost continuous line off into the distance for a kilometre or more. You can see the feature going out of sight and reappearing further on. A muddy track runs on the right side of the bank. The bank is not straight, often curving slightly. You may also notice that it is not entirely continuous. In at least one place the bank dies out and is replaced by another bank starting a few metres east. Again these are signs of a natural feature, and mimic the ways in which faults occur in the rocks.

Follow the bank south for about 500m until you are level with the Cwm Nant-hir valley on the western (right) side. On the right side of the valley you can see another bank running across the ridge line. This is a notable fault running through the Pennant Sandstone known as the Tableland Fault.

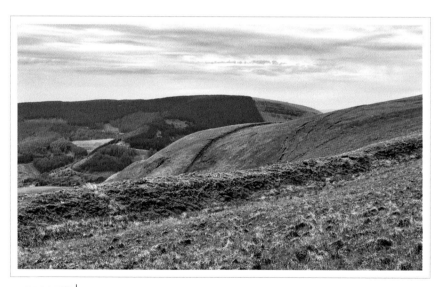

Photo w9.2 | 'Counterscarp' bank, Werfa, in the foreground; Tableland Fault counterscarp is visible as a dark line near the tip of the ridge in the centre of the photo.

Werfa

You'll see more of this feature on the way back, so carry further along the north/south bank heading towards the cairn at Carn-yr-hyrddod (SN 9198 9324) and a nearby trig point a short distance further. Note how the bank is not dead straight, but has sections that are slightly curved and even splits into two in places. A couple of times it even comes to an end and restarts a couple of metres away, but at an offset. From the trig point head roughly south-east for 400m dropping down to see closer up the graben seen in the far distance on Rhiw'r Mynach earlier on.

Head back to the trig point and then back along the bank towards the top of Cwm Nant-hir. You can see the first bank running up the ridge and the Tableland Fault off to the left. Note the dark patches between these two linear features. These are fissures indicating that the sandstone is extending laterally across all these features.

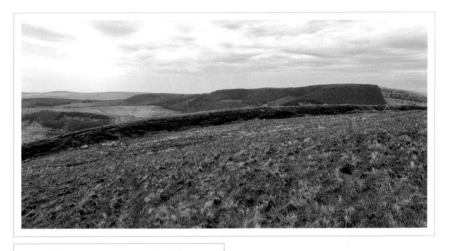

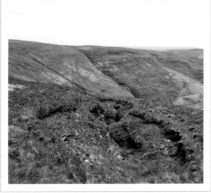

Photo w9.3 (above) | Approaching the Tableland Fault counterscarp.

Photo w9.4 (left) | Fissures in the foreground near the counterscarp; continuation of fault on far side of valley (see text).

Aim for the Tableland Fault counterscarp (see Photo w9.3) at SS 9104 9383 (where it is crossed by a right of way) by traversing across from the north/south bank. A landslide, Darren Goch, lies below the Tableland Fault near the base of the west-facing slope. The fault can be seen on the far side of the valley to the left, Cwm Nant-hir. This is visible in Photo w9.4 as the slightly dark diagonal line running towards the upper left from near the centre of the photo (and left of a thicker darker line formed by a water cut gully).

On reaching the bank, turn right and follow along either the top or the bottom of the Tableland Fault counterscarp for about 50m, heading north to get views on the head of the valley ahead. The surface expression of the fault can be seen crossing up the far side of the small valley ahead, Cwm Garw, looking like a footpath as shown in Photo w9.5 and the accompanying diagram.

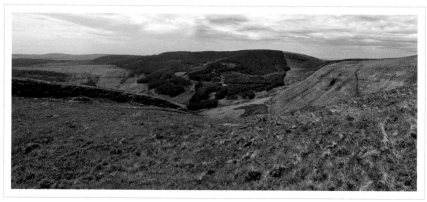

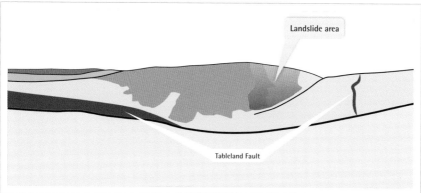

Landslide area

Tableland Fault

Photo w9.5 & Diagram w9.2 | The Tableland Fault seen running across the hills towards the distant ridge.

Werfa

Leave the bank when it starts to head down, turn right to head uphill to meet the bridleway and north/south track at about SN 9130 9400. Follow the bridleway back north-west towards and to the right of the telecoms masts. Leave the bridleway (at SS 9195 9500) about 175m before reaching the road, turning right onto a footpath which you follow to the top of the crags, Craig Ogwr, overlooking the head of the Ogwr Fawr valley. Follow the undulating narrow path along the edge of the crags for the best views, or a wider path a bit further back from the edge (and with correspondingly less dramatic views). After a while, pass through a graben cutting north/south across the finger of high land isolated between Craig Ogwr to the south and Graig Fâch to the north.

Continue to head roughly east along the footpath to join the A4107 road opposite the disused parking area and steps down to the start/finish point.

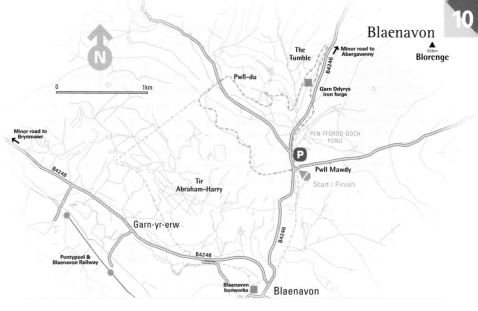

Walk #10 – Blaenavon

START	▶	SO 254 107
FINISH	●	SO 254 107
TIME	☾	4 HOURS PLUS
GRADE	⚙	NAVIGATION ● ● ● ●
	☁	TERRAIN ● ● ● ●
	⊗	SEVERITY ● ● ●

Blaenavon lies in the north-eastern corner of the coalfield at the head of the Afon Lwyd, where the valley loses its shape and blends into the undulating landscape. The lower Coal Measures occupy a large part of the area around the town, to its north, east and south. Beyond this lie the Carboniferous Limestone and Old Red Sandstone, just a short distance away. These rocks were the source of ironstone, coal and limestone from the late 17th century.

This is a landscape that has been deeply modified by human action, and so much of the ground has been dug up and dumped upon that it is often difficult to distinguish the natural from the human-made. This apparently desolate landscape was declared

Blaenavon

a World Heritage Site in the year 2000, being considered "one of the finest surviving examples in the world of a landscape created by coal mining and iron making".

The presence in the area of accessible iron, coal and lime meant that Blaenavon became one of the centres of the early iron and coal industries in South Wales, thanks to early surface and near-surface extraction techniques. The area near Blaenavon is one of the few remaining places where remains of these early surface ironstone and coal extraction activities are still evident on the ground, having escaped being entirely obliterated by later works (though only a small proportion of the original workings of the Blaenavon area survive).

By the middle of the 19th century local sources of iron began to be exhausted, and cheaper, better quality ironstone was imported. Yet coal extraction only grew in importance. In this period, coal was exploited by the iconic deep mines, sunk in the valley floors intending to intersect the rich coal seams of the lower Coal Measures, even where they were covered by the upper Coal Measures (which were dominated by the Pennant Sandstones and enclosed but a few thin coal seams).

Today there is little coal extraction in the immediate area. All the same, the landscape remains essentially an industrial construct. So, whereas most of the walks in this book relate the natural landscape to the geology, this walk is largely about the geology of this intensely human landscape.

A medium-sized protuberance of lower Coal Measures to the north-northwest of the town, named on the OS 1:25,000 map as Tir Abraham-Harry (Abraham Harry's land) and Blaen Pig (pointed breast) is the arena for the recommended walk. It passes by the remains of an old iron foundry, uses a spectacular tramway, trudges over old iron pits and other remains, finally to pass through an area of gross geological devastation. The distant views are superb.

The walk also offers an option to walk into Blaenavon itself. Here the deep mine, conspicuous from its colourful winding wheel, although no longer in operation as a mine, is open as a museum offering underground tours where you can gain some feel for the experience of these grim underground tunnels.

There are also remains of the old Blaenavon iron works in the town. It was opened in 1789 with three blast furnaces initially and six in all by 1860. They were built into the hillside below Tir Abraham-Harry so that iron, coal and lime, which were all extracted from the hill, could all be dumped into the furnaces from above.

The hill is thick with remains of quarries, 'patching' or 'slush' gullies, winding houses, chimneys, pits, 'water balance' lifts, tunnels, tramways and inclines, all associated with extracting and transporting the necessary ingredients to the ironworks. The area is sometimes known as 'Cordell Country' after Alexander Cordell, the author of searing novels about the violent social conflicts between the owners and the workers. Cordell's *Rape of the Fair Country* is essential reading for understanding the history of the area. The scant remnants of the ironworks (most obviously marked by some piles of slag passed early on in this walk) is where Cordell's story was set.

Although the nearby Blaenavon ironworks closed in 1904, large parts of its remains have survived, and it is considered an important site in the history of the industrial revolution. As the recommended walk is comparatively shorter than others in the book, time could be made available if desired to visit the ironworks and/or Big Pit sites as part of the walk. Others may prefer to stomp up to the summit of Blorenge, which is well within reach from the start/finish point, for its views and yet more industrial archaeological remains.

If using public transport, it may make sense to juggle the walk description to start and finish in Blaenavon.

Start at the car parking area near Pen-ffordd-goch Pond, known as the Keeper's Pond. Pen-ffordd-goch translates as 'head of the red road' and the road was originally built in 1835 using a crushed reddish-coloured mix of Old Red Sandstone rocks and waste slag from iron making. From the car park, walk back to the B4246 road and follow alongside it on the vegetated verge heading northwards downhill for nearly a kilometre to Garn Ddyrys, where a footpath heads south-east from grid reference SO 258 118.

Leave the road at this point, but before following the footpath have a look round the area about you just below the road. Garn Ddyrys is the site of an old iron foundry, as featured in Cordell's novel. The Keeper's Pond at the start of the walk was used to provide waterpower for the forge.

Look out for, and head towards, some substantial, knobbly rock outcrops (see Photo w10.1). These are not actually natural rock outcrops but piles of waste slag, the unwanted leftovers from iron smelting that have been dumped here.

Pick up the footpath heading just west of south. It turns out to be a wide track cut into the steep hillside above a rural valley where the Old Red Sandstone lies under the soil. The

Blaenavon

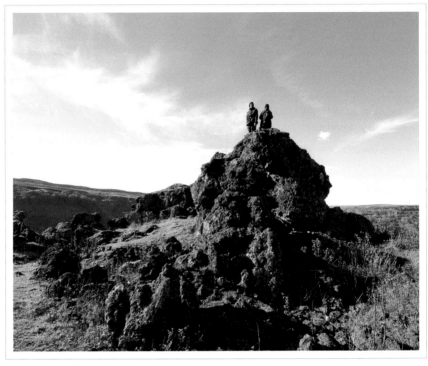

Photo w10.1 | Slag heap at the site of Garn Ddyrys iron foundry.

quarry visible on the far side of the valley is known as Pwll-du (black pit/pool) and is where Carboniferous Limestone was extracted for use in the ironworks. The track, indeed, is an old tramway that served to take ironstone and coal as well as limestone to the Garn Ddyrys forge, and to start its products on their way down to the canal in the valley below. The track runs up to the head of the valley at this level for about 750m before it performs a very sharp turn to head north-west for another 350m or so. Ignore the footpath sign pointing downhill to the right about 100m after the very sharp bend, and keep along the level track until another footpath sign points uphill at about SO 2533 1142, and make note of this point.

Carry on along the level track which swings left and right and passes over a very wet patch. This takes you closer to the Pwll-du quarry face and up to a fence for good views of the limestone quarry. It is possible to get closer still, but the track narrows and becomes risky, so before it gets dodgy turn round and head back the way you came. Once you have gone past the wet section, you can break off right at any point, climbing up through rather rough vegetation, or you can carry on to the footpath sign and follow the path.

Look for the boggy remains of a large reservoir and the banks around it. This was used to store water that drove a balance lift which raised to ground level iron and coal from pits dug into the rock. The weight of the water was greater than that of the material to be raised, so when water was released from the reservoir into the lift it would cause the part of the lift holding the coal and/or iron to rise upward through part of the shaft, and the part holding the water would sink down its part of the shaft. The water was then allowed to drain away from within the pit (perhaps using natural waterways or through specially dug levels).

Follow the footpath towards the abandoned village of Pwll-du where virtually the only remains are the pub and an outdoor pursuits centre. There are also some hard-to-spot signs of where a tunnel entered the hillside around here (just to the west of the road). The tunnel started life as a level dug into the hillside to extract iron, but in about 1815 was extended, and eventually turned into a tunnel about 2km long right through the mountain to above Blaenavon. Horses dragged trams full of materials from one valley to another. Around the middle of the 19th century the tunnel was replaced by engines that hauled the materials over the top of the hill using 'inclines' and winding houses. This was a cheaper solution than maintaining the tunnel.

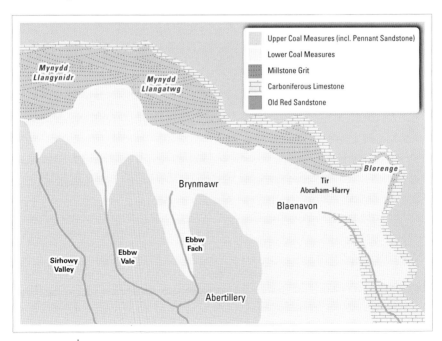

Map w10.1 | Outline geology of the Blaenavon area.

Blaenavon

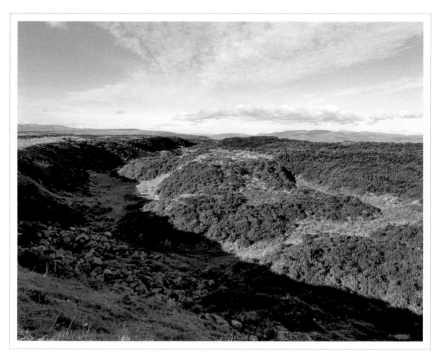

Photo w10.2 │ Hush gullies are remnants of early iron and coal extraction in the area at the outset of the Industrial Revolution.

Join a wide track marking the course of the incline, shown as a bridleway, at SO 2468 1148, and bear left to follow the track uphill to the undistinguished summit area where the remains of the winding engine may be found.

It is possible here to continue downhill, following the incline down towards Blaenavon and possibly to visit the ironworks and Big Pit National Coal Museum. Details of this alternative route are given below.

The summit route stays on the highest land, heading south-east from the winding house ruins at the apex of the incline (at SO 2421 1112), following a wide track towards the shaly waste tips on the skyline.

Watch out for the remnants of early ironstone extraction in the area. Where it was obvious that an iron or a coal seam was hidden under vegetation on a hillside, the technique of 'hushing' was deployed. Water would be gathered in a temporary reservoir and then repeatedly released in sudden flows, with the aim of creating such forceful flows that the vegetation and soil would be scoured away, exposing the underlying iron or coal.

These 'hush' gullies, though now reoccupied by soil and vegetation, have left their mark on the landscape and can still be seen in places (see Photo w10.2). When the hushing had exposed all the surface rocks, shallow 'bell pits' were dug out and adits or levels driven into the hillsides.

Eventually you reach the ugly waste tips from open-cast extraction operations during the Second World War. There is no specific route through this grim and rather raw scar on the surface and you can pick your own way, checking out the different tips and extraction areas (see Photo w10.3). On the slopes of some of the extraction areas you can still see a few strata of sandstone sticking out. There are some blocks of sandstone in the waste tips, but in general the discarded material is fairly finely broken up shale.

The objective is to reach a point overlooking the valley and the Afon Lwyd, looking to the south (see Photo w10.4). It is easy to be drawn to walk to yet one more potential vantage point thus losing some height, but it is worth it for the view over the upper reaches of the valley and its surrounding hills. The valley sides slope down gently from the hilltops, creating a wide shallow valley, unlike the deep, narrow valleys typical of the central parts

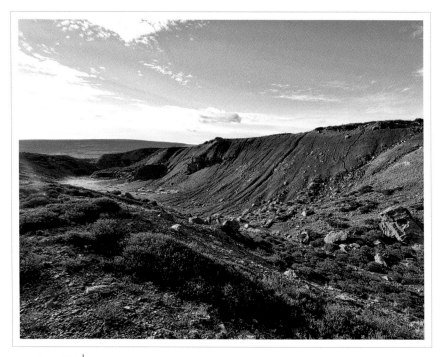

Photo w10.3 | Waste tips from WWII open-cast coal extraction.

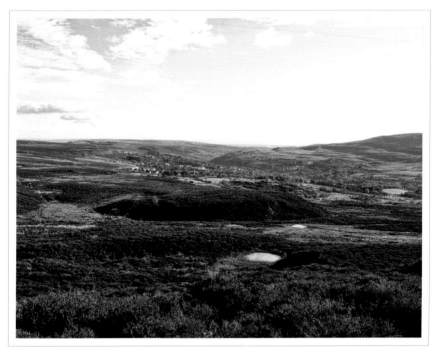

Photo w10.4 | Looking south over Blaenavon and Cwmavon.

of the coalfield. The reason for the difference here is that the lower Coal Measures which form a large part of the scene before you is much less resistant than the tougher Pennant Sandstones of the upper Coal Measures.

The valley clearly does deepen and narrow in the distance. Here the valley floor is based on a finger of Carboniferous Limestone that pushes up the valley from near Abersychan. The limestone is part of a wider outcrop at that point but splits into two north of the town, with one finger pushing up the Afon Lwyd valley and the other going east of the prominence, Mynydd Garnclochdy. This eastern outcrop is bounded to the east by the Old Red Sandstone and together they form the eastern scarp slope that runs northwards towards Abergavenny and beyond, with the limestone marking the tip of the scarp.

On the western side of the valley the gently sloped hillside was carved out of the lower Coal Measures and gave relatively easy surface access to the rich coal seams found in those strata. Therefore this hillside is one that was heavily worked in the early days of the coal and iron industry, and is almost entirely human-made in profile, with numerous levels and tips littering its slopes (see Photo w10.5).

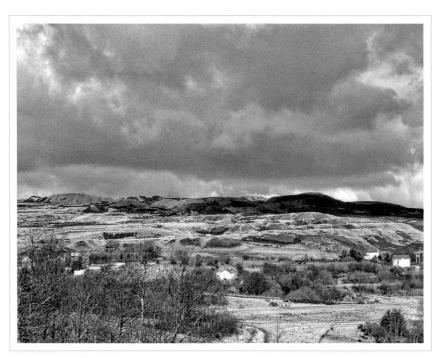

Photo w10.5 | A landscape altered by intense quarrying and mining since the 18th century.

From your vantage point over the valley, turn round and pick a route back towards the Keeper's Pond, aiming to meet the B4246 road at its junction with a minor road at SO 2544 1051. A large part of the land to the east of the B4246 is scarred by early iron patching gullies. Make your way along the east side of the road back to the start/finish point, where you can decide whether to plough on to Blorenge or not.

If you wish to follow the alternative route, follow the incline down from the summit, missing out the open-cast devastation, and carry on to about grid reference SO 2348 1061. Here you turn left and follow the bridleway, passing beneath waste tips from a pit dug to supply coal to the ironworks, to join the road at about SO 2438 0957. Bear left onto the road and then after 50m or so, turn right and pick up a footpath on the left as the road bends right (at SO 2462 0951). After a while this path brings you to an overview of the remains of the ironworks.

At the T junction you can turn right to visit either or both the ironworks and Big Pit (see Photo w10.6), though the latter requires about a kilometre of road walking to the far side of the valley, and another kilometre back. Or, to return to the start/finish point, turn left and

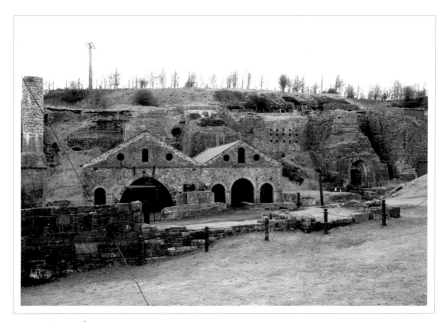

Photo w10.6 | Remains of the Blaenavon ironworks.

then right onto the B4248, and then again left onto the B4246. Walk up the road to pick up a footpath on the right of the road at SO 2525 0944. Follow footpaths east of the road all the way up to the junction of the B4246 with a minor road at SO 2544 1051, then make your way on the west side of the B4246 back to the Keeper's Pond car park. The area on the east of the road from just above the town was heavily used for 'hushing', that is; scouring away the vegetation to expose ironstone and coal on the surface.

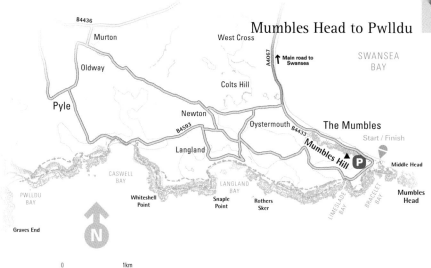

Mumbles Head to Pwlldu

Walk #11 – Mumbles Head to Pwlldu

START	▶	SS 631 873
FINISH	●	SS 631 873
TIME	◔	UP TO 5 HOURS
GRADE	⊙	NAVIGATION ●
	◔	TERRAIN ● ●
	⊗	SEVERITY ● ●

The south Gower coast is one of the scenic gems of Wales. The mix of rocky headland and sandy bay offers delight for all. For those with an interest in hillwalking and geology there is virtually universal access to paths along the rocky coastal outcrops, where the rock layers are tilted into manic angles and carved into an endless of variety of striking architectural forms.

For this book I have selected two walks to sample some of the highlights of the geology of Gower with one walk at each end of the peninsula – Mumbles Head to Pwlldu and Worms Head to Port Eynon (see Walk 12). It would be easy to add a third day's walking between Port Eynon and Pwlldu if you wanted to cover the entire south Gower coast.

Mumbles Head to Pwlldu

The Rhossili walk undoubtedly has the finer sea cliff scenery, but it takes an effort to reach the route, whether by car, bicycle or public transport. Mumbles Head to Pwlldu is a much easier walk to get to, with ready access at both ends by bus, bike or foot from Swansea, as well as by use of car parks. The scenery is not quite so dramatic, but is nonetheless outstanding.

The south Gower coast is an extravaganza of limestone architecture. If you approach Mumbles along the coast from Swansea, you pass the upper Coal Measures which form the hills behind the city centre. Kilvey Hill on the east bank of the Tawe, and Townhill on the west side of the city, are uplands thanks to the tough Pennant Sandstone that forms the greater part of the upper Coal Measures. You then pass into the lower Coal Measures around the university area and around Black Pill, where the Clyne valley, with several once-worked coal seams, meets the coast (see Map w11.1).

Nowadays the old railway lines that ran up Clyne valley are parkland, walking and cycling routes through what was once a thriving industrial area, and you need a keen eye to appreciate the many remnants of the coal industry around here, such as leats and millponds. If you do wander through the Clyne valley, the rocks in the tracks and occasional outcrops, however, give the game away and you can stumble across many lumps of coal, shale and ironstone.

Further along the coast, around West Cross, you pass from the Coal Measures into the Millstone Grit. There are just a few exposures of the Millstone Grit rocks along the coastal path and the outcrop is limited in extent and easily missed. Then, as you approach Mumbles, you reach the Carboniferous Limestone, though it is dark and grimy until you reach the start of the walk at Mumbles Head.

The recommended route between Limeslade Bay and Pwlldu uses the lower level path on the outward journey and upper level paths (where available) on the return. There is only one difficult point on the lower level track, namely a rather big drop next to a narrow bit of the track a short distance west of Caswell Bay. This difficulty can be avoided by using the high level track in both directions. Otherwise, the lower levels tracks are in generally good condition – especially between Limeslade Bay and Langland Bay. The upper tracks vary in quality and can be narrow and muddy in places.

The described route includes crossing the tidal causeway to Middle Head at Mumbles. This must only be done if the tide is well out, and tide times should be

verified before crossing. However, some of the features to be seen in Caswell Bay, such as a syncline and thrust zone, are only visible at low tide. It will not generally be possible to see both ends of the walk at low tide in one day.

Buses call at Mumbles, Limeslade Bay, close to Langland Bay, Caswell Bay and Southgate (a short way beyond Pwlldu Bay). However, the buses to Southgate do not link up with the buses to/from Mumbles, Limeslade, Langland and Caswell, except between Black Pill and Swansea. The paths and car parks will be busy at weekends and in summer. The walk should be avoided in very strong winds.

If the tide permits, cross the first part of the causeway at the very end of Mumbles mainland, using steps found just beyond the pier entrance leading down to a 'wave cut platform'. By crossing to Middle Head and climbing up the prominence you can get a good view of the 'anticline' that runs through Bracelet Bay. Take care climbing up and down Middle Head as the rocks can be slippery when wet. It is a bit of a scramble and will not appeal to everyone.

From the top of Middle Head you can survey the rocks on either side of Bracelet Bay. You can see how the rock strata of Middle Head are tilted from upper right to lower left. The same pattern is continued on the mainland to the left of the pier. The slope running down to the left in front of the concrete wall is a single bed, with other tilted beds on top from the concrete wall going inland. The steeper, rougher slope down to the right is a slice through the bedding which is easily seen. Clearly, also, the inland rocks are a continuation of the rocks you are standing on atop Middle Head.

Look next at the western end of Bracelet Bay (underneath the coastguard building). Here the tilt is not so immediately obvious, but it can be discerned in the strata running from lower left to upper right (visible in the tidal sector only). This is the opposite direction to the tilt we've just seen on the mainland. The reason for this is that Bracelet Bay is situated on the axis of an anticline, or upward fold, of the limestone rocks. Masses of overlying rock have now been eroded away, and once these two ends of the bay would have been joined up with the tilt changing direction to fit both ends (see Photo w11.1 and accompanying diagram). The anticline continues for a couple of kilometres inland.

It is quite common for the rocks in the core of an anticline to be eroded away, as the folding motion that created the anticline, from what were originally horizontally bedded rocks, caused the upper layers to be stretched, and thus to crack. Erosion then worked on these weaknesses and carried away the intervening layers.

Mumbles Head to Pwlldu

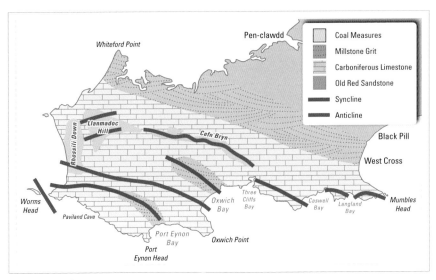

Map w11.1 | Outline geology of Gower.

Descend Middle Head with care. If the tide is favourable you can cross the wave cut platform directly into Bracelet Bay, but if you follow this route take great care on the rocks. Do not attempt to beat an incoming tide – this is no place to be caught by the contrary flows generated around the headlands and bays. Otherwise head back to the steps, climb to the promenade, then take some stone steps, from opposite the pier restaurant, up to the higher level car park (with an apple-shaped ice-cream kiosk).

If the tide rules out a crossing to Middle Head, climb up from opposite the pier restaurant on stone steps to an upper car park (with the apple-shaped ice-cream kiosk) then climb up the slope next to a metal fence to the top of the headland for the view of the bay.

From the apple-shaped shack, enter the main Bracelet Bay car park and go to the coastal path along its southern edge. If the tide permits, drop down onto the beach, turn left and head towards the eastern end of the bay to a small cave. A clear fault line is seen in the rocks here.

If you have come across the wave cut platform from Middle Head into Bracelet Bay you will pass this cave if you keep close to the cliffs.

The cave is located on a fault where the rocks have cracked during tectonic compression (the same compression that caused the anticline seen earlier on from Middle Head). Calcium carbonate leached from the limestone into the fault zone and crystallised into the milky-white coloured 'calcite' seen here. The whiter bands show stretching of the crystals that would have happened during crystallisation as the fault was enlarged (see Photo w11.2).

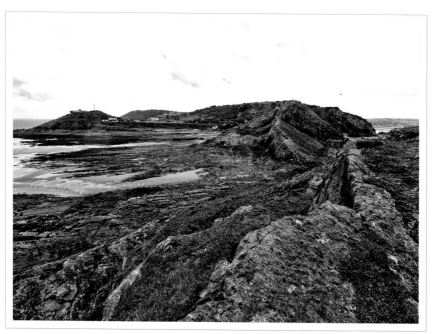

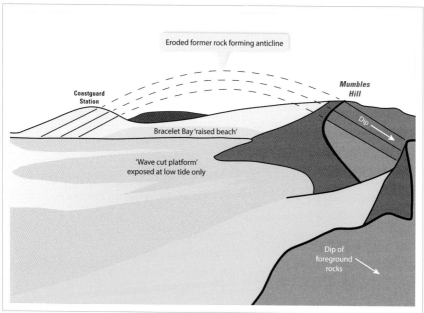

Photo w11.1 & Diagram w11.1 | Bracelet Bay, centre; Mumbles Hill, right; seen from Middle Head.

Mumbles Head to Pwlldu

Photo w11.2 |

Banded calcite formed in a fault in the Carboniferous Limestone, eastern end of Bracelet Bay.

From the cave, head towards the western end of the bay. Either cross the bay on the rock outcrops or follow the narrow track just below the car park level and head towards the restaurant below and to the right of the coastguard building. Pass below the restaurant building then rise up to the restaurant level. A narrow path cuts through dense vegetation to go around the headland some way below the coastguard building. If you have stayed on the car park level you will have to walk through the restaurant grounds to its far end and pick up the narrow path on the same level.

The track initially picks a way through dense vegetation, but as it rounds the headland the terrain opens out and you are at the top of the un-vegetated rocks. Pick a route further round the headland, exploring or not the vegetation-free rock outcrops as you wish. The rock outcrops rise in tilted bands running diagonally across your direction and involve a lot of moving around to find a route. Take great care as the limestone rock is very hard and sharp; it is guaranteed to scrape and to hurt if you trip up.

Keep an eye out for fossil beds that run across these outcrops (see Photo w11.3) and for tension gashes created when the rocks were being folded into the anticline (see Photo w11.4). These gashes have been filled by calcite leaching from the surrounding limestone rock.

Continue round the headland, picking up a track that comes out near the car park exit at the western end of Bracelet Bay, eventually meeting the road just before Limeslade Bay. Follow the narrow pavement and then down the steps to Limeslade Bay. Leave the concrete base (unless the tide is right in) and look for some convoluted patterns of red, pink and white-coloured rocks just off to the left side (i.e. facing the sea) of the concrete base. These raspberry ripple shapes are thought to be signs of sediments dating from the Triassic Period.

The coloured rocks are found in a fairly thin seam which runs into a gash in the rocks. The gash can be seen to carry on up the headland behind the road and indeed, out of sight. It

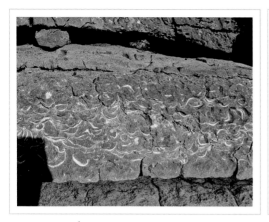

Photo w11.3 | Bivalve fossil bed.

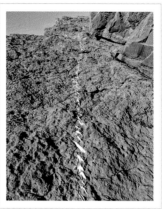

Photo w11.4 | Tension gashes running through the limestone.

carries on all the way across the headland to emerge on the other side behind the Mumbles Yacht Club site that you would have passed if you walked from Mumbles to the pier. This gash is a fault, and was once quarried away and then later filled in so that we can see only hints of it such as here in Limeslade Bay. It is thought that Triassic Period sediments (red from the desert environment in which they were originally laid down, see Chapter 7) were washed slowly down the fault to be mixed in with the crystallising calcium carbonate (see Photo w11.5).

Return to the concrete base and climb up the other set of steps to rejoin the coastal path and follow it on a stroll though some fine coastal scenery. There is only a limited amount of

Photo w11.5 | Reddish Triassic deposits add colour to whitish Carboniferous calcite.

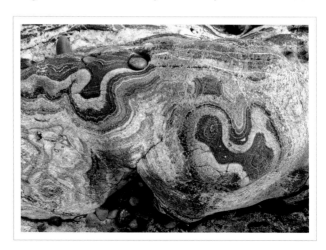

up and down and the path is in excellent condition all the way from here to Rotherslade Bay, making for pretty easy walking. There are moments of delight as new views of the distant headlands are revealed as you round corners, or reach slightly higher points. At other times the attention will no doubt be drawn to the rocks between the path and the sea, and the great variety of erosional forms cut into the tilted and angled limestone. The small rocky inlets are most impressive when being battered by heavy seas at high tide – under such conditions the erosive power of the sea can be appreciated.

The cliffs dip quite sharply here and even at low tide the wave cut platform is not exposed. However, its edge can be seen some distance out at sea, where a line of breakers offers a telltale sign of where deeper waters meet shallower ones.

The profile of the cliffs along this section of the walk has a rather well-defined shape, with largely vegetated slopes above the path which is tucked in on a slightly less steep area, before the cliffs steepen even more to reach the sea (see Diagram 9.1). This profile reflects a change in sea level (whether by falling sea or rising land, or both).

Sometimes the steep, uppermost section of the cliffs may well show some limestone bedding sticking through the vegetation, but below this section the cliff is less steep and thoroughly vegetated, with no bedrock seen. This section of the cliff is covered by scree and other 'superficial' deposits which mask the original cliff face.

The path level runs near the bottom of this section and there is often a very steep slope immediately below the path. This is a storm-eroded cliff that has been cut into the superficial deposits. At the base of the storm cliff is an area of pebbles and shells all seemingly cemented together. These are remains of a 'raised beach' which was probably formed about 120,000 years ago. The superficial deposits rest directly on top of the raised beach (thus hiding much of it from view). The beach was created during an 'inter-glacial' phase with fairly warm climate, and when there was thus a comparatively high sea level. The sea level is now lower, isolating the raised beach some way above current sea level, which has fallen by about 10m below the level when the beach was formed.

The beach is replete with shells, in particular those of a limpet known as 'patella'. The beach is thus often called the 'patella' beach. The shells, pebbles and sand grains have been cemented together by calcium carbonate and the shells are on their way to becoming fossils (see Photo 9.6), unless they are eroded away. As storms erode the superficial deposits back, the beach at the base is exposed. The beach itself sits on an old wave cut platform that is now almost entirely covered by the superficial deposits.

The track soon takes you round into Rotherslade Bay. If the tide is low you may well not recognise this little bay as being separate from its much bigger neighbour, Langland. If the

tide is in, on the other hand, the tiny bay is clearly cut off from Langland and an artificial walkway is followed round the headland below a block of apartments. There is not much to be seen in geological terms in Langland and we will pass along the path next to a line of beach huts – though you may wish to tarry on the sand or in a café and enjoy the holiday atmosphere. Otherwise follow the path out towards the western headland.

If you want to watch the surfers, several benches on the side and at tip of the headland encourage a stop. The dip of limestone strata on the eastern side of the bay can also be examined in leisurely fashion from here.

Continue along the coastal path towards Caswell. At first the cliffs here also run down steeply to the sea. However, only if the tide is well out or falling, as you begin to approach Caswell is it possible to find a way down through the tidal cliffs to reach a sandy beach. There are one or two obvious gaps in the thick vegetation on the coast side of the path where you can drop down – with care – over the sharp, tilted rocks. Having reached the floor of the cliffs, cross onto the sand and step a few tens of metres away from the fairly low cliffs.

Just before where the cliffs start to turn away from the sea, and in towards the bay, you should be able to see a syncline in the cliffs. Once you've identified the syncline you can go up to it and climb over the first set of low cliffs to see the syncline in a bit more detail. However, be warned the rock that is exposed on this small rise is extremely sharp and jagged, so special care needs to be taken to avoid a trip or fall. The low cliffs are examples of a 'non-biogenic' limestone (i.e. limestone that is not made from life forms), namely an 'oolitic' limestone formed from the precipitation of calcium carbonate from seawater in a calcium-saturated, warm, shallow sea. The precipitation of calcium carbonate reverses the process of its earlier dissolution by rainwater. The precipitated calcium carbonate attaches to a minute particle and then is rolled around by waves, picking up more precipitated calcium carbonate as it goes, thus getting bigger (up to about 1mm) and circular in shape.

Cross the platform of oolitic limestone to the rocks forming the next low cliff where the syncline is apparent. The rocks here are well-bedded and are formed of a fairly muddy limestone in a lagoon environment. Up at the left end of the syncline the rock strata are not quite regular, and appear broken up with a sloping break in the rocks crossing over the strata.

This is a 'thrust' where, during continental collision, the compressive forces cause the rocks to break and one section to be shoved up on top of another section of rock. This often occurs where there are weaker rocks in the strata. In this case, the muddy limestone lies between the tough oolitic limestone below and tough fossiliferous limestone above. The softer rocks gave way and formed thrust planes under compression (see Photo w11.6 and w11.7).

Mumbles Head to Pwlldu

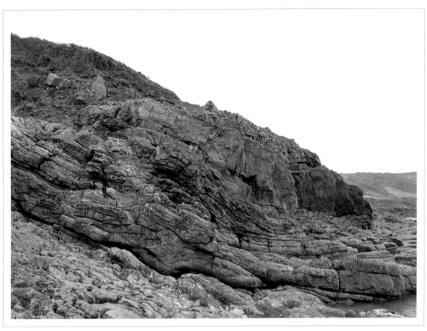

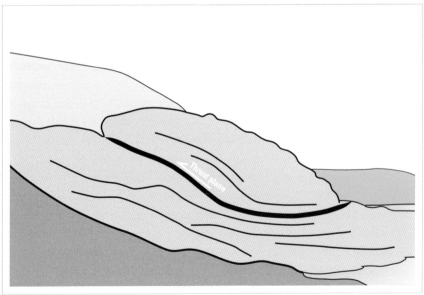

Photo w11.6 & Diagram w11.2 | Syncline and thrust exposed in oolitic limestone and mudstone in Caswell Bay.

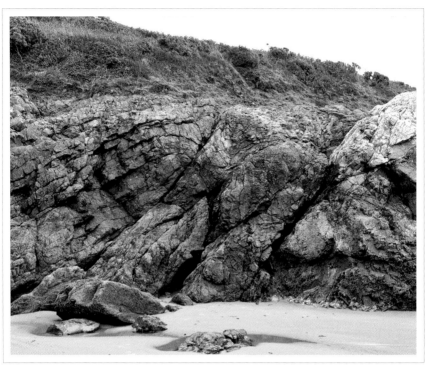

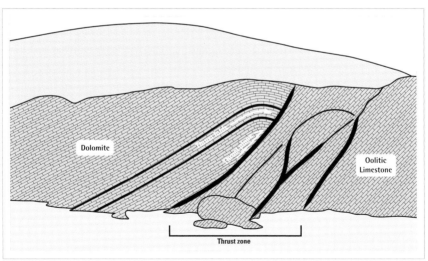

Dolomite

Oolitic
Limestone

Thrust zone

Photo w11.7 & Diagram w11.3 | Thrusting in the strata of
limestone sea cliffs on the east side of Caswell Bay.

Return to the sandy beach and follow the cliffs around to the right as they head in towards the valley. Keep an eye on the strata, looking for a fairly convoluted section (see Photo w11.7). Here you can see a much bigger thrust along with a fault zone.

From this point it is possible, at low tide only, to cross the bay on the glorious sandy beach. If the tide is fully in you will have to follow the road, and at highest tide it is necessary to go up the road for some distance before turning left on the coastal path.

If you cross the sand at low tide, a set of steep steps leads up to the path from the far corner of the bay just left of the concrete sea wall. Climb the steep steps to join the footpath coming in from the road. Turn left and follow the path alongside the cliffs. There is something of a dizziness-inducing moment where a narrow section of the path is crossed along here, with the swirling sea below. But beyond that the track is pretty good, though nowhere near as easy as the sections between Mumbles and Caswell. This difficulty can be avoided by taking the signed higher level track on leaving Caswell Bay at the top of the steep steps.

Follow the path all the way round to Pwlldu Bay. In my eyes this is one of the most enchanting of Gower's bays – perhaps in part because only residents can access it via motor vehicle and everyone else has to walk some distance to get here. It is a world away from Caswell and Langland on a busy summer's day. The attractiveness is not lost even if one translates the bay's name into English – Blackpool.

The stream draining the Bishopston valley into Pwlldu Bay has to find its way into the sea by filtering through the natural barrier created by storms piling up pebbles and boulders into an impressive barrier. If you were to wander up the (rather muddy) Bishopston valley, you would encounter a point where the stream emerges from underground where it has flowed in caverns within the limestone from higher up.

If the tide is low, cross the bay below the pebble bar to the western side, noting the regular large rills running down the lower part of the cliff above the western end of the bay. You may also note an unusually large number of loose, large blocks lying all around. This was once a limestone quarry, and the rock was shipped away from here at high tide at the base of the rills.

As you approach the cliffs around this area keep an eye out for a limestone 'mega-breccia' where limestone boulders have been cemented together with smaller pieces in a limestone cement.

To return to Swansea by bus, return to the path and climb upwards following signs to Pwlldu Head and then head directly along the vehicle track or, much better but a bit longer, follow the cliff tops to Southgate and the bus stop. If you are going to get the bus back to Swansea you may want first to carry on along the cliff top past Southgate to overlook or even visit Three Cliffs Bay (see Photo w11.8) with its magnificent limestone cliffs, caves and coves.

To return by foot to Mumbles via the high level path, follow the bridleway up from Pwlldu, ignoring the lower level path, then higher up bearing off right at the first gate and following the cliff top path. The first promontory on the right (SS 578 872) demands a visit for its magnificent views of the cliffs both close up, below you, and in the distance. Cliff top paths often offer rather restrictive views, however this rule of thumb doesn't apply on this part of the Gower coast. The shape of the cliffs, with the upper 'fossil' cliff coated with superficial deposits and running down at a medium-angle, means that views of the coast are not necessarily cut off. Also, the continual interplay of headland and inlet means that there are plenty of stunning views of the medium-distant cliffs.

The higher level paths (as well offering the pleasure of walking through intensely scented patches of wild garlic in spring and early summer) also open up some views into the core of Gower, and the higher ground of Cefn Bryn is prominent (exposing the older, underlying Old Red Sandstone).

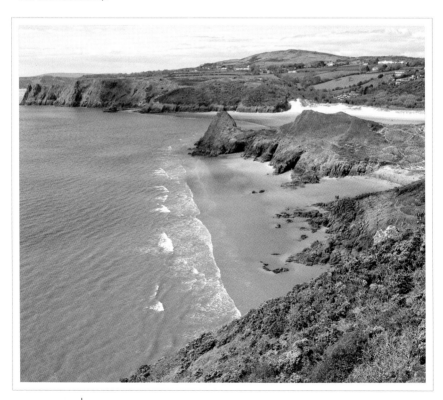

Photo w11.8 | Three Cliffs Bay.

11

Mumbles Head to Pwlldu

After dropping down to Brandy Cove, take the higher level track to Caswell Bay. From Caswell follow the low level path initially, then follow the path up to the top of Newton Cliff. The upper level path here follows the edge of a golf course, then descends again at the headland west of Langland (which offers plenty of seats with a view).

Again, from Rotherslade start initially along the lower level path and stick with it to grid reference SS 6135 8715 and then ascend to the upper level path, with superb views towards Mumbles Head and back towards Pwlldu Head. Follow the track all the way to Limeslade Bay. It's a pure delight, except for the final couple of minutes as you descend underneath a disturbingly bulging garden wall to emerge with relief at Limeslade.

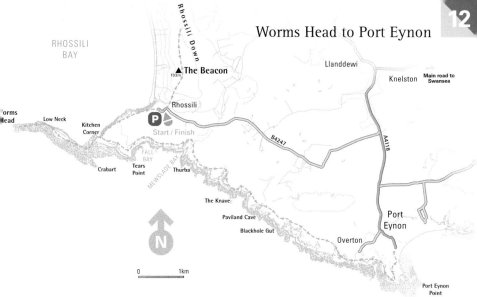

RHOSSILI
BAY

Rhossili Down

▲The Beacon
193m *The Beacon*

Llanddewi

Knelston Main road to
Swansea

Rhossili

Low Neck
orms
lead

Kitchen
Corner

P
Start / Finish

FALL
BAY

B4247

A4118

Crabart

Tears
Point

Thurba

MEWSLADE BAY

The Knave

Paviland Cave

Blackhole Gut

Overton

Port
Eynon

Port Eynon
Point

N

0 1km

Walk #12 – Worms Head to Port Eynon

START	▶	SS 414 880
FINISH	●	SS 414 880
TIME	⊙	5 HOURS PLUS
GRADE	⊙ NAVIGATION	●
	⊙ TERRAIN	● ●
	⊙ SEVERITY	● ● (TIDAL SECTION IS MORE SEVERE)

Worms Head is one of Wales's most celebrated landscapes and its reptilian profile graces many a tourist brochure. However, the journey out from Swansea to Rhossili is a long one, mainly travelling deep within high-hedged country lanes with limited views. Only occasionally do you get a glimpse of coast, though views of distant higher land (first Cefn Bryn and then Rhossili Down) are more frequent. The scenic delights of Three Cliffs Bay are hinted at en route, but eventually you reach the village of Rhossili and the coastal landscape finally strikes home.

Rhossili Head, Worms Head and the stretch of coast from Rhossili to Port Eynon, offer some sustained outcrops of tilted and convoluted limestone strata, forming

some of the most amazing limestone crags to be seen in the British Isles. On this walk, while taking time to appreciate some of the detail, such as some superb fossil areas, a main attraction is letting the imagination ponder the extravagant structure of the strata in the cliffs and narrow headlands.

Rhossili Down rises up above the northern end of the village and brings older rocks to the surface – the Old Red Sandstone from the Devonian Period, the same rock type that forms the great scarp slope of the Brecon Beacons range. There are limited bits of the Carboniferous Period Millstone Grit in between the Old Red Sandstone forming the hills, and Carboniferous Limestone that forms the cliffs, but we can ignore these largely vegetation-covered Millstone Grit rocks. On the coast, it is the limestone that dominates. There are also some traces of later rocks, but these play only an extremely minor role and are easily missed.

If the tide is falling it is possible to visit Worms Head, crossing the axis of an anticline exposed in the wave cut platform that underlies the tidal causeway, giving access to the serpent-like headland. Make sure that you check the tide times. Do not attempt to cross if the tide is coming in – very strong currents sweep across the sharp rocks and make any attempt to swim fatal. I describe crossing at the start of the walk, but it could be done on the return if the tide times demand a later attempt.

Paviland Cave is a celebrated archaeological site as the source of the earliest known 'human' fossil discovered in Western Europe, dating from some 33,000 years ago. The climate was probably colder than at present and sea level was thus lower too, so the cave looked out on a plain sloping away to the south, rather than the sea as is the case today. Attempts to get down to the cave should only be made at low tide.

It is possible to do this walk either as a linear route ending at Port Eynon if returning to Swansea by bus. Unfortunately I'm not sure that it is a practical idea to expect to get a bus back to Rhossili from Port Eynon if you are parking or camping at Rhossili. In that case the walk can be done in 'there and back' manner. If time and energy permit on such a 'there and back' walk, try to get to at least Overton Cliff before turning back. The scenery is a delight on the return – and seeking some alternatives may encourage exploration of some of the lower level paths cutting across the cliffs that are safely accessible near Overton.

Start by ascending Rhossili Down from just behind the village. The Down forms the highest point on Gower at 193 metres. It is worth walking along the length of the highest part of Rhossili Down for the views, and also to see the tough, pebbly red and grey sandstones (see Photo w12.1) that form this and other high points on Gower, including Cefn Bryn (188 metres), the long ridge that crosses the core of the peninsular.

Rhossili Bay and its glorious sweep of sandy beach is one of the most popular seaside areas in South Wales, but our trip today is intended to look at the geology of the area. The steep sea-facing side of the Rhossili Down, which runs down to the extensive sandy beach, is one side of a fault, whereby the Old Red Sandstone to the west has been thrown down in relation to the Down itself, so that to the west of the fault the sandstone is now below the surface.

The gently sloping ground at the foot of the steep western side of Rhossili Down is what is known as a 'solifluction terrace'. This is the product of repeated freeze/thaw processes acting on the sandstone cliffs, with water repeatedly getting into joints in the rock, expanding on turning into ice, and slowly forcing the rock face to break up into boulders, which then fall down to the base of the steep slope. Although the frozen water would melt during summer days, the climate then was generally cold enough to prevent underlying groundwater from melting so that the melted surface water was prevented from draining away, thus producing unstable deposits that slid downwards even on very gently angled slopes and creating the terrace as they moved further. The steep end of the terrace is a storm cliff produced with the sea at its present level.

A very distinctive 'breccia' is found towards the northern end of Rhossili Down. A breccia is a rock which contains a significant proportion of lumps of other rocks (with the lumps being bigger than 64mm in size). Breccias can be sedimentary or volcanic in origin or be related to crushing of the rocks in a fault zone. The lumps in this outcrop are clearly well-rounded on their edges, and look for all the world just like the pebbles you can see on many a coastal shore and riverbank. This indicates that this breccia is sedimentary in origin, the pebbles being cemented together with smaller particles in the form of sand grains. The cementing is part of the original process of transforming the grains of sand and pebbles into a coherent rock in a process known as 'diagenesis'. Chemical changes occur during this process, cementing the sand particles and pebbles into this tough conglomerate.

The rocks are a bright pinkish colour, though plenty of the pebbles are white indicating that they are purer quartz than the reddish ones. Rocks undergo more chemical changes when they are exposed to the atmosphere. This is evident in the darker greyish colour of the outcrops that have been exposed for longer, compared with the lighter colours visible where the rocks have been freshly broken (see Photo w12.1). Another change the rocks undergo in

the atmosphere is the slow, imperceptible breakdown of the cement, releasing the tiny sand particles, and occasionally the pebbles, onto the ground – leaving the reddish sandy soil exposed in paths and a few other places.

The panoramic views from Rhossili Head, including inland across the bulk of Gower and to Llanmadoc Hill in the north, reveals that the bulk of the land above the coastal cliffs is fairly flat, with only isolated hills sticking out above the general level – Llanmadoc Hill, Hardings Down, Ryer's Down and Cefn Bryn. All these higher points are formed from the Old Red Sandstone, as is Rhossili Down itself (see Map w11.1).

These Old Red Sandstone bastions are fairly similar in height, with Rhossili Down running from 193m at its southern end to 185m at the northern end, Llanmadoc Hill reaching 186m, Hardings Down touching 152m, and Cefn Bryn stretching to between 188m and 167m, south-east to north-west. Only Ryer's Down is distinctly lower, at 114m, despite being Old Red Sandstone. The tough quartz rocks give little sustenance to the soil, so these areas are largely common grazing land. In contrast the lower land is underlain by limestone and intensely farmed.

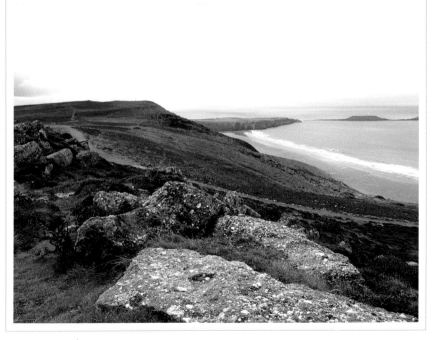

Photo w12.1 | View south along Rhossili Down (with pebbly Old Red Sandstone exposed in the foreground); Worms Head in the distance (Carboniferous Limestone).

Worms Head to Port Eynon

These Old Red Sandstone outcrops, interspersed with Carboniferous Limestone, are the result of the tectonic compression of the once horizontal strata. Later on the walk the tilt of the limestone will be easy to spot, but from this point there is little rock to be seen under the vegetation. However geologists have worked out how the rocks have been folded (see Map w11.1). As can be seen in the map, the Old Red Sandstone is found along 'anticlines' or upward folds, breaking through the younger, overlying limestone.

It is quite common for older rocks to be exposed at the core of anticlines, as the upper sides of rock layers are stretched and fractured when folded like this. These stress weaknesses and fractures are later exploited by erosion. Here the limestone has been eroded away from above the sandstone. The sandstone is more resistant than the limestone which is found where there are 'synclines' or down folds, so the younger rock is eroded into the lower land in today's landscape by a mix of the forces of tectonic compression and erosion by ice. The resistant Old Red Sandstone was not carved entirely flat and today forms Gower's high points (see Map w11.1). The height differences range from around 60–80m on the cliff tops, to about 100m within a few hundred metres inland (while as seen above, the sandstone downs rise to about 180–190m). The bays of Port Eynon and Oxwich are located where synclines have brought the soft shales of the Millstone Grit to the surface.

The flatter land around the higher points falls away suddenly to the sea in coastal cliffs forming the classic Gower coastline – or to be more accurate, the present coastline which is just one out of many different coastlines that have existed in the past. Geologists are not entirely certain how this all happened, or even when (estimates range from 200 million years ago to a comparatively recent 20 million years). The current view is that these are different 'erosion surfaces' (sometimes called 'peneplains'), probably due to the sea levelling off the weaker rocks before the land rose up towards its present height as a result of tectonic forces. This cycle of events happened a few times, explaining the existence of the various levels.

From Rhossili Down return to the village and follow the path along Rhossili Head towards the causeway linking the mainland to Worms Head (the causeway is only visible at low tide). Note the sharp tilt of the rocks exposed in the cliffs on the right as you walk towards Worms Head.

The tidal peninsular derives its name from its apparent serpent-like form. It is a fascinating mix of the regular and the irregular. While its line twists and turns, its high points share the flat 'peneplain' level of the mainland around Rhossili Head; the highest point on Worms Head being 47m on Inner Head, and 56m on Outer Head. There is also a great regularity in the 'scarp' and 'dip' arrangement of the tilted rocks. The limestone is tilted downwards, but very steeply, from north-east to south-west giving the steep upper cliffs of the scarp slope on the

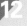

face looking towards Rhossili Down (cut into at the base by new sea cliffs), and the grassy and regular dip slope down to the south-west. The irregularity comes in the form of the contorted rock strata and the twisting line of the peninsular. This is an expression of the complex folding of the rocks with an anticline being centred on the tidal causeway linking Worms Head to the mainland. Note that the slippery, rocky terrain on this tidal section requires great care.

Worms Head as a whole consists of several smaller sections. Inner Head is the largest in area but narrows to its own tidal causeway at Low Neck. The land then rises some 20m above sea level to expose an impressive natural arch, the Devil's Bridge (see Photo w12.2). The land then rears up to the isolated bookend-shaped lump of Outer Head which, despite its small size, reaches the height of 56m, making it the highest point on Worms Head.

Return to the mainland and climb up to the top of the cliffs to follow the track towards Tears Point and Fall Bay. Make sure to leave the track (which hugs a stonewall) near where the wall and track make a sharp left bend as you first start to overlook Fall Bay. At this corner in the stonewall, head away from the wall to the top of the cliffs overlooking Tears Point for magnificent views back along the cliffs to Worms Head.

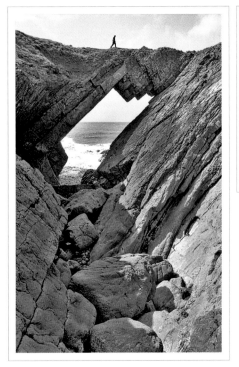

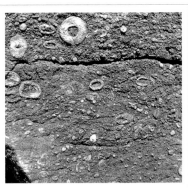

Photo w12.2 (left)
Devil's Bridge, a natural arch cut into tilted limestone strata, on Worms Head.

Photo w12.3 (above)
Crinoid fragments in the Carboniferous Limestone near Tears Point.

The headland above Tears Point is also a good viewpoint for studying Fall Bay and the coast beyond. Fall Bay shows quite clearly the tilted strata forming a series of steps and slopes over which you have to climb if you walk along the rocks at low tide.

From the headland above Tears Point pick a route down the slope to the rock outcrops just above sea level (at about SS 410 870) where some richly fossiliferous strata can be found in the tilted beds, with fragments of cylindrical or ring-like crinoids, brachiopod shells and corals (see Photo w12.3). Some easy rock scrambling is required.

At low tide it is possible to walk all the way to Mewslade Bay at beach level, enjoying a view of the impressive cliff scenery from below. At higher tide levels it is essential to follow the highest level path. A tiny notice tells you that a lower level path (just above the steep section of the cliffs) is closed. It would be highly inadvisable to ignore this warning and risk a perilous journey at this level, where a single slip or trip could be fatal. So, take the highest path and enjoy superb views of the cliff architecture from a safer vantage point.

Follow this higher level path until you meet the track leading down into Mewslade Bay (marked by signposts). The narrow valley down to Mewslade Bay runs along a fault (as do some other narrow valleys further on). The valley is a 'dry valley' with a spring lower down near to sea level, where water running in underground channels in the limestone resurfaces just before entering the bay. The valley was dug out by powerful meltwater flowing over frozen ground during the last ice age, when an ice sheet was a short way to the north. The fault provided a zone of weakness which the meltwater could exploit.

It takes a little effort to scramble down a small rock step to get on to the beach itself (and indeed it may not be possible to get that far at very high tide). Note the rocks as you descend this rock step. The rock is known as a 'fault breccia'. As noted above, a breccia is defined as a rock containing lumps over 64mm in size. In this instance the breccia has been created by the breaking of the rocks by the enormous pressures exerted along the zone around the fault.

There's plenty of white or creamy calcite, the crystallised form of the calcium carbonate that makes up the limestone. But you can also see chunks of darker material, some of it reddish in colour (see Photo w12.4). These are remains of deposits of sedimentary material during the Triassic Period (250–200 million years ago). The Triassic deposits have become churned up and mixed with the calcite in the gross tectonic movements that took place along the fault. Similar Triassic deposits mixed with calcite are encountered on Walk 11 at Limeslade Bay.

The deposits are tiny remnants of a once much wider cover of Triassic rocks which has now, by and large, been eroded away (though Triassic rocks do outcrop elsewhere in Britain including the South Wales coast further east from here). These deposits in Mewslade only survive as they fell into, and they have been protected deep within, the fault zone.

Worms Head to Port Eynon

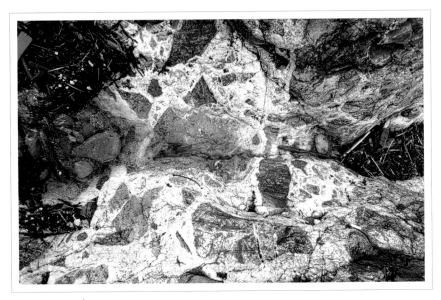

Photo w12.4 | Triassic deposits (reddish) mixed up with calcite (white) derived from the Carboniferous Limestone.

Return up the dry valley of Mewslade to the marked coastal path and head further east at the top of the cliffs.

Two further narrow dry valleys are met over the next couple of kilometres, Rams Grove and Foxhole Slade. Both are situated along faults and both have springs just above the beach level, as in Mewslade. The famous Paviland Cave is accessible from Foxhole Slade but at low tide only, by going round to the west side of the bay and ascending to the cave with great care (see Chapter 9 and Photo 9.1).

All the way along the walk there is an obvious main path that stays some way from the cliffs, sticking close to the edge of agricultural land, but there are also innumerable tracks which allow you to walk nearer the edge of the cliffs (while returning to the main track to cross the top of several large coastal indentations). These tracks offer better views of the cliffs, allowing you to follow all the indentations and benefit from the vistas found on the intervening headlands. However, this does involve more ground to be covered and thus takes longer, especially as the ever-changing views grab the attention and draw you to stop and admire them, perhaps also to take photographs (see Photos w12.5 and w12.6).

In addition there are also some tracks lower down in places. These are potentially dangerous, but with a little care can be tackled by the experienced walker, though there are also

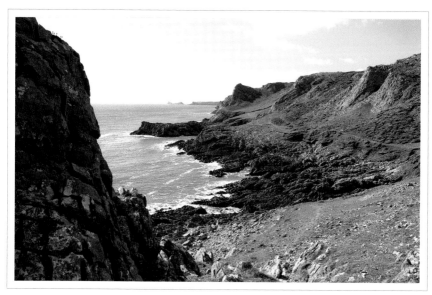

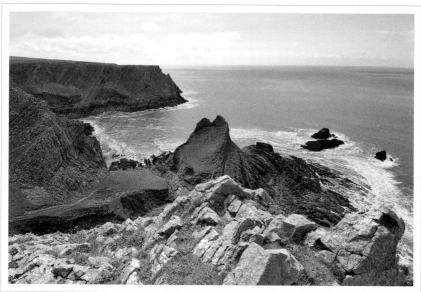

Photos w12.5 & w12.6

Gower limestone cliff scenery: w12.5, current sea cliffs, raised beach

(just below path level) and 'fossil' sea cliffs, with Worms Head in distance);

w12.6, steeply tilted limestone strata carved into sea cliffs.

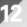

much easier sections (see Photo w12.5). In the long days of spring and summer it can be worth exploring these tracks on the return leg of the journey, especially near to Overton Cliff. Further west the difficulties and dangers increase, and the cliff top path needs to be regained after a short while.

The shape of the cliffs is obviously highly dependent on the dip of the rocks, as well as the way each section of coast faces into the powerful westerly currents. The raised patella beach is well exposed around the base of the cliffs near Overton Cliff (see Photo 9.5). Further west and at low tide some impressive sections of wave cut platform can be seen along the coast around here (see Photo 9.4). From Overton Cliff, either return on foot to Rhossili or continue to Port Eynon as preferred.

Nash Point

Walk #13 – Nash Point

START	▶	SS 916 682
FINISH	●	SS 916 682
TIME	☾	4 HOURS PLUS
GRADE	⊙ NAVIGATION	●
	☁ TERRAIN	● ●
	✪ SEVERITY	● ● ● ● ● (BECAUSE OF TIDES)

The coast of South Glamorgan between Ogmore in the west and Penarth, near Cardiff, in the east is a delight for those interested in rocks and the structure of the earth's uppermost crust. The bedded sedimentary rocks interleave different rock types in a mass of layers, now exposed in section. These cliffs are best seen from below on the platform cut by waves into the retreating cliff face. Views of the cliffs are limited from the cliff top path except at a few points.

The section of the coast near Ogmore (a short distance north-west of this walk) is home to the youngest rocks in South Wales, dating from the Jurassic Period. The

Nash Point

recommended route offers the chance to view slices through slightly older rocks, but still ones much younger than those found elsewhere in South Wales.

A critical feature of coastal cliffs is that their creation is one of the faster acting geological processes. It takes an inordinate time to lay down sediment, convert it into solid rock, allow for accumulations of different layers or types of rock and then to push those rocks up towards the surface. All this happens too slowly to impinge on everyday human consciousness. Erosion, too, is a normally a slow process.

The creation of sea cliffs, however, happens on a much faster timescale. Sections of the cliffs can collapse at any time and a walk along the rocky 'wave cut platform' below the cliffs (at low tide) will display several recent falls. A walk along the cliff top path will also offer plenty of evidence of how the route of the path has had to be moved inland because of the collapse of the cliffs. On the recommended route parts of a stonewall have disappeared along with the land on which they stood and only a short section of wall remains, isolated between two falls, looking set to last only a short time longer. The creation of sea cliffs is a process that we can see happening in a human timescale.

The recommended route is to follow the cliff top coastal path in one direction and to attempt a trip along the wave cut platform in the other direction. **Given that there are only a few places where you can get off the wave cut platform when the tide comes in, it is vital that you only venture on to the wave cut platform on a falling tide so that you have enough time to get to a safe point.** Check tide times before you go on the walk and pick a day where high tide is an hour or so before you intend to start. If necessary, you can reverse the directions and walk outwards on the cliff top path, returning along the wave cut platform.

While walking along the wave cut platform keep well away from the base of the cliff – a collapse could occur at any time. For the same reason it makes sense not to be tempted to enter caves. Care needs to be taken on the platform as it would be easy to trip up.

For emergencies, take a mobile phone and a whistle (you may well not get a mobile signal due to the cliffs). Six long blasts on a whistle repeated every minute is the recognised emergency signal. If you can get a mobile signal, call 112 and ask for the coastguard.

Cliff collapse means that there are dangers with the cliff top path too. Keep well away from the edge and avoid this path in very high wind conditions. This path, I'm afraid, can be a bit disappointing, as the views of the cliffs and the wave cut platform are infrequent, but it does serve as a useful and pretty easy way of getting back to the start point.

The start/finish is at a car park 1.5km south-west of Marcross. Start by dropping down to the floor of the steep-sided valley, Cwm Marcross, a channel carved into the rock by boulder-laden high-powered glacial meltwater flows towards the end of the ice age when large amounts of ice were melting. Only if the tide is falling, follow the headland out onto the rock cut platform, keeping a sensible distance from the base of the cliffs. The rock headland is dramatic in outline from virtually any angle, but especially from below. It is clearly made up of layer upon layer of rock, limestone and mudstone, built up one on top of another. The rocks were laid down about 200 million years ago in the Jurassic Period – making these some of the youngest rocks in Wales.

Not all the layers are of equal thickness, and clearly not all are equally resistant to erosion – there is an obvious notch cut into the corner of the headland a short distance above the wave cut platform (see Photo w13.1). This reflects differences in the proportion of limestone and mudstone in each section of the cliff. The tougher limestone beds are slightly thicker and more dominant in the upper part of the cliff, while lower down the mudstone is almost in equal proportions so the cliff is more easily eroded.

Follow the headland round to the west for a short distance to appreciate the view along the cliffs towards Ogmore. The run of the cliffs is an impressive sight. A gentle anticline can be detected in the strata by looking north-west along the cliffs from just round Nash Point. Carry on north-west for a short distance, checking the rocks in the wave cut platform as you cross from one bed to another for fossils embedded in the rocks.

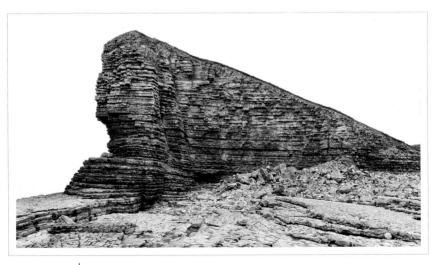

Photo w13.1 | Nash Point.

Nash Point

There are some quite interesting features where you can see how the cliff is being undermined. Photo w13.2 shows a set of faults in the rocks along which a collapse is preparing to happen. The lower section will be eroded away until the upper section is overhanging and eventually collapses – perhaps as a solid block. Photo w13.3 shows an area a bit further on where a collapse has taken place. A coherent block can be seen in the centre of the lower section surrounded by smaller material. Also several faults can be seen around the collapsed area.

If you plan to walk the full described route it is best not to go too far to the north-west, but instead use the falling tide to turn back, rounding Nash Point once again and then following the coast roughly eastwards. Once you have rounded the Point the wave cut platform contains blocks of fallen rock with prominent fossils apparently stuck on top of the rock (see Photo 7.5). The fossils, popularly known as 'devil's toenails' and formally as *Gryphaea*, are an extinct form of oyster. They appear rather like a colony of modern snails crossing the rock surface, but they are indeed fossils, and a close examination reveals that their surface is pitted from being bashed by other rocks in the churning seas at high tide. The limestone surrounding the fossils has been weathered away to leave the fossils standing proud on the surface.

The next section of the walk following the wave cut platform should only be attempted on a falling tide (otherwise use the cliff top path). There is no way off the wave cut platform until you reach the 'bay' at St Donat's/Atlantic College. Similarly if you carry on along the wave cut platform after St Donat's it will again be difficult to get out of danger until you reach Llantwit Major, so make sure that you will be safe before heading east.

The cliffs form an impressive and fairly uniform-looking wall running away into the distance for nearly 2 kilometres. They are cut into at their base by a series of caves, battered out of the rock by pounding during storms. The caves have been excavated on 'joints' or

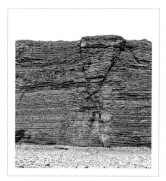 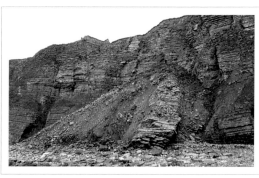

Photos w13.2 & w13.3 | Cliff erosion: Photo w13.2: fault zone provides weakness where cliff collapse can take place; Photo w13.3: the aftermath of a cliff collapse.

natural cracks in the rock. The roof of the caves is formed by a rather resistant band of limestone (with some thin mudstone), known to geologists as the Sandwich Bed. As the caves are enlarged they eventually undermine the overlying cliffs and a collapse occurs.

Pass over layer after layer of the rocks sticking out to sea as you head along the wave cut platform towards St Donat's/Atlantic College, which remains out of sight until you round the headland shortly before arriving at the concrete jetty which allows the college to get its boats in and out of the sea. Watch out for the fixed rope on the jetty. Access to the cliff top path is possible here where it passes in front of the concrete sea walls.

There is another way off the wave cut platform about 350m east of St Donat's, at Stradling Well, where there is a set of steps to the lowish cliff top. Beyond that there is no way off the tidal zone for another 1.5 kilometres or so.

Just beyond St Donat's the cliffs curl away from the sea and the rock outcrops actually disappear under vegetation for a few metres, forming a slight bay, Stradling Well (see Photo w13.4). This is a chunk of land, some 70m wide, that is located on a fault zone, and where the land in the middle has dropped downwards between two faults at the edges of the area. You can see the way in which the strata have been pulled downwards on the western side of the bay, and also to the right of the set of steps seen at the back of the bay on the eastern side. The vertical line of a fault is quite clear on the eastern side.

Geologists reckon that this dropping down of the central block must have happened some time ago as the vegetated cliffs at the back of the bay are level with the rocky cliffs on either side, so the movement must have pre-dated the creation of the cliff face at least.

You can fairly safely approach the cliff near where the strata disappear on the western side. Here you can see where drainage water containing dissolved calcium carbonate has seeped through the rock and, on coming into contact with the atmosphere, precipitated the calcium

Photo w13.4

A block of rock has 'downfaulted' in this area.

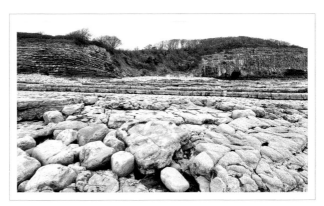

carbonate which has then collected on the surface to form what looks like a sodden mass, but is actually hard to the touch. This material is known as 'tufa'. Some tufa mixed with twigs can also found forming strange boulder-like shapes near the western edge of the fault zone.

If you wish, and the tide is still well out, you can attempt the next 1.5km or so to Tresilian Bay and another 1km to Llantwit Major. Near to Tresilian Bay you pass an especially large cave cut into the cliff base, known as Reynard's Cave, extending nearly 50m into the rock. You can reach the cliff top path here. If you carry on along the wave cut platform, more small caves are seen beyond Tresilian Bay.

The wave cut platform increasingly disappears out of sight under a blanket of boulders and pebbles. The river flowing down the valley from Llantwit Major, the Afon Col-huw, is responsible for this feature both directly and indirectly, despite being a rather small river in a rather over-sized valley. The river has indeed built out a small delta, so is directly the cause of part of the pebble cover here. The delta has also acted as a barrier to wave-borne movement of pebbles eastwards along the wave cut platform, so such pebbles have built up along the western edge of the delta, indirectly as a result of the river. Like the Marcross valley seen at the start of the walk, this valley is rather large for such a tiny stream and was carved out by boulder-laden glacial meltwater flows towards the end of the ice age. A good view of the delta and bank of pebbles is had from the cliff top path near the start on the return leg of the walk.

Once beyond the pebbles, and alongside more rocky wave cut platform, the patterns created by the way the slightly tilted rock strata intersect with the earth's surface can best be appreciated on the higher level cliff top path on your way back between Tresilian Bay and St Donat's. The patterns can be very striking at low tide (see Photo w13.5). A number of faults cross the wave cut platform on the approach to St Donat's and can be distinguished from the cliff top path. The views are more limited from the high level path after you have passed St Donat's. Two lighthouses herald your return to the vicinity of the start/finish point.

Photo w13.5

The wave cut platform between Tresilian Bay and St Donat's, looking west.

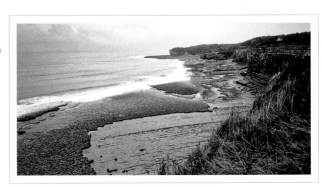

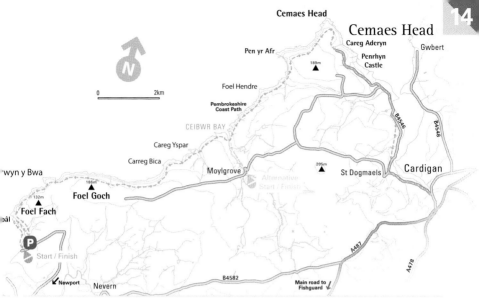

Walk #14 – Cemaes Head

START	▶	SN 055 406
FINISH	●	SN 178 457
		START & FINISH POINT FOR THE 'THERE AND BACK' WALK:
		CAR PARK AT MOYLGROVE, GRID REFERENCE SN 117 446
TIME	☾	UP TO 6 HOURS
GRADE	⬆	NAVIGATION ●
	☁	TERRAIN ● ● ●
	✦	SEVERITY ● ● ●

The Pembroke Coast Path runs for just under 300km around the jagged south-western tip of Wales. Virtually every step, every corner, every cliff and every cove presents the walker with a stunning new vista of the rocky coastal architecture and stark geological structure. The path offers walkers and those interested in earth sciences a delightful plentitude of sharp slices through the contorted geology of early Wales.

Given the variety of geology to be encountered on the coast path, one could write a guidebook just about the geology along its length, and indeed there are such

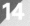

books available (*Folds, Faults and Fossils: Exploring Geology in Pembrokeshire* by John Downes; and Brian S John's book *The Geology of Pembrokeshire*). For this book about South Wales in general the author is inevitably presented with the invidious task of having to select one or two examples to cover in these pages.

I decided to exclude the southern sections of the coast path area, as the rocks which outcrop along the coast there are Old Red Sandstone and Carboniferous Limestone. These rocks have been given some coverage elsewhere in the walks contained in this book, including coastal limestone scenery on Gower. Unfortunately this exclusion applies to some exquisite cliffscapes cut into the red sandstone and grey limestone on that southern part of the Pembrokeshire Path.

North Pembrokeshire, however, is home to older rocks, including some of the oldest in Wales, dating from the pre-Cambrian as well as the Cambrian and Ordovician Periods. The coastal (and some inland) outcrops in Pembrokeshire also include volcanic or 'igneous' rocks, whereas all the rocks elsewhere in South Wales (apart from an igneous outcrop near Builth Wells) are sedimentary. So it makes sense to cover these rocks in order to ensure there is a wide geological range in the walks in the book. This walk covers the quieter, wilder end of the path, while Walk 15 looks at the area around St Davids.

The very ancient rocks of this area have undergone compression, folding and faulting in times before the rocks of the Carboniferous Period and even younger rocks of South Wales were created. This means that a record of South Wales's earlier geological history is stored in these rocks – a record that is uncovered along the coast at some spectacular geological coastal sites. This recommended walk has been selected in part because it contains such graphic illustrations, including some of the best examples in the whole of Britain of intense, large-scale folding caused by the collision of continental plates.

On a more subjective level, I personally find this section to be the most magnificent part of the Pembrokeshire Coast Path, the cliffs and headlands seeming to support a much wider range of sea birds as well as being a bit bigger and wilder than coast to the south – though I'm sure that many justifiably would differ from this opinion.

I have described the walk in two forms – as a long, linear walk with different start and finish points, and a shorter version as a circular route. If the linear version is followed you will need to think about transport arrangements such as using the bus service, which is eminently possible provided you check bus times in advance.

For a long linear walk, beginning near Newport and ending at St Dogmaels, start from the car park on Newport Sands. If the tide is out it is possible to start by walking along the wave cut platform for a distance of 3–400 metres (to about SN 054 409) to see an impressive example of a large-scale fold in the rocks, an 'anticline'. The steep, narrow nature of the sides to the anticline, and the sharp angle of the fold, make this what geologists call a 'chevron' anticline. A slightly less impressively clear set of anticlines and synclines is seen in the next cove.

The rocks are a 'mudstone', that is a sedimentary rock formed from tiny grains of sediment. Over 400 million years ago these sediments were brought down by streams and rivers from land to be dumped in river flood plains, deltas and the seas. There the sediments slowly drifted to the bottom and, over a few thousand years, as more and more material accumulated, the sediments dried out, hardened and underwent chemical changes that cemented the loose grains into solid rock.

Mudstones are often a comparatively less strong rock than many other rock types. When, some 350 million years ago, the continent containing these newly-created mudstones collided with another continent, enormous pressures were generated, crushing the rocks together and building a mountain range. The less strong mudstones were the first to deform in response to these pressures – resulting in horizontal layers of solid rock being bent like plastic. The result of all this can be seen right before your eyes here at this beach and on several other locations on this walk.

Pick up the coast path and start on a wonderful journey along this stunning part of the coast. One of the most interesting sections is at Pwll y Wrach (the Witch's Cauldron), marked along with 'Natural Arch', 'Caves' and 'Traeth Bach' at about grid reference SN 102 451.

The waves exploited weaknesses in the mudstones to cut a narrow cave into the land. The waves have then widened inner parts of the cave. Part of the rocks have then collapsed, creating this complex inner pool with its two natural arches giving access to the raging seas (see Photo w14.1).

If you want to follow a shorter, there and back walk, begin at Moylgrove (car park at SN 117 446) and use either the footpath on the northern side of Cwm Trewyddel or the road to reach Ceibwr Bay. It is well worth taking a diversion to the south when you reach the bay to visit Pwll y Wrach, and then returning to Ceibwr Bay to begin the remainder of the walk.

More broken off great lumps of rock form stacks on the coast between Pwll y Wrach and Ceibwr Bay. A superb view of the coast, with headland after headland running up to Pen yr Afr (the goat's headland), is opened up as you approach Ceibwr Bay. The headlands jut out

Cemaes Head

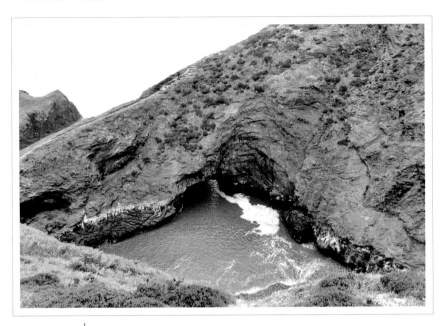

Photo w14.1 | Pwll y Wrach (the Witch's Cauldron) created by
the collapse of a sea cave, leaving a natural arch.

into the sea, displaying intense folding on the side where the sea has eroded the rock away to leave steep cliffs. Ceibwr Bay is where a major fault crosses the coast and runs inland for several kilometres on a line trending just north of east.

The rocks in this area are a mix of softer mudstones and more resistant sandstones. A headland formed of sandstone is passed at Pen-y-Graig (at about SN 112 164). About a kilometre further on, at Foel Hendre (SN 117 474) you encounter an excellent view of an example of sustained folding on Pen yr Afr (see Photo 2.4 and accompanying diagram) and other sections of the cliffs around here. This is among the most dramatic large-scale folding to be seen anywhere in Britain and it is well worth the walk out along the coastal path to see it.

The folding is fairly regular on the left of the cliffs, but is less regular on the right where faulting has shifted the strata up and down and broken the regularity of the folds. These less regular folds also have steeper sides (or 'limbs') than the more regular folds further left. In the far south-east corner some of the limbs have even been overturned during folding.

Continue to Cemaes Head with innumerable opportunities to study the folds of Pen yr Afr. If you are doing a linear version of the walk, do remember to stop and turn around to look back at the scenery you have walked past for super views and also for some interesting

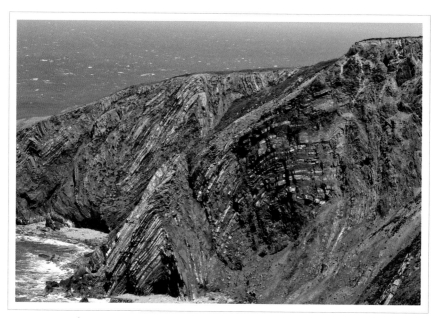

Photo w14.2 | Intense folding exposed in sea cliffs near Pen yr Afr.

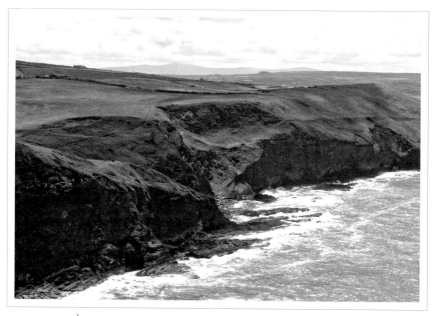

Photo w14.3 | Landslip area in the upper part of the cliffs, centre of photo.

geological features. If you are doing a 'there and back' version you'll see these features on the return leg. Look out for the landslip in the upper cliff section south of Pwllygranant (see Photo w14.3). You can imagine by looking at this landslide area how the Witch's Cauldron was formed. There is also an interesting section of folded rocks that form a stepped, curved cliff low down at the base of the sea cliffs.

From Pen yr Afr you can either continue the walk towards St Dogmaels and Cardigan or return along the coastal path to Moylgrove.

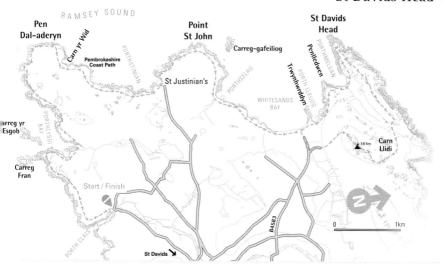

Walk #15 – St Davids Head

START	▶	SM 741 242
FINISH	●	SM 733 272
TIME	☕	6 HOURS PLUS
GRADE	⊙	NAVIGATION ● ●
	☁	TERRAIN ● ● ●
	⊗	SEVERITY ● ● ●

St Davids Head is a geological rarity in that it contains some of the oldest rocks in southern Britain, dating from the later part of pre-Cambrian times in what is known now as the Ediacaran Period. The far south-western corner of Wales and the central core of the blunt St Davids peninsular are made up of such rocks, including the area around the city of St Davids itself. These are truly ancient 'igneous' rocks of various types including 'lavas' and 'tuffs' (from explosive 'pyroclastic' eruptions).

Cambrian rocks are found to the south-east of St Davids, while Ordovician rocks line the northern coast of the peninsular and further inland. There are both sedimentary and igneous rocks among the Ordovician outcrops, while those from the

Cambrian Period are sedimentary. The term igneous includes volcanic rocks erupted onto the surface, as well as 'intrusive' rocks which didn't make it all the way to the surface but cooled down below ground. Such intrusive rocks have been isolated by erosion of the rocks that surrounded them, and now form the distinctive small hill of Carn Llidi and other isolated highpoints just inland of the coast.

This walk is intended to introduce the walker to a variety of rocks from these periods as representing episodes from the early geological history of Wales, and indeed southern Britain generally. Walking these coastal outcrops you are traversing the rocks laid down on the ancient 'basement' of the tectonic crust which even today underlies Wales, and which has travelled from the southern hemisphere thanks to plate tectonics in the intervening millions of years.

The route starts at Porth Clais, a short walk from St Davids, and ends at Whitesands Bay, near St Davids Head. The walk could be cut short by leaving out the loop around Carn Llidi and St Davids Head. A bus service can be used to return to St Davids from Whitesands Bay between early May and late September. At the time of writing the last bus was scheduled to leave Whitesands Bay at 18.40.

Follow the coast path above the western side of the 'drowned valley' harbouring the port of Porth Clais. The valley was created when sea level was lower than it is today. When sea level rose (and/or the land level fell) the sea invaded the valley, 'drowning' it and creating the inlet which forms a 'natural harbour'. Follow the coastal path, passing mainly Cambrian sandstones, some reddish in colour, but also some intrusive igneous rocks (where the molten magma did not make it all the way to erupt but cooled down below the surface).

The path is initially constrained by vegetation, but when it turns west at the head of the drowned valley there is open ground on the left between the path and the sea. At this point the main rocks are still Cambrian sedimentary rocks, but an igneous intrusion runs through these sandstones in two bands, one quite thin and the other much wider. The intrusive 'dyke' runs parallel to the coast here, that is roughly east/west, however 'jointing' within the dyke, created when the molten magma cooled to form solid rock and contracted very slightly, runs across the outcrop. The Cambrian sedimentary rocks are quite distinct with strata running east/west (see Photo w15.1 and Diagram w15.1).

You can leave the track and head down to the rock outcrops to locate the igneous rock if you wish, but the best view is from the next minor headland west. No precise date for the

intrusion is given on the official geology map of the area, but it probably dates from the Cambrian or Ordovician Periods.

The dyke runs parallel with the coast for about 1km, though it is cut into two lengths by erosion at a bay midway along this section (at about SM 739 236). There are several other outcrops of the same rock type running in a narrow (1.5km) wide arc inland from the coast

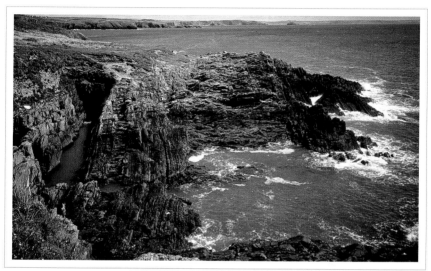

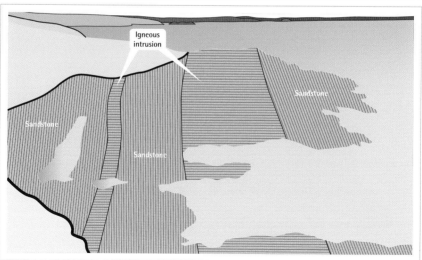

Photo & Diagram w15.1 | An igneous 'dyke' cuts through the Cambrian sedimentary rock; Porth Clais.

near Solva (some 5km to the east). These may well be connected with the igneous dyke here, and represent cooled magma that was once on its way moving up towards the surface of the earth. If it had reached the surface it would have erupted as a volcano. But this magma was probably created towards the end of the volcanic episode and lacked the ability to rise all the way, so instead it cooled down in dykes or 'sills'. These outcrops may well represent the ancient 'conduits' which fed surface volcanoes with their molten magma.

A bit further on, where the coast turns more south-westerly in direction, the rocks change, and both the Cambrian sedimentary rocks and the igneous intrusion are abruptly truncated by a much more substantial igneous intrusion forming the entire headland of Picrite. Clearly this is a much tougher rock than those you've just passed over, as it forms the headland which was once continuous out to Carreg Fran, the island/stack south of the mainland.

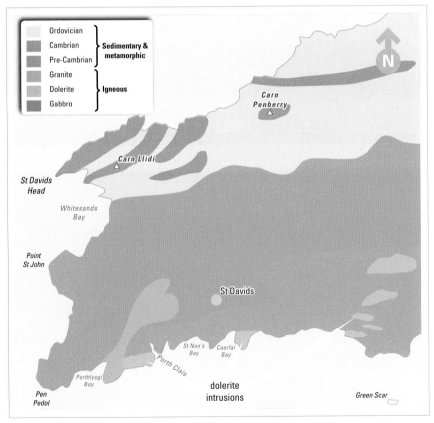

Map w15.1 | Simplified geology map of the St Davids area.

This is a 'granite' that dates from pre-Cambrian times, making it the oldest rocks on the walk so far. Granite is frequently formed from a mass of melted rocks at the base of the continental crust due to thickening of the plate (during mountain-building episodes) and heating of the deepened plate. The molten magma is less dense than the surrounding solid rock and moves upwards. Granitic magma is very viscous and doesn't flow easily, so it frequently doesn't go on to form volcanoes and the magma gets stuck low down, cooling slowly and developing large crystals that bond and offer a very tough rock, as here.

Pre-Cambrian rocks of the Ediacaran Period form the coastal section from the western side of Picrite to the bay near Maen Bachau. The rocks inland of Porthlysgi Bay, on the north-west to south-east trending back to the bay, are ancient volcanic 'tuffs' created in pyroclastic or explosive fragmental eruptions. The rocks on the west side of the bay, also tuffs, are the most ancient in Wales. These varied ancient rocks form the bulk of the coast from here to Carn ar Wig, except for a few 'dolerite' igneous intrusions. These intrusions often form local headlands (for example at SM 722 231 and 719 230) and the cliffs themselves much of the way from Pen Dal-aderyn to Carn ar Wig. They date from somewhat later than the tuffs and probably represent volcanic conduits.

More pre-Cambrian rocks are passed between Carn ar Wig and near Carn Goch. After that the rocks are once again from the Cambrian Period, although the overall seam of pre-Cambrian rocks is just a short distance inland and arcs around to the north of St Davids then runs to the east for 15km. From Carn Goch to Whitesands Bay the rocks date from the Cambrian Period and are more sedimentary rocks. The view to the north is most spectacular when you round Point St John when the outlook to Carn Llidi opens up (see Photo w15.2).

Once you reach Whitesands Bay, if you plan to take the bus back to St Davids, it is a good idea to check the bus times before venturing further so as to gain an idea of how long you can devote to the next section of the walk.

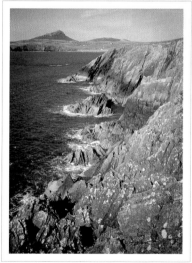

Photo w15.2 | View along Cambrian rocks forming the coast near St Davids; Ordovician igneous rocks form Carn Llidi and Carn Perfedd, surrounded by Ordovician sedimentary rock, in the distance.

St Davids Head

From the northern end of Whitesands Bay the rock type changes significantly with a mix of sedimentary and intrusive igneous rocks, dating from the Ordovician Period. The two types of rock are interlaid along a south/west to north/east trend (see Map w15.1) and form the coastal and immediate inland scenery for about 15km between St Davids Head and Mynydd Morfa (SM 874 341). The locations of the igneous intrusions are generally obvious as they form distinct high points rising above the general level of the land. Carn Llidi is the highest point and the furthest west of the obvious hills. In fact there are more such areas than is immediately obvious, as will be seen when the route follows its way around the area.

From the northern end of Whitesands Bay bear right at SM 733 271 to reach the tarmac road. Bear left at SM 732 534 and follow the footpath past Upper Porthmawr to reach access land at SM 736 276. The most direct route heads roughly north-west to curl around the back of Carn Llidi to reach the summit of the tough 'gabbro' and 'dolerite' outcrop.

There are wonderful panoramic views from the summit, most spectacularly along the coastal stretches laid out below you. This is surely one of the most magnificent coastal views in the whole of Wales. Photo w15.3 shows the view across Whitesands Bay and the headlands you walked around on the earlier part of the walk, looking roughly south-west. The overall landscape is formed from a short, sharp cliff area on the edge of a mildly undulating plain, an ancient erosion surface when the relative sea level was higher than at present.

Photo w15.4 shows the view in the other direction, looking roughly north-east. On a good day this view extends a considerable distance to Strumble Head on the coast and the Mynydd Preseli range inland on the distant skyline. A patch of farmed land lies immediately north of Carn Llidi (which reaches just over 180m), but within a couple of hundred metres there is another area of rough vegetation and slightly higher relief, Carn Perfedd (central cairn), reaching about 140m. Further north there is another pointed high point, Carn Penberry, at 175m a slightly smaller version of Carn Llidi. From this vantage point you can also see how frequently rocks protrude through the thin vegetation.

The relief and the vegetation are almost as good as any geology map in informing the seeing eye about the way in which the igneous and sedimentary rocks are interlaid, with the igneous rocks protruding through heathland, whereas the sedimentary rocks are hidden beneath thick soil. Carn Llidi and Carn Perfedd are formed of gabbro, while Carn Penberry is made up of dolerite. Indeed, on some geology maps all these rocks are marked as being gabbros. In fact, the gabbro and dolerite are derived from the same type of magma (basaltic magma), with the difference between them reflecting the size of the crystals within them. Gabbro (like granite) has larger crystals, having taken longer to cool down, while dolerite has medium-sized crystals having cooled down somewhat more rapidly.

The photos don't show the area between Carn Llidi and the coast, looking in the direction of the tip of St Davids. However, you should be able to work out where the igneous and sedimentary rocks are found, although the latter are hidden under rough vegetation rather than agricultural land. The coast from Penllechwen to St Davids Head is made of gabbro, while sedimentary rocks lie between the coast and Carn Llidi.

Drop down from the summit area towards the north then pick up one of several tracks heading back south-west. The best track is that nearest the coast, but you can reduce the effort by taking the more direct routes. Follow whichever track you prefer to the tip of St Davids Head. By following the track nearest the coast, and leaving it every so often to study the views from different rises, you see plenty of examples of the rock in close-up in the cliffs. The

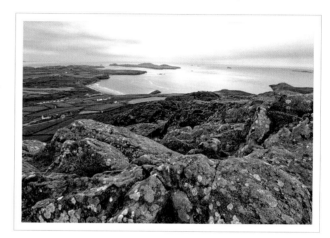

Photo w15.3
View from Carn Llidi looking south-west over Whitesands Bay.

Photo w15.4
View north-east from Carn Llidi along the Pembrokeshire coast, with Carn Penberry forming a cone shape in the centre of the photo.

St Davids Head

gabbro is clearly well-jointed with regular tilted joints as well as less regular ones. However, the rock is very well covered by lichen and few 'fresh' faces are available for closer inspection.

From the tip of St Davids Head start heading along the coast path back towards Whitesands Bay. The first bay you come to, Porthmelgan, is quite different, with the ground well-covered by vegetation with bare rock on display only in the hard to get to sides of the bay. The bay is located on the Ordovician sedimentary rocks and exists here because these rocks are less resistant to erosion than the igneous rocks that form the headlands on either side of the bay.

The next bay, Porth Lleuog, is also sited on sedimentary rock, though a thin outcrop of volcanic tuffs provides an intervening local headland, with a stack made of light-coloured rocks, towards the bay's northern end. The light colour betrays the fact that these volcanic rocks are formed from 'rhyolitic' magma. The same magma as forms granite if the crystals are large and rhyolite if they are small (whereas gabbro and dolerite are formed from darker basaltic magma).

The sedimentary rocks are exposed in the bay back wall showing highly tilted layers of rock (see Photo w15.5).

The long, thin headland of Trwynhwrddyn (the ram's nose) is sited on a fault that has displaced the Ordovician sedimentary rocks here. Walk out to the tip of the narrow headland if the tide permits. The sedimentary sandstones and mudstones date from the Cambrian Period. Return to Whitesands Bay and take the bus back to St Davids.

Photo w15.5 | Porth Lleuog; tooth-like, light-coloured, 'rhyolitic tuffs' stack in the centre, surrounded by sedimentary rocks.

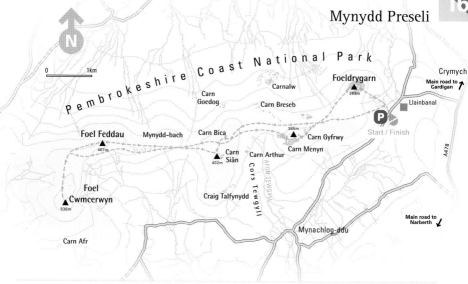

Walk #16 – Mynydd Preseli

START	▶	SN 165 330
FINISH	●	SN 165 330
TIME	🕐	4 HOURS
GRADE	⊕	NAVIGATION ● ● ● ●
	☁	TERRAIN ● ● ●
	❸	SEVERITY ● ● ● ●

There is general agreement that the 'bluestones' which form an important part of the magnificent Neolithic monument at Stonehenge are exactly the same type of rock as that which outcrops on Mynydd Preseli in Pembrokeshire, and that the stones must have originated in South West Wales. There is less agreement on how the rocks got to Stonehenge, and whether they were transported by ice as 'erratics' or whether the agency of their removal was human beings. Geologists, except those who think that the ice sheets never reached that far south, favour glacial transport. Archaeologists tend to favour humans as being responsible for their movement.

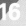

Mynydd Preseli

Whatever the truth of their transportation, the bluestones of Mynydd Preseli and Stonehenge point to the central role of rock – the 'lith' of Neolithic – for early British populations. The rocks of Mynydd Preseli were also used to make large numbers of stone tools, examples of which have been found in various places in Britain. We should recognise those involved as the first geologists. These pioneers sought out, extracted and worked and then prized the rock which made good tools, and awarded it a central religious/cultural role too.

This walk covers quite a large area, but due to the prevalence of vegetation visits only a handful of rock outcrops. However, for anyone interested in geology or archaeology, a visit to the source of the Stonehenge 'menhirs' is a must if you are in the region. Menhir means long stone, from Breton 'men' and Welsh 'maen' (stone) and 'hir' (long). The reason the rocks here break up into long stones is because of the way 'joints' are created in these originally igneous rocks when they cooled from a hot molten state to a colder solid state.

I have generally ignored archaeology, both ancient and modern, in these walks. The reason being that there is so much archaeology on South Wales's hills and in its valleys and along its coasts, that to mention many examples would have put significant demands on the available space, so I have mentioned only the occasional feature or facet, often ignoring plentiful archaeology. Alas, there is also far more archaeology on Mynydd Preseli than I can find space to mention, as the whole area is immensely thick with ancient sites.

The shape of the Preseli range rather mitigates against circular routes and encourages instead a linear, there and back route, largely using roughly parallel outward and return tracks. The outward leg visits various locations, while the return leg by-passes most of them for a more direct line.

Navigation would be extremely testing if you had ventured well into the walk and the mist descended. The geological features are confined to the first few locations mentioned in the text. The recommended route, however, guides you to the highest spot in the range and a very fine viewpoint. You can include or leave out this section of the walk as you wish.

Follow the bridleway along a lane that leaves the road at the parking place. After about 200m go through a gate and head right (north) for a short distance to pick up a track heading north-west to the rock outcrops of Foeldrygarn (smooth, rounded hill of three cairns).

As well as being home to the three Bronze Age cairns of its name, Foeldrygarn is also an ancient 'hillfort', probably dating from the Iron Age, with a series of overlapping enclosures demarcated by stone-revetted banks. The fortress-like effect is amplified by the natural outcrops of the hill which present, in places, mildly formidable bastions (though with ease of access in the intervening areas). Some 200 plus house platforms have been traced within the inner enclosure. These remains probably represent a long-standing Iron Age village – perhaps acting as a centre for a wider area.

As for the rocks of Foeldrygarn, they are all 'igneous' rocks, the product of the cooling of molten magma that erupted onto the surface either as lava flows or as explosive 'pyroclastic' ('fragmental') eruptions. Pyroclastic eruptions occur where the magma is sticky and contains lots of gas. Instead of flowing easily as lava, this type of magma cools down and congeals in the vents until the pressure of the contained gases can no longer be withstood, and the whole mass shatters into tiny fragments of molten magma and masses of exploding gas. This cools down to form a type of rock known as a 'tuff'. Lavas are formed from magma that is not viscous and flows easily, thus instead of congealing it flows out of 'vents' onto the surface and cools down to form lava as a rock type.

Bedded, splintery tuffs can be found on the south-western side of the hill, while 'flow-banding' is visible in lavas forming crags on the eastern side. Columnar jointing can also be seen in the crags of Foeldrygarn (see Photo w16.1). Jointing occurs when magma cools and contracts slightly. If the cooling happens rapidly enough, the jointing can take on this regular 'columnar' form. When the rocks are exposed to the atmosphere water can enter the joints, freeze and expand, and start to break up the rock physically. The natural jointing thus creates the menhirs that typify stone henges.

Photo w16.1 Columnar jointing in lavas on Foeldrygarn.

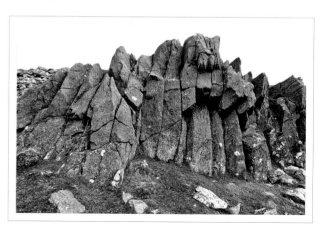

Mynydd Preseli

From Foeldrygarn head just south of west towards the complex of outcrops around Carn Menyn. The rocks of this area are often identified as one of main sources on Mynydd Preseli of the Stonehenge bluestones (which are actually a variety of igneous rocks). Geologically speaking the rock exposed in the Carn Menyn 'tors' is an igneous rock known as 'dolerite'. This is what is called an 'intrusive igneous' rock, meaning that although it started out as molten magma that rose up through the crust to near the surface, it did not manage to erupt, and cooled down underneath the surface, sandwiched between layers of existing rock (around here sedimentary mudstones). Dolerite has medium-sized crystals which means that it cooled a bit more slowly than the fine-grained lavas that cooled to form the columnar jointing on Foeldrygarn.

The dolerite of the bluestones is often described as 'spotted'. This name is due to the mix of white and dark crystals that make up the dolerite. Because of the slowish cooling and the development of large crystals, these 'spots' are easily distinguishable by the naked eye. Regular jointing is discernible in some of the outcrops.

The jointed tors are surrounded by loose blocks of the same rock. It is probable that these rocks have been broken off a once much bigger tor by 'periglacial' action, that is water getting into the joints, freezing and expanding before thawing and then re-freezing. With sufficient

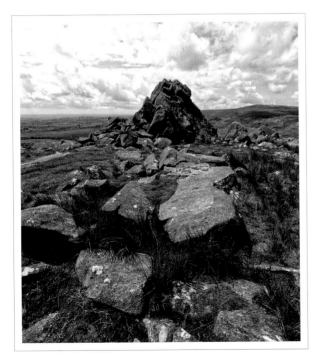

Photo w16.2 |

A 'tor' of dolerite;

Carn Menyn.

time such freeze/thaw action can bust open the exposed rocks. It would have happened during the ice age itself, when the ice sheet didn't quite stretch this far south-west but temperatures were low enough to ensure the freeze/thaw cycle.

Not all the Stonehenge bluestones are dolerite (which derives from a 'basaltic' magma) and some are what is known as 'rhyolite' (from 'rhyolitic' magma). Recently some of the Stonehenge rhyolitic bluestones have been traced to having come from north of the Mynydd Preseli range, near Pont Saeson (English bridge). If this theory is correct it gives added weight to the assumption that the stones must have been transported by ice, as otherwise a land route would have involved moving the blocks uphill, across Mynydd Preseli. Another possibility is that the ice moved the blocks of stone at least some of the way towards Stonehenge, dumping them as erratics at some point.

Bedd Arthur or Arthur's Grave is a stone circle that is passed further on the route west near Carn Bica and Carn Siân. I should add that the monument undoubtedly dates from several thousand years ago, and well before the era of Arthurian legend which comes from early medieval times. Actually Bedd Arthur is not circular but more oval in shape and is oriented with its longer axis pointing just to the north of the Preseli range (see Photo w16.3).

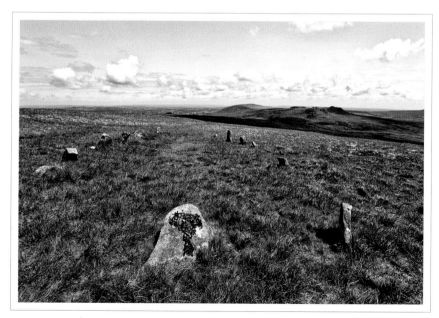

Photo w16.3 | A stone circle, 'Bedd Arthur' (Arthur's Grave), with Carn Melyn and Foeldrygarn in the distance.

Mynydd Preseli

It is probably no coincidence that the main track which runs east/west across the Preseli range passes through the centre of Bedd Arthur and suggests that one is truly following in the footsteps of people going back several thousand years when you tramp these hills.

For the geologist, monuments such as Bedd Arthur represent a connection through the medium of rock back to those ancient times, and the central importance of stone in the culture then – no doubt because rock was widely valued for its practical contribution to life. Such ancient monuments can help reminds us that it is not just life that depends on rocks and geology. Agriculture, settlement and all the accoutrements of civilisation may seem a long way from the humble subject of rock, but geology is what allows it all to happen.

The remainder of the recommended route to the highest point in the Mynydd Preseli range, Foel Cwmcerwyn, at 536m, passes but a few rock outcrops, although a mysterious stone circle is encountered at one stage. The route undulates very gently and offers far-reaching views of the 20km-wide range of hills (see Photo w16.4). From the summit make your way back to the starting point following the main track which runs between the various high points visited on the outward leg (although there is of course nothing to stop you from visiting them again if you wish).

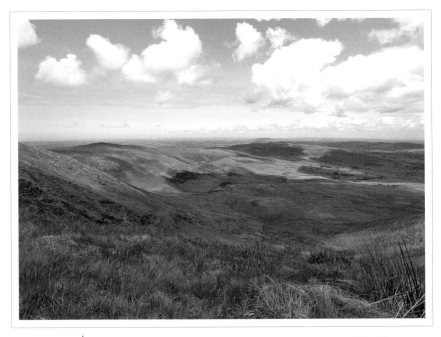

Photo w16.4 | View east from Foel Cwmcerwyn, the highest point in the Mynydd Preseli range.

Glossary of Geological & Geomorphological Terms

Algae – micro-organisms – one of the oldest forms of life on earth; blue-green algae live in colonies which secrete a carbonate mat which can survive as fossils – see 'stromatolite'.

Apron reef limestone – 'limestone' laid down on the rim of a 'limestone platform'. Often consists of a 'fore-reef' and a 'back-reef' as well as other sub-sections.

Basalt – a type of igneous rock formed from 'basaltic' magma.

Basin – low lying area (usually but not necessarily undersea level) of basement or present day surface. Rivers drain into basins and sediments are dumped in them.

Bedding – common feature of 'sedimentary' rocks, usually indicating a change in the pattern of sedimentation. Very thin bedding is known as 'lamination' (as frequently found in 'shale').

Brittle deformation – deformation as a result of cracking of rocks, as opposed to plastic or ductile deformation. Occurs on the surface and up to a depth of about 15km.

Calcareous – containing some proportion of calcium carbonate.

Calcite – a crystalline form of 'calcium carbonate'.

Calcium carbonate – an insoluble salt occurring in 'limestone' and other rocks; dissolves in water containing carbon dioxide.

Carbonaceous – as applied to rocks or sediments, contains some carbon from life forms.

Carbonate conclusion – cave, cavity or small hole created by dissolving of calcareous cement and erosion of material.

Carbonate mud – see 'limestone mud'.

Coal – a rock formed from undecayed plant debris which has undergone chemical and physical change. Strictly speaking not a rock (defined as an aggregate of minerals) as it does not contain minerals, but this distinction is best ignored.

Deformation – changes in the physical structure of rocks due to immense pressures generated by continental collision; can be 'brittle' deformation or 'plastic' ('ductile') deformation.

Diagenesis – processes affecting sediments at low pressure and low temperature (i.e. on or near the earth's surface) and result in the formation of a mass of solid rock from loose sediments – see 'lithification'.

Dolerite – medium-grained 'basaltic' intrusive igneous rock (i.e. it did not reach the surface when the molten magma rose up through the crust).

Fault – a crack in bedrock, can be a few centimetres to many kilometres wide, can be deep or shallow, can be active or passive. Often caused by tectonic activity.

Flaggy sandstones – thinly bedded sandstone which easily splits on bedding.

Fossil – the preserved form of ancient animals or plants, or traces left by them. The hard parts are either preserved or replaced by another mineral (such as 'calcite' or quartz). The term is also applied to preserved geological features, for example a fossil sea bed or a fossil cliff.

Gabbro – large-grained 'basaltic' intrusive igneous rock.

Granite – intrusive rhyolitic rock, large grain size as it cools slowly deep down.

Grit – a 'sedimentary' rock made from large particles of sand. No longer an accepted term for academic purposes but is too well established to be ignored.

Igneous – rock formed from molten magma; can be erupted by volcanoes ('volcanic' including 'lava' and 'pyroclastic' or fragmental eruptions) or can cool down under the surface ('intrusive').

Jointing, joints – cracks or small fractures in rocks with no obvious signs of displacement, often in 'joint sets' with similar orientations and origins; in sedimentary rocks joints are often either vertical or horizontal or both, while in igneous rocks jointing can form regular 'columnar' effects.

Lamination – very thin 'bedding' as occurs in 'shale' – see bedding.

Lava – 1) molten magma that flows onto the surface of the earth; 2) rock formed from lava flows.

Limestone – a general name for any sedimentary rock containing more than 50% calcium carbonate, usually, but not always, derived from animal shells and skeletons. There are many different types of limestone.

Limestone mud – very fine calcium carbonate particles, secreted by algae and other microscopic life forms, forms a well-cemented limestone; 'limestone reefs' are frequently made of limestone mud.

Limestone platform – a large platform of limestone built up on an area of higher sea floor, bounded by basins.

Lithification – the process of forming a 'rock' from loose material (e.g. sand grains) both close to the earth's surface and deeper in the crust (following subsidence, deep burial, etc.).

Lithology – name for the general characteristics such as composition and texture of rocks, usually sedimentary rocks but not always.

Lithosphere – the 'sphere of the rocks', combines the crust and outer mantle to form tectonic plates.

Magma – molten rock.

Mantle – the layer of the earth between the crust and the core; divided into the inner mantle and outer mantle, with the crust and outer mantle forming the lithosphere or tectonic plates.

Metamorphic – rock formed from another type of rock that has undergone physical, temperature or chemical transformation.

Mineralisation – process where gases and fluids from heated lower layers of the crust pass up through faults and cracks, causing changes to rock and depositing minerals, some of economic value.

Mineral vein – line, usually along a fault, where mineralisation has taken place.

Mudstone – made from mud grains eroded from land and deposited as sediments in a sea, lake or river, then hardening into rock; 'shale' is sometimes treated as mudstone.

Plastic deformation – rocks change internal shape as a result of the application of forces generated by continental collision; takes place from about 10km below the earth's surface.

Plate tectonics – see 'tectonic plate'.

Platform – see 'limestone platform'.

Platform limestone – generic name for 'limestones' laid down on the shelf, ramp or slope of a 'limestone platform'.

Rhyolite – an igneous rock formed from 'rhyolitic' magma.

Rock – an aggregate of minerals.

Quartzite – 1) sandstone made of fairly pure quartz; 2) metamorphosed sandstone with over 80% quartz.

Sandstone – a 'sedimentary' rock made from sand grains eroded from land and deposited as sediments in a sea, lake or river, then hardening into rock.

Sedimentary – rocks formed from sediments dumped in seas, lakes and rivers. Limestone, sandstone, shale, etc. are all sedimentary rocks. Other categories of rock are 'igneous' (volcanic) and 'metamorphic'.

Shale – made from mud grains eroded from land with the addition of small amounts of carbonaceous

material, deposited as sediments in a sea, lake or river, then hardening into rock. Shale is usually dark in colour, laminated into thin layers or beds, and is soft and friable. No longer an accepted term for academic purposes but is too well established to be ignored (replaced by 'mudstone', sometimes with a qualifier such as laminated, sometimes without).

Shelf limestone – 'limestone' laid down on the main part of a 'limestone platform'.

Siltstone – a 'sedimentary rock' made from silt grains eroded from land and deposited as sediments in a sea, lake or river, then hardening into rock.

Shake hole – see 'sink hole'.

Sink hole – hole in the surface of limestone into which surface water drains. Also known as swallow hole, swallet, shake hole.

Slate – low grade metamorphic rock where high pressure, but not high temperature, realigns minerals so that they split easily along a 'cleavage' plane.

Stromatolite – fossilised form of algae, common in 'reef limestones'.

Swallow hole – see 'sink hole'.

Swallet – see 'sink hole'.

Tectonic activity – earthquakes, folding, faulting, and earth movements (up, down and/or lateral) caused by the interaction of 'tectonic plate' boundaries.

Tectonic plate – the earth's surface is divided into a series of interlocking but independent plates of which there are two types: continental and oceanic. Tectonic plates, or the lithsophere, consist of the earth's outer layer, the crust, and the next inner layer, the outer mantle. There is a discontinuity between the outer mantle and the inner mantle and the plates move around on this discontinuity, propelled by convection currents within the inner mantle.

Thrusting – large-scale, more or less horizontal movement of rocks as a result of pressure generated by colliding continental plates; occurs in a 'thrust zone' about 10-15km below the surface, where plastic and brittle deformation both take place.

Tufa – precipitated calcium carbonate deposits.

Tuff – rock created by fragmental (pyroclastic) eruption; various forms including air-fall tuffs, ash-flow tuffs and welded tuffs.

Books and pamphlets consulted in writing this book

Archer A., Geology of the South Wales Coalfield: Gwendraeth Valley and adjoining areas (1968)

Balchin W (ed), Swansea and its Region (1971)

Barclay W et al, Geology of the South Wales Coalfield, Part V, the country around Merthyr Tydfil (1988)

Barclay W et al, Geology of the Brecon District (2005)

Bassett M (ed), Geological Expeditions in Dyfed, South Wales (1982)

Bridges E, Classic Landforms of the Gower Coast (1997)

Browne D & Hughes S (eds), The Archaeology of the Welsh Uplands (2003)

Carr S et al (eds), The Quaternary of the Brecon Beacons: A Field Guide (2007)

Cornwell J, Collieries of Blaenavon & the Eastern Valleys (2009)

Cornwell J, Collieries from Aberdare to the Ebbw Vale (2009)

Coyle G, The Riches Between our Feet: How Mining shaped Britain (2010)

Dobson M, The Aberystwyth District (1995)

Donnelly L et al, The Origin of Fault Scarps & Fissures on Moorland Plateaux & in the Vicinity of Landslides, in the South Wales Coalfield (2010)

Donnelly L et al, Block movements in the Pennines and South Wales and their Association with Landslides (2002)

Downes J, Folds, Faults and Fossils: Exploring Geology in Pembrokeshire (2011)

Driver T, Pembrokeshire: Historic Landscapes from the Air (2008)

Earp J et al, British Regional Geology: The Welsh Borderland (1971)

Edwards N (ed), Landscape and Settlement in Medieval Wales (1997)

Ford T (ed), Limestones and Caves of Wales (1989)

Francis W, Coal: Its Formation and Composition (1954)

Gayer R and Jones J, The Variscan Foreland in South Wales (1989)

George G, The Geology of South Wales: A Field Guide (2008)

George T, British Regional Geology: South Wales (1970)

Griffin A, The British Coal Mining Industry: Retrospect and Prospect (1977)

Hallworth C & Knox R, British Geological Survey Rock Classification Scheme, Vol 3, Classification of sediments and sedimentary rocks (1999)

Howe S et al, Walking the Rocks: Six walks discovering scenery & geology along the Glamorgan coast (2004)

Hughes S et al, Collieries of Wales: Engineering and Architecture (undated)

Hughes S, The Brecon Forest Tramroads: The Archaeology of an Early Railway System (1990)

Hughes S, Copperopolis: Landscapes of the Early Industrial Period in Swansea (2005)

Humphreys G, Industrial Britain: South Wales (1972)

Hunter E & Easterbrook G, The Geological History of the British Isles (2004)

John A., The Industrial Development of South Wales (1950)

John A & Williams G, Glamorgan County History Vol V: Industrial Glamorgan (1980)

John B., The Geology of Pembrokeshire (1979)

Jones E, Some Contributions to the Economic History of Wales (1928)

Leighton D, The Western Brecon Beacons: The Archaeology of Mynydd Du and Fforest Fawr (2012)

Leighton D, Mynydd Du and Fforest Fawr: The Evolution of an Upland Landscape in South Wales (1997)

Lewis C & Richards A (eds), The Glaciations of Wales and Adjacent Areas (2005)

Minchinton W (ed), Industrial South Wales 1750–1914 (1969)

Morris J & Williams L, The South Wales Coal Industry: 1841–1875 (1958)

North F, Mining for Metals in Wales (1962)

Owen T & Rhodes F, Geology around the University Towns: Swansea, South Wales (1969)

Owen T, Geology Explained in South Wales (1973)

Schofield D et al, Geology of the Builth Wells District (2004)

Shakesby R, Classic Landforms of the Brecon Beacons (2002)

Siddle et al (eds), Landslides and Landslide Management in South Wales (2000)

Simms M, Caves and Karst of the Brecon Beacons National Park (1998)

Toghill P, The Geology of Britain: An Introduction (2000)

Trueman A, The Coalfields of Great Britain (1954)

Waters C et al, British Geological Survey, A lithostratigraphical framework for the Carboniferous successions of southern Great Britain (Onshore) (2009)

Williams M, The Making of the South Wales Landscape (1975)

Wilson D et al, Geology of the South Wales Coalfield, Part VI, the country around Bridgend (1990)

Woodcock N & Bassett M (eds), Geological Excursions in Powys (1993)

Woodcock N & Strachan R (eds), Geological History of Britain and Ireland (2000)

Acknowledgements

I was fortunate enough to study at Swansea and to live in South Wales for some years afterwards and have been a frequent visitor to the region ever since, delighting in the wonderful landscape as well as visiting old friends. I have enjoyed the company of innumerable people over the years, and the following is a far from complete list of those with whom I have explored the area: Reg Atherton, Debbie Neale, Mike Pany, Jacqui Pany, Tony Ward, Mike Witchell and Gill Witchell.

My thanks to Franco Ferrero of Pesda Press for the support given to the *Rock Trails* series (in which this book is the fifth) and for the high quality of the books. Also thanks go to Heather Hall for proofreading and copy-editing the text, Vicky Barlow for the layout of the book, Don Williams of Bute Cartographics for transforming my rough diagrams and maps into a finished product, and Ros Morley for the final proofreading. Thanks are also due to Richard Robinson and colleagues at Cordee, the books' distributors, who ensure that the printed final product is available for readers in bookshops.

Photo copyright: All photos by the author except: photos 2.2, 4.11, 9.1, 9.8, 9.13, 9.15, 9.15a, 9.17 and w5.5 by Reg Atherton; photo 6.6 from Rhondda Cynon Taff Library Services, Digital Archive (photo taken by Glyn Davies 1961).

Welsh Words

A few useful tips on pronunciation – W and Y are a vowel in many words (pronounced respectively, 'oo' and 'uh'); F is pronounced as v; FF as f; OE as oi (e.g. Moel as in English 'coil'); U as 'ee' (e.g. Du as in English 'Dee'); DD as th.

Words common in place names

Aber – (river) mouth or confluence

Afon – river (see also Nant)

Allt – height or bluff, often wooded

Aran – high place

Arddu – dark heights

Bach (and Fach), also bychan, fechan – small, minor, lesser

Ber – hilltop

Beudy – cowshed

Blaen – top, crest, source of river, stream or valley

Bod – home or house

Bont (also Pont) – bridge

Braich – spur or height

Bron – breast (including of hillside) or slope

Brwynog – reedy or rushy place

Bryn (plural Bryniau) – hill

Bwlch – col or pass, entrance or gap

Bychan – see Bach

Cae – field

Caer – enclosed pre-historic or Roman site

Canol (also Ganol) – centre, middle

Capel – chapel

Carn, Carnedd (plural: Carneddau), also Garn, Garnedd – cairn, tumulus, mound

Carreg – stone or rock

Castell – castle

Cau – hollow or dip

Cefn – mountain ridge or arm

Ceunant – gorge or ravine

Chwarel – quarry

Clogwyn – cliff or crag

Coch (also Goch) – red

Coed – wood

Copa (also Cop) – summit

Cors (also Gors) – bog or marsh

Craig (also Graig) – rock or crag (so Craigafon – river crags) (also Gribin) – jagged ridge

Croes – cross

Crug – mound

Cwm – two meanings for us: 1) a mountain valley, e.g. Cwm Dudodyn or Cwm Brwynog; 2) a glacial valley or the seat of a glacier (the latter also known in English by the Scots 'corrie' and French 'coire')

Ddu (also Du) – black

Dinas – fortress

Dol – meadow

Drosgyl – rough hill

Drum – high ridge

Drws – door (Drws y Coed – door or gateway to the wood or forest)

Du (also Ddu) – black

Dŵr – water

Dyffryn – major valley, wide and flat bottomed

Esgair – shoulder of a mountain

Fach (also Bach, Fechan, Bychan) – small, minor

Faes (also Maes) – field

Fawr (also Mawr) – large, major

Fechan – see Fach

Felin (also Melin) – mill

Ffordd – road

Ffynnon – spring or source (also used as lake name where lake is the source of a river, e.g. Ffynnon Lloer in the Carneddau, or Ffynnon y Gwas below Snowdon)

Foel (also Moel) – smooth, rounded or treeless hill

Gaer (also Caer) – enclosed pre-historic or Roman site

Gallt (also Allt) – height or bluff, often wooded

Ganol (also Canol) – centre, middle

Garth – enclosure

Glan – shore or bank (so Glanafon – river bank)

Glas – greenish-blue or grey

Glyn – major valley, deep

Goch (also Coch) – red

Graig (also Craig) – rock or crag

Gwaun – marsh, moorland

Gwern – swampy land

Gwyn – white

Gwynt – wind

Haf – summer

Hafod – upland dwelling originally used for summer transhumance

Hen – old

Hir – long or tall

Isaf – lower

Llan – parish or church

Llech – slabby or slaty

Llwybr – path (Llwybr Cyhoeddus – public footpath)

Llwyd – grey

Llyn – lake

Maen – large stone (e.g. standing stone)

Maes (also Faes) – field

Mawr (also Fawr) – big, major, greater

Moel (also Foel) – smooth, rounded or treeless hill

Mynydd (plural Mynyddoedd) – mountain

Nant – usually a stream, but sometimes also used as a name for a valley, e.g. Nant Ffrancon and Nant Gwynant

Newydd – new

Ogof – cave

Pant – hollow

Pen – head

Pont (also Bont) – bridge

Pwll – pool

Rhos (also Penrhos) – moor

Rhyd – ford

Twll – hole or chasm

Ty – house (Tyn y Coed – the house in the woods)

Uchaf – upper

Waun – moor

Wen (also Gwyn) – white

Ynys – island

Ystrad – valley floor

Ystum – bend in river

Geological Names in the Carboniferous Period in South Wales

Upper Coal Measures (incl. Pennant Sandstone)	**Upper Coal Measures** (incl. Pennant Sandstone)	**Warwickshire Group** (incl. Pennant Sandstone)
Lower Coal Measures	**Middle Coal Measures** — — — — — — **Lower Coal Measures**	**Upper Coal Measures** — — — — — — **Middle Coal Measures** — — — — — — **Lower Coal Measures**
Millstone Grit	**Namurian**	**Marros Group**
Carboniferous Limestone	**Dinantian**	**Dinantian**

The Coal Measures are known as the Silesian, divided into the Westphalian (lower Coal Measures) and the Stephanian (upper Coal Measures). In the US another set of divisions is used, the Mississippian for the lower Carboniferous and Pennsylvanian for the upper Carboniferous, with other sub-divisions.

Index of Place Names